THE HOTEL
ON PLACE VENDÔME

THE HOTEL
ON PLACE VENDÔME

Life, Death, and Betrayal at the Hôtel Ritz in Paris

TILAR J. MAZZEO

HARPER

www.harpercollins.com

HarperCollins books may be purchased for educational, business, or sales promotional use. For information, please e-mail the Special Markets Department at SPsales@harpercollins.com.

FIRST EDITION

Designed by Michael P. Correy

Library of Congress Cataloging-in-Publication Data has been applied for.

ISBN: 978-0-06-179108-6 (Hardcover)
ISBN: 978-0-06-232334-7 (International Edition)

14 15 16 17 18 ov/rrd 10 9 8 7 6 5 4 3 2 1

MAR 2 5 2014

FOR EMMANUEL

IL FAUT ÊTRE TRÈS PATIENT. . .
JE TE REGARDERAI DU COIN DE
L'OEIL ET TU NE DIRAS RIEN.

LUXURY STAINS EVERYONE IT TOUCHES.

—*Charles Ritz*

CONTENTS

Cast of Characters xiii

Prologue: The Hôtel Ritz, the Mirror of Paris 1

1 This Switzerland in Paris: June 1940 7

2 All the Talk of Paris: June 1, 1898 23

3 Dogfight above the Place Vendôme: July 27, 1917 39

4 Diamonds as Big as the Ritz: September 1, 1940 49

5 The Americans Drifting to Paris: 1944 61

6 The French Actress and Her Nazi Lover 75

7 The Jewish Bartender and the German Resistance 87

8 The American Wife and the Swiss Director 103

9 The German General and the Fate of Paris 115

10 The Press Corps and the Race to Paris 123

11 Ernest Hemingway and the Ritz Liberated 139

12 Those Dame Reporters: August 26, 1944 151

13 The Last Trains from Paris 163

14 Coco's War and Other Dirty Linen 175

15 The Blond Bombshell and the Nuclear Scientists 195

16 From Berlin with Love and Last Battles in Paris: 1945 205

17 Waning Powers in Paris: June 1951 217

18 The War's Long Shadow: May 29, 1969 227

Afterword 235

Acknowledgments 239

Notes 243

Selected Bibliography 267

Photography Credits 277

Index 279

Cast of Characters

The Hotel Staff

BLANCHE AUZELLO: Reckless and beautiful American-born, German-Jewish wife of the director of the Hôtel Ritz. She lived in Paris during the war on a forged passport and was drawn unwittingly into the secret networks of the resistance.

CLAUDE AUZELLO: Chief director of the Hôtel Ritz, an old French soldier, skilled at catering to the whims of the rich and famous. Otherwise gravely polite, he was rash in his contempt for the hotel's German occupiers. Unbeknownst to his wife, he was part of a second resistance network run from the kitchens of the Hôtel Ritz and under close German surveillance.

HANS FRANZ ELMINGER: Officious German-speaking, Swiss-born deputy manager, delegated with managing day-to-day operations involving the Nazis. He was the nephew of the Hôtel Ritz president, the baron Hans von Pfyffer. Studiously neutral to all appearances, in the last summer of the war he and his wife, LUCIENNE, guarded a dangerous secret.

MARIE-LOUISE, MADAME RITZ: Widow of the hotel's late founder, César Ritz; she was a savvy Swiss businesswoman but frequently vain and foolish. Accompanied everywhere by two Belgian griffons, Madame Ritz despised BLANCHE AUZELLO, who ardently returned the favor.

CHARLES "CHARLEY" RITZ: Son of MARIE-LOUISE and the hotel's eponymous founder, César Ritz; a passionate sportsman, reluctant hotelier, and drinking buddy of ERNEST HEMINGWAY.

FRANK MEIER: Legendary bartender at the rue Cambon side bar at the Hôtel Ritz, inventor of some of the most famous classic cocktails of the 1930s; one-quarter Jewish, Austrian-born, and active in the resistance. The informal post office run from behind Frank's bar was known to both French and German intelligence operatives. His second-in-command and successor was barman GEORGES SCHEUER.

MONSIEUR SÜSS: The Swiss assistant director of the Ritz who played both sides against the middle. With Claude Auzello, he worked to circumvent German air raid regulations and to aid the Allies; with the Germans, he colluded in looting the cultural patrimony of Paris.

OLIVIER DABESCAT: Waiter, maître d'hôtel, and MARCEL PROUST's chatty informer. Stern, precise, cool, and forbidding, he was the final arbiter of social prestige at the Hôtel Ritz and, in the eyes of those who feared him, one of the silent powers behind the thrones of Europe.

AUGUSTE ESCOFFIER: One of the Hôtel Ritz's cofounders and the greatest chef of the twentieth century, he introduced the modern menu and made it possible for women to dine in public. The French actress SARAH BERNHARDT was his on-again, off-again lover and his greatest passion.

THE GERMANS

REICHSMARSCHALL HERMANN GÖRING: The morphine-addicted, flamboyantly excessive, and often ludicrous German air force general, Hermann Göring spent much of the war at the Hôtel Ritz pillaging art, running the Nazi war machine, and desperately trying to avoid the brutal rages of ADOLF HITLER, who blamed his second-in-command for failing to secure world domination.

COLONEL HANS SPEIDEL: German colonel who occupied various chief-of-staff positions in occupied Paris. Responsible in the early years of the occupation for overseeing the daily administration of the Hôtel Ritz in Paris, he was later part of Operation Valkyrie, the doomed summer plot to assassinate ADOLF HITLER.

CARL-HEINRICH VON STÜLPNAGEL: Military commander of occupied Paris; with his cousin LIEUTENANT COLONEL CAESAR VON HOFACKER, central players in the failed Operation Valkyrie.

CAESAR VON HOFACKER: With his cousin CARL-HEINRICH VON STÜLPNAGEL, one of the architects in Paris of the failed Operation Valkyrie.

HANS GÜNTHER VON DINCKLAGE: Charming, forty-something German diplomat, best known for his success with the ladies and his scandalous wartime liaison with fashion designer COCO CHANEL. Resident playboy spy of the Hôtel Ritz, he was a man of uncertain loyalties.

HANS-JÜRGEN SOEHRING: German Luftwaffe officer and wartime lover of the famous French film star ARLETTY.

DIETRICH VON CHOLTITZ: In charge of Paris during the last days of the occupation, the German general who defied ADOLF

HITLER and refused to burn Paris—perhaps not entirely out of altruism.

WILHELM CANARIS: Head of the German intelligence offices at the Abwehr in Paris, he played a dark game of counterintelligence as a British double agent until his discovery and arrest in the winter of 1944.

ARNO BREKER: "Hitler's Michelangelo" and a card-carrying member of the Nazi Party, he hobnobbed in the Paris art world during the 1920s and 1930s, becoming friends with JEAN COCTEAU and PABLO PICASSO, for whom his wife, Demetra, modeled. In 1942, he returned to occupied Paris for a celebrated art exhibit during the season that became the high-water mark of collaboration.

THE POLITICIANS

GENERAL CHARLES DE GAULLE: Cantankerous, patriotic leader of the Free French government-in-exile, whose views of the liberation of Paris were increasingly at odds with the military strategies of the Allies in that last summer of 1944.

WINSTON CHURCHILL: Eloquent and posh wartime prime minister of Great Britain and frequent Hôtel Ritz denizen, he knew COCO CHANEL from summers on the French Riviera. Increasingly exasperated with the obstreperous CHARLES DE GAULLE, WINSTON CHURCHILL would have much preferred GEORGES MANDEL in the French leadership and didn't mind saying so in the last days of the occupation.

GEORGES MANDEL: Sartorially challenged Jewish-born journalist and former French minister, he was a long-term resident of the Hôtel Ritz and persuaded MARIE-LOUISE RITZ at the fall of France to keep the hotel's doors open. Arrested early

in the war and incarcerated as a prisoner by the Germans, his execution sealed the fate of his ancient archrival.

PIERRE LAVAL: Chain-smoking chief minister of the French government established at Vichy during the Nazi period; a brutal pragmatist and arch-collaborator, often found at the Hôtel Ritz. He amassed great personal power and was responsible for the deportation of Jewish children from France but claimed he was only a "trustee in bankruptcy."

PAUL MORAND: French diplomat and writer, friend of COCO CHANEL, JEAN COCTEAU, and MARCEL PROUST, he was the PRINCESS SOUTZO's secret lover and later husband; under her influence, he took the side of Vichy France during the occupation.

THE AMERICAN WAR PERSONNEL AND CORRESPONDENTS

ROBERT CAPA: Courageous, charismatic, and dangerously handsome Hungarian-born American war photographer, he quarreled bitterly with ERNEST HEMINGWAY in the days before the liberation of Paris. INGRID BERGMAN's lover, he was part of the complicated tangle of loyalties and betrayals that ended ERNEST HEMINGWAY's third marriage.

MARTHA GELLHORN: American war correspondent and ERNEST HEMINGWAY's third wife, she was vivacious, witty, fiercely independent, and the unknowing target of MARLENE DIETRICH's devious sexual jealousy.

LEE MILLER: Famously beautiful American photographer and war correspondent for *Vogue*, friend of PABLO PICASSO; like American journalist HELEN KIRKPATRICK, she reported on the liberation of Paris.

MARY WELSH: A perky and cute American "dame" journalist with a penchant for frank talk and for going braless under tight sweaters. She had a wartime affair with ERNEST HEMINGWAY at the Hôtel Ritz and went on to become the fourth wife of the famous writer. Cozy with MARLENE DIETRICH but scorned by ROBERT CAPA, she, too, reported firsthand on the liberation of Paris.

HENRY WOODRUM: Shot down during a daytime air raid over Paris in the weeks before the liberation, the American pilot was the only man known to have "walked out" of the occupied capital. Hunted by the Gestapo, he had French citizens to thank for his unprecedented survival.

FRED WARDENBURG: Career executive at Du Pont in chemical manufacturing, he was called upon in the days after the liberation to become the scientific James Bond of his generation— and to join the undercover wing of the Manhattan Project in Paris in the race to prevent the Germans from developing nuclear weapons.

IRWIN SHAW: Novelist, playwright, journalist, and unlucky lover, he was the man who introduced his girlfriend MARY WELSH to the macho ERNEST HEMINGWAY. Later, he footed the bill while ROBERT CAPA made love to INGRID BERGMAN in a newly liberated Paris.

JAMES GAVIN: Lieutenant general in the United States Army, "Jumpin' Jim" found himself caught up in 1945 between his passion for MARTHA GELLHORN and the stratagem of a determined MARLENE DIETRICH.

THE WRITERS

MARCEL PROUST: Nervous, twitchy, eccentric, and brilliant, he wrote what many consider the greatest novel in the world—and made the Hôtel Ritz his truest home in the process.

JEAN COCTEAU: Opium-addicted and wildly talented, a writer, artist, and filmmaker who tried to save some Jewish friends from deportation but respected ADOLF HITLER; an old friend of COCO CHANEL, MARCEL PROUST, SACHA GUITRY, and ARLETTY. His were the sins of neutrality.

JEAN-PAUL SARTRE AND SIMONE DE BEAUVOIR: France's mismatched celebrity intellectual couple, they enjoyed heavy drinking at the Hôtel Ritz in ERNEST HEMINGWAY's bedroom. SIMONE DE BEAUVOIR and "Papa" sometimes did a bit more than just drinking, and hotel staff noted her leaving the hotel looking suspiciously rumpled in the morning.

SACHA GUITRY: Renowned French playwright and screenwriter; the witty, flamboyant darling of Paris, he blithely pursued his own pleasure and frivolity at the Hôtel Ritz with no regard for politics or the human consequences.

F. SCOTT FITZGERALD: Voice of the Jazz Age and celebrated American author; the Hôtel Ritz bar was his favorite watering hole during his descent into alcoholism.

ERNEST HEMINGWAY: American novelist and celebrated adventurer, known for his macho exploits and terse sentences. He and his rogue band of "irregulars" liberated the Hôtel Ritz—and many bottles of vintage wine from its cellars—in the last hours of the occupation. "Papa" then made the Hôtel Ritz home for months to follow, in a new, American-style deluxe occupation.

THE FILM STARS AND THE GLITTERATI

ARLETTY: Sultry French film star and national celebrity, she passed the war in luxury at the Hôtel Ritz with her German lover, HANS-JÜRGEN SOEHRING. Her "horizontal collaboration" earned her the dangerous hatred of many in occupied Paris and a terrible retribution.

SARAH BERNHARDT: Known the world over simply as "the divine Sarah," she was the stage legend of the late nineteenth and early twentieth centuries and the friend and lover of the Hôtel Ritz's founding chef, AUGUSTE ESCOFFIER.

ELSA MAXWELL: Brash, pudgy, and distinctly unattractive, she was the lesbian midwestern American girl who took over-the-top partying to new heights in the 1920s and found herself one of the acknowledged queens of high society, all from her start in the salons of the Hôtel Ritz.

LAURA MAE CORRIGAN: Disdained by many at home in the United States as a nasty gold digger, the pretty young waitress found herself a man with a vast fortune and a cardiac condition. When he exited the scene early, she lived in splendor between London and the grandest suite at the Hôtel Ritz in Paris—until the Second World War started and she had to make a brave decision.

DUKE AND DUCHESS OF WINDSOR: Better known as the former King Edward VIII of Great Britain and the American divorcée Mrs. Wallis Simpson, their love story made headlines. Behind the scenes, their pro-fascist sympathies caused considerable consternation.

LUISA, MARQUISE CASATI: Staggeringly rich, famously extravagant, possibly unbalanced, the marquise turned her life into

a uniquely modernist kind of performance art; in Paris of the 1910s and 1920s, the Hôtel Ritz was her favorite background setting.

ALEXANDRE ROSENBERG: The cultivated twenty-four-year-old son of the Jewish art dealer whose gallery was at the epicenter of artistic Paris, he fought for the Free French Forces under Charles de Gaulle from Britain. In August 1944, he returned to Paris as an officer in the liberation and made an astonishing discovery on one of the last German trains fleeing the capital.

PRINCESS SOUTZO: Beautiful, calculating, flirtatious, and ultimately pro-German, the married princess was MARCEL PROUST's last great passion and coolly played the writer off his friend PAUL MORAND in the final days of the First World War.

MARLENE DIETRICH: German-born Hollywood film legend, she boosted Allied troop morale at the end of the war with military tours but called the Hôtel Ritz home. She was a friend of ERNEST HEMINGWAY and became MARTHA GELLHORN's sworn enemy.

COCO CHANEL: Aging French fashion designer and longtime resident of the Hôtel Ritz, her flagship boutique was across the street on rue Cambon. She closed her fashion house during the war and lived at the Hôtel Ritz with her German lover, HANS VON DINCKLAGE. Questioned by the British, French, and American governments after the liberation about her dubious and illicit wartime activities, she quipped that, given the chance of a lover at her age, she wasn't going to ask to see his passport.

JOSÉE, COUNTESS DE CHAMBRUN: Daughter of French collaborator PIERRE LAVAL and wartime socialite, often seen at the

Hôtel Ritz during the occupation. Friends with COCO CHANEL, ARLETTY, and SACHA GUITRY, she was a film industry "angel" and used her influence with the Germans.

INGRID BERGMAN: Swedish movie star who played opposite Humphrey Bogart in the wartime classic *Casablanca*, she fell in love with a restless ROBERT CAPA at the Hôtel Ritz in the months after the liberation of Paris.

THE HOTEL
ON PLACE VENDÔME

Prologue: The Hôtel Ritz, the Mirror of Paris

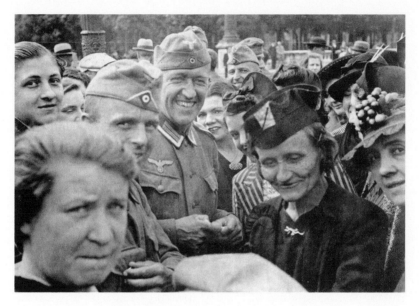

German troops and French civilians, 1940.

OF COURSE GREAT HOTELS HAVE ALWAYS BEEN SOCIAL IDEAS,
FLAWLESS MIRRORS TO THE PARTICULAR SOCIETIES THEY SERVICE.
—*Joan Didion*, The White Album, *1979*

This book did not begin on the beautiful Place Vendôme. It did not even begin in Paris. This book first took shape, instead, one winter afternoon in the former eastern zone of Berlin, in a friend's apartment overlooking the Alexanderplatz.

I was poring over a thick photocopied stack of British and French government documents on the wartime activities of the fashion designer Coco Chanel as we talked. Over and over again in declassified correspondence describing intelligence coming in from occupied Paris, I read the name of the Hôtel Ritz and its alternately famous and infamous residents. Some of those residents were high-ranking German officers and their Axis counterparts. Some were wealthy French civilians, some American. Many were spies with dizzyingly complicated loyalties and dangerous secrets. There, in opulent splendor, they all lived cheek by jowl on the Place Vendôme, bound up together in a complicated dance in a divided Europe.

What, I wondered aloud to my German friend that afternoon, was the story of those who lived in this renowned hotel during the occupation of Paris? How did what happened, over champagne cocktails and white-linen dinner tables, in the corridors and palatial suites and basement kitchens, shape the lives of those who met there by chance or assignation—and, more importantly, how did it shape the lives of thousands of others? How did it shape France and the course of our shared, tangled, pan-European twenty-first century?

These men and women, coming from all sides of their century's greatest conflict, were caught up together in the eddy of history. For a couple of hundred people in the course of the war, life went on—and sometimes life ended—inside the walls of a palace that was already part of the cultural legend that was modern Paris. What happened there, when the Hôtel Ritz was

a crossroad of international power, would change each of them. They, together, would change the history of our last century. This book is the story of that moving and remarkable history, in all its alternately inspiring and terrifying human complexity and drama.

Paris in the 1940s is a whole lifetime ago now. It was a world where women in satin evening gowns smoked cigarettes from long ivory holders and men still wore fedoras. A world where bellhops in caps whisked away fur stoles and chauffeurs waited on street corners while jazz singers crooned in late-night cabarets on Montmartre.

It is the past now. But for many there is no way to leave the past behind. And so, in some essential ways, this is also the story of our present moment. We all live in the long shadow of this history.

In the dining rooms of the grand hotel, the outward trappings of the war and its treacheries were suspended—at least on the surface. German officers during the occupation set aside their uniforms and, more often than not, French was the language of conversation. The Parisians who dined with them adopted a pose of studied neutrality in exchange for their pleasures. Over "roundtable" luncheons, the economics of collaboration were hammered out among designers, industrialists, diplomats, and politicians. Those conversations at the Hôtel Ritz laid the foundations for the establishment of today's European Union.

For others, what remains of this history is far more personal. The occupation is at the heart of modern France and—from the perspective of someone who considers herself both a Francophile and a realist—at the heart of its most difficult evasions.

In any culture, there are some things that feel dangerous, even after decades or centuries. In France, this is that subject. On at least one occasion, I was warned that I should not attempt to tell this story. The warning came from an elderly Frenchwoman, a neatly dressed lady with sharp eyes and a long

memory of what happened in Paris during the dark years of the war—and the dark years that followed. One afternoon in the spring of 2010, we met in an obscure and studiously average café just off rue de Rome in the distinctly unfashionable seventeenth arrondissement. Her late husband had been in the resistance, part of the underground movement that fought against fascist control of occupied France—and against fascists who were not always conveniently German. Through the contact of a contact of a contact, she had agreed to meet me and maybe to talk.

This was the first thing she told me:

"Most of those who tell you they were in the resistance are fabulists at best. The worst are simply liars. It was a frighteningly small movement, covert, secret, and the price of discovery was monstrous. After the war, everyone wanted to believe that they had supported it. It is a collective French national fantasy."

Then, as the room around us grew very quiet, she placed on the café table in front of me, one after another, her husband's war medals.

"So you know that I am not among the pretenders." Then she said, "Here is what I need to tell you: The truth you are looking for, it was lost to history the moment the war ended. Perhaps it was lost even before that. The questions you are asking are more treacherous than you think. This book about the Hôtel Ritz and the story of the occupation, you should not write it. I am sorry."

You hold in your hands the evidence, for better or worse, that I did not take that advice. Perhaps I have not taken it because it seems too impossibly cloak-and-dagger to an American author raised in the Cold War of the 1970s. What, really, about this past could touch me? What about it could touch anyone of my now middle-aged post-atomic generation? Yet what happened at the Hôtel Ritz during the Second World War and in Paris during the occupation was part of what laid the founda-

tions for those same nuclear conflicts that are not yet fully behind us. And the occupation of Paris was nothing if not a kind of mass urban terrorism.

But it is also true that the history of the Second World War is often told too simplistically, in black and white, as an epic battle between the forces of good and evil. There are those who resisted, and there are collaborators, we learn. And, of course, there *are* those whose actions fall starkly into one category or the other. For most of those who lived in Paris during the occupation, however, survival depended on how adeptly one could navigate the nuances of wartime reality. At the Hôtel Ritz, the shades of gray were at their most impenetrable. In its spaces, astonishing things happened. In those gray areas—where courage and desire collided with brutality and terror—were powerful human stories. This is the astonishing history of those lives and deaths and their dangerous liaisons, as it all took shape there on the Place Vendôme in an always seductive Paris.

1

THIS SWITZERLAND IN PARIS

June 1940

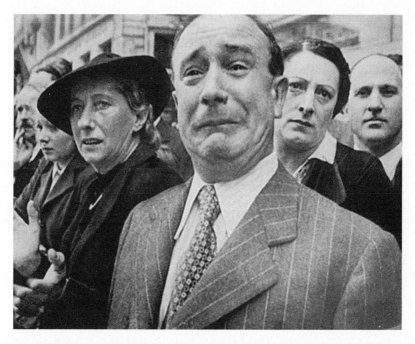

A Frenchman weeps, watching Nazi troops occupy Paris, June 14, 1940.

JUST AS A PORTRAIT TELLS THE SITTER'S DESTINY, SO THE MAP OF FRANCE FORETELLS OUR FORTUNE . . . OUR COUNTRY HAS AT ITS CENTER A CITADEL . . . BUT IN THE NORTHEAST THERE IS A TERRIBLE BREACH THAT LINKS [TO] GERMAN TERRITORY . . . [OUR] FATAL AVENUE.

—*Charles de Gaulle*, Toward a Professional Army, *1934*

For anyone looking at a map of France, that breach to which de Gaulle refers lies where the borders of the Alsace and the Lorraine jut sharply into the German Rhineland. To the north rest the low-lying countries of Belgium, Holland, and Luxembourg. To the south rise up the Alps and the mountain state of Switzerland.

By 1939—after ten years of disastrously expensive construction and the hard-won lessons of the First World War— the French had built, along that boundary from Luxembourg to Switzerland, a barricade against a dark future: a series of formidable steel-and-concrete fortresses known simply as the Maginot Line, named after the general who planned them.

Those fortifications, however, also had a fatal weakness. At the northern edge of the French border, to the east, lay Belgium, and that deep and friendly frontier remained largely unprotected. Nowhere were the fortifications lighter than where the border ran along the dense forestland of the Ardennes. It was considered impenetrable. In a matter of days in May 1940, a million German soldiers proved that it was not.

With fearsome speed that spring, the forces of the Third Reich swept through the Low Countries and into France. Their object was the citadel at the heart of the country: the storied capital city of Paris.

And for many of the high-ranking German officers, who were no more immune to the enticements of legend than the rest of their generation, the Hôtel Ritz was already at the heart of Paris. Since the end of the nineteenth century, this palace hotel on the spacious Place Vendôme in the city's first arrondissement, or "district," had been an international symbol of luxury and all that was glamorous about modernity, home to film stars and celebrity writers, American heiresses and risqué flappers,

playboys, and princes. The 300,000 Germans who would soon occupy the city would live in Paris not just as an army and as bureaucrats but also as tourists, many of whom wanted nothing more than to be delighted with the pleasures of this famously beautiful metropolis.

Before the war had even begun, the Hôtel Ritz had already been at the center of political action on the Continent and was shaping this century. The German arrival would change nothing about that. Winston Churchill had visited the hotel not once but twice in the weeks before the Germans skirted the Maginot Line. In fact, immediately after delivering at mid-month his first radio broadcast as Britain's prime minister—in which he conceded that "[i]t would be foolish to disguise the gravity of the hour"—he headed straight to Paris for a crisis meeting of the supreme war council with his French counterpart, Paul Reynaud. At the end of the month, on May 31, 1940, Winston Churchill came again, this time to see if there was any way France could survive the westward onslaught.

Winston Churchill always preferred to stay at the Hôtel Ritz. "When in Paris," Ernest Hemingway once quipped, "the only reason not to stay at the Ritz is if you can't afford it," and Winston Churchill, the son of an English lord, had never been short of resources.

With the Germans on the march that spring, there was one old friend that Churchill especially wanted to talk things over with. He and Georges Mandel, the Jewish-born French minister of the interior, had talked things over like this many times in the last decade, when, together in the political wilderness of the 1930s, they had warned their countrymen that the unfettered rise of a nostalgic German nationalism would have terrible consequences. Their predictions had been sadly accurate.

Georges Mandel, however, didn't just stay at the Hôtel Ritz occasionally. He had lived in darkened rooms on the fourth floor full-time since the mid-1930s. The Hôtel Ritz had among

its numbers in those days at least a dozen permanent residents, none of them obscure or powerless.

Some of those residents would soon be leaving. By June 11, 1940, with German troops within thirty miles of the city, a collective panic swept through Paris. The French government fled the capital overnight and decamped to Bordeaux, in the southwest of the country. The railway system ground to a halt only a few hours later. Over the radio the next afternoon came an order for all the men in the city to leave the capital to prevent their capture. Rumors flew about the brutality and sadism of the advancing German soldiers, and no woman relished being left behind as a war trophy in a fallen city.

In the mass exodus that followed, a full 70 percent of the city's population—close to two million people—took to the highways, hauling their possessions and their infirm relatives behind them in an effort to flee the German advance, joining a stream of refugees from Belgium and Holland. But it was already hopeless. They would turn the roads heading south into a colossal traffic jam. Most would never make it more than a hundred miles beyond Paris.

The Hôtel Ritz was not immune to the panic. By June 12, 1940, for the second time since the battle for France had begun, the German air force, the fearsome Luftwaffe, was pounding the city of Paris with incendiary bombs, and a siege seemed inevitable. The hotel's newly promoted director, an old French soldier named Claude Auzello, had been called up for military service, and his American-born wife, Blanche, had followed him to his posting in Provence. His deputy director, Hans Franz Elminger, the nephew of the hotel's most important aristocratic investor, however, was Swiss—and the Swiss, of course, were famously neutral. So that week it was left to Hans Elminger, along with the elderly Marie-Louise Ritz, the Swiss widow of the hotel's eponymous founder, César Ritz, to chart a course for the

cast of characters who inhabited this luxurious refuge. The next few days would require deft diplomacy and all their combined efforts.

Suddenly there were fewer characters in the Place Vendôme lobby. The Hôtel Ritz had been operating on a skeleton crew for weeks. The staff was normally a force of 450 men and women—from bartenders and chambermaids to waiters and oyster buyers—in a palace hotel with just over 150 rooms. Now, Hans Elminger reported to his uncle in Switzerland, "[m]any people have naturally left Paris, and we are down to thirty-six masters and seven servants. . . . Despite everything, the restaurant is working and we even had a large room of thirty-eight places." "Unfortunately," he added, "the lunch was interrupted by the bombing of Paris." Eventually, the wartime staff would stabilize at around twenty employees, almost all of them older men, women, or, like Hans Elminger, people whose passports listed them as the citizens of a neutral country.

Soon there would be a fresh influx of visitors. For the moment, the guest numbers at the hotel were plummeting. The long-term residents of the Hôtel Ritz and many of its Parisian regulars were disappearing quickly in the exodus. With mass hysteria gripping the city, even the rich and famous in France could not know what awaited them with the fall of the capital.

These socialites and celebrities were a close network of friends and acquaintances, and many of them had made the Hôtel Ritz their de facto living room for years. Georges Mandel wasn't the only old friend whom Winston Churchill saw that spring in Paris. The iconic Coco Chanel had lived in rooms at the Hôtel Ritz since the early 1930s. She and the British prime minister owned summer villas near each other on the French Riviera.

At Coco Chanel's table in the Hôtel Ritz dining room on any given evening, one might find the flamboyant playwright and screenwriter Sacha Guitry, the lithe Russian ballet star

Serge Diaghilev, or the increasingly drug-addled Jean Cocteau.

In the same dining room, Georges Mandel's mistress, the curvaceous comic actress Béatrice Bretty, shared cocktails and good times with France's most acclaimed film star, a woman known simply as Arletty. As early as 1935, Georges Mandel and the two film stars had celebrated together the night Béatrice Bretty made history by delivering in Paris the first television broadcast in France.

They all knew the Spanish painter Pablo Picasso and his wartime lover, the surrealist artist Dora Maar, as well as the couple's friend Lee Miller, a celebrated and sexually liberated American fashion model and art photographer. Of course, no one was a stranger to all those American writers of the Lost Generation, from Ernest Hemingway to F. Scott Fitzgerald, either. They were regulars, themselves inspired by an earlier generation of writers and stage stars who had made the Hôtel Ritz a meeting place and home since the last days of the nineteenth century.

Finally, a generation of exiled European princes and princesses had also made the Hôtel Ritz a home in Paris. It was the first sign of things to come when the Duke and Duchess of Windsor gave up their extravagant suite at the Ritz with the beginning of German hostilities.

As the word came of the German advance, there were hushed and frantic conversations at the hotel during the second week in June 1940. To stay or to go was the pressing question. Arletty, wavering to the last, ultimately joined the caravans of Parisians heading south to safety. Coco Chanel shuttered her couture house across the street from the Hôtel Ritz, on rue Cambon, declaring it was no time for business. Coco Chanel didn't want to leave her permanent rooms at the Ritz that week, but her maids, sisters Germaine and Jeanne, were too frightened to stay in the capital, and she couldn't see how to get by

without her domestics. Just as she was ready to flee, the new chauffeur that the hotel staff had found for her refused to drive her powder-blue Rolls-Royce through the crowds.

A nine-year-old girl named Anne Dubonnet, another familiar denizen of the Ritz, was trundled into a less ostentatious waiting car with her wealthy French parents and her Scottish nanny. The Dubonnet family had spent several weeks a year at the hotel since the mid-1920s.

Georges Mandel was also making plans to leave Paris with Béatrice Bretty and their young daughter, Claude. He would go south with the French government. But he couldn't bring himself to abandon the fight for France entirely. Already, Winston Churchill was urging him to come to London. It was Georges Mandel whom the prime minister always wanted as the leader of the Free French resistance in exile, not Charles de Gaulle, and there was a spot on a military plane waiting for him. Georges could not stomach the idea of it. "It is because I am a Jew that I won't go," he explained. "It would look as though I were afraid, as though I were running away."

Before Georges decamped, Marie-Louise Ritz sought out her old friend. Georges was a man whom everyone at the Hôtel Ritz trusted. After all, they had lived with him in their midst for the better part of a decade.

Marie-Louise Ritz had a tricky dilemma. The hard-nosed and eminently pragmatic Marie-Louise—or "Mimi," most often—was Swiss, and, like the Americans in the spring of 1940, the Swiss were not part of this war that Hitler was waging. Once described by Ernest Hemingway as a "small, steep country, much more up and down than sideways," Switzerland was perched high among the Alps and was studiously neutral. The Nazis left it unmolested in their march eastward. In a sense, none of this was her battle.

Her dilemma: Should she and the other investors keep the hotel open now under the Third Reich? Or should she close

the city's famed luxury establishment? The moment the Nazis arrived in Paris, there would be high-ranking Germans in the lobby, and Marie-Louise knew it.

In a rumpled coat, sleepless and worried, Georges Mandel confidently assured his elderly landlady that there was no other option. If she closed the hotel, the building would be requisitioned. Then "you will never get it back, Madame Ritz," he told her. With manager Hans Elminger, he was even more direct: "You are Swiss," Georges told him, and "therefore neutral, and speak German perfectly, which is an advantage in the circumstances. Your hotel will certainly be occupied by the Germans when they enter Paris and they will respect it, because of your presence and neutrality."

So the Hôtel Ritz stayed open. When the government fled, Georges Mandel went south with Charles de Gaulle and a cadre of important ministers.

By June 12, the British papers were reporting "thousands upon thousands of Parisians leaving the capital by every possible means, preferring to abandon home and property rather than risk even temporary Nazi domination." Even as the French residents and the elite international refugees of an already vanquished eastern continent fled the capital, others were arriving—scores of journalists from the American press corps on assignment budgets, especially, all looking for plush rooms at the Hôtel Ritz.

On Thursday, June 13—the last day in a free Paris for more than four years to come—those two passing worlds held their collective breath for one fragile moment and raised a glass to the uncertain future of Paris together at a memorable dinner party at the Hôtel Ritz. Tomorrow, perhaps, Paris would be burning.

In the morning would come the last possible moment to flee Paris. That June evening, though, the party went on at the hotel like always. The hosts were the American writer and journalist

Clare Boothe Luce, on assignment for *Life* magazine, and Hugh Gibson, the former United States ambassador to Belgium, now occupied Nazi territory. At the table were dignitaries of a world that no longer existed, among them head of the Polish émigré government and the twenty-eight-year-old exiled crown prince of the defunct Austro-Hungarian Empire, Otto von Hapsburg. The Nazis had a bounty on his head. "It was," Otto von Hapsburg later remembered, "incredibly macabre: the city was two-thirds surrounded by German troops, the sky was lit up with artillery fire, and there, at the Ritz, everything was as it had always been: waiters in tails, the food, the wine."

That evening, Hans Elminger asked his distinguished visitors to sign the guest book before retiring. The next entry would be the registration of the German field marshal Erwin Rommel, there to take command of the capital.

On the morning of June 14, the last exiles struggled to make their way to safety before the city fell to the conquerors. By afternoon, German tanks rolled unopposed down the broad avenues, and the Third Reich took possession of Paris. The occupation had started.

Louis Lochner, a news correspondent from Milwaukee, was there to see the arrival of some of those Germans. "I have passed," he wrote in his news brief to *Life*, "through many ghost towns in Belgium and northern France . . . but no experience has become more indelibly fixed in my mind than that of entering the French nation's incomparable capital, Paris, on June 14, immediately after the first German vanguard. It seemed inconceivable, even though I stood on the spot, that this teeming, gay, noisy metropolis should be dead. Yet dead it was." A swastika flew from the Eiffel Tower, and "Paris' famed galaxy of luxurious hotels had vanished behind shutters."

Except, that is, at the Hôtel Ritz. The remaining staff assembled in the dim hours of the morning to listen to the broadcast come across the radio announcing the fall of Paris and wept. Then

there was work to be done. The Ritz would stay open, and there would be the same white-glove service as always.

By the time Louis Lochner entered the capital that day, word had spread through Paris that the first German officers were dining at the Ritz in splendor just as Marie-Louise had predicted. The German lieutenant colonel Hans Speidel lunched that day at the hotel on a victory menu that included filet of sole poached in German white wine, roast chickens (presumably French), asparagus dressed in Hollandaise sauce, and *fruits au choix*—his choice of local fruits, now ripe for the picking. It was a darkly symbolic choice of national dishes.

When Louis Lochner and a cadre of bedraggled American war correspondents embedded with the German army arrived looking for food and lodging, the dining rooms were shut, and the reception was less than enthusiastic. The "vain manager," Louis recalled, "almost had an apoplectic stroke, then mumbled something about his kitchen being already closed." That manager was a somewhat frazzled and indignant Hans Elminger. When the determined German lieutenant in charge announced that this would be no obstacle and that his men would cook their own meals, four waiters in smart coats materialized instantly and a case of champagne from the basement also. Soon, "[a]s if by magic, delicious ham, mellow cheese, tastily prepared scalloped eggs appeared. Such was our sumptuous repast on that first night"—the first night of the occupation of Paris.

In the days to come, Paris was indeed ripe fruit for the picking. Soon German tanks would roll in a victory parade down the Champs-Élysées, past the Arc de Triomphe, and Adolf Hitler himself would come to see—for the onlyt time in his life—the tourist attractions of Paris. Among the stops on his itinerary was the Place Vendôme, where armed German sentries already guarded the monumental front entrance to the legendary palace hotel. While in Paris, the Führer made arrangements to meet one of the hotel's regulars, Serge Diaghilev, the founder

of the Ballets Russes, the Russian ballet in Paris, to ask him personally to carry on making art in Paris. After all, that was what the German conquerors wanted most: a luxurious modern playground and the ultimate Parisian experience. The disappointed ballet star managed to oversleep and miss the meeting—but he did carry on entertaining the occupiers.

This included enjoying the good life with some of the city's most talented and famous residents. For those who were rich and beautiful and willing to be reasonably accommodating, the occupation need not be a terrible inconvenience. In fact, there was no reason why they should not stay and enjoy the Hôtel Ritz also. The German government would soon take over dozens of hotels and private mansions across the city for use as accommodation and military offices—including other elite hotel establishments like the Crillon, the Georges V, and the Meurice. The Ritz alone among the great palace hotels of the city, however, would become a Switzerland in Paris.

Like France, it would be partitioned. An accident of architecture made it possible. When Marie-Louise Ritz had expanded the hotel after the long madness and premature death of her husband, César Ritz, decades earlier, she had connected with a long corridor what had once been two buildings—one a small eighteenth-century palace facing onto the Place Vendôme and another, more modest set of buildings with a cozy entrance on a side avenue, rue Cambon, that ran north from the river in the direction of the Opéra. That passage would shape the destiny of the Hôtel Ritz and the destiny of those who passed the occupation in its salons and bedchambers.

Word came from Berlin of the hotel's unique Janus-faced future. The propaganda maestro of the Third Reich, Joseph Goebbels, famously declared that the capital would be gay and happy—or else. Orders from Berlin specified that the Hôtel Ritz would be the only luxury hotel of its kind in occupied Paris. Goebbels insisted on it because, for the German invad-

ers, Paris and the Ritz were legends that could not be easily disentangled.

The "Hôtel Ritz," the order read that summer, "occupies a supreme and exceptional place among the hotels requisitioned." The Place Vendôme side of the hotel would be, according to the official documents, the sumptuous residence of the German high-ranking officers and "occupied by the German army." There, "[i]n the entry of the Hôtel Ritz on the Place Vendôme and in the interior hallway, immediately on the stairs giving access to the Hotel [will be] two German sentinels with weapons over the shoulders who present arms to the military chiefs who enter and leave the hotel. Further within, in the gilded salons and on the other floors, in the corridors and lobbies . . . all civilians [are] excluded."

Soon Adolf Hitler's second-in-command, the corpulent Reichsmarschall Hermann Göring, would move into a sprawling imperial suite taking up an entire floor. With him would come an entourage of German functionaries, including Hans Speidel, the newly appointed chief of staff of the military governor of Paris and the man in charge of making sure life went on smoothly for the hotel's resident Nazi dignitaries.

For those rooms at the Hôtel Ritz, the Germans would take a 90 percent discount—paying a mere twenty-five francs a day on average. As "guests" of the French people, they would ultimately send even that reduced bill to the new French puppet government of the occupation, the Vichy regime, named after a spa town south of the occupied territory.

Marie-Louise Ritz and the hotel's investors would not be seeing any vast windfall profits. Quite the opposite: only with the grudging help of the German officials did the Hôtel Ritz arrange the desperately needed million-franc credit line at the Bank of France, required to keep the business up and running. As Hans Elminger explained to the commandant of Paris, surely Adolf Hitler would be unhappy if the hotel were to go

bankrupt and could not host dignitaries and Nazi celebrities as Berlin ordered.

If one half of the Hôtel Ritz was an exclusive retreat for German private indulgence, on the rue Cambon side of the ancient palace and in the bars and restaurant the hotel remained open to the public—to the citizens of France and of neutral countries and to that select group of artists, writers, film stars, playwrights, entrepreneurs, and fashion designers allowed to stay in residence.

Many of those in that group were familiar faces already. Arletty and Coco Chanel soon returned to Paris and to the Ritz. So, too, did the young Anne Dubonnet and her parents, Jean and Paul. Even with the help of an antifascist Austrian officer, the Dubonnet family had been unable to cross the border from Biarritz, and it would take them more than a year to obtain the visas from the American embassy needed to flee, at last, to New York City.

Those faces that were not familiar should have made the Germans wary. The hordes of American journalists who arrived at the hotel were not the only ones looking to get to the bottom of the story. Agents and spies playing deep and dangerous games of intelligence and counterintelligence also soon made their way to the Ritz. After all, where else in all of Europe could one sit down to dinner in the same room with Hermann Göring?

Only here, in the public spaces of the Hôtel Ritz, could the silent combatants of occupied Paris come together under the guise of neutrality. Here, the façade at least was unchanged and glittering. As Josée de Chambrun, the titled daughter of a leading French collaborator, remembered of the parties during those years in Paris, "Champagne flowed, and the German officers, dressed in white tie and splendid uniforms, spoke only French. Social life had returned with friends and our new guests, the Germans." In the dining rooms and bars at the Ritz, it happened nightly.

"The occupiers," to everyone's astonishment, were blatantly un-interested in keeping secrets: they "made little use of the [private] first-floor lounges; everything took place in public." No German officer was permitted to appear in uniform in those public spaces, and all weapons were checked at a kiosk just beyond the Place Vendôme entrance. No low-ranking German officer was admitted at all. Illicit love affairs and tawdry passions unsurprisingly flour-ished. Art dealers intent on looting Paris and garnering vast for-tunes hawked their wares to ready German "buyers," and, before the war was over, there would even be one or two private prisoners locked in suites on the upper stories. Within weeks of the fall of Paris, Hans Elminger could report to his uncle in Switzerland that at the Ritz they were all on good terms with the high officials and that life was nearly back to normal.

Yet, behind the façade, everything was not always so gen-teel or so neutral. The Hôtel Ritz was a wartime hotbed of es-pionage and resistance. In the kitchens, some on the staff were running a dangerous resistance network smuggling informa-tion out of the capital. Others were hiding refugees in secret rooms built among the roof beams. The part-Jewish bartender passed coded messages for the German resistance, and the plot to assassinate Adolf Hitler took shape over some of those cel-ebrated Ritz signature cocktails, all under the nose of the Ge-stapo. These were high-stakes games, and not everyone who was there at the beginning would survive the occupation.

One of those who did survive, the hotel's chief director, Claude Auzello, later put it bluntly: "You didn't hear cannons in the Ritz, but the war was fought there too." Under one roof—a roof like no other place in Europe during the Nazi period—a dozen astonishingly powerful stories of personal courage and stunning betrayal played out together, in the crucible where the future of postwar France—and the future of all of postwar Europe—was transmuted. In the spring of 1940, those stories were only beginning.

By the spring of 1944, as the war drew to an agonizing close, those stories were all coming to their dramatic and sometimes heartbreaking conclusions. Some whose stories started there on the Place Vendôme were en route, at long last, back to the Ritz and to a shattered life in Paris. Others who had passed the war in opulence at the palace hotel were just coming to grips with the stain of luxury. And some, faced with the impossible intensification of death and horror that summer, could not finally avoid the agonizing eleventh-hour crises of conscience that would lead them to confront the inhumanity of their actions and inactions.

The result was a singular season at the Hôtel Ritz—and an intimate portrait of the last days of the Second World War and of the destiny of the world that would survive it. This is the story of the last months of the Nazi occupation and of how the Hôtel Ritz, from its beginnings decades earlier, was destined to be the meeting place for the people who made Paris modern.

2
ALL THE TALK OF PARIS
June 1, 1898

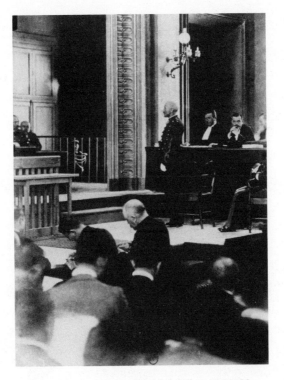

Courtroom trial, the Dreyfus Affair, 1896–99.

THE PRESENT CONTAINS NOTHING MORE THAN THE PAST, AND
WHAT IS FOUND IN THE EFFECT WAS ALREADY IN THE CAUSE.
—*Henri Bergson*, Creative Evolution, *1907*

That story of twentieth-century Paris and the Hôtel Ritz all started much, much earlier, on a warm and rainy June night in 1898, at the tail end of another century entirely, in the midst of a political scandal that cleared the space for the emergence of modern France. It was the night that the Hôtel Ritz first opened its doors to the public, with a lavish gala celebration.

For the hosts of this inaugural event—the hotel's founders, Marie-Louise and César Ritz—the off-and-on drizzle that evening was problematic. One never knew beforehand whether inclement weather would keep the guests away in numbers, and the list of those invited that evening included the most elite and finicky of all Parisian social circles. It was a crowd that liked to think of itself not just as the *crème* of society, but as its *gratin*—the perfect, deliciously thin layer of crust on the top of something already rich and wonderful. Considering that the man said to be the finest chef in the world—another of the hotel's founding partners—would be showcasing his talents that evening, it was a particularly apt image for the occasion.

On damp evenings, the hard pavements and the worn stone façades that encircled the Place Vendôme, an octagonal circus in the city's ultrafashionable first arrondissement, sent the sounds of wheels and horses' hooves and shrill women's voices off in clattering echoes that seemed to come back from all directions like a surprise assault on the senses.

For one of that evening's guests, the racket of an increasingly urban Paris was unbearable. Marcel didn't like noise. In fact, he found it painful. But he had come to the Place Vendôme this evening because, at just this moment, the imposing building at No. 15 was the epicenter of a closed and ancient world of which he had struggled to become a part for more than six years now—ever since, at the age of twenty-one, he started fre-

quenting the exclusive intellectual salons of Paris as a law student at the university.

His father, a wealthy doctor in the capital and a man honored with the ribbon of the French Legion of Honor and not a little fame, had put Marcel's fragile nerves and his persistent troubles with asthma down to an illness that was fast becoming the modern condition. His father had published, with a colleague, just that autumn, in October 1897, an expert tome on the disease, called neurasthenia.

At least Marcel could be flattered to know that the cause of his cutting-edge pathology came down to having a sensitive aristocratic temperament that was rattled by the fast-paced metropolitan changes that were already reshaping Europe and North America. His father reasoned that, as the upper classes used their intellect more than their muscles, so they were naturally prone to these kinds of rarefied neuroses. That part of things, at any rate, had a certain appeal to a young social climber.

Marcel was undoubtedly less flattered to know that, along with the hypersensitivity to noise, his asthma, and his chronic insomnia, the other symptoms of his newfangled disease were eccentric phobias, a crippling lack of self-will, and a tendency toward abusive masturbation.

The only cure, the doctor emphasized, was a complete avoidance of the kind of frenetic Parisian high society that had turned young Marcel into a playboy and a spendthrift. But avoiding the high life of the French capital city would have required willpower that Marcel could not have possessed, by definition, so he cheerfully ignored this boring parental prescription.

Thus, on the evening of June 1, 1898, dressed in the flamboyantly fashionable attire that he made his personal hallmark as a man-about-town, Marcel joined a select group of several hundred of the late nineteenth century's most influential trendsetters.

Marcel was not an aristocrat—except perhaps in temperament. His father was simply talented and rich. But for Marcel, the world of counts and countesses drew him strangely and powerfully and expensively—as his father reminded him, to little effect—to it. For years he had desired little more than entrée to their rarefied circle, the only circle that mattered in Paris during the 1880s and 1890s.

At last he had gained a toehold in this strange old world. It was all thanks to the influence of a few noble patrons, the women and mostly the men whom he cultivated with sycophantic poems and embarrassing public devotion. He still inhabited, though, only the outer reaches of this social world, and behind his back those who professed to be his new friends mocked him, calling him a "little flatterer" and "a vulgar little creature, uncivil in his bourgeois plebeian politeness." That meant that evenings like this one were always high-stakes auditions. And his relationship with his most important patron, the count Robert de Montesquiou, was deteriorating alarmingly, a result of the scandal gripping French society that season.

The Parisian upper classes were on the brink of a civil war from which there would be no returning. It was a war that was still playing out, in one fashion or another, decades later on the eve of the German occupation. Some say that France, in fact, has never recovered from its ravages. That night would determine which faction in the cultural battle would claim the Hôtel Ritz as its unofficial headquarters.

The opening of the Hôtel Ritz in Paris was the society sensation of June 1898. As the newspaper *Le Figaro* reported that morning, "Everyone is talking about the Ritz hotel, inaugurated today." But that little column appeared squeezed between news of the controversy gripping the nation—the scandal already known as the Dreyfus Affair. It had rocked the nation to its foundations. It divided the glittering society of the French aristocracy and government from the ranks of

the country's greatest writers and thinkers and artists. It also divided the aristocracy against itself. On the one side were the noble traditionalists, people whose inherited wealth and privilege epitomized the so-called Belle Époque—the golden age of prewar France in the 1880s, 1890s, and in the first decade of the twentieth century. On the other side were the artists and intellectuals, the champions of a new and as yet uncharted vision for the country's future.

Marcel, then, would have to come to a decision. He would have to choose between being a society playboy in the old mold of the Gilded Age or an artist devoted to breaking down the boundaries of an ossified culture and embracing the tumult of modernity. The events of that week had made any middle ground impossible.

From the perspective of the ruling elite, the scandal never should have been a scandal at all. In 1894, the military discovered that someone was passing secrets to the German embassy in Paris. Someone had to be brought to justice for this act of treason, and in a rush to find an unpopular scapegoat, the court charged a young artillery officer named Alfred Dreyfus with the crime. They had selected him for one simple reason: he was Jewish.

That might have been the end of the matter. But in 1896 evidence emerged that pointed to the innocence of Alfred Dreyfus. A second inquiry was ordered. Now the senior officers and the government, determined to prove that they had condemned the right man to a brutalizing solitary confinement on Devil's Island, found a new solution to their dilemma: they forged and fabricated evidence against the unlucky officer and whipped up an anti-Semitic fervor that drew on deep prejudices in French culture.

In 1898, the Dreyfus Affair at last reached its sorry nadir. That winter, as word spread of the new revelations and of a whispered cover-up, literary and intellectual France broke ranks

with the aristocracy and came to the aid of Alfred Dreyfus. On that evening of June 1, at the Hôtel Ritz's inaugural gala, the nation was riveted by the unfolding consequences.

Marcel had watched firsthand as the drama escalated in the cultural salons of Paris that winter. Paris in the 1890s was a city of private salons—soirées where the capital's elite gathered in the homes of fashionable women to debate ideas and shape politics. The salons had been Marcel's entrée into the world of high society, and Robert de Montesquiou more than anyone else had unlocked for Marcel the doors. Now that relationship was newly precarious.

Count de Montesquiou and Marcel attended all the same salons—and there were many of them. At the Wednesday-evening salon of Madame Arman de Caillavet, her literary lover, the novelist Anatole France, held court. There Marcel listened keenly as luminaries such as the actress Sarah Bernhardt and the count passionately debated the case.

All the gossips in Paris whispered that Bernhardt was the longtime lover of one of the partners in the Hôtel Ritz enterprise, the legendary Auguste Escoffier. Every year for her birthday, the two dined together in a private celebration on a meal the great chef prepared for her. They had known each other for nearly two decades, long before either of them rose to world renown and public attention. Food was his métier, but the "divine Sarah" was Auguste Escoffier's great consuming passion. Sarah Bernhardt's zeal in the Dreyfus Affair would play a leading role in the hotel's future.

Marcel and the count regularly appeared at other soirées across the city, too. The salon of the immensely powerful but shallow Mélanie, Countess de Pourtalès, was the pinnacle of exclusivity. Marcel secretly preferred, however, the friendlier salon of his friend and patroness Geneviève Straus, which Robert de Montesquiou often attended with his cousin, the Countess de Greffulhe. Here Marcel encountered the young

playwright Sacha Guitry and the daring English aristocrat Lady de Grey, whose husband was another of the substantial investors in the Hôtel Ritz project in Paris.

It was over a heated conversation at the salon of Madame Straus that the Dreyfus Affair reignited in this small circle of Parisian high society that past autumn. In October 1897, one of Geneviève Straus's old friends, a lawyer and politician named Joseph Reinach, rashly announced that he knew who the real culprit was in this treason scandal. It was not Alfred Dreyfus. It was a certain major, whose aristocratic last name—Esterházy—linked him to one of the noble families of Hungary. The anti-Semitic impressionist painter Edgar Degas stormed out of the party in a fury. Others in the world of intellectual and artistic Paris listened.

One of those who soon became persuaded that the French government had framed an innocent man was the nation's greatest living writer and another of Geneviève Straus's regular visitors—Émile Zola. On January 13, 1898, Zola published in the Paris newspaper *L'Aurore* history's most influential letter to the editor. The letter was directed to the president of France and began with the daring words *J'accuse*. It is French for "I accuse," and the writer knew that the letter was certain to get him charged with libel. That was precisely his intention.

The next day, there was a second letter in the paper, this one titled "Manifesto of the Intellectuals." It was an impassioned statement of support for Émile Zola's bravery and a call for an investigation into *l'affaire Dreyfus*—the "Dreyfus business." It was also the moment in France when the concept of the French "intellectual" as a voice of political conscience first captured the public imagination.

Marcel was an aspiring writer, now at work on his first novel. He also had—like Madame Arman and Madame Straus—a Jewish family background. In the letter published on January 14, 1898, he added his name as one of the three thou-

sand signatories. The count had not been amused by this act of social rebellion. Marcel explained gently to Robert de Montesquiou that, when it came to embracing this deeply rooted French anti-Semitism, "our ideas do differ." Or, rather, Marcel went on, "I have no choice of opinions on this subject," having an Israelite mother.

The last week of May 1898, those simmering tensions intensified in elite Paris. On May 23, the week before the opening of the Hôtel Ritz, Zola—whose first conviction for libel had been overturned on appeal—went on trial for a second time in a courtroom in Versailles, just outside Paris. Marcel, in a second act of defiance, went with coffee and sandwiches every morning to hear the evidence in the public gallery. He was trained in law: why shouldn't he be interested?

The trial would continue for weeks, and no one doubted that this would be the essential topic of conversation at any gathering. The examination of Émile Zola had emotions at a fever pitch, and polite neutrality and open-minded tolerance were fast becoming casualties of the shifting climate. The Dreyfus Affair was a turning point in French culture that summer— and it was the turning point in Marcel's most important friendships, however much he tried to prevent any hard feelings.

The door through which Marcel entered that evening was as powerful a symbol as any of just how many things in France were changing and why the aristocracy was so stridently anxious. No. 15, Place Vendôme, had been for centuries the private home of princes. Built at the beginning of the eighteenth century as a family mansion—an *hôtel particulier*, in the parlance of Parisian architecture—on the site of the Renaissance palace of the dukes of Vendôme, its four-story façade skirted the embroiled French Ministry of Justice.

Behind the stone doorways of the plaza and in the small streets and alleys that ran outward from its center still lived aging aristocrats like Virginia Oldoini Verasis, Countess di

Castiglione—the ruined beauty known as the "madwoman of the place Vendôme." She had once been the mistress of France's last emperor. Living connections to that imperial world were swiftly disappearing, and the countess was already suffering from the illness that would kill her the following autumn. Robert de Montesquiou was determined to write her biography.

Now, the small palace at No. 15, Place Vendôme, refurnished and refitted, opened its doors to guests that included a different kind of emerging elite, who were challenging the old aristocratic supremacy—guests whose celebrity stemmed from innovation and an embrace of a culture swiftly moving in bold new directions.

That night, Marcel's future and the future of the Hôtel Ritz would both take a step in the same direction. He had spent years currying favor with the aristocratic young dandies of his generation, with aesthetes and backward-looking decadents like the count. They aspired to be, like their model Oscar Wilde, the beautiful "boys" of a high society that was already dying. Marcel had wanted to be one of them. He was coming to understand that it was futile. Artists and intellectuals and innovators were grasping at the reins of the coming twentieth century. His destiny was among them.

From the first moment it opened its doors, the Hôtel Ritz was the province of that new world, even if nobody ever planned it. The Ritz was on the brink of becoming the celebrated haunt of the so-called *Dreyfusards* and their artistic supporters—of those who already in the last days of the nineteenth century had their eye on a kind of exhilarating horizon of creative possibilities. It wasn't something that everyone on the hotel staff necessarily welcomed. But not even the most powerful maître d'hôtel could dictate the whims of fashion or hold back the tide of change rising across Europe.

The Hôtel Ritz would become from the moment of its

inauguration the herald of the modern—the center of all that was "new" about the era and of all that in the next two or three decades would become so intoxicating and magical about Paris. It would be part of what would make Paris a legend in the twentieth century. It would be part of why starving young artists, students, and dreamers still find in the city a kind of spiritual intoxication.

Beginning in 1898, the Hôtel Ritz became the home and meeting place of this modern tribe—of the artists and intellectuals; rising film stars and stage actresses; the movie directors and the avant-garde designers; the photographers, sculptors, and flamboyant and eccentric writers of the coming twentieth century. It became the chosen province, too, of the most homeless of all in this new world: the outcasts from those old aristocratic circles, the restless and creative and sometimes brilliantly mad countesses, the princes and princesses whom history turned to stateless exiles, the kings who jettisoned their thrones for undutiful romantic passions for women with names like Mrs. Simpson. (Decades later, unsurprisingly, it was still the last refuge of a recently divorced princess of Wales and her companion.)

Soon the Hôtel Ritz also became a beacon to the vast numbers of Americans arriving in Paris—a transient colony of the newly rich and envoys from metropolises that had been modern from their inception. Much of the old Parisian aristocracy disdained these newcomers almost as much as it did France's Jewish population.

Perhaps it was inevitable that the Hôtel Ritz would become the playground of these new modern celebrities and socialites. There is a truism in the world of architecture that design creates culture. The Hôtel Ritz was designed with a forward-thinking sense of the innovative and the novel. In fact, that was precisely why the Belle Époque decadent Oscar Wilde quickly decided that he despised it.

The founder, César Ritz, personally planned the layout of the Hôtel Ritz. Born the son of a Swiss peasant, César Ritz had risen through the ranks as a young man, from waiter to hotel manager and now to partner. With Auguste Escoffier, he had redefined at the Savoy in London how the wealthy thought of luxury hotels. In the spring of 1898, he was at the apex of his career, opening one new grand establishment after another.

The Hôtel Ritz epitomized his personal philosophy of modern luxury. On the one hand, it was a palace hotel, meant to be the kind of place in which royalty might feel at home on a jaunt to Paris. The hotel famously had—indeed, famously has—no lobby proper. That was to prevent those who were not in residence from lurking voyeuristically in the foyer. It was part of a whole set of decisions calculated to make the palace feel private and intimate and cozy.

Those admitted to its magic circle needed the chance to strut the stage, however. That was how it worked in high society, where much depended on visual cues and performance. So there was a grand staircase, from which the ladies could descend in their finery, watched by all eyes as they made their dramatic runway entrance. It was not by chance that the Hôtel Ritz was established in the heart of the new Parisian couture district at the very moment that the French were inventing modern fashion. The shops touting the great names of design and luxury were clustered around the Place Vendôme and to its west along the rue du Faubourg Saint Honoré. On the small streets that spun off the Place Vendôme, and along rue Cambon, especially, were milliners and fabric merchants and British tea shops and the ateliers of up-and-coming young designers.

The Hôtel Ritz was a palace hotel, but there was nothing stuffy or ancestral about it, despite its aesthetic or its conveniences. To be sure, the furniture was classic and expensive, in the styles of the French kings. But all the rooms were designed to be contemporary and—since César Ritz had a not

unreasonable fear of tuberculosis and cholera spreading among his guests—scrupulously hygienic. Heavy carpets and drapes that gathered dust and germs were anathema, and the bedrooms had newfangled innovations such as built-in closets and private, plumbed bathrooms. In tribute to his Swiss-born zeal for precision, in every room a small bronze clock on the wall kept the time exactly.

As Oscar Wilde complained, bitterly if not entirely logically, the elevators moved too fast and each room had "[a] harsh and ugly light, enough to ruin your eyes, and not a candle or lamp for bedside reading. And who wants an immovable washing basin in one's room? I do not. Hide the thing. I prefer to ring for water when I need it." In 1898 bathroom sinks with indoor plumbing were a novelty. In the coming years—when war would mow down entire generations of young men and when professional careers for women became new possibilities—only the truly rich would be able to keep household retainers to fetch their water.

Oscar Wilde might have despaired of the modern plumbing, but the early American visitors praised the Hôtel Ritz as the pinnacle of new luxury hotels. "It is beautifully situated," wrote one Mrs. Elizabeth William:

> Some of its side rooms look out on the garden of the Bureau du Ministre de la Justice, and are very quiet as well as airy . . . [although] the view is not so entertaining as from those rooms that have windows looking out on the place Vendôme. . . . The hotel is quite up to date, and all the appointments are thoroughly sanitary.

Marcel, with his asthma, approved entirely.

From the kitchens, Auguste Escoffier modernized dining in Paris. With the help of Lady de Grey, he had already popularized high tea and made it fashionable—and accepted—

for women to dine in public in London. He intended to do the same in the French capital. Escoffier invented the modern meal as we know it, popularizing "Russian service," the system of serving dishes in courses. For generations before that, the French royalty had feasted on groaning buffets of elaborate dishes. And, for fine restaurant dining, Escoffier invented the prix fixe menu—and, of course, he invented several dishes that he named after his "divine" Sarah.

From the night of its inaugural gala, the fate of the Hôtel Ritz was decided. Marcel could not defer much longer putting off his own decision, either.

In the grand doorway of the Hôtel Ritz, as the sounds of the Place Vendôme faded away behind him, Marcel felt his coat gently borne away from him. He had not thought quickly enough to stop the porter. Things like this distressed him greatly. He liked to keep his coat on. It was something people noticed about him particularly.

As he entered the grand room, guided by the dapper maître d'hôtel, the furious chatter of voices made him flinch again for an instant.

One look around the room was enough to tell any keen social observer where the future of the Hôtel Ritz lay. There, to one side of the salon, stood the art-mad Middle Eastern oil magnate Calouste Gulbenkian, cutting some new deal or another. Here was the exiled Russian grand duke Michael Mikhailovich and the woman for whom he had given up an empire in an illicit morganatic marriage, the Countess of Torby. Hardly a "nobody," she was the granddaughter of the Russian poet Aleksandr Pushkin.

Marcel could see familiar faces from the salon circles, and there were also the familiar faces of some of the city's most elite and desirable courtesans—the so-called *grandes horizontales*, or "grand horizontal women." There was the dancing star of the Folies Bergère, Liane de Pougy, and, it was whispered,

her Spanish archrival, Carolina Otero, known in Paris simply as La Belle, the beautiful. Carolina Otero and Sarah Bernhardt shared the Italian poet and playwright Gabriele D'Annunzio as lovers. Professional mistresses and tangled liaisons were calmly accepted in Paris.

Somewhere perhaps Marcel could catch the eye of Robert de Montesquiou. One never knew for certain where one stood with the mercurial count, but Marcel had reason to be anxious. Letters between the two following the Dreyfus Affair had taken on a tone of resentment. One icy look was a fair warning.

And there, looking haughty and somehow ancient even in her youth, no one could fail to see Mélanie, the Countess de Pourtalès, looking aloof and out of place in a world that was changing.

She was beautiful, a society queen. Marcel had watched how her brown eyes could darken almost to purple in a certain light. Eyes were something he noticed. People often were unsettled by the intensity of his observation. Marcel was undeniably drawn to the countess. She was the epitome of the old world he had been on the brink of penetrating.

Those changeable eyes looked out on the world coolly, and it would come only as a small jolt of pain now should they pass over him unseeing. He was watching before him that summer's evening an era beginning to unravel slowly—the Belle Époque was already waning. He would remember later, thinking of that time, how women like the Countess de Pourtalès were dead before they were born. What he meant was that they lived in a world closed to him—a world closed even to them already. It was the heart of any true moment of decadence: the knowledge that an *époque* is already slipping from us, inexorably, even in the moment of its glory.

Marcel knew that the lines dividing him and the count and countess now were simple and absolute ones. "I do claim to move with the times; but damn it all, when one goes by the

name of 'Marquis de Saint-Loup' one isn't a Dreyfusard; what more can I say?" he would write later. To support Alfred Dreyfus was the ultimate treason for a man in Marcel's position. That was how they saw it. "[H]e who has taken the side of Dreyfus . . . against a society that had adopted him," Marcel knew, had in their minds already made the bourgeois, plebeian decision. For the word *Dreyfusard* one might as well have exchanged it simply with the word *modern*.

There were rosy lights and soft lampshades bathing the tables in the grand dining room of the Hôtel Ritz that night, and the June air was heavy with the scent of white flowers. The light that Marcel might have imagined flickering had another source—the Dreyfus Affair would extinguish it. He watched with the opening of the Hôtel Ritz something different rising on the horizon.

Before the nineteenth century was over, the Hôtel Ritz would be home to a new world and to a newly emergent twentieth-century France. It would be the world of celebrity of a different kind—a world where illegitimate café dancers could rewrite the history of global fashion. Where middle-class girls from America could become the new duchesses and where prostitutes could become princesses. Where young Jewish men could change the world of literature. That birth, however, would be a terrible and painful one, and it would come at a human cost that we still find staggering.

That night, as the Countess de Pourtalès glided away, out of the orbit of this galaxy of newborn stars and starlets, Marcel watched those two worlds on the brink of collision face each other, one taking form, the other dissolving. The fact would sear itself into his memory. He would try to remember that lost world and the scents and sounds that could evoke it. In the midst of that last season of the Dreyfus Affair, Marcel would finally make his decision.

Soon he would again take up the pages of the novel he was

beginning to shape in his imagination. He would become, he knew, a writer and an intellectual. His novel would take many forms, and its path would be circuitous. It would be the work of decades. But in that novel he would memorialize this moment—Paris in 1898—where two cultures edged up against each other in darkness. He would set that novel in this *époque*, in the days when France was torn apart over the fate of a Jewish officer named Alfred Dreyfus and over the courage of an elderly writer to speak truth to power.

Marcel would turn the Countess de Pourtalès—along with Sarah Bernhardt and Robert de Montesquiou and Madame Arman and even some of the Hôtel Ritz's staff members—into characters.

He would write it, in the decades to come, increasingly ill and often isolated, in cork-lined rooms that could deaden the sounds of the urban clamor that assaulted him. It would come to be—many would say then and many still say now—the greatest novel ever written. It would be one of modernity's greatest achievements. He would give his epic story of our search for lost time and for this lost moment particularly the title *À la recherche du temps perdu*. It is a story set in France in the spring of 1898, in the weeks and days when the Hôtel Ritz first opened.

Marcel Proust—Proust of the Ritz, as some later called him—would become a name more legendary than any of those in that dying generation. Émile Zola would be his only rival in fame. The Hôtel Ritz would be his truest home while he—and the rest of those talented but sometimes fatally flawed characters that gathered around the Place Vendôme in the years to come—together wrote the new story of Paris in the twentieth century.

It was a story that, sadly, always had war at the heart of it.

3
DOGFIGHT ABOVE THE PLACE VENDÔME
July 27, 1917

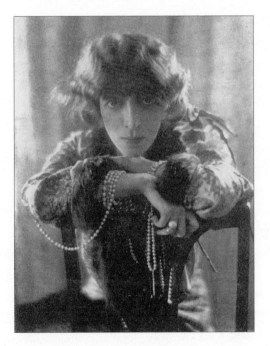

Luisa, Marquise Casati

IN PARIS, EVERYBODY WANTS TO BE AN ACTOR; NOBODY IS CONTENT TO BE A SPECTATOR.

—Jean Cocteau

I n the summer of 1917, they were bombing Paris. After nearly a six-month hiatus, German air raids were once again a regular feature of nightlife in the capital.

But you had to marvel at the calm of maître d'hôtel Olivier Dabescat, who glided unperturbed throughout the rooms of the Hôtel Ritz no matter what happened. Olivier knew where the levers of power were and how to pull them silently. Jean Cocteau saw that much plainly. There was something sinister about the power that Olivier wielded and the delight he took in it.

It was after eleven on the night of July 27, 1917. The party in the princess's lavish suite showed no signs of winding down early. She had been hosting a series of exclusive dinner parties like this for months, and they rarely ended until the small hours of the morning.

Stifling a yawn, Cocteau was caught somewhere between feelings of amusement and frustration. Amusement because the dinner party could easily have been staged as a romantic comedy over at the Théâtre du Vaudeville, frustration because the romantic drama would have been more diverting if he hadn't already seen this performance on more than one occasion. Marcel Proust and the dapper young French diplomat Paul Morand were across the room, doggedly pursuing the same woman: Hélène Chrissoveloni Soutzo, the thirty-eight-year-old Romanian princess who was their hostess.

It was Morand's own fault. He was the one who had introduced the bisexual writer to the princess just a few months earlier. Now the diplomat pretended not to mind the competition, though friends surely noticed the edge of bitterness in his description of Marcel Proust's first meeting with her. It was instant bug-eyed fascination. "The writer had studied her black

wrap and ermine muff like an entomologist absorbed in the *nervures* of a firefly's wing, while the waiters fluttered in circles around him," Paul remembered testily. It was just the kind of encounter that captured Cocteau's sense of the absurd.

Absurdity was in vogue. That year a new artistic movement had burst on the Paris scene. In his play *Les Mamelles de Tirésias*—"The Breasts of Tiresias"—which appeared that spring, the writer Guillaume Apollinaire had given it a name: *surréalisme*. The art world ever since had been caught up in a fever for new works with strange cinematic juxtapositions and with the nightmarish quality of fantasies so intense that the boundaries of the real collapsed under the weight of them. With word reaching Paris every day of renewed trench warfare and poison gas attacks and with food rationed, it was becoming increasingly difficult to make logical sense of anything. Surrealism articulated the modern condition.

Surrealism and the stage drew this circle together that evening. The artists, writers, and society patrons made up the kind of artsy crowd that had claimed the Hôtel Ritz as a central landmark in their Parisian geography since its inauguration. Indeed, the connection between the Hôtel Ritz and the well-heeled international avant-garde had only intensified since the days of the Dreyfus scandal. Jean Cocteau had met the cultivated and curious Paul Morand for the first time that spring, at the opening of the experimental ballet *Parade*, which Jean and Pablo Picasso had produced in collaboration with Apollinaire. Cocteau was in the grip of his own romantic infatuation with the famous Spanish painter at the moment. Unhappily, the attraction wasn't reciprocated; Picasso was in Madrid planning his ill-fated marriage to a Russian ballet dancer named Olga Khokhlova.

Since 1898, the Hôtel Ritz also had remained a favorite retreat for those with Dreyfusard credentials—those whose ranks ranged from the experimental artists and beret-clad

intellectuals of Paris to the renegade aristocrats who had turned their back on old French culture and embraced the avant-garde. Dreyfusards often went on to become modernists and surrealists and existentialists. Paul Morand's father had been a Dreyfusard—although everyone politely pretended not to notice that he refused to allow his son to bring home Jewish visitors. The Count and Countess de Beaumont were also in the princess's suite that night. They were rich and generous patrons of the avant-garde, famous in the capital for hosting extravagant masquerade parties and for their support of innovative artists. Over in plush chairs sat the aging Princess Marat and Marcel's old friend Joseph Reinach, the Jewish journalist who had ignited the Dreyfus controversy at Geneviève Straus's salon the spring that the Hôtel Ritz first opened.

When Marcel Proust thought about his passion for the Princess Soutzo—"the only woman," he said, "who to my misfortune has succeeded in making me leave my retirement"—it was her political determination above all that he found intoxicating. "What strikes me most about this woman and her keen sense of politics," he wrote, is "this particular force that fascinates me as much as it horrifies me. There's always something magical about her, and especially this iron will!" Her political commitments were fierce and calculating—and not always principled.

The First World War was all around them in Paris in 1917. Even meals at the Hôtel Ritz were occasionally curtailed by rations and shortages. Not for Marcel and the Princess Soutzo, however. Olivier Dabescat hunted down for Marcel anything that he desired through black-market channels—and at staggering black-market prices. When the writer in an idle moment longed for some of his favorite tea biscuits, Olivier found him enough, Marcel told Straus laughingly, for "thirty years' captivity." They dined that night on champagne and lobster, despite widespread hunger in the capital.

Overall, it was best to ignore the war as far as possible on such occasions. This was the tacit social convention. So instead of the trenches and troops, one talked of art and travels and scandal. It was difficult, though, to evade the topic entirely. That week in the capital, a military tribunal had condemned the Dutch courtesan and dancer Margaretha Zelle to death. It was the talk of the city. Better known to history as Mata Hari, she had spied for the Germans.

On a lighter note, conversation could have turned to Cocteau's springtime tour of Italy with Picasso and the principal choreographer of the Ballets Russes, Serge Diaghilev. In Venice that spring, the three men had visited one of the most eccentric of the old Hôtel Ritz regulars—Luisa, the Marquise Casati—at her storied palazzo on the Grand Canal. She had appeared with the Russian ballet troupe as a celebrity stage attraction and had known Diaghilev for the better part of a decade. That spring she captivated Cocteau and Picasso. After all, she *was* surrealism—devoted to becoming the art's living modern spirit.

During the years before the war, when Luisa Casati had lived at the Hôtel Ritz, she had been a society sensation. The marquise was bound to be on everyone's mind, tonight especially. She was renowned for her passion for the black arts and the occult and spiritualism, and tonight the Princess Soutzo had invited a spirit-world hypnotist as entertainment.

Cocteau could regale them with stories of Marquise Casati's palazzo parties if he wanted. Witnessing Luisa's performances—because there was no other word for it—was the only time, Jean confessed, that he had ever seen Picasso astonished. Casati had greeted them at her palazzo wearing wild creations, usually made for her by the avant-garde ballet-set designer Léon Bakst. Sometimes she appeared in costumes with a neckline cut to her navel. Sometimes she dressed only in furs to walk her pet cheetahs on jewel-encrusted leashes through

the midnight streets of Venice, to the spontaneous applause of late-night revelers.

The marquise wore a gold-painted snake, drugged into submission, around her neck as a living necklace and dangerously tinctured her eyes with drops of poisonous belladonna to dilate her pupils enormously and create an effect that was half satanic. She dyed her hair the color of flames. Her eyes were painted in dramatic black kohl shadow. Her naked footmen—gilded alive, like all her creatures—silently tossed copper filings into the fires to make them burn blue and green and hellish while the guests smoked opium. Around them, rites of the occult and hints of the sadomasochistic pleasures she openly enjoyed with her lover, the promiscuous Italian poet Gabriele D'Annunzio, unfolded in the backdrop of the evening.

They had all seen the same performance, albeit on a smaller scale, played out right here on the Place Vendôme. Olivier—who told Marcel Proust everything—vividly described a scene that had taken place at the Ritz one afternoon three summers before, in 1914, the week the First World War started.

Luisa Casati turned her suite at the Hôtel Ritz in those years into an exquisite stage setting. Her daring sense of fashion was a source of inspiration for the young designers who clustered around the Place Vendôme, including a young woman named Mademoiselle Coco Chanel, who recently had moved into a modest atelier on a side street just across from the Hôtel Ritz's back entrance.

In the marquise's luxury suite, the signature French sofas and elegant armchairs that Marie-Louise Ritz selected with such care and an eye for detail were soon covered with exotic animal skins. But the animals that everyone remembered were the live ones: in the marquise's rooms at the Ritz, she kept her half-tamed pet cheetahs and (to the periodic terror of the other hotel guests) a freedom-loving boa constrictor, which Olivier patiently fed with a diet of live rabbits.

It wasn't just her penchant for snakes that earned her the nickname "Medusa of the Grand Hotels." Like the Gorgon of Greek myth, she could be positively petrifying, especially in her rages, which were legendary among the hotel staff. A small delay or minor mishap in service could leave her hurling jewels out onto the Place Vendôme—sending the frantic staff out to retrieve the treasures. And her hours were notoriously unpredictable.

Late in the afternoon of August 4, 1914, Luisa Casati decided that she wanted her breakfast. When she rang, no one came running. The marquise stepped into the hallway to collar an unlucky maid to see to the matter. The halls were unaccountably deserted. The elevator boy had fled his post. The gilded cage whose speed had caused Oscar Wilde such consternation remained stubbornly motionless. The marquise was furious.

What had escaped her notice was the fact that Germany had declared war on France. That morning, Belgium had been invaded. The Germans were on the march to capture the ultimate prize of Europe: Paris.

When the marquise descended the hotel's grand staircase that afternoon in 1914, the world that she knew was in chaos. Olivier did not come running; he barely seemed to notice her presence. As another guest, the sculptress Catherine Barjansky, later recalled: "I found the Marquise Casati screaming hysterically. Her red hair was wild. In her Bakst-Poiret dress she suddenly looked like an evil and helpless fury, as useless and lost in this new life as the little lady in wax. War had touched the roots of life. Art was no longer necessary."

The marquise vowed that she would return to the Hôtel Ritz and take up her old residence when the war ended. But the roots of life had been more than touched in what followed. Food shortages and the Spanish flu combined with tanks and guns and missiles to kill nearly a million French citizens before the Americans ended their neutrality and joined the war in April

1917. Because of those cumulative losses and crippling depriva-
tions, the French would insist that the treaty signed in Versailles
to end the First World War, still two years in the future, shame
and impoverish the Germans, unwittingly laying the founda-
tion for a second terrible conflict and a vindictive Germany.

When the remains of the dinner had been carried away,
the Princess Soutzo's hypnotist began her strange performance.
Psychological automatism held an intense fascination for the
avant-gardist. Like the Marquise Casati, the Princess Soutzo
found the new field of psychoanalysis fascinating, and she
spoke of a doctor in Vienna named Freud who had recently
published a book on the theory of dreams and the unconscious.
Ironically, it was here on the Place Vendôme that hypnotism
had been invented. Just next door—at No. 16—the German
physician Franz Mesmer founded his clinic in the 1770s and
gave his name to mesmerism. Marcel Proust's current work in
progress—a third volume of his long-delayed novel about the
search for lost time—was very much about the workings of the
mind, memory, time, and fantasy. One by one, the hypnotist
asked for volunteers, and the guests took turns exploring the
suggestive realms of their unconscious in trances.

The most dramatic unconscious act, however, was the one
still playing out between Paul Morand and Marcel Proust as
they pursued the affections of the Princess Soutzo. Jean Coc-
teau could only watch in wonder. Marcel had retreated years
ago to his cork-lined room, where even the hum of the out-
side world had been deadened. Now his infatuation with this
princess had done what no one had imagined possible: brought
him back into the whirl of high society. But it was a bizarre
triangulation. Marcel Proust's most recent lovers had been not
society women but louche playboys and handsome young Hôtel
Ritz waiters.

The bronze clock on the wall of the suite now chimed pre-
cisely half past eleven, but its sound was quickly lost in the

shrill blast of the air raid siren on the Eiffel Tower. They were once again bombing the capital. The sirens wailed into the darkness. Cocteau, sardonic and weary, quipped lightly to the room, "There goes the Eiffel tower again, complaining because someone's trodden on her." The politely appreciative laughs sounded hollow.

Overhead, German planes appeared in the heavens, engaged in a perilous chase with a French squadron. By the summer of 1917, the "Red Baron" was already a fearsome legend, but the young Luftwaffe pilot who was making a name for himself over northern France in those months was a German officer named Hermann Göring. Since June, he had shot down more than ten Allied pilots.

The stars seemed unnaturally bright against the darkened city, and the falling bombs and machine-gun fire lit up the air in punctuated bursts of terror. The crowd gathered in the princess's salon went quietly out onto the open-air terrace looking out over the Place Vendôme, where a silent crowd was gathering below them to witness the apocalyptic drama. "We watched," Marcel wrote to Geneviève Straus in a description of the night, the "sublime mid-air spectacle from the balcony."

In the shadows of the Place Vendôme, "ladies in nightdresses or bathrobes roamed . . . clutching their pearl necklaces to their bosoms." The hotel staff ushered the more cautious and sensible of their guests into well-appointed cellar shelters. Late-night patrons of the hotel bars stood warily in the doorways, with the small red embers of their cigarettes burning. The scent of tobacco—a luxury in wartime—wafted lightly.

On the horizon two pilots appeared in desperate dogfight in the skies above Paris. For one of those pilots it would end in victory; for the other, in conflagration.

Cocteau watched a strange battle unfolding before him on the balcony, too. Marcel edged toward the princess, wrapped in his hulking overcoat even in the summer. There was the murmur

of his quiet voice. "Just as the voice of a ventriloquist comes out of his chest," Cocteau remembered, "so Proust's [voice] emerged from his soul" in conversation. Marcel was unfailingly, even oppressively, solicitous and flattering. The princess—a cold and controlling mistress—encouraged his attentions. Paul Morand gazed off into the far distance.

Paul could afford a secret smile that warm July evening as the skies above Paris exploded. Proust had already lost the battle. The princess soon would divorce her husband. She would marry Morand as soon as she had her freedom. They were almost certainly lovers already. Let her make her little conquest.

When dawn came, Marcel—perhaps tormented, perhaps unfazed—would return to his cork-lined room and once again resume writing. He already knew that, "[i]f we are to make reality endurable, we must all nourish a fantasy or two." In the afternoons, he would summon Olivier to bring him beer and cold chicken and tell him all the Hôtel Ritz gossip. Everything was fodder for his grand Parisian novel, the work that would soon win him the most coveted literary prize in all of France and make him famous. Soon counts and princesses would be courting him. Soon others would be the flatterers.

And soon Jean Cocteau's own career would rise—and falter—all precisely because of his cool detachment. Perhaps it was true, as he once said, that in Paris everyone wanted to be an actor. By the time it came to test his mettle two decades later, Cocteau would lack either the presence of mind or the courage. Although Cocteau didn't know it yet, he had already adopted the only role that would define him: the cornered observer.

4
DIAMONDS AS BIG AS THE RITZ
September 1, 1940

Laura Mae Corrigan.

HE WAS NOT REALLY DISAPPOINTED TO FIND PARIS WAS SO EMPTY. BUT THE STILLNESS IN THE RITZ BAR WAS STRANGE AND POR- TENTOUS. IT WAS NOT AN AMERICAN BAR ANY MORE—HE FELT POLITE IN IT, AND NOT AS IF HE OWNED IT.

—*F. Scott Fitzgerald, "Babylon Revisited," 1931*

More than twenty years later, a second war was on the horizon for Paris, and once again the conflict shaping life in France was that fated rendezvous with the Germans that Charles de Gaulle had predicted.

On September 1, 1940, the occupation began in earnest for those on the Place Vendôme. That was the morning that the World War One ace pilot—and now German air force general—Hermann Göring officially took up residence in the imperial suite.

The staff had been preparing for this event since Göring first strode through the doors of the Hôtel Ritz ten weeks earlier.

There had been new renovations and a flurry of activity in advance of this newest occupation. Above all, workmen had come to install in the apartments a massive, oversized bathtub to accommodate Adolf Hitler's second-in-command, the fleshy Reichsmarschall.

It wasn't just that the German Luftwaffe commander enjoyed a long soak in the bubbles while sipping champagne and wolfing down caviar in Paris. Not that he was opposed to such pleasures. But the hotel staff assigned to attend to the German commander soon learned that the bathtub masked a darker secret, one shared by many of his generation.

Hermann Göring was a morphine addict. He had been trying to kick the habit since the mid-1920s. Painkillers were a basic fact of postwar life for many of the men who had survived the "Great War." Both cocaine and narcotics became wildly popular in modernist Berlin during the years of the so-called Weimar Republic—the epoch that had ended with Adolf Hitler's ascension to power and with the peculiarly backward-looking brand of German pre-industrial nationalism that came

with the rise of fascism. Modern warfare—with technological "innovations" that included the first widespread use of the self-powered machine gun and chemical weapons—had also inaugurated a new era of addiction to pharmaceuticals.

In the 1930s, a German doctor from Cologne named Hubert Kahle had announced the medical discovery of a new "wonder cure" for morphine addiction, and Hermann Göring had turned to the eminent professor for a course of treatment that included long baths to manage the symptoms of withdrawal. There in the Hôtel Ritz, the doctor would come to "submerge Göring in a tub of water, give him injections, then submerge him again, for hours and hours," the staff remembered. "We had to bring the professor piles of towels and lots of food, because the procedure made Göring ravenous."

When Göring took over the imperial suite at the Hôtel Ritz, the previous occupant of the room found herself abruptly relocated—and she faced that week an agonizing dilemma.

That previous occupant was a certain Laura Mae Corrigan, the widow of a midwestern steel industrialist and since his death one of the richest women in America. Her monthly income in the summer of 1940 was $800,000—something significantly more than $12 million a month in today's value. That meant that Mrs. Corrigan could afford to live at the Hôtel Ritz more or less permanently.

Since 1938, she more or less had. Of course, when the newly appointed British prime minister Winston Churchill had come to visit Paris in the spring of 1940, in the weeks and days before the Battle of France, he had stayed in the imperial suite. One had to give way to dignitaries and heads of state, naturally. Corrigan understood as clearly as anyone how much the niceties of rank mattered. But, in general, the grand apartments on the Place Vendôme were Laura Mae's favorite. They were the best rooms in the palace. And she had deeper pockets than almost any of them.

It hadn't always been the silver spoon for her. Born in 1879 into a working-class family in Waupaca, Wisconsin, Laura Mae Whitrock had worked her way from a waitress to a telephone switchboard operator to the wife of a Chicago doctor and then the mistress of the great iron and steel industrialist James Corrigan. After a quick and quiet divorce from her doctor, in 1916 she and Corrigan dismayed his family and much of Cleveland high society by getting married.

When the Cleveland elite snubbed them, the couple took off for Manhattan. There the gates were closed just as firmly. In his 1925 novel *The Great Gatsby*, F. Scott Fitzgerald told the story of a midwestern upstart trying to buy his way into old-money East Coast circles and failing tragically. Laura Mae ran up against the same obstacles. When several hundred thousand dollars' worth of lavish parties couldn't buy Mrs. Corrigan entrée to the upper crust, the couple relocated to Europe. There no one imagined that a rich American had a pedigree anyhow. And, after the financial losses of the First World War and the Great Depression, a generous hand with a vast personal fortune more than made up for the lack of prominent ancestors.

By the time Jimmy Corrigan's heart condition caught up with him, Laura Mae was a sensation. As America's most famous social-climbing hostess—the squat and singularly unattractive party planner Elsa Maxwell—so succinctly put it, "A great London Hostess in the twenties was the irrepressible Laura Corrigan who established a formidable handicap in the American Cinderella Derby by covering the ground from switchboard operator to rich widow in a record six months." It was a wild exaggeration. Jimmy Corrigan died in 1928, not 1916. When it came to cutting witticisms, though, no one cared about precise chronology.

In Europe, Laura Mae pursued a reliable old-world strategy. She bought her way swiftly into the gilded reaches of society, and before long she was cavorting with dukes and duchesses, princes

and princesses. She threw extravagant gala events and carefully started inviting all the right people. She gave expensive gifts and paid cash-strapped duchesses to come to her dinner parties.

It was a tactic that, at the Hôtel Ritz, Elsa Maxwell had perfected. As Janet Flanner, the *New Yorker* correspondent in Paris during the 1920s and 1930s, dryly observed, Elsa Maxwell had a knack for establishing upstart American socialites in European aristocratic society—if they had enough money. For a fee, Elsa Maxwell "transformed un-notables into notables, using the publicity surrounding their galas to the best possible advantage for them and herself. She preferred to give her soirées at the Ritz" in Paris. Most often, those soirées were masquerade balls, where appearing in drag was considered witty. Flanner noted that Coco Chanel, in particular, "did land-office business generally, cutting and fitting gowns for the young men about town, who appeared as some of the best-known women in Paris."

The Ritz was where wealthy Americans in Paris inevitably headed. It had been since as early as 1900. For decades already, the new-world rich had rubbed shoulders with the rootless Dreyfusards, artists, and intellectuals of the European continent. The result was a kind of rare cultural magic.

By the late 1930s, Laura Mae Corrigan, too, had arrived in in the French capital. Her parties were "generally considered at the time to be the most generous free meal ticket for downgraded entries in *Burke's Peerage*" on the Continent. Even with all her millions, it was sometimes tough going. As Elsa Maxwell put it, the trouble was that Laura Mae "was not beautiful, she was not educated or particularly clever—[and] her innocent blunders of speech provided almost as much amusement, behind her back, as her parties." Eventually, though, she cracked the nut that was Parisian society.

On September 1, 1940, Laura Mae Corrigan was in a particular sort of predicament. She was vastly rich, and her investments in Treasury notes had weathered the Wall Street crash

beautifully. And having deep pockets mattered a great deal in Paris in the 1930s and 1940s. At no time did it matter more than during the occupation. For those with money at the Hôtel Ritz, life went on in those first days after the fall of France more or less as always. Of course, there had been a few obstacles and some deftly managed alterations. But luxury was a powerful insulation.

Now, however, the United States government, afraid that her monthly millions—whether through design or accident— would fall into the hands of the Germans and aid the fascist war effort, had frozen her income and limited her to a budget of five hundred dollars a month for as long as she stayed in Europe.

Had it not been for this freezing of her assets, she would have preferred to stay on in the capital. She had made plans that depended on it. With a number of other high-society American women and the French Duke de Doudeauville, she had thrown herself into charitable relief work in Paris weeks earlier. Everyone expected a display of wartime concern and philanthropy. Their organization Bienvenue au Soldat—"Welcome, Soldier"—sent care packages to the war wounded and supported hospitals.

Laura Mae Corrigan found herself if not penniless, then certainly cramped significantly. With Hermann Göring firmly ensconced in her suites at the Ritz, she also found herself homeless.

Harder yet, Laura Mae understood plainly and painfully that even European high society tolerated her only because of her fortune. Five hundred dollars a month was around eight thousand dollars a month in today's value, enough to keep her comfortably in France but not enough to hole up in the hotel's imperial suite for the duration—even if those rooms hadn't just been claimed by the German general. It was certainly not enough to sustain her philanthropy in Paris's most posh circles.

The dilemma for Laura Mae was what to do and where to go without a fortune. Staying on in Paris was not impossible for a rich American in the summer of 1940. The Hôtel Ritz, long a favorite among the Americans in Paris, had been filled with them in the spring. Marlene Dietrich had ended a liaison with Joseph Kennedy there the year before, and her paramour moved on quickly to a new conquest. The socialite Clare Boothe Luce, the journalist wife of the owner of *Time* and *Life* magazines, was rumored to have been carrying on with Joe Kennedy in her Ritz bedroom in April. When Clare fled France in the mass exodus, she famously insisted that Hans Elminger tell her how he could possibly know that the Germans were coming. (He quipped, in response, a deadpan "Because they have reservations.")

Plenty of other Americans had stayed on after the occupation started. Legendary decorator Lady Mendl. Socialite Barbara Hutton. Despite the United States ambassador urging citizens to leave France while it was still easy, the heiress Florence Jay Gould was insisting that she planned to stay in the capital under any conditions.

The wife of the hotel's managing director was fast coming to the same decision. Claude Auzello and his feisty American-born wife, Blanche, were always rowing violently about his determination to keep a mistress. With a husband like hers, she had no intention of leaving France, either.

There were a surprising number of women at the Hôtel Ritz that September. With the arrival of Hermann Göring and the other officers, the trend quickly accelerated. In the hotel bar, Laura Mae Corrigan would have found some new regulars. Secretaries like the pretty Inga Haag from the nearby Abwehr—one branch of fascist intelligence offices—caroused with Daisy Fellowes, the heiress to the Singer sewing-machine fortune (and a cousin of Winston Churchill by marriage). Of course, Daisy Fellowes's maiden name was

Glücksbierg, something the Germans surely noted in their files. Inga Haag was not without her own connections, either; her uncle was the Abwehr director, Admiral Wilhelm Canaris.

Fern Bedaux and her husband, Charles, were part of the lingering American smart set in Paris. Like more than a few of those who stayed on, their politics were distinctly pro-fascist. Wartime dinner guests at their country estate included Göring and the German foreign minister Joachim von Ribbentrop. They had hosted the royal wedding between the American-born Wallis Simpson and the former king Edward VIII at the château three years earlier. After the abdication and the marriage, the new king gave them the titles of Duke and Duchess of Windsor.

The royals were pressed to abandon Paris when the German advance became serious. But both were sympathetic to Adolf Hitler. When the Germans first invaded France and began bombing London, the Duchess of Windsor won few British admirers with her callous comment to the press that "I can't say I feel sorry for them." The Führer appeared to return the mark of favor: their *hôtel particulier* at 85, boulevard Suchet, was carefully "looked after by a German caretaker and handed back in 1944 in perfect order."

British intelligence was concerned, however, about something far more sinister than the duchess's press outrages. The Duchess of Windsor was still passing information to her former love von Ribbentrop in 1940. Rumor had it that von Ribbentrop in return still sent her seventeen carnations each morning—one for every time they had been to bed with each other.

Laura Mae Corrigan had never liked Wallis Simpson. But she had been friendly with the Duke of Windsor since early days in London, when he came to one of her parties. She had entertained von Ribbentrop at her mansion in London.

It all meant just one thing. Laura Mae could stay on comfortably enough—if only she had the money. Returning to America, on the other hand, would be disastrous. She would be going home to the life of a rich social outcast. The Cleveland elite had not warmed to her in the years since she had left the Midwest in the dust, and New York high society had not become more inviting.

In those last days of summer, Corrigan considered whether she should take up the obvious solution to her financial problems. She could raise quite a lot of cash if she were to start selling her personal items to the Germans. In Paris, the Germans were buying up everything—from bottles of Chanel No. 5 for sale across the street at rue Cambon to antiques, art, couture, and jewelry.

In fact, the moment he arrived in the capital, the Reichsmarschall had demanded fresh supplies of a favorite perfume made by the nearby house of Guerlain. It was Hans Elminger's unlucky task to reveal to the general that, so late in the evening, the boutique was closed until morning. Göring in a roar advised Elminger that somebody had better go and open it and ordered his chauffeur to drive the hotel manager to the store directly. Göring had been on an art-collecting binge since then, and snapping up works of art across Paris. "With a carload of detectives following a hundred yards behind him," writes one of Göring's biographers, "he cruised through the bazaars of Paris" picking up luxuries and bargains.

Corrigan's personal effects were a fantastic bazaar of their own. Göring wouldn't have to step one foot outside the Hôtel Ritz for his pleasures if she decided to raise funds for herself by selectively offering treasures to him.

She couldn't sell her fur coats, of course, which was a pity since Göring loved mink and sables. When the Germans informed her that she would have to vacate her three-bedroom imperial suite (complete with maids' quarters, several salons, a

dining room, and a boudoir), there had been no option but to hide her fur collection. If the Germans understood the extent of her valuables, they undoubtedly would take them by force. So she piled them into one of César Ritz's built-in cupboards and dragged a massive old armoire in front of the door as a disguise. There Corrigan's furs passed the war undetected and secure—even from her access to them. Throughout the Hôtel Ritz, César's unexpectedly discreet amenities served clandestine wartime purposes on more than one occasion.

Göring was trying to charm or bully Laura Mae's emeralds out of her, though. She had made the mistake of letting him catch a glimpse of them. The stones were exquisite. In fact, Laura Mae had a massive collection of important gems—not just emeralds but diamonds and gold pieces. And as much as Göring liked to luxuriate in furs and confiscate Old Masters, gems were his true obsession.

One of the Reichsmarschall's coveted purchases in those first days in Paris was a gold marshal's baton, studded with diamonds, that he ordered the luxury firm of Cartier to make for him in short order, paying pennies on the dollar. One could catch sight of him sometimes that summer, walking grandly up and down the central staircase of the Hôtel Ritz, outlandishly dressed, drug-addled, and twirling his baton like a tipsy cheerleader. Those who had seen his closets in the imperial suite knew that lavender trousers and silk kimonos were just the start of it. Staff reported finding "lavish gowns trimmed in ermine and mink . . . jeweled sandals, the emerald brooches and diamond earrings. He wore makeup and doused himself with exotic perfumes, they said, and kept a crystal bowl filled with morphine tablets on a table beside an armchair, alongside another bowl, which contained a *mélange* of precious gems—emeralds, black pearls, opals, garnets, rubies."

The Italian foreign minister Count Galeazzo Ciano, son-in-law of the fascist dictator Benito Mussolini, came to stay

at the Hôtel Ritz in the spring of 1942 and noted wryly in his wartime journal that "Göring talked of little else but the jewels he owned. . . . he played with his gems like a little boy with his marbles." This about a man capable of terrible violence and cold indifference.

People laughed at Göring. Even the German soldiers on sentry in the Ritz had a hard time not mocking him discreetly. Laura Mae knew that people laughed at her, too. The whole purpose of the high-society sniping was to make sure she knew that she was tolerated on sufferance. In that one small way, she and the German air force commander were not so different.

Faced with the choice between returning to America and carrying on in France, Laura Mae made an agonizing decision. She offered her emerald ring to Göring. For it he gave her fifty thousand British pounds sterling—nearly $2 million in today's figures. Through the Reichsmarschall, she sold a gold dressing case to Adolf Hitler. She liquidated her Renaissance tapestries and all her beautiful French antique furniture. She cashed out—some said she sold out—to the Nazis. And she was formulating a secret plan for what she was going to do with her riches.

She was going to stay in France. She was going to keep on selling her treasures. But she wasn't going to do it in occupied Paris. Instead Corrigan headed for the neutral territory of Vichy, the famous spa town in central France that became the headquarters of the collaborationist French government during German occupation, taking her cash and remaining hoard of luxuries with her.

At Vichy, she could have rented a lavish mansion or thrown wartime parties to curry favor with French and German officials. But she did something different and unexpected. She checked into a small and decidedly average hotel. Without fanfare or ceremony, Laura Mae Corrigan began funneling all her

money—an average of two thousand dollars a month—into her charity for wounded French soldiers. She would earn among those veterans the title of the "American Angel."

In time, the chief of the French state, the general Philippe Pétain, learned of it and was moved to award Laura Mae Corrigan with the Legion of Honor—the nation's highest recognition of service to his country. Historians note that "Mrs. Corrigan had the distinction of being the only American woman apart from [the African-American showgirl and spy] Josephine Baker to receive this most coveted of French honors."

For her efforts in France, Laura Mae would also spend time as a prisoner in the internment camp at Vittel, when the United States entered the war in December 1941 and all neutrality for Americans vanished. When she was released from the camp in 1942, she made her way to London. There she continued to dedicate her fortune to helping wounded soldiers. For that service, the British government awarded her the King's Medal in recognition.

Elsa Maxwell had said of Corrigan that "she was not beautiful, she was not educated or particularly clever." But Elsa also went on to say that "she was honest, she had vitality, and she had a heart as big as her bank."

For the moment, she was a wartime heroine. Years later, Charles de Gaulle would ask post-liberation France to judge Laura Mae Corrigan from a different perspective entirely.

5

THE AMERICANS
DRIFTING TO PARIS

1944

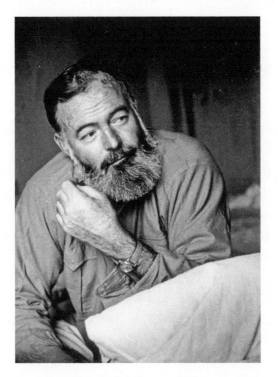

Ernest Hemingway, 1944.

WHEN I DREAM OF AN AFTERLIFE . . . THE ACTION ALWAYS TAKES
PLACE AT THE RITZ PARIS.

—*Ernest Hemingway*

n May 1944, the world had been at war for the better part of five years. Paris had been occupied for nearly four of them. And, if wars have their stories, this one was quickly approaching its climax.

Certainly, Ernest Hemingway thought of war as a kind of uniquely human drama, and for many of the American journalists reporting from Europe in the spring of 1944, it was the return to Paris that mattered. That was where the action was.

Hemingway wasn't the only one who thought that the best kind of action took place at the Hôtel Ritz in Paris. In the heyday of the Roaring Twenties and into the early 1930s, a talented group of American writers known as the "Lost Generation" had been young together in the French capital, and their antics were hotel legend. F. Scott Fitzgerald had dreamed of diamonds as big as the Ritz and had once mused on how "the best of America drifts to Paris."

Scott had been dead since the winter of 1940 from a heart attack in California. Now a group of the old regulars at the Hôtel Ritz were slowly making their way back to Paris without him. Their return would end more happily for some than for others. But for each of them, it was a circuitous and tangled journey, filled with heartache, danger, and more than a bit of nasty double-crossing.

For Hemingway, the return would start with a night of some competitive drinking just across the English Channel— less than three hundred miles north of Paris, but a different world entirely. The celebrated American author's return would take many by surprise: on the morning of May 26, several newspapers reported that Hemingway had perished in a terrible car crash on the streets of London.

The trouble had all started two nights before at a debauched party in Belgrave Square, in one of the old terraced mansions that surrounded the park, now a wartime parking lot for tanks and military equipment and the haunt of foreign correspondents.

The combat photographer Robert Capa had run into his old friend Hemingway in the bar of the Dorchester Hotel, and, as the correspondent later put it, Ernest "was a sore sight for sore eyes, but I was really happy to see him. . . . To prove my devotion and prosperity, I decided to give him a party in my useless and very expensive apartment." Besides, "Papa" Hemingway—as Ernest liked people to call him—had a foul-looking beard that was covering up a skin condition, and, as his friend quipped, "Papa's got troubles . . . that beard scares off all the girls." He was going to need some spirited uplifting.

So, with the skill for rounding up black-market supplies that his friends always admired in him, Capa nicked a "ten-gallon glass jug borrowed from an atomic research laboratory," soaked a half dozen ripe peaches in a bottle of precious brandy, and poured in a case of champagne—at thirty dollars a bottle, wartime prices—to make one of the war's most lethal party punches. Then Capa opened the doors of his apartment on the square to a select group of unruly friends in London. No one was surprised when it turned into a late-night bender.

When the party wound down in the wee hours of the morning, Hemingway was too drunk to get behind the wheel. In fact, by all reports so was his friend Dr. Peter Gorer. They set off anyhow, with the doctor's wife in tow, for a wild ride back to the Dorchester, in the neighboring district of Mayfair. The German Luftwaffe—the Nazi air force, under the command of Hermann Göring—had been bombing metropolitan London again since early January, in what later came to be known as the "Baby Blitz" of 1944. The city was pitch dark because of the blackouts. Headlights were strictly forbidden, but no one thought that the dark that night was at the heart of the problem.

Long before the revelers reached their beds, Gorer lost control of the car and smashed them all headlong into a water tower. The revelers were rushed with injuries to the nearby St. George Hospital. Hemingway was hurt seriously, with a nasty gash on the head from where he hit the windshield and with dreadfully mangled knees. Capa got a call from the hospital soon after, and when he arrived in the emergency room at seven o'clock that morning, "There, on an operating table, I found 215 pounds of Papa. His skull was split wide open and his beard was full of blood. The doctors were about to give him an anesthetic and sew his head together. Papa politely thanked me for the party. He asked me to look after the doctor, who had driven him into a water tank, and who must have been hurt pretty badly too."

The accident left the writer with a serious concussion that should have kept him in bed and off booze for days. Instead of contemplating the good fortune of his near miss and vowing reformation, though, Ernest Hemingway's thoughts were on other matters. In fact, they were mostly on a petite and nicely plump blue-eyed American journalist named Mary Welsh. She had caught his attention at lunch just a few days earlier, on May 22, at the White Tower restaurant in London, with her tight-knit sweater and curly brown hair. As a fellow war correspondent, she had a confident, breezy style that he found enchanting. She was lunching with another war journalist and novelist, Irwin Shaw, a native New Yorker. Allied war correspondents from all over were descending on London in droves that week, and they all had their eye on the same prize: filing the first report from a liberated Paris. But the competition between Hemingway and Shaw quickly took on a sharper edge. Mary Welsh also just happened to be Irwin Shaw's lover.

By her own testimony, Welsh had an attractive figure, and she wasn't shy about making the best of it. She wasn't wearing a brassiere under that tight-knit sweater, either.

"God bless the machine that knit that sweater," sighed Shaw when he saw her.

As they walked across the room, there were jokes from all the correspondents. "Nice sweater," one whistled. There were murmurs of "The warmth does bring things out, doesn't it?" and "Mary, I'd like to see more of you."

Hemingway took one look and said, "Introduce me to your friend, Shaw," and of course Irwin Shaw made the fateful introduction. There was no getting around it. Mary wrote for *Time* magazine, and Ernest boldly asked her if she would have lunch with him alone another day. So what if, besides being Shaw's girlfriend, she also happened to be Mrs. Noel Monks and another man's wife? Ernest Hemingway was smitten. The feeling was apparently mutual.

There was just one other complication on the horizon: another American war correspondent, by the name of Martha Gellhorn, was also on her way to London. "Marty," as her friends called her, was hell-bent on getting back to Paris and on getting the big story, too. She happened to be Mrs. Ernest Hemingway.

In fact, the night of Bob Capa's blowout party, Martha was just arriving in London, and she was unsettled in the extreme. She had been the only civilian on a war transport ship, loaded with explosives, crossing the Atlantic since May 13, 1944.

It was a risky way to get back to Europe to cover her stories for *Collier's* magazine, which was her turf in the world of wartime journalism. A weapons transport ship was a high-value target that spring, and she had taken an astonishing risk in traveling on it. That month, German submarines sank three Allied ships and a United States escort carrier in the Atlantic, and the risks were so great that Winston Churchill later confessed in his memoirs that "the only thing that ever really frightened me was the U-boat peril." During the war, tens of thousands of sailors died at sea transporting supplies from the

United States to Britain. Throughout the voyage, the captain kept blowing the ship's whistle incessantly at anything that came near them on the horizon. It was a whistle that meant, as Martha put it sarcastically, "for Christ's sake don't run into me, you baboon, I'll explode."

Martha was on that transport ship for one simple reason: it was the only way she could find to get across the Atlantic. And that was a pinch she found herself in because of the double-dealing of a certain Ernest Hemingway. Something big was going to happen in the European theater that spring. The temperature of the war was heating up dramatically, with the Allies bombing over France now almost every night. Being there was something as a correspondent she wanted badly.

Hemingway not only had poached her assignment from *Collier's*—leaving her without official press accreditation going into the summer of 1944 and officially sidelined—but he also had refused to help her get a seat on the Pan Am flight from New York City that ferried journalists to Britain in advance of what everyone already knew was going to be a momentous few weeks in France. "Oh no, I couldn't do that," he had told her back in New York. "They only fly men." He knew perfectly well that other women correspondents were on that flight, of course. He simply wanted his wife to stay at home and to act like a woman.

For Martha, the blow was cruel and devastating. "The way it looks," she told a friend in despair, "I am going to lose out on the thing I most care about seeing or writing on in the world, and maybe in my whole life." Sitting sidelined during the Allied invasion of France was going to take "an awful lot more humility and good sense than I now have at my command," and she knew her husband well enough to suspect that teaching her some humility was part of his mean-spirited object lesson. Professional jealousy and a nasty competitive undercurrent ran throughout their relationship, which was now seriously foundering.

Arriving at the docks in Liverpool that afternoon, Martha had had seventeen days at sea on a Norwegian freighter to work up a white fury. By the time she made her way to London and stashed her bags in their hotel room at the Dorchester, Hemingway was already back to partying in his London hospital room with Shaw and Capa. Despite the concussion and a head wrapped up in white gauzy bandages, there were empty bottles of booze and champagne under the bed.

Bob Capa was one of their closest mutual friends, and he had photographed the Gellhorn-Hemingway wedding for *Life* magazine back in 1940. It had been a big story, this celebrity marriage of the writer and the journalist. Now the photographer was taking cheeky shots of a bare-butted and tipsy Ernest Hemingway in the hospital room, happily posing in his gown with "Pinky," Bob Capa's pretty young redheaded girlfriend Elaine Justin. For his friends, Papa always played up the wry machismo. But from Martha, even after the dirty trick he had played with her press accreditation, he wanted wifely compassion for his suffering and not steely pragmatism.

Unluckily, Martha wasn't much in the mood for sympathy. Ernest's "mock-heroics" only got her laughing contemptuously at his melodrama and self-pity. After all, as Martha put it, "[i]f he really had a concussion he could hardly have been drinking with his pals." He was playing it up: bragging about his derring-do and, as usual, exaggerating. Narrowly escaping death once again was part of the old Hemingway story, and just at the moment she was a bit tired of hearing it.

The hospital room marital quarrel was spectacular, and Martha didn't stay around to nurse the tiresome patient in the aftermath. The perky Mary Welsh, however, came bouncing into his room afterward with a huge bouquet of spring tulips and daffodils and dripping sympathy. As far as Papa was concerned, that settled it. What Martha didn't know was that Hemingway had already more or less proposed to Mary Welsh

in her hotel room one night at the Dorchester anyhow. "I don't know you," he had told her, as they sat in the air raid darkness on her bed one warm spring evening. "But I want to marry you. You are very alive. You're beautiful, like a May fly. I want to marry you now, and I hope to marry you sometime. Sometime you may want to marry me." Mary wasn't precisely repulsed by the flattering attention of the literary giant.

Hemingway was released from the hospital a few days later, on Tuesday, May 30, 1944, and, wanting some peace from the endless "Papa" party and his tirades on her wifely failures, Martha moved into her own room on the top floor of the Dorchester. The marriage was in trouble, and she was miserably unhappy, but she figured the row would blow over as usual. Down on the second floor of the Dorchester Hotel, Ernest Hemingway and Mary Welsh were figuring something different. As Ernest put it to Mary, "This war may keep us apart for a while, but we must begin on our Combined Operations."

Back in New York, it had been a game of cross and double-cross already between the two celebrity journalists, and the *Collier's* business had been a painful win for Hemingway. The rivalry between the two, however, was just gearing up, and there would be more high-stakes one-upmanship. Ultimately, their story would end in France and would lead them—and Robert Capa and Mary Welsh, too—back to the Hôtel Ritz in Paris before the end of the summer.

In some respects, it was at the Ritz where their stories had all begun anyhow.

There is a reason that the bar on the rue Cambon side of the hotel is called the Bar Hemingway. In the early days of the Second World War, after Paris had fallen to the Germans and before Pearl Harbor, when the Americans were still neutral, the bar at the Hôtel Ritz had been the second home of a whole generation of daring war correspondents and modernist expatriate artists.

Almost precisely six years earlier, in May 1938, Martha and Ernest had been in Paris together. Back then they were less than two years into their love affair, which had begun in a not dissimilarly complicated fashion. Ernest had visited his old friend Sylvia Beach, the American owner of the Shakespeare and Company bookstore. That afternoon, Sylvia joined them both for a long lunch, and who could help but reminisce about the days of their youth in Paris? After all, the Ritz had also been at the heart of the American literary scene in the 1920s and early 1930s, back in the years when the exchange rate made the city cheap for artists and dreamers.

Back in the crazy years of the Roaring Twenties, Scott Fitzgerald tried his charms on a pretty girl in the Ritz bar by offering her a bouquet of flowers and then, when she refused him, gallantly ate the whole thing petal by petal in front of her. "The amazing part of it," Hemingway said, laughing, "was that it worked and Scott got his way with that beauty. Afterwards, I always referred to such ruses and maneuvers as the Orchid Ploy." The Hôtel Ritz had been synonymous with the carefree glamour of those freewheeling days, when the girls still danced the Charleston and kept dancing when the pearls went flying.

It had remained a glittering beacon throughout the 1930s, part of the legend that was Paris. As far away as Harlem, "Putting on the Ritz" had been the youth culture anthem. Coco Chanel—long since a fashion icon—had made the Ritz her home already for the better part of a decade.

The hotel staff and owners knew them all and had helped to keep the party going. For decades, Marie-Louise Ritz—in her trademark white gloves, trailed by two coddled Belgian griffons—had run the hotel with an iron fist. Ernest Hemingway and Charley Ritz, Marie-Louise's son, the bored heir apparent, were infamous old drinking buddies. His mother had ordered Charley back from his adventures in the fledgling American film industry to work in the family business—after

having sent him out of the country in 1928 in complete exasperation. But Charley couldn't muster a passion for running a luxury hotel. All he really cared about was fly-fishing and his favorite Dutch lager. Marie-Louise, Charley put it bluntly, was "the most critical person I ever knew," and her son did not particularly impress her.

Charley's American wife, Betty, was an even more devoted tippler, and it was because of Betty and another American woman, Blanche Auzello, the wife of the hotel's director, that the ladies could drink in the hotel bars. Charley Ritz and Claude Auzello were left to bicker over whose wife was the bigger alcoholic. Hemingway thought Blanche was great fun, and he always planned to write a novel about the place. If Blanche would just give him the inside gossip, he promised, he'd even make her a character—just like Proust had done for the loyal Olivier.

Now, at the beginning of June 1944, the same journalists who had camped out in the Ritz bar in the late 1930s, covering the Spanish Civil War, were the ones on their way back to Paris, waiting in London for the chance to be among the first wave of reporters to arrive in the French capital. After all, although Adolf Hitler and his generals didn't know it, the Allied troops were only days away from landing on the beaches in Normandy. Within weeks, tens of thousands of young American men would be on the march toward Paris.

Martha was determined to follow the troops back to France and get the scoop, even if she had to do it on the sly, without her press credential. She certainly wasn't going to ask her husband's permission.

Ernest, his head still bandaged from the car crash, still limping from his knee injuries, had his press credentials in order. The head injury meant that he couldn't fly with the Royal Air Force, as he had promised *Collier's*. Instead, Hemingway saw the D-Day invasion from a landing craft at sea, coming in on the seventh wave, late in the action.

The landings at Normandy had originally been planned for June 5, 1944, in that narrow window of a full moon and a good tide, but the weather wouldn't cooperate. So, instead, the Allied troops left England in darkness, and the first troops landed after sunrise on June 6.

From where Ernest Hemingway watched, the artillery "sounded as though they were throwing whole railway trains across the sky," and he could see the infantry on the shoreline, advancing "[s]lowly, laboriously, as though they were Atlas, carrying the world on their shoulders." In a sense, they were. The future of postwar France depended on this operation.

Hemingway filed his story for *Collier's* back safely ashore in Britain, and it was the magazine's lead article of D-Day coverage. But he was not among those soldiers making their perilous way across the headlands. At Normandy, he never stepped foot on land. It would be six weeks still before Ernest Hemingway would find his way back to France, en route at last to Paris and the Hôtel Ritz.

For Robert Capa and Martha Gellhorn, D-Day ended very differently. Bob Capa always said of war photojournalism, "If your pictures aren't good enough, you're not close enough." When the American First Infantry Division landed at Omaha Beach that June morning, the thirty-year-old Bob Capa was among them, covering the story for *Life*. And he wasn't in the rear of the action. "The war correspondent has his stake—his life—in his own hands," he explained later. "I'm a gambler. I decided to go in with E Company, in the first wave."

On the transport ship in the English Channel in the darkness of June 5, the correspondents and some of the officers passed the night shooting craps and playing poker. "It didn't matter whether you won or lost," one sergeant on board remembered, "it was just a way to pass the time. You knew you probably weren't gonna get a chance to win your money back anyway." At three in the morning, all the men assembled for

a final breakfast, a white-glove service of pancakes, eggs, sausages, and coffee. By four A.M. the ship was ten miles from the beach, and everyone aboard stood on the deck silently. "I was thinking a little bit of everything," Robert Capa said afterward, "of green fields, pink clouds, grazing sheep, all the good times, and very much of getting the best pictures of the day. None of us was at all impatient, and we wouldn't have minded standing in the darkness for a very long time."

Over the loudspeaker came the final orders: "Fight to get your troops ashore . . . and if you've got any strength left, fight to save yourselves. . . . Away all boats! . . . Our Father, which art in Heaven, hallowed be thy name." At 5:50 in the morning, the shelling started.

Later, he would remember the moment when "the flat bottom of our boat hit the earth of France. . . . [M]y beautiful France looked sordid and uninviting, and a German machine gun, spitting bullets . . . fully spoiled my return." In the water with the troops, his rolls of films protected from the damp by Army-issue condoms, he started shooting pictures, with bullets cutting up the surf around him. He took 106 photographs of the combat before he clambered aboard an infantry landing craft and was pulled from the action by a nineteen-year-old machinist named Charles Jarreau. As the ship began to pull away from the shore, he thought, "This is my last chance to return to the beach." "I did not go," he confessed later. "The mess boys who had served our coffee in white jackets and with white gloves at three in the morning were covered with blood and were sewing the dead in white sacks." He had spent ninety minutes in the water and now passed out on the deck from exhaustion.

When he landed back on the docks in England early on June 7, a plane was waiting to whisk him off to London. The world wanted to hear the first radio broadcasts of those who had witnessed the landings. Capa, however, couldn't do it. He

handed his rolls of film over to a courier who would take them to be developed in London, and then he took the first boat that he could find back to Normandy. He was back on the beaches by the next morning. Of those 106 images, only eleven would survive the bungling of a careless darkroom assistant. Those that did survive became the iconic images of the D-Day landings.

Martha Gellhorn made it to the beaches of Normandy as well. Without an official press accreditation, despite her years as a war correspondent, she had to lie to do it. On June 5, the night before the invasion, she sweet-talked a British sailor into letting her aboard a hospital ship, claiming she was there to interview a nurse on board for a story. In fact, it was the first hospital ship to cross the Channel, destined for the front lines of the battle. Then Martha locked herself in the bathroom until the ship, painted a ghostly white and marked only with red crosses, had left the harbor. She wrote in her diary, "9.46 or so. In five seconds the command will be given to the world."

When she could feel the swell of the waves as the ship crept out into the Channel, she went above with the nurses. "Pulling out of the harbor that night," she reported, "we passed a ship going the same way. The ship was grey against the grey water and grey sky and standing on her decks, packed solidly together, khaki, silent and unmoving, were American troops. No one waved and no one called. The crowded grey ship and the empty white ship sailed slowly out of the harbor toward France." There were more than five thousand Allied ships in the Channel that night. Some ten thousand of those young men and women on board them would not live to return to Britain.

The nurses that night were all "[b]adly spooked," she remembered. "We drank a lot of whisky. . . . I was very scared, drank, got unscared." In the morning, in the first rush of the landing, Martha watched helplessly as the bodies of some of those young men, now "swollen greyish sacks," floated past the

ship. They were the ones who never made it to the shores of France but were killed in the water.

When the nurses landed onshore, Martha Gellhorn was among them. She joined the ambulance team and worked side by side with the other medics feverishly on the beaches and headlands. Only later would she return to London and file her stories with *Collier's* as a freelancer. The magazine had too much sense not to publish them, and Hemingway never forgave her for getting to France before him.

For illegally sailing to France and reporting without credentials, she was arrested by the military police and interned in a nurses' training camp outside London. The wily Martha, however, would not be contained. She made her dramatic escape from the camp convict-style, one step ahead of the military police. She was on her way back to the European theater. Ultimately she would rendezvous again with Bob Capa and with Ernest Hemingway and Mary Welsh—along with some of those soldiers—in the Hôtel Ritz. The Allied troops were already battling their way east toward Paris.

Some of those who had passed the Second World War living at the Ritz in luxury were just beginning to understand that with the arrival of the Allies would come a terrible reckoning.

6
THE FRENCH ACTRESS AND HER NAZI LOVER

Still shot, Arletty in *Les visiteurs du soir* (The Devil's Envoys), 1942.

IT'S TOUGH, COLLABORATION IS.

—*René, Count de Chambrun*

On May 27, 1944, while Ernest Hemingway was boozing it up in his hospital bed in London, the diminutive black-bereted French philosopher and author Jean-Paul Sartre was in Paris, celebrating the premiere of his new play *Huis Clos* at the Théâtre du Vieux-Colombier, where before the war crowds had gathered to see Béatrice Bretty in celebrated roles. Though she was living in exile, during the occupation the theaters were still packed. In fact, rarely had the scene been livelier. A play with a famously absurdist message, *Huis Clos* was the story of three self-indulgent sinners locked in a room with "no exit." In French, the title is a pointedly sharp one: *Huis Clos* is the literal translation of the Latin judicial term *in camera*, the phrase for a trial held in private chambers.

Sartre's play was disturbingly timely. As the occupation was reaching its turning point that summer, it would soon start dawning on plenty of sinners that they, too, might end up trapped behind closed doors in Paris, facing judgment and agonizing consequences.

One of the women in the audience at the Vieux-Colombier that night was the forty-six-year-old aging beauty Léonie Marie Julie Bathiat. Born in a working-class suburb of Paris only a few weeks before the Hôtel Ritz had first opened its own doors to the public in 1898, she had risen from those humble origins and her early days as a cabaret performer to international fame with her role in Marcel Carné's 1938 film *Hôtel du Nord*. Set not on the glitzy Place Vendôme but along the far scruffier Canal Saint-Martin in Paris, she played in that film an unrepentant prostitute in a dark comedy set on Bastille Day. Now one of the most celebrated movie stars of her generation, she was known to all of France simply as Arletty. She remembered later of Jean-Paul Sartre's play that, despite the arrest of the

leading actress by the Gestapo, the performance that night was "an enormous success."

Perhaps Arletty had even gone to the premiere with her young Nazi lover. She was in love that summer. Her paramour was a handsome blond German lieutenant named Hans-Jürgen Soehring, who had begun his career by studying law in Grenoble and was now attached to the office of the commanding general of the Paris Luftwaffe.

Arletty's love affair with Soehring had been a very public romance. The son of a diplomat, Hans-Jürgen introduced her to German literature over cozy evenings in front the fireplace with her old friend, the playwright and screenwriter Sacha Guitry. The lovers enjoyed long lunches à deux just around the corner from the Hôtel Ritz at the expensive Café Voisin on rue Cambon, a favorite local hangout of the German officers. She introduced him to the pleasures of metropolitan Paris—especially its theaters and operas. They were often seen around the capital attending performances.

As word of the Allied landings at Normandy swept through Paris on June 6, Arletty now found herself faced with a difficult decision. It was the same decision others had faced before her. Like many of the private citizens of occupied Paris, she thought of herself as a neutral party. After all, the fall of France hadn't been her idea. When asked, she admitted that she wasn't a supporter of Charles de Gaulle and his "Gaullist" party. But she wasn't a Nazi, either. She was, she proclaimed saucily, nothing more than a "Gauloise"—a fan of the ultra-French cigarette brand, Gauloises, that was the trademark of fellow artists and friends like Pablo Picasso and Jean-Paul Sartre.

Sooner or later, however, she would have to throw in her lot with one side or the other. Her German friends were already warning her that the moment of decision was coming. Soon she would have to choose between Hans-Jürgen and Paris.

Arletty was not the only Frenchwoman to spend the occupation living in luxury at the Hôtel Ritz with a German lover. In fact, that summer of 1944 there were several. After all, the hotel was uniquely a place where high-ranking officers of the Third Reich and diplomats for the Axis powers could live in easy proximity with French civilians.

Some of the women who made the Hôtel Ritz their wartime homes were simply beautiful and charming French girls who were willing—or compelled—to overlook the niceties of patriotism. In her memoirs of the occupation, the American-born B-list actress and courageous resistant Drue Tartière remembered how, even on her street in a small suburb of Paris, there was a woman whose daughter lived at the Ritz and sent home from the Place Vendôme enough food to sustain the family. German writer Ernst Jünger, another wartime Ritz regular and a friend of Arletty, put it succinctly one night during the 1940s over a sumptuous dinner at the famed Tour d'Argent, the oldest restaurant in Paris: "food is power." While there was champagne and oysters at the Ritz, during the occupation much of the city suffered from devastating food shortages and malnutrition, perhaps as many as 20 percent of the inhabitants.

Even Coco Chanel had her own German beau, the suave aristocratic divorcé Hans von Dincklage. He was another of the spies who lurked in the hotel's bars and worked the secret wires—though whom he spied for, no one was ever quite certain. Some said he was close with Admiral Wilhelm Canaris, a double agent for the German resistance in Paris. Others said he spied for the Third Reich.

Many of those at the Ritz during the occupation had connections with the film industry. It was the inevitable hangover from the 1910s and 1920s, when the hotel had been at the epicenter of the cinema world—a world that was pioneered not in Los Angeles but in Paris. That was why Blanche Auzello had first come to the capital. Now the German general Otto von

Stülpnagel—a man "who loved to take hostages and kill them," as one person who knew him remembered—was regularly seen lunching in the hotel dining room with a notorious Dutch motion-picture provocateur and spy. Josée de Chambrun, the aristocratic daughter of the Vichy high official Pierre Laval, was a determined patroness of movie stars and, with her talent for procuring travel passes, practically their wartime manager.

Since the spring of 1943, Arletty had been traveling off and on to the south of France for another film that she was starring in under the direction of Marcel Carné, the movie ultimately released in 1945 as *Les enfants du paradis* (The Children of Paradise). Josée de Chambrun had pulled all sorts of connections to get the actors and the film crew the necessary German approval, and Arletty benefited materially from her friend's assistance. Her movie-star salary that spring was 100,000 francs a week—160 times the weekly salary of the average Parisian family.

Beyond the doors of the Hôtel Ritz, France was spiraling into a brutal chaos by mid-month. The Allied landings at Normandy were still under way, and, emboldened, the fledgling resistance was on the rise. There were also steady air raid alerts in the city, often coming as many as three or four times a day. Every evening, Allied pilots and gunners were getting shot down over France. On the ground, the Gestapo feverishly hunted down with dogs and bullets those airmen who survived the midair combat. Josée de Chambrun's father, one of the architects of Vichy collaboration, was smack in the middle of the terror operations.

At the Hôtel Ritz, however, even the air raid shelters were first-class indulgences. The cellars were equipped with fur rugs and silk Hermès sleeping bags, and the British wit Noël Coward—posted for a time to the British war propaganda bureau in Paris during the phony war—couldn't help but laugh remembering Coco Chanel's servants trailing behind her, carrying her gas mask on a satin pillow. It was so much hustle and

bustle. Everyone knew the military targets were far from the Place Vendôme, located somewhere out by the railway yards in the suburbs. Nights that spring, the death tolls in parts of Paris rivaled the worst losses during the Blitz on London, in 1940–41. Arletty's response to anything unpleasant was to make a joke of it. She wrote to Hans-Jürgen, "Paris decrees, France follows. . . . It's kaboom everywhere."

By mid-June 1944, things were intensifying quickly across Europe, in part because the Allies were quarreling. Charles de Gaulle was in a tiff with the British and the Americans, who refused to tap him as the inevitable ruler of postwar France and were insisting on an interim Allied military government. Winston Churchill was exasperated, and it ended with Charles de Gaulle calling the British prime minister "a gangster" and setting off for Bayeux, France, on June 14.

De Gaulle's accusation aside, a whole cadre of real-life gangsters *was* running amok by that point in Paris. On June 14, Joseph Darnand—who had earned himself the sorry sobriquet "the French Himmler"—was the Vichy minister of the interior. He directed the day-to-day terror operations for the French police, which Josée's father, Pierre Laval, officially headed.

But Darnand was running a rogue operation. With his promotion to secretary, the city descended into what was effectively a civil war between his paramilitary Milice goon squads and the ruthless guerrilla resistance network. Even as late as the end of June, astonishingly few French citizens were actively resisting the German occupation. Before the summer ended, the organized resistance would swell to perhaps a couple of hundred thousand people in all of France—less than 3 percent of the population, no matter what tales of bravado anyone told later.

As the landings at Normandy wound down and word spread that the Allies were gaining ground by the end of the

month, the senior German administrators were showing signs of apprehension. Ambassador Otto Abetz and his French-born wife, Suzanne, were making evacuation plans. Hans-Jürgen Soehring encouraged Arletty to do the same.

Once again, Arletty laughed off his worries. She couldn't believe that Otto and Suzanne were planning an escape route. Otto was "[t]he first German official I met," she complained to Hans-Jürgen. It had been at Sacha Guitry's house in 1940. If he were to leave, it would be the end of an era.

Hans-Jürgen, who talked to Otto and Suzanne about the situation, knew that when the Allies arrived no one was going to imagine the occupiers had been neutral. Arletty could leave with them when they left for Germany. The paperwork might take a while, but Josée promised that she would help. Or he could take her with him to Berlin if she wanted. He even offered to arrange for her to go to Switzerland if fleeing to Germany offended her patriotic sympathies. But he urged her to do something—and to leave Paris at once.

She wouldn't listen. The point of crisis didn't come for Arletty until the end of the first week of July, when two things happened.

First, Hans-Jürgen Soehring told her that he was leaving, regardless. He still wanted her to go with him. But the Germans were going to evacuate Paris.

The second was a brutal murder. The victim was her old friend from the Hôtel Ritz, Georges Mandel. Pierre Laval's Milice gangsters had taken him out to the forest of Fontainebleau, not far from the city, on July 7 and shot him as a warning to the resistance. Arletty could no longer avoid the stark reality: for some people, Paris was getting dangerous. The trouble was, she couldn't yet see that she was among the vulnerable.

Georges Mandel's wartime story had started and ended in Paris. What had happened was ugly. Journalist-turned-politician Georges Mandel had been a prisoner for nearly four

years, and he had spent much of the first part of the internment in solitary isolation outside Berlin. In the spring of 1943, his captors had transferred him to Buchenwald, where for a while—until the Gestapo took offense at their tone—he was at last allowed to write a few love letters to Béatrice Bretty. He didn't confess in those letters how desperately ill he was already. "With camp sleeping pills," he noted in his last journal entry, "I slept only five hours. . . . Woke up sick, with pain and nausea. Had a great deal of difficulty in getting up and dressing. Took only a cup of weak tea in the morning. . . . I feel very much alone. Cannot count on anyone. Every move I make is watched." He was under constant surveillance.

Now word was spreading throughout the Hôtel Ritz that a favorite long-term resident—the man whose encouragement had almost single-handedly convinced Marie-Louise Ritz that she was right to keep the hotel open—had been brought back to Paris and assassinated. The orders had come from Ministry of Justice offices just across from the Hôtel Ritz on the Place Vendôme.

Behind the scenes it had been a wrenching weeklong showdown between Pierre Laval and Otto Abetz. On the first of the month, a smug Abetz—who had been agitating for this death for months—told Laval, as the head of the Vichy ministers, that the Jewish prisoner was being flown to Paris. Laval was to make sure he was executed. "This isn't much of a gift you're giving me," Laval protested weakly.

A week later, the French Gestapo put nine bullets into Georges Mandel, loaded his riddled body into the trunk of a car, and shot up the vehicle. It was meant to mock the resistance by making the death of Georges Mandel look like the act of a deranged French movement.

Hearing the news in London, Georges Mandel's old friend Winston Churchill couldn't help feeling downtrodden. Charles de Gaulle was still stirring up friction with the Anglo-

Americans. Mandel was, Churchill had always proclaimed, "the first resister." That last summer of the occupation, the British prime minister could be heard wishing aloud that things had turned out differently for France and her allies. Those tensions between de Gaulle and the Anglo-American alliance would be a lasting legacy of the war and shape the future of a modern, postwar Europe.

The newspaper coverage was a sign of just how dark the climate was in Paris that summer. For those who cared to remember the trial of Alfred Dreyfus, the rhetoric was depressingly familiar. *Je Suis Partout*, a right-wing newspaper formerly edited by the French writer Robert Brasillach, and now by a certain Pierre-Antoine Cousteau reported the news of the assassination in the language of stark anti-Semitism: "We regret that the Jew Mandel, who had deserved death a thousand times . . . was not publicly judged and shot. But the most important thing is that the Jew Mandel no longer exists."

Laval insisted that the death of his ancient political archrival was not his doing. In fact, although it was late in the war for Laval—the man who signed the Jewish deportation orders—to be developing a conscience, he swore that he had tried to stop it. He had only heard of the assassination—and "I cannot use any other word" for it, he had sputtered in fury—on the morning of July 8. The orders came, Laval was certain, from the highest reaches of the German government. It didn't take much to suspect that Otto Abetz knew something about it. "You are to go immediately to the German embassy," he told a subordinate, "and tell Abetz quite plainly" that this is the end of it. "One corpse is enough!"

But soon there would be other corpses.

The assassination was a new escalation in the gangster-style warfare sweeping through Paris, and what was suddenly clear to many of those who had collaborated with the Germans was that neutrality was not going to be much of a defense when—

not if, but when—Paris was liberated. Laval was insistent that he had done nothing to betray his country. "I was," he said until the end, nothing more than "the trustee in bankruptcy." Some in his quisling government were even now turning on him, decrying his "policy of 'neutrality'" and demanding fuller French support for the Third Reich—and greater powers for the bureaucracy that had betrayed him.

Beyond those inner circles of collaboration and accommodation, where he was disdained for his weakness, Laval knew that many of his countrymen loathed him. Few in Paris would believe that the execution had not been his doing. As the Allied troops drew closer to the capital, a time of judgment was coming.

With the murder of Georges Mandel, Pierre Laval had lost, as a fellow in the ministry later remembered, the only man "capable of interceding effectively for him on the day of reckoning." For Laval—who had started his own career in the law and was no stranger to judgment—Sartre's play *Huis Clos* had already proven prophetic: there was no exit strategy possible any longer. He knew it the moment he set down the telephone receiver that morning.

Arletty had seen Georges Mandel for the last time on the docks in Bordeaux in 1940. She had watched as the boat carrying Béatrice Bretty to exile and safety crept from the harbor. Arletty had decided not to leave on one of those last boats but to return home instead to Paris.

Mandel had refused to flee, too, despite Churchill's urgings. He had gone on to fight with the Free French in North Africa. He had been captured almost immediately and betrayed into the hands of German captors.

A few days later, Arletty would catch her last glimpse of Pierre Laval on a street in Paris. He was walking near the river, making his way back from Mandel's funeral. She watched for a moment as he turned his footsteps, hunched and weary, toward the Notre Dame cathedral.

For weeks, Arletty had dismissed out of hand all of Hans-Jürgen Soehring's plans and worried suggestions. Now she considered them seriously for the first time. Over and over, she had refused his pleading. "Me, leave?" she kidded him. "Never. I'd prefer to have my head cut off in France. In my country." "When I said to him I wouldn't go," she remembered afterward, "he said to me: 'I'll save it.'"

Now Soehring wasn't making any more promises about the Germans saving the French capital.

She called Sacha Guitry, her old confidant. He knew she was struggling with her decision. "She was already uneasy," he later remembered. "She spoke, even her, of eventual troubles. She chatted a bit—but only for form." She didn't want to admit it, but the fearless Arletty was getting nervous.

Arletty simply could not bring herself to trade in reality. She had lived in cocooned luxury throughout the occupation as a movie star and a celebrity. Sometimes the line between life and those fantasy projections had become more than a little blurry.

That sense of unreality would be her undoing. The German administrators billeted at the Hôtel Ritz and at the confiscated grand private mansions throughout Paris saw the future plainly. In the grand suites along the Place Vendôme, the Nazi officers were packing.

Faced with the choice between bravado and acknowledging her vulnerability, Arletty did what had made her famous as a movie character time and time again. She resorted to ironic jocular defiance. She weighed in her mind the questions of neutrality and culpability and decided that none of it—this war and all its ugliness—had been her business. Her only crime, as far as she could see, was falling in love with a charming officer who happened to be German, and that was surely her private affair. For anyone who challenged her liaison with the occupiers, she had a sharp quip at the ready: "If you hadn't let them in,

I wouldn't have slept with him." Later, she would put it more crudely: "My heart is French, but my ass is international."

She loved Hans-Jürgen Soehring. She loved him not just passionately but dramatically, even distractedly. But she stubbornly told him again that she would not leave Paris. This decision now would have to be irrevocable. Things between them would never be the same again, not with what came after.

It was only after Soehring had gone that Arletty began to suspect that her defiance and defensiveness would have consequences. Paris seemed lonelier and more brutal than she had imagined possible. When she called Guitry now, it wasn't just to chat.

"What do you think is going to happen?" she asked him.

Sacha told her, "Don't worry."

But the words meant nothing to either of them any longer.

Tearfully, she told Sacha that she wished she had gone with Hans after all. Perhaps she would, in the weeks to come, leave Paris. But leaving now was no longer that easy. In the summer of 1944 at the Ritz they were all *huis clos*—behind closed doors in a city on the brink of an explosion of wild vigilante justice that would leave even a war-weary world gasping at its cruelty.

Arletty would soon find herself one of its main targets.

7
THE JEWISH BARTENDER AND THE GERMAN RESISTANCE

The Hôtel Ritz Bar, Paris, just before the occupation.

A GOOD BARMAN REALLY REQUIRES EVERYTHING A DIPLOMAT SHOULD HAVE AND SOMETHING MORE.

—*introduction to Frank Meier's* The Artistry of Mixing Drinks, *1936*

n the rue Cambon bar at the Hôtel Ritz, it all looked lustrously placid. The mahogany counter gleamed, and Frank saw that overnight someone had polished the brass and the mirrors until they sparkled, just as always.

But Friday, July 21, 1944, was anything but an ordinary day at the Ritz, and Frank was rattled.

Both General Carl-Heinrich von Stülpnagel, the military commander of Paris, and his liaison, Colonel Caesar von Hofacker, had been edgy since the previous Friday. The general lived in rooms at the Ritz and had governed day-to-day operations in the city from the hotel since his appointment.

Word had spread quickly through Paris that the day before a German nationalist attempt to assassinate Adolf Hitler had failed miserably. It was a spectacular loss for the German resistance.

Frank knew that a good part of the plot had taken shape over his cocktails. He knew because he'd been part of it, at least tangentially.

The lobby of the Ritz was swarming already with storm troopers from the SS—Heinrich Himmler's notorious Schutzstaffel militia—and even Germans who had known nothing of the plot were frightened. General von Stülpnagel, ordered to return to Berlin instantly, had attempted suicide that morning on the road out of Paris and was now in the custody of the Gestapo. Von Hofacker and Hans Speidel, another German colonel and regular on the Place Vendôme, were missing.

Frank had worked as a kind of agent for all of them.

With so many high-ranking Nazis caught up in this debacle, it wasn't likely that the Gestapo would come asking him questions immediately. No, it was Blanche Auzello who was the real liability. The Gestapo had arrested her six weeks earlier, on June 6,

when she had rashly been out celebrating the Allied landings at Normandy. She was Jewish. Frank knew because he had helped her forge a passport. She was also working with the resistance.

In fact, Frank knew of at least two other members of the Ritz staff who were also running defiant operations. One way or another, a good part of the staff was in on the secret. The Ritz was just too small a place to hide everything. Now they all faced the ultimate test of loyalty and mettle: Would someone crack under the atmosphere of terror and betray them all to the Gestapo? Was there some way to give the weakest links among them a warning?

Shrugging into his white bar coat and adjusting his pince-nez neatly, Frank thought back to the week before. Last Friday had been Bastille Day—July 14—the French patriotic national holiday. In a sign of how quickly things were changing, a hundred thousand Parisians had turned out to face down the panzer tanks of the military government and had closed off the streets with gunshots and bonfires. German military intimidation quelled the demonstration, but for the first time there had been a distinct whiff of smoke and sullen resistance in the air.

That night Colonel Speidel unexpectedly returned to Paris. He had lived at the Hôtel Ritz full-time for several years at the beginning of the war, when he first took up his post as the chief of staff for the military commander of the city in 1940. For the first two years after the fall of France, Speidel had been more or less in charge of overseeing the hotel operations, which mostly meant a fair bit of smoothing ruffled diplomatic feathers and trying to explain why caviar was in short supply during wartime. It was the perfect location for his second assignment: nurturing a select group of artists and scientists who would continue to keep Parisian culture vibrant. It was part of the Führer's grand vision. In fact, when Adolf Hitler visited Paris in the first summer of the occupation, Hans Speidel had been his tour guide.

Now Speidel had moved on to more important military and political matters and spent most of his days at the fortress château of La Roche-Guyon, twenty-five miles outside the capital. It was regional military headquarters, and he hadn't been back in Paris since April, when he'd started a new appointment as the chief of staff to the commander of Army Group B, the "Desert Fox," Field Marshal Erwin Rommel. When Hans did make it to Paris, it was the Hôtel Ritz that felt like home, and everyone still remembered him.

As Frank thought back over the risks and the vulnerabilities and all the times the staff at the Ritz had evaded German attention, it was hard not to think of Hans Speidel. For one thing, Hans was one of the Germans who surely suspected Blanche's true identity. It was whispered that back in the 1920s she'd stepped off the boat in Paris as Mademoiselle Blanche Rubenstein, a Jewish-born German-American B-grade film starlet, the lover of an Egyptian prince and playboys.

Coco Chanel also knew her secret from those early days. One day, passing Blanche on a back staircase at the Ritz, the aging fashion designer had stopped her. "One of my salesgirls told me you are a Jewess, Blanche," she had mentioned. "You can't prove you're Jewish, can you?" she continued. Nothing more was said, and it was a cryptic sort of comment, but Blanche read the innuendo ominously. Everyone knew that Chanel was willing to play dirty when it came to the Jewish question. Her lawyer, René de Chambrun, the husband of Pierre Laval's fashionable daughter, Josée, was already helping her try to have her perfume company taken from the Jewish business partners to whom she had sold a majority stake in the early 1920s. And Blanche was not one of Coco's favorites.

When the Germans had looked into Blanche's paperwork, everything was technically in order. Her passport for years had read Blanche Ross, Catholic, from Ohio. Yet she didn't seem to have a clear idea of where on a map one located Cleveland. No

one had been persuaded. Somehow, the matter never went any further, and because she was married to a French citizen, she had been allowed to stay in Paris.

Frank was glad that Blanche hadn't cracked then, and he hoped she wouldn't crack now either. However, with a conspiracy to assassinate Hitler and Göring linked to hotel residents, it was easy to imagine a clever Gestapo agent putting renewed pressure on her.

The passport was old news, of course. Frank had been the one who helped her to fake it more than a decade earlier. He was still helping forge passports for people who needed to get out of occupied France. He had put her in touch with a Jewish contact named Greep, who for a hundred dollars had forged the false papers and knocked a few years off Blanche's official age in the process. She had renewed the passport with the American consulate, and the new document was perfectly legitimate.

The trouble was, Blanche had worked with Greep more recently. Greep was also part of the resistance, and they had needed his help as part of an operation to help a downed British Royal Air Force gunner escape the capital. Blanche spoke German like a native, and throughout the war she helped fallen airmen make their way out of enemy territory through various underground networks. Airmen were falling from the skies again with a startling regularity.

Blanche, though, was in prison, and the trouble was that even at her best she wasn't particularly discreet or reliable. She liked the ill-timed show of defiance. In fact, it was ill-timed defiance that accounted for her present predicament—which was not the first time she had been arrested by the Gestapo. According to one source, she and an Eastern European girlfriend named Lily Kharmayeff were dining at Maxim's on June 6, when the news of the Normandy landings was making some of the Germans especially ferocious. Different accounts of the story were making the rounds. Some said a tipsy Blanche

repeatedly demanded in German a rendition of "God Save the King" from the orchestra and complained about the fresh oysters being reserved for the Germans. Others said that she had turned on two Frenchwomen having an amorous lunch with Nazi lovers and told them plainly that they were whores and traitors. Her nephew later remembered that Blanche claimed to have thrown a glass of champagne on the crotch of a German officer when he offered her a "Heil Hitler!" Those who knew her best suspected that any of those comments were unfortunately likely, though the stories of her several arrests are frequently jumbled. A lot of people in Paris appreciated the sentiments, but expressing them aloud was foolhardy.

Lily and Blanche were hauled off to the notorious prison camp at Fresnes immediately for showing disrespect to the Germans. It was foolish and not just because of the immediate consequences. Now Lily and Blanche were both under investigation. If the Gestapo discovered what they had really been up to, the result was going to be summary execution. And they wouldn't be the only ones, either. They could easily pull a good part of the Ritz staff down with them.

Lily Kharmayeff had fought in Spain during the civil war and now was involved with the Franco-Spanish resistance in Paris. She was also likely part of the circle of Russian émigré filmmakers and actors who worked in Paris during the 1920s and 1930s with director Yakov Protazanov. Perhaps she and Blanche first met on the set of his 1923 film *Pour une nuit d'amour* (For a Night of Love). One of the supporting actresses in the film was Blanche Ross—Blanche Rubenstein's stage name in the 1920s and the name she eventually used on her false passport.

However they first met, Lily now recruited her old friend into the network. Blanche smuggled military photographs out of Paris by impersonating the wife of a railway worker and—most dangerously for them all—once hid Lily and a wounded communist fighter named Vincenzo in room 414 at the Hôtel

Ritz while he recovered from his injuries. Again, some of the staff had known about it. The concierge had given them the keys, and Claude—kept in the dark about her cloak-and-dagger activities—had still covered for her when the Nazis suspected that something was up. It was Marie-Louise Ritz that everyone had moved heaven and earth to keep in the dark. As her son Charley put it, she saw "every damned thing." Sooner or later, someone was going to have to warn Marie-Louise that it was dangerous to be so friendly with the Germans.

The Germans already suspected Blanche of harboring fugitives and of political terrorism, and if she cracked now and the Gestapo decided to interrogate Claude, there was plenty to discover. He had already been arrested once, too, on the suspicion that he was a communist sympathizer. He wasn't caught up with any of the city's loosely organized movements, but with some of the other staff he was running his own resistance network, informing the Allies when the Hôtel Ritz hosted high-value "guests of the Führer." The Germans already guessed that he was an agent for the British intelligence service. Both Frank and the hotel's doorman, the "chasseur" Jacques, were working with the director.

Claude's network was an ingenious system that utilized the hotel's Swiss contacts. Working with a business associate in the occupied zone, Claude would call from his office and casually convey the coded information. Claude's contact passed the information along to a railway worker near the Swiss border, who carried the information with him down the line to Allied agents in neutral territory. There were numbers assigned to each German military or political figure—or sometimes the code was based on quantities of fruits and vegetables. They had sardonically nicknamed Reichsmarschall Hermann Göring "potato." Claude had tried to get other hotel managers in Paris to join the network. When his counterpart at the Georges V refused, Claude vowed that was the end of their friendship.

On the afternoon of July 21, in the hours after the failed assassination of Adolf Hitler and Hermann Göring, Frank Meier might not have been the most immediate suspect, but he was in dire jeopardy if his secrets were discovered. It wasn't just down to Blanche whether he made it through the next week of reprisals. The storm troopers at the Ritz that day weren't looking for wounded gunmen or members of the French resistance. It was the German plot they were working to uncover. The Ritz bar— Frank's domain—had been a center of the German resistance in Paris, almost since the war began.

And the Austrian-born Frank had been their secret mailbox. He didn't know what had been in all those messages. He was far too smart to be that dangerously curious. But he had passed messages throughout the war for both Carl von Stülpnagel and Hans Speidel and was a high-value asset.

The Ritz bar had been at the heart of a good deal of espionage action. There were spy offices all along the Place Vendôme. At No. 7 were the offices of Compagnie Intercommerciale, an intelligence front run by the German economist Dr. Franz Grüger, providing cover for foreign sections of the Abwehr. Another spymaster, Hauptmann Wiegand, had his quarters at No. 22 on the Place Vendôme, along with a "very bad tempered" Corsican agent named Pierre Costantini. The rue Cambon bar had also been a favorite hangout for the "painted doll," the buxom German socialite named Inga Haag, who was the niece of the Abwehr director, Admiral Wilhelm Canaris, himself a double agent for Britain's MI-6 spy organization.

During the early years of the war, Inga Haag worked as a secretary at the German high command over at the requisitioned Hôtel Lutétia, but several times a week she and her friends came to swill Frank's signature cocktails on rue Cambon. Frank never knew for certain, but Haag—like most of her friends in that circle—was another spy for her uncle's Abwehr and part of the German resistance. Her brief was to supply

Jewish residents with the necessary false passports. They were in the same business.

One of those Hôtel Ritz regulars who came to the bar with Inga was Pierre André Chavannes. He was there often enough that Frank had invented a signature cocktail just for him, the Happy Honey Annie—two-thirds brandy, one-third grapefruit juice, and a dash of honey. Pierre André was also part of the anti-Nazi network in Paris, but he had been arrested back in 1941 and sentenced to execution. Ironically, it was Frank's *The Artistry of Mixing Drinks* (1936) that inexplicably saved Pierre André's life at the eleventh hour in Paris. At Pierre André's apartment on avenue Foch with his German captors, the translator in tow with the Germans happened to see a copy of Frank's famous cocktail bible. A few stiff drinks later and he was able to make a dramatic escape from his addled jail masters and flee to safety beyond Paris.

Frank had passed messages for Inga and her friends. But Inga noticed that he seemed also to be passing messages for Carl von Stülpnagel and Hans Speidel—and they were protecting the bartender. Ironically, it was one circle of the German resistance spying on another circle, each suspecting the other of loyalty to Berlin. Inga and her uncle never seem to have discovered—just as Claude didn't learn until later what Blanche was up to—that von Stülpnagel and Speidel were plotting an unimaginably bold action. It was just too dangerous to trust anyone with those kinds of life-or-death secrets.

Inga's uncle, Admiral Wilhelm Canaris, had disappeared suddenly in February 1944, and his replacement was the greasy Walter Schellenberg. No one knew precisely what Walter Schellenberg and Coco Chanel were up to, but the *couturière* made two trips to Berlin with his help in the winter of 1943 and 1944, and no one suspected that SS general Walter Schellenberg was part of the German resistance.

Now Frank couldn't help but notice that another set of

regulars at the Ritz had disappeared in the aftermath of this attempt on the life of Hitler and Göring. The story was being broadcast over the British radio, and those with hidden transistors were finally learning the tale in tantalizingly vague bits and pieces. Eventually, the whole world would know the details.

What had transpired was an astonishing story of courage and betrayal. In recent days, the three main conspirators in Paris—Hans Speidel, Caesar von Hofacker, and Carl von Stülpnagel—had persuaded Speidel's boss, Field Marshal Erwin Rommel, to meet with them in Paris for a secret war council.

The field marshal had promised in February to support his old friend von Stülpnagel's plan for a military toppling of the Führer, but he had stubbornly drawn the line at a political assassination.

All that had changed during their last meeting in Paris around the time of the Bastille Day riots. The field marshal agreed, at last, that there was no question that Hitler had descended into fantasy and madness. As the commander of Army Group B, Rommel knew better than anyone that the German hold on France was growing more precarious with each passing day, as the Allies continued their march eastward and northward toward the capital.

Rommel was still morally opposed to assassination, and he wanted to give the Führer one last chance to see reason. If he would not, then the Desert Fox vowed that he would throw in his full weight with the conspirators, "openly and unconditionally," to the end. And he vowed that he would do everything in his power to make sure that his second-in-command, Field Marshal Günther von Kluge, didn't balk at the last minute. Von Kluge had agreed to support the conspiracy, but everyone had doubts about his reliability.

Then the conspirators lost Erwin Rommel after all, in a car crash on July 17. On a French country road that day, the Canadian Royal Air Force hit the field marshal's car with a volley

of machine-gun fire. His driver was killed instantly. The result was a terrible wreck as the car hurtled into a roadside ditch at top speed. The Desert Fox had dangerous head injuries and was definitely out of commission. He would spend the coming days in a hospital, before being transferred back to Germany for recuperation—and, after what had happened now, inevitable execution.

They would now have to rely on von Kluge for support when they took control of Paris. He was now in charge of the German military in northern France.

Maybe Günther von Kluge had even intended to give his support to the plan, depending on the outcome. At last, on July 20, Operation Valkyrie finally swung into motion, after months—even years—of secret consternation and planning. In Hitler's distant Wolf's Lair headquarters, Caesar von Hofacker's cousin, Prince Claus von Stauffenberg, planted a briefcase wired with explosives under the Führer's table. He lit the fuse and excused himself calmly. When the bomb blast ripped through the wooden barrack, Claus boarded a waiting plane back to Berlin to set in motion stage two of the military takeover.

In Paris, Hans, Caesar, and Carl had waited anxiously all afternoon that Thursday. At 4:45 P.M. the long-wished-for telegram came over the wires, with the simple statement "internal unrest." It was the code word that meant Adolf Hitler was dead.

At six P.M. another telegram arrived. In the case of the death of the Führer, there was a fixed plan in place, in which the local commanding generals would be given control of occupied districts. These were the very men who had been carefully recruited into the plot to take command of Germany. Von Stülpnagel—the military governor of France—embraced the orders. He immediately ordered the arrest and detention of the entire command structure of the fearsome SS and its intelligence branch, the Sicherheitsdienst, or SD.

By early evening on July 20, 1944, Paris was entirely in the hands of the German resistance.

Soon there would have been a tipping point. In a matter of hours, the word would have spread through the streets of Paris. After that Bastille Day demonstration, the conspirators could not have doubted that the French would soon make any continued occupation impossible.

It all depended only on Günther von Kluge ordering the military to support the governor.

Carl and Caesar raced to the army headquarters at La Roche-Guyon that evening to plan the final stages of the internal liberation of France with the field marshal. With the backing of the military, the occupation would crumble. The capital would be laid open to the Allies, already only a few hundred miles from the city, and they would broker a deal that would save Germany. For months already, those plotting against the Führer and his Reichsmarschall had been trying to gather information on what it might take to convince the Allies to end their war with a post-Hitler Germany.

At the La Roche-Guyon château, von Stülpnagel burst into von Kluge's office with the news. They had immobilized the elite Nazi security troops. Paris was in hand. Now von Kluge needed only contact the Allies and negotiate a peace settlement in France.

In a moment, von Kluge broke the news to them that there would be no armistice. At 7 P.M. Hitler had gone on the radio to assure his commanders that he was not dead. Claus von Stauffenberg had not stayed in the Wolf's Lair long enough to discover that the suitcase with the bomb had been moved away from Hitler only moments before the explosion. They had acted before confirming that the most crucial element of the plan had been successful. It was a catastrophic tactical error.

In light of this failure, Günther von Kluge refused to support them. It would be different, he told von Stülpnagel, "if the pig

were dead." But if the military would back them, they argued, the plan to wrest control of France from Adolf Hitler could still succeed. Von Kluge, however, wasn't prepared to take that gamble. For von Hofacker and von Stülpnagel, it was a long and desperate ride back to Paris. As their car pulled away, von Kluge decided to protect himself from the coming brutal reparations. Von Stülpnagel would have to be arrested and turned over to the Gestapo. He issued the order immediately.

Hans, Caesar, and Carl did not return to the palatial suites at the Hôtel Ritz or to the rue Cambon bar that evening. Still home of the elite German leadership that remained, it would have been far too dangerous. Instead, the conspirators gathered in suite 703 of the Hôtel Raphäel, a stone's throw from the headquarters of the SD and the Gestapo on avenue Foch. The Hôtel Raphäel had been their primary operational headquarters for certain organizational meetings.

Word had already reached their other conspirators in Paris. While a small group of German resistors waited for Carl and Caesar to return from La Roche-Guyon that evening, Carl's chief of staff, Colonel Hans von Linstow, listened in stunned silence to the desperate message by telephone from Germany. He stumbled into the room to tell the others, and someone rose to steady him, thinking the colonel was having a heart attack. Instead he looked at them in horror and choked out the words. "It's all over in Berlin," he cried. "Stauffenberg just called. He gave the news himself and told me that his assassins were at the door."

Back in Berlin, Claus von Stauffenberg did not survive the night. He was summarily court-martialed. At ten minutes past midnight, on July 21, he and three other German ringleaders of the plot to assassinate Hitler and Göring were executed in the low beam of army headlights by a firing squad in the courtyard of the military headquarters. There in Paris, no one doubted that they, too, would be next.

When Carl von Stülpnagel returned at last, he had decided to make a desperate final play for survival. The arrested SS and SD officers had been imprisoned in the grand ballroom of the Hôtel Continental. Confused and worried, the leaders had passed the evening getting drunk on expensive cognac. Ultimately, Carl now knew they would have to release the prisoners. He knew, too, that the ease with which the elite security forces had been disabled was more than an embarrassment. Heads would roll when Hitler learned of it. This was part of the reason why that next morning in the Hôtel Ritz even the SS was frightened.

Carl summoned the SS leader, Carl Oberg, and the German ambassador, Otto Abetz, to the Hôtel Raphäel for an emergency conference. They agreed to all come up with a story to save the SS and SD from embarrassment—in exchange for covering up the plot of the conspirators. They agreed that they would all tell Hitler and Himmler that it was a joint exercise to show that the city could deal with any threat to the Reich.

It all might have worked, except for von Kluge. He called Hitler and explained exactly what Carl and the conspirators had done. Already that night, Carl knew that he was a dead man. He and Caesar stayed up until dawn, destroying as many documents as they could to protect the other conspirators.

In the morning, sometime between eight and eight thirty, Carl went to his office in the military headquarters at the Hôtel Majestic. Thirty minutes later, the order came: the Führer wanted his military commandant of Paris to report to Berlin by plane, instantly. Taking one last look around his office, Carl knew that there was nothing more to be done.

He called Berlin to say he was en route and decided there could be no harm in disobeying one last order. He would drive there instead. Heading east out of Paris, on a French country road, he ordered his driver and his attendant to pull over at a First World War battlefield. He had fought there once and

watched friends die in the meadow. The German humiliation at the Treaty of Versailles was part of what had brought them all to this present juncture. He wanted just a few moments of private reflection, Carl told his attendants. He walked into the distance. Soon, out of the silence, came the echo of two gunshots. His driver found him, one eye blown out and a bullet wound to the head, floating in bloodied canal water. They rushed him to the hospital in Verdun, where he was patched back up and then tortured—ultimately betraying Erwin Rommel in his delirium of anguish.

Adolf Hitler, in his fury, would order the merciless roundup of conspirators and all their relatives and decree that the traitors be killed like cattle—hanged from meat hooks and strung up with piano wire. It was an agonizing death by slow strangulation, and it followed days and sometimes weeks of horrific torture. Hitler and his intimate circle watched filmed recordings of the executions in the evenings with a grisly pleasure. Before the summer was over, Carl would swing from those wires in Berlin.

In Paris, the others ran. The Gestapo was on the hunt for them already. Hans von Linstow would survive on the run for only a matter of days. Caesar von Hofacker made it six days in Paris. Under torture, he would also betray Erwin Rommel. They, too, would end on the wires in Berlin.

In the weeks that followed, some five thousand people were arrested throughout the Third Reich and nearly two hundred of them were executed as a result of that failed plot, many of them innocent.

In the days to come in Paris, only Hans Speidel survived the immediate bloodbath. After July 20, the German resisters were fugitives in enemy territory, and if Hans were captured he would pay with his life. He was on the run, hunted by the Gestapo in the capital.

If those who had helped those conspirators were discovered,

they, too, would pay the consequences. Watching over the rue Cambon bar that evening, as nervous Germans glided in and out of the doorway, everyone listening anxiously for boots and doors banging, Frank Meier knew this was so. They had all played a role in the conspiracy, in one small way or another. With Blanche in the hands of a half-crazed Gestapo, Claude was looking especially pinched and haggard. The regular games of backgammon in the bar were subdued, and even the normal steady stream of small bets that Frank took odds on most days were surprisingly tempered. On a day like this, no one much felt like gambling.

Undoubtedly, there was now more than the usual crowd of spies and double agents at smoky corner tables. Everyone was watching and waiting to see what the fallout would be and who was going to be implicated.

Frank was waiting and wondering also. The German insurgents they knew best—those who had lived at the Ritz among them—had gambled and lost terribly. The plot had failed. But for a few fleeting hours the night before, Paris had been liberated, even if they were the only ones who knew it. He hoped that Blanche would be able to keep silent until the next liberation came. He hoped that they all would keep each other's secrets. Tonight, the bar would close at nine o'clock sharp, as always, and that was enough to focus on for the moment.

But whatever the thoughts running through the head of the barman, to those watching him, Frank of the Ritz looked just the same as always, dapper and impassive.

8

THE AMERICAN WIFE AND
THE SWISS DIRECTOR

Blanche Auzello.

EFFICIENT AND ENDURING INTIMIDATION CAN ONLY BE ACHIEVED
EITHER BY CAPITAL PUNISHMENT OR BY MEASURES BY WHICH
THE RELATIVES OF THE CRIMINALS DO NOT KNOW THE FATE OF
THE CRIMINAL. . . . A. THE PRISONERS WILL VANISH WITHOUT A
TRACE. B. NO INFORMATION MAY BE GIVEN AS TO THEIR WHERE-
ABOUTS OR THEIR FATE.

—*Field Marshal Wilhelm Keitel, "Nacht und Nebel" order, 1941*

On the heels of the failed assassination attempt a new proclamation came from Berlin ordering all military salutes throughout the territories of the Third Reich to be replaced with an outstretched arm and a robust "Heil Hitler." Even the sentries at the Hôtel Ritz entrance obliged; no one would have dreamed of flouting an edict from Berlin that bloody week in Paris.

The show of fresh zeal for the Führer didn't change the coming reality, however. Throughout July, the Allied ground advance had been thwarted, but by August 1 the tide had turned at last in their favor. The fall of Paris was inevitable. Across the capital, the Nazi officers threw themselves into a fever of activity. The Germans who remained were busy getting as much loot out of the capital as they could before anyone could arrive to stop them.

By the beginning of August, one downed American pilot was also looking forward eagerly to the arrival of the Allies and watching the Germans taking their last pleasures in Paris. United States Air Force Lieutenant Colonel Henry Woodrum, from Redding, California, had been behind enemy lines for weeks. The young lieutenant colonel's Martin Marauder B-26 had been shot down in a daytime combat raid over the capital.

At the beginning of August, he was still free in the French capital. Thanks to the bravery of a local family, Henry watched the occupying forces gathering up their final memories of Paris. Many of the "tourists were German soldiers . . . men in their forties and fifties . . . snapping pictures." There was a cheeky acronym used by the officers in the German army: "JEIP." It stood for *Jeder einmal in Paris*, meaning "everyone should see Paris once." "I was thinking privately," Henry chuckled, "that

Paris wasn't going to be the German treasure much longer." Already, the roads heading east out of the city were clogged.

The staff at the Hôtel Ritz was well aware, however, that the Germans were taking plenty of treasure with them. It was the job of the quiet and commanding Hans Elminger to make sure that the exodus went ahead smoothly. The Ritz was celebrated for its impeccable service under any circumstances and for its implacable Swiss neutrality.

Like the other luxury hotels in the capital, the Ritz was buzzing with movement at the beginning of the month. The last Luftwaffe officers, "taking their cue from Göring, loaded trucks with fancy women, *chaise longues* and other booty, and headed for the German frontier." What annoyed Hans Elminger was the fact that he spent his days trying—mostly unsuccessfully—to stop them from loading up the expensive furniture from their rooms at the Hôtel Ritz along with the rest of their booty.

They hadn't seen Hermann Göring at the Ritz since before Christmas, so the Reichsmarschall's cue was long distance. With the war floundering and Adolf Hitler enraged, Göring fled to his remote country retreat in Germany and was pleading the return of his debilitating illness. The Führer was inclined to hold his Luftwaffe commandant responsible for the failure of the war's progress, and Göring had seen firsthand what happened to people who earned Hitler's displeasure. When Göring warned Hitler that winter that the war couldn't be won, the Führer snarled, "One more move in this direction, Göring, and I'll have you shot." The Reichsmarschall didn't doubt that he meant it. Göring later confessed that, in those last months, "things got so crazy that I said to myself: let's hope it's all over quickly so I can get out of this lunatic asylum."

In August 1944, Hermann Göring still had his trusted agents in Paris. Like Hitler, Göring was a voracious and unscrupulous art collector. He wasn't done trying to get his loot

out of the capital—and neither were the other German officers.

Except for the new sense of urgency, from where Hans El-minger sat this looting was all just business as usual. The Hôtel Ritz had been at the center of some of the war's most under-handed art dealing for years. Hitler's personal agent, the elite German art broker Karl Haberstock, made the celebrated hotel his home in Paris and made a great show of living sumptuously among his collected works.

So did his archrival, the Swiss art dealer Hans Wendland. According to the spies at the American Office of Strategic Services (OSS)—the precursor to today's Central Intelligence Agency—Wendland was the "unofficial 'king' of the Paris art world" and, it was whispered, another one of the Nazi covert operatives living in their midst there on the Place Vendôme. Once, Wendland and Haberstock had been allies in the high-stakes world of art dealing. A dispute over Karl's wife had ended the friendship back in the late 1920s. Now the two were ruthless competitors. During the last summer of the occupa-tion, both dealers were among those scrambling to cash in on the looting of Paris.

By the summer of 1944, it was mostly the "minor" works of art and some nice bits of furniture that were still left in the capital. What counted as minor to the Germans now seems richly ironic. Pablo Picasso often came to lunch at the Hôtel Ritz during the war, but throughout the occupation the Nazis publicly reviled the work of Pablo Picasso as "degenerate" and dangerous.

Adolf Hitler, who fancied himself a promising artist, re-portedly opined, "Anyone who sees and paints a sky green and fields blue ought to be sterilized." By the 1940s, Picasso was doing more than imagining blue fields; he was making portraits in which women had multiple faces and contorted perspective.

The Germans mostly left the celebrated Spanish painter alone, but they banned him from exhibiting his works during

the occupation. Privately, however, many in the German art world recognized the value of his work on the international markets. That week the official Nazi art-looting operation, the ERR—the Einsatzstab Reichsleiter Rosenberg—packed up more than sixty of Picasso's paintings as part of the last shipment out of the capital. They would fetch a good price for the officers. Within days, the headquarters of the ERR would be abandoned, "the staff having effected a somewhat disorderly and hysterical evacuation of the premises."

Many of the confiscated objects would ultimately find their way to the art market in Switzerland, where experts suspect many of them remain still. It was an immensely lucrative trade, and Hans Elminger surely knew that a senior member of the Hôtel Ritz had been helping Karl Haberstock and Hans Wendland.

That man was named Süss, suggesting the possibility of German-Jewish heritage. His first name isn't listed anywhere in the surviving records. He was born forty years earlier, in 1905. He was a Swiss citizen, from the city of Brunnen, and worked at the Ritz as Hans Elminger's assistant director. It is possible that he and Hans were related.

In the OSS archives, a file from 1944 on art looting reads: "Suess. Paris, Hôtel Ritz. Director of the Hôtel Ritz during the occupation. Acted on Haberstock's behalf as middleman and informer. Arranged contacts with other Germans visiting Paris for Haberstock."

Acting as a middleman and informer was a dicey proposition during the occupation. Part of the challenge was remaining relevant. By 1943, with the ERR a well-oiled machine and the major private collections already confiscated, Süss knew enough to be a liability unless he could prove his continued usefulness to the Germans.

And it wasn't just the American OSS agents who had the Hôtel Ritz under surveillance. The Germans had been watch-

ing all the employees carefully since early in the war, and in Berlin there were details in classified files on all of the key staff members. By the beginning of August in 1944, both the French Milice and the French Forces of the Interior (Forces Françaises de l'Intérieur, or FFI) were watching the hotel closely as well. Sometimes it was hard to tell who was on which side at any given moment. That month, a spy and black-market agent named Rebattet, who had worked earlier in the war for the German public works and civil engineering outfit known as the Todt Organization, turned coat and joined the communists. Operating under the cover name "Colonel Renard," he set up an observation post at the Ritz and was running an intelligence network from offices on the nearby boulevard des Capucines.

Downstairs in the rue Cambon bar, Frank Meier had more reasons to be worried than he yet realized. The Third Reich already knew that he was an active wartime British agent and classified him as a "fanatic enemy of Germany." They were watching him constantly. The managing director of the hotel, Claude Auzello, was "urgently suspected of working for the enemy intelligence."

The general manager of the hotel, Hans Elminger, the Germans more or less trusted. It was ironic, considering that he and his wife, Lucienne, were even now hiding several refugees in a cluster of concealed maids' rooms, accessible through a hidden door on a second-floor corridor. One man was a friend whom they had helped with the bribe he needed to escape from a train bound for the feared transit camp at Drancy. Throughout the hotel, there were rooms like this, "wedged between false ceilings and corridors." It was another unexpected wartime advantage of César Ritz's passion for "modern" built-in—and now built-over—closets.

If Hans Elminger wasn't in the resistance exactly, he wasn't without a keen sense of conscience, either. Neutrality was how he managed to fly under the radar, and he guarded the pose

carefully. With the Germans, it had been a smart and success-
ful strategy: "as far as we could observe," the file in Berlin read,
Monsieur Elminger has "acted correctly toward German of-
ficers and civilians" and maintained an appropriately neutral
attitude. It helped that his uncle was president of the Hôtel
Ritz board of directors and that his grandfather, the aristocratic
baron Maximilien von Pfyffer d'Altishofen, had been one of
César Ritz's earliest mentors and supporters.

The Pfyffer d'Altishofen family was at the heart of the
founding of the Hôtel Ritz in the 1890s. German intelligence
files characterized Uncle Hans von Pfyffer, quite simply, as
"one of the most influential people in Switzerland." Rumor had
it that Marie-Louise Ritz had been having an affair with Un-
cle Hans for decades. Hans von Pfyffer and Marie-Louise Ritz
shared something else: they both despised Blanche Auzello.

Blanche's wartime activities were more convoluted and cou-
rageous than almost anyone knew. She had kept it all a dark se-
cret even from her husband, Claude, for everyone's protection.
Unfortunately, Süss was one of the few people in a position to
know about them. It was likely that he had caught her in action.

It wasn't just that she and Lily Kharmayeff had been ar-
rested in early June 1944 for showing tipsy disrespect to Ger-
man officers, as one version of the story had it. It wasn't just
that she had been helping the odd fallen airman out of the
occupied city. The Germans had been watching Blanche since
the summer of 1940. She had been imprisoned on at least one
earlier occasion, and in the spring of 1943, there had been
an incident at the hotel. The Germans discovered that some-
one had turned on the lights in a kitchen basement on the
Place Vendôme side of the Hôtel Ritz during the air raids.
The lights illuminated the front of the hotel, which faced
the Ministry of Justice—and gave the Allies a perfect way to
orient themselves in the skies above a darkened Paris and to
locate targets.

Berlin was furious. Someone needed to be held accountable for the gross violation. "[I]n the interest of the reputation of the German Wehrmacht," the Third Reich's foreign office recommended a severe and "exemplary" punishment of the culprit. It was code word for *torture* and *execution*. The report went further. It recommended a "staff cleansing . . . as soon as possible."

Those on the watch in Paris deeply suspected that the guilty party was Blanche Auzello.

The Germans didn't act immediately against her, however. She was left free to run her wartime operations for the moment. In time, one supposes, there must have been the expectation of bringing down not just Blanche Auzello but a whole network of conspirators.

Finally, in June 1944, the Germans had run out of patience with the brash American. She disappeared into the machinery of the Gestapo, and by August there had been no word of her fate. That was not surprising. Since 1941, troublesome civilians across occupied Europe simply disappeared into "night and fog" in a stated policy of terrorism known as Nacht und Nebel.

Then, one day in the third week of August, someone at the hotel switchboard got a disturbing phone call. A man had found an emaciated, barefoot woman stumbling through the streets of his neighborhood, barely able to stand any longer. Could someone at the Hôtel Ritz come and get her? She said that her name was Madame Auzello.

Claude was out of the door in an instant. Was it possible that somehow Blanche had escaped the Gestapo? What might be required to save her still?

And—as Frank Meier had feared—she *had* cracked under the interrogation.

For those who had passed the occupation in the capital, what happened in the police offices and prisons across Paris was no great secret. Jean Cocteau remembered later what Jean-Paul Sartre said, about how the sense of fear in the capital was infec-

tious: "When women went to the Gestapo headquarters on the avenue Foch or the rue des Saussaies to find out what had happened to their men, they were received with courtesy. . . . Yet people who lived . . . near the headquarters heard screams of pain and terror all day and late into the night. . . . [N]ot a single person in Paris [passed the war] without a friend or relative who had been arrested or deported or shot." And sometimes those interrogated were women. Those lucky enough to survive often returned home disfigured by cigarette burns to the breasts and sadistic mutilation. It was part of the reason why being involved in the resistance or asking too many questions, harboring a fallen pilot or hiding a Jewish woman in cupboards beneath a hotel staircase, was so dangerous.

Those torture centers ranged all over the city, from rooms on rue des Rosiers in the Jewish quarter of the Marais to the notorious chambers at 84, avenue Foch, in the sixteenth arrondissement; at 11, rue des Saussaies, in the eighth, the Gestapo conducted interrogations, using brutal beatings, gang rape, and their signature "bathtub" torture, a particularly vicious variation on waterboarding.

In the basements under some of the prison centers were vast ovens where people were burned, slowly, feetfirst, for punishment and the pleasure of the guards. In underground cells, infested with huge, hungry rats, prisoners with broken bodies were thrown into solitary confinement and forgotten. On the walls throughout Paris, the liberating soldiers would later find heartrending graffiti scratched into the stone: "I am afraid" and "Believing in yourself gives you the power to resist despite the bathtub and all the rest," "Guillaume loves Marianne," or simply "Revenge me."

Blanche had been in custody for months. Her interrogators pressed her to confess that Lily Kharmayeff was a Jew and a member of the resistance. "In my lucid moments," Blanche said, "I was sure I'd never get out of there alive and would be

dead in a day or two." She was dragged limp into some of the repeated interrogations.

Pushed to the point of despair, Blanche finally told a German agent the truth. "I am a Jew, not Lily," she blurted out. "I was born on the east side in New York, the Jewish section. My name is Rubenstein. My parents came from Germany."

"Madame Auzello! I warn you!" the German had admonished her sternly.

She told her interrogator about her fake name and her fake passport. He warned her again that, if she continued in this manner, he would take her outside and shoot her. She insisted wildly that she was Jewish. Perhaps she told him, as well, about the kitchen lights in the Hôtel Ritz and the air raid sabotage. About the downed airmen she had helped escape the city. She expected execution.

After a long pause, the exasperated German at last ordered his subordinate to take her outside into the courtyard.

He then ordered the officer to release her. "Let the damned French take care of her," he said, wearily.

When she cracked under their interrogation, by some miracle the officer either hadn't wanted to execute her or simply hadn't believed her. Logically, it can only have been the former. The German files on Blanche Auzello already contained all the information being wrung from her.

In the end, the Gestapo simply opened the doors to the prison. Blanche found the strength somehow to walk through them, onto the streets of Paris. It was an amazingly lucky escape by any measure. All Blanche had to do now was keep quiet, and soon the last days of the occupation would be over.

Blanche had more than cracked under interrogation, though. Her time in Gestapo custody had broken something essential in her. She was forty pounds lighter, and her mental health was shaken.

In the days that followed, Blanche spiraled out of control.

She seemed to be trying to get herself executed. She insulted German officers on the street; she was now brazen to the point of near insanity.

From an upstairs window of the Hôtel Ritz, she raved at those passing below. *"Le Boche est fini!"*—"The Germans are finished"—she yelled at sentries. The end of the war might be coming, but the liberation hadn't happened yet. Her conduct could only prove fatal. Claude dragged her from the windows, screaming and weeping. He couldn't stop her heavy drinking or her search for some kind of oblivion.

"I had a hate for Germans," she told her nephew after the war, "yes, I was strong on that point—but as they were about to kill me I felt they deserved all the hatred I had for them. They hated my family, my mom and pop, my sisters and brothers, just for being Jewish, and I felt that was reason enough to hate them." In August 1944, she had lost control of any ability to contain that emotion.

If the Germans came for her again—if there was a crack-down on the Hôtel Ritz that accounted for what the files in the foreign office already documented about their resistance networks and the spies and agents among them—it would be a terrible reckoning. It would mean an almost certain death for many of them.

Lily Kharmayeff did meet her death somewhere in Paris. Or at least she disappeared forever, and no one has ever managed to find any trace of her.

In the files on the Hôtel Ritz, stored in a government archive not far from the Alexanderplatz in Berlin's Mitte district, there is no trace of the fate of one other person, either. Monsieur Süss also went missing.

He helped the German occupiers strip Paris of its riches. He conspired in the seizure of property and inevitably made money through his dark dealings. He cozied up to Nazi kingpins and killers. He was an informer.

But what the files in Berlin—at last declassified—seem to suggest is that Monsieur Süss covered in the spring of 1943 for Blanche Auzello. On that night of April 10, 1943, as Allied planes flew over the heart of central Paris, as lights from the kitchens of the Hôtel Ritz illuminated a small garden and, beyond, the walls of the Ministry of Justice, the Germans turned to Monsieur Süss, expecting his usual cooperation. He replied instead that he was not their air raid warden. It was none of his business. He refused to say whether he knew anything. The Germans were furious.

Messages flew from Berlin to Paris. It was indecent behavior. There would have to be consequences—of the highest order. What they were or when they came, it is impossible to say. Süss disappeared without a trace, one of the war's millions of silent stories.

9

THE GERMAN GENERAL AND THE FATE OF PARIS

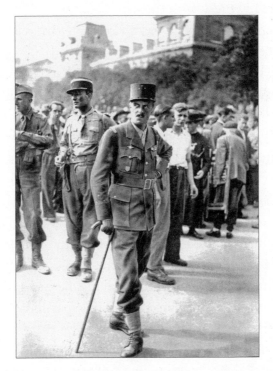

General Leclerc's arrival in Paris during the liberation, August 1944.

EVER SINCE OUR ENEMIES HAVE REFUSED TO LISTEN TO AND OBEY OUR FÜHRER, THE WHOLE WAR HAS GONE BADLY.

—*General Dietrich von Choltitz, Paris, August 1944*

The war in France had started with that first great human exodus from Paris in June 1940. Four years later, a second summer exodus bookended the last weeks of Nazi occupation in the capital. This time it was the Germans who were fleeing—the Germans and those who had passed the occupation in luxury with them.

By August 15, 1944, it was no longer business as usual even at the Hôtel Ritz.

At the height of the occupation, there had been swank dinner dances on Sunday evenings at the hotel, where Parisian socialites flirted with handsome Luftwaffe officers, while artists and entrepreneurs swilled champagne cocktails proffered by silent waiters. There had been long, boozy lunches under the flowering chestnut tree in the small courtyard garden, and low voices speaking in undertones of French and German.

Those days were over. Not only were the last remaining Germans abandoning Paris in advance of the Allies, but many of the more prudent members of the Parisian *gratin* were lying low. More than a few of them were quietly disappearing to country homes or shuttering their grand apartments in the city and hiding.

General Dietrich von Choltitz, however, was just arriving in Paris. Like all the highest-ranking German brass, he was put up at the Hôtel Ritz. He was the newest military governor of the occupied city, and he was replacing Baron Hans von Boineburg Lengsfeld. The baron was another of the Operation Valkyrie conspirators whom Carl von Stülpnagel's frantic cover-up had saved from the gallows in those few precious hours when the capital of France was in the hands of the German resistance.

By August 15, General von Choltitz had been in the capital only a week, and he had his hands full trying to prevent

Paris from igniting in a revolution. Law and order were unraveling quickly. Most of the other German personnel had abandoned the Hôtel Ritz, and the intelligence officers were burning files systematically in a "destructive measure." The French communist resistance fighters intensified their guerrilla strikes against well-known collaborators, and agents of the FFI—or *fifi* in Parisian slang of the 1940s—were organizing coordinated resistance actions across the capital. The French police walked out on strike that day. By afternoon the subways stopped running. The Gestapo was rounding up suspected political dissidents and agitators, and the general wasn't asking them to keep up any foolish pretense of due process any longer. Twenty-six hundred unruly Parisians were crammed onto a train destined for the concentration camp at Buchenwald that afternoon.

The next morning came more purges and executions. An informer betrayed thirty-five members of the FFI to the Gestapo. Von Choltitz ordered them eliminated with machine-gun fire and hand grenades in the park at the Bois de Boulogne.

It was a logistical nightmare. The German administrative corps had all but abandoned Paris, and the faltering Vichy government was imploding. But systematic terror was something the French still understood and respected. And Dietrich von Choltitz was there to deliver it.

He'd start by sending troops to burn the grain windmills in the northeastern suburb of Pantin so the Parisians would slowly starve. Then, according to plan, the troops would turn to planting bombs under bridges and landmarks across the city. When the fuses were lit, Paris would become an inferno. Adolf Hitler wanted the capital of France razed to the ground before the Germans retreated. Destroying one of the great cities of the world would be a powerful "moral weapon" against the enemy, the Führer declared. He ordered von Choltitz to leave the city "a field of ruins."

To the dismay of even some of his fellow Germans, the general showed every sign of compliance. He had a reputation for ruthlessness. In Russia, he had carried out the extermination of large parts of the Jewish population. Ambassador Otto Abetz sent repeated telegrams to Berlin, complaining of the "brutality and rudeness of Choltitz" and decrying the escalation of the violence in the capital. It was a useless protest. The Führer was in a punishing mood, and he wanted Paris flattened.

Yet even with the Allies just beyond the city, theoretically capable of entering the capital at almost any moment, the planned destruction was unaccountably slow in starting. On August 17, 1944, the American troops reached the River Seine and the outskirts of Paris, to the north and the south.

For days, still nothing happened.

Lighting the fuses shouldn't be taking this kind of time. Furious with the delays, Hitler was screaming to his staff in Berlin, *"Brennt Paris?"*—"Is Paris burning?"

Dietrich von Choltitz had long since come to the conclusion that the German leader was insane. He also knew that surrendering Paris was inevitable. He was a general, not a humanitarian, and he had blood on his hands in this war, without question. But he had already made a tactical decision. He didn't want to destroy the capital of France. That was not how he wanted history to remember him.

By the third week of August, he figured that he could stall the burning of Paris, at best, for another forty-eight hours. If the Allies could liberate the city before then, he would let it happen.

After that, he would have to show Berlin action. The fuses would have to be ignited. It would be the end of the "City of Light," as the modern world knew it—the end of that particular version of Paris that had become one of the twentieth century's most enduring legends.

The general—aided by representative resistance insurgents within Paris, to whom he could not with dignity or safety

surrender—arranged for a diplomatic emissary to cross the front lines and deliver a message to the formal French forces-in-exile and to the American general Dwight D. Eisenhower. The message was a stark one. Enter the capital quickly, before I have to destroy it. Dietrich von Choltitz warned them that he had "not more than 24–48 hours left" before he would have to show Hitler that he was moving ahead with the explosions. The Allies had until noon on August 24, 1944, to make their liberation happen.

After that, if he didn't show the Führer results, he had no doubt that someone else would be authorized to give the orders.

The general started moving the German heavy artillery and tanks out of the city. On the morning of August 23, in anticipation of an imminent Allied advance, Dietrich von Choltitz moved out of his suite at the Hôtel Ritz and took up military residence in German government offices at the requisitioned Hôtel Meurice, down on the rue de Rivoli.

It all should have been perfectly simple. The trouble was that the French and the other Allies—especially the Americans and the British, who were in charge of the military operations outside Paris—were now caught up in another round of bitter squabbling that threatened to squander the fleeting opportunity to save Paris.

It was just the latest flare-up in a tussle between the French and the Anglo-Americans that would ultimately, in one fashion or another, shape the contours of postwar European politics for more than another half century.

Poised on the edge of the city, the Allies had been holding back from entering the capital. There were a number of reasons, and like Dietrich von Choltitz they had been stalling. The most important reason was resolutely and unromantically logistical. Once Paris was free, the Allies would need to supply the city with vast quantities of food and fuel, supplies that were still needed desperately on the front lines of the battle. Taking Paris

would distract from a swift push eastward, toward Berlin and victory. Now the German general's offer and the French insistence on liberating the capital had forced the Allies' hand. They would have to go ahead with a premature liberation.

The Allied operation to take Paris accordingly swung into motion. That was when the real trouble started.

As a matter of national pride, the French wanted to be the first forces to enter the city. There was a protracted brouhaha about the matter. The Allies promised to honor the French wishes, but the French were intractably suspicious, despite the fact that the leader of the national division, General Philippe Leclerc, had reached the outskirts of Paris on the morning of August 24. Going so far ahead of the operation had already been an act of serious military insubordination.

The locals in the suburbs had welcomed Leclerc's troops as conquering heroes. The celebrations seemed a bit premature to some of the Allied commanders.

Suddenly, the French started dragging their feet and trying to slow down the entire operation. The clock was ticking. They had only until noon to take the capital.

Yet Leclerc would not budge. The French were not advancing. The Allies were losing patience with him—and above all with Charles de Gaulle, who was ultimately behind it. It was an escalation of tensions that had been simmering more or less openly since 1940.

"If von Choltitz was to deliver the city," as the American general Omar Bradley said, then "we had a compact to fulfill." That meant the troops pushing on through to Paris and not partying on the fringes. It seemed to Bradley that Leclerc's men that day "stumbled reluctantly through a Gallic wall of townsfolk [and] slowed the French advance with wine and celebration."

When his Allied commanders ordered him "to take more aggressive action and speed up his advance," General Leclerc

dismissed the directive out of hand—despite the fact that the order came from his military superiors.

Noon on August 24 passed without the liberation.

Outside of Paris, the Allied troops met with a surprisingly fierce resistance. The bridge at Sevrès, connecting the capital to routes southwest of the city, exploded.

Part of what General Leclerc couldn't point out was that in fact he *had* been trying to delay liberation, even if it meant missing von Choltitz's deadline and undermining a unified Allied operation. General de Gaulle had already made it clear to Leclerc that he didn't want the French troops taking control of Paris until he could make political arrangements to oust the pro-communist resistance and install his own post-occupation government. At stake was his leadership of postwar Paris.

Thoroughly exasperated with de Gaulle by the summer of 1944, the Allies wouldn't much have cared even if they had known the reason. There had already been a tussle over de Gaulle's plans to lead postwar France solo. There was a reason Winston Churchill was going around in 1944 muttering aloud that he wished he'd been able to save Georges Mandel when the French government fled in the beginning. De Gaulle called the Allies gangsters and bullies. The Allies saw de Gaulle as power-hungry and ungrateful. With Allied casualties in the tens of thousands since the Normandy landings, from the Anglo-American perspective it was time to get this bloody war in Europe over.

Exclaiming that no one could afford to wait for the French "to dance their way to Paris," General Omar Bradley took matters into hand directly. "To hell with prestige, tell the 4th [American infantry] to slam on in and take the liberation," he ordered.

When General Leclerc heard that the Americans were geared up to advance on Paris at dawn the next morning, he sent a small detachment of French troops, under the command

of Captain Raymond Dronne, and ordered their symbolic entrance into the capital instantly. The first French soldiers—an impossibly small division—passed the city gates and crossed the Pont d'Austerlitz over the Seine. Their destination was the medieval Hôtel de Ville, the ancient city hall in the fourth arrondissement.

There was no telling now if the armistice would hold or if in the morning the Allies could take the city.

Just off the rue de Rivoli, Dietrich von Choltitz sat that night waiting. There was no telling what, for him and his family in Germany, would be the consequences of his decision. The deadline had passed unmarked. He was desolate and worried. If the Allies did not arrive in the morning—if he could not honorably surrender—there would be death in Berlin on the piano wires for treason. In those last days he once remarked dryly to one of his staff at dinner, "Ever since our enemies have refused to listen to and obey our Führer, the whole war has gone badly." At the crossroads, he had made the same decision not to listen.

Before him were the silent gardens of the Tuileries. Beyond those, the Seine ran all the way to those distant bridges to the south, where the Allies waited somewhere outside Paris. Borne along through the city, the water washed clean the banks of the steep seawalls. It slapped somewhere farther east against the heart of France, its Île de la Cité, where Notre Dame sat in the darkness as it had done for centuries, one of the legends of Paris.

Underneath the ancient cathedral, bombs waited. With them would begin the end of Paris.

Then, just before midnight and from a distance, Dietrich von Choltitz heard the sound of church bells. Soon they were ringing madly.

It could mean only one thing. The liberation at last had started.

10
THE PRESS CORPS AND
THE RACE TO PARIS

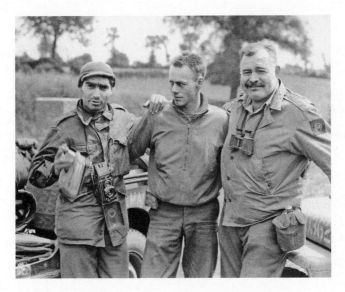

Robert Capa, Olin L. Tompkins, and Ernest Heming-
way at Mont Bocard, France, July 30, 1944.

I HAD A FUNNY CHOKE IN MY THROAT AND I HAD TO CLEAN MY
GLASSES BECAUSE THERE NOW, BELOW US, GRAY AND ALWAYS BEAU-
TIFUL, WAS SPREAD THE CITY I LOVE BEST IN ALL THE WORLD.

—*Ernest Hemingway*

Ernest Hemingway was still steamed at Martha Gellhorn for beating him to the punch in Normandy. But come August, "Papa" was a man with a new objective in mind. He was bound and determined to be the first journalist back at the Hôtel Ritz after the occupation.

He was not alone. As Robert Capa put it, "The road to Paris was calling . . . and every international typewriter . . . and every accredited war correspondent [was] wrangling and conspiring to be the first to enter Paris and file history from the great city of former lights."

Hemingway was pretty sure he could count on Capa and Gellhorn making their way to the Place Vendôme as soon as one or the other managed to get back to the capital. At the moment he was furious with both of them. He certainly wasn't going to get beaten to the prize a second time.

Everyone knew that the Hôtel Ritz was where Papa stayed in Paris. And everyone could guess that Mary Welsh was going to be there with him as soon as she could arrange it. The entire press corps in London had watched with jaded, cynical amusement as their liaison took shape. Martha Gellhorn was probably the only person in their circle who didn't have a clear idea of the situation.

Ernest Hemingway was just plain all-around competitive, but, in the last few weeks, beating Robert Capa back to the Hôtel Ritz had taken on a special significance for the celebrated literary master. It wasn't just that "Capa"—that was all most people ever called him—had made it back to France before he had or that the photographer's gritty images of the Allied advance through France had been making headlines for *Life* magazine ever since. It was personal.

For one thing, there was the whole sorry business with

Martha Gellhorn. Martha and Bob had never made a secret of the fact that they shared a deep and intimate connection. Among her small circle of close friends, Bob Capa was "the best, the nearest in every way . . . my brother, my real brother," as she put it frankly. With the Gellhorn-Hemingway marriage in tatters and Martha struggling with depression that spring, Ernest was perhaps feeling a bit defensive and even jealous. After all, Capa's friendship with Hemingway "dated from the good old days"—back when they had reported on the war in Spain together in 1937. "I was a young freelance photographer" then, Capa remembered, and Hemingway "was a very famous writer." "His nickname was 'Papa' anyway," and "I soon adopted him as a father." That made all of this a complicated little family romance, and the crumbling celebrity marriage was putting strains on everyone.

As the liberation of Paris approached, Gellhorn was far from France, reporting on the Allied advance through Italy and attached to a Canadian outfit. On the ground in Normandy, though, the simmering tensions between Capa and Hemingway had taken on a dark competitive undercurrent as early as August 5.

Papa was keen to be the first to liberate more or less anything, and that morning he sent a message to Capa, who was reporting out of Granville, on the shores of Normandy, not far from Mont St. Michel. The Fourth Infantry "was having a good war for a photographer," the note teased, and Capa "ought to stop fooling around behind a lot of tanks." Hemingway had just captured a sleek Mercedes from some Germans and sent a driver round in it to fetch him. The photographer, knowing what Papa could be like when he was set on an adventure, climbed in reluctantly.

When the Mercedes and driver rolled into camp with Capa in tow, Ernest was full of bonhomie and gusto. It was the first time the two men had seen each other since before D-Day in

London. Then it had been Capa who walked off with the big press story. Now the photographer noticed that Ernest had shaved off his grizzled beard and that the forty-eight stitches it had taken to repair his skull after that drunken late-night car ride through Mayfair had healed nicely.

Capa also noticed that Papa had managed to set himself up in style at the Allied military post. Sweet-talking the commander, General Raymond "Tubby" Barton, with his war stories, he had cobbled together his own private brigade more or less through sheer personal charisma. He had a certain Lieutenant "Stevie" Stevenson as his public relations officer, a private cook, a camp photographer, and his own supply of scotch whiskey. His right-hand man was a brash twenty-nine-year-old Jeep driver, a redheaded American private named Archie "Red" Pelkey. "Barred from carrying a weapon, as were all war correspondents," Capa remembered, "Hemingway made sure his personal platoon carried 'every weapon imaginable'—both German and American."

Ernest announced gleefully that he and his band of "irregulars" had a plan to liberate the village of St. Pois. He generously invited Capa to come along to get some shots of the mission. As Papa pulled out the map and started explaining his strategy, Capa started to get a bad feeling. The Allied regiment, as Ernest showed him, was planning to take the village from a route shown on the left. His idea was to take a shortcut on the map and drive into the village from the right, beating the military sticklers to the punch and to the glory with their rogue assistance. The Budapest-born Capa was unambiguously dubious. His "Hungarian strategy," he told Ernest Hemingway, always wisely "consisted of going behind a good number of soldiers, and never of taking lonely shortcuts through no-man's-land."

Things got tense quickly. Hemingway suggested Capa was a coward. Indignant, the seasoned war photographer took the bait and grudgingly decided that going along was the only op-

tion. After all, there might be a good story, even if it was a hare-brained scheme. Stranger things had happened. And Capa wasn't going to be accused of a lack of macho toughness—not by Papa.

Along with his Mercedes, Hemingway had commandeered a motorcycle with a sidecar. Papa, Red Pelkey, and their army-assigned photographer loaded up the sidecar with whiskey and machine guns and led the convoy off with a surprising sedateness. Behind in the luxury sedan Capa and Lieutenant "Stevie" followed ruefully.

As a photographer, Bob Capa had been in one war or another his whole adult life. He had the instincts of a man used to living by his wits. As they came up on a sharp bend in the road, stopping every few minutes to check the map and the terrain together, he had a grim sense that things were just too quiet. Ernest Hemingway brushed him off and took the corner boldly.

As Papa rounded the bend, the shelling started.

One shell exploded ten yards from the motorcycle, out in front of the convoy. The brakes screeched as the bike slid to a stop, launching Ernest Hemingway out of the sidecar and up into the air. Papa landed with a dusty thud in a narrow ditch on the roadside. The other two abandoned the motorcycle and beat a hasty retreat back to safety on the far side of the curve in the road, out of the range of the artillery. As his compatriots watched, the tracer bullets starting popping in the dirt around Hemingway's head, and Capa knew that if they could all see an inch of his head poking out of that ditch so could the Germans.

Then he looked up to see a panzer tank moving at a slow, steady clip in their general direction.

Hanging around wasn't a great idea, and Capa hadn't been much in the mood for this sort of mock heroics from the beginning, but he couldn't exactly leave a friend in a ditch to be shot at by the Germans—though he thought about it. As they began

inching forward, tempting the Germans with fresh targets, Hemingway let loose with a furious "Get back, goddammit."

But no one was following Papa's orders.

At last, when the Germans turned their sights toward a bigger prize—the arrival of the Allied regiment on the other flank—Hemingway made a run for it and reached the bend in the road, white with fury. Capa later regaled people with the story. He accused me, Capa laughed, "of standing by during his crisis so that I might take the first picture of the famous writer's dead body." "During the evening," the photographer quipped, "relations were somewhat strained between the strategist and the Hungarian military expert."

Though Capa laughed it off publicly, for the two friends it wasn't ultimately a joking matter. Hemingway fumed and stormed, and it ended with a cold, studied silence. For days they didn't speak to each other. After that, Papa didn't have room for a Hungarian photographer in his band of fighters. Robert Capa left camp and headed back to Mont St. Michel and then, on August 18, moved on again, this time to meet up with *Time* journalist and editor Charles Wertenbaker as part of the vanguard of the press corps reporting on the liberation of Chartres, where French civilians were already dishing out mob justice to local traitors.

For Ernest Hemingway the race to the Hôtel Ritz was now the only thing he could think about. The ego-bruising humiliation of that hour in a roadside ditch outside St. Pois had left the forty-five-year-old writer all the more determined that Capa, especially, wasn't going to scoop him. "My own war aim at this moment," wrote Hemingway in a report for *Collier's* magazine, is "to get into Paris without being shot." He was hell-bent on the competition and wasn't much concerned about following the rules of combat and military order—not if it meant missing out on his share of the action and a front-row seat for the liberation of Paris.

On August 19, with Capa in Chartres, Hemingway broke free from the main body of the Fourth Infantry Division and from the cadre of international journalists that followed the Allied main advance. By now, "more than 300 members of the press corps . . . were vying for pole position in the race to Paris: the city's Liberation was the next great story." Hoping to outwit them all, Hemingway headed to the small village of Rambouillet, about sixty miles outside of Paris, where his four-man crew met up with another dozen or so French Maquis fighters who were headed to the capital.

That morning—"a beautiful day that day," Ernest Hemingway extolled—Papa, Red, and his motley group decided to set up a staging ground in the village and fight their way into the capital as a private militia. They even had uniforms. "Mary," Hemingway wrote in one of his typically telegraphic amorous dispatches later, "we have had very strange life since wrote you last. On nineteenth made contact with group of Maquis who placed themselves under my command. Because so old and ugly looking I guess. Clothed them with clothing of cavalry recon outfit which had been killed at entrance to Rambouillet." It was in complete contravention of all the rules for war correspondents and accredited noncombatants.

By August 22, Hemingway and his men had purportedly blown up with a hand grenade some Germans hiding in a cellar and, tired of camp life, checked into the local inn at Rambouillet en masse on his press budget. With him by now were Colonel David Bruce of the OSS American espionage service, army historians Lieutenant Colonel S. L. A. Marshall and Lieutenant John Westover, a resistance fighter named Marcel, another local patriot named Jean-Marie L'Allinec, and a small group of Frenchmen determined to use code names in case they were captured.

The group had spent those last few late nights bonding over copious supplies of the local wine and a bottle of Grand Mar-

nier. Hemingway had strong ideas about liquor and male bond-
ing. "Hey, Jean-Marie, unless you have a drink," he chided the
more sober-minded L'Allinec, "there'll be distance between us.
We have a few drinks—it closes that distance."

The real distance Hemingway wanted to close was be-
tween Rambouillet and Place Vendôme. As Jean-Marie told
a *San Francisco Chronicle* reporter years later, "It was more
than just being the first American in Paris. [Hemingway]
said, 'I will be the first American at the Ritz. And I will
liberate the Ritz.'"

Before too long the French division also arrived in the vil-
lage. With the French troops came, of course, the press corps
that Papa had been slyly outwitting. By August 22, the village
was flooded with journalists.

On the night of August 22, drinking wine in the same
café were Colonel George Stevens, a Hollywood film director,
and his crew. Before long, Irwin Shaw showed up and joined
them. Irwin was long accustomed to taking Ernest Heming-
way's boozy antics in good-natured stride. The "irregulars"
had adopted Papa's boisterous mannerisms and, Robert Capa
teased, went around "spitting short sentences from the corners
of their mouths in their different languages [and carried] more
hand grenades and brandy than a full division."

It was taking over the hotel so no one else could get a decent
bed that especially irritated American journalist Bruce Grant,
who loudly expressed his indignant dissatisfaction. A colorful
exchange of profanity and a barroom tussle ensued. Heming-
way laid a boxer's punch on the journalist's chin, and before
long the two war correspondents were pounding each other
in a tangle of fists and army boots on the floor of the bistro.
A young war correspondent named Andy Rooney watched it
all from a café table and said afterward that he "could never
take Hemingway seriously after that. I'd always liked him as a
writer, but this was such a schoolboy thing."

When Capa showed up in Rambouillet, that was the last straw for Hemingway. There were too many journalists and photographers crawling about. He was going to run his own operations while they all sat around waiting for someone to give them their marching orders. "Every night," Capa noted, Hemingway and his band "went out to harass the remaining Germans between Rambouillet and Paris." He pointedly didn't invite along his old friend.

On August 23, with the plans of the military brass taking shape at last for the liberation, the press corps was buzzing with rumors.

It started to appear that General Leclerc wasn't going to let any of the foreign Allied journalists be there to witness any of it—or to share in any of the glory. That morning, the press corps at Rambouillet got wind that Leclerc had moved the French Second Armored Division out of the village and toward Paris and deliberately not told any of them.

To a group of experienced war correspondents and journalists, this was throwing down the gauntlet, and the competition to be the first reporter in Paris only accelerated now that many were likely to miss the liberation entirely.

There was full-scale race on now between the Anglo-Americans and the French to see who was going to be the first to liberate Paris.

True to form, Capa and Hemingway each pursued a different strategy. Capa and Charlie Wertenbaker set off from Rambouillet to try to catch up with the main flank of Leclerc's army. By the evening of August 24, they found the tank formations at Étampes, thirty miles southwest of the center of Paris. Capa was still determined to keep as many soldiers as possible in front of him. They slept that night on the side of National Route 20. "From beneath the Big Dipper came occasional flashes of light and then the sound of artillery in the distance. The French tanks were dark blurry shapes beneath the trees,"

Capa remembered. Those flashes of light on the far horizon and the silent French tanks on the roadside were at the heart of the diplomatic and military storm that was still brewing.

In the press camp, Hemingway, Colonel Bruce, and their gang formed their own rogue column. Ralph Morse, another correspondent for *Time*, had worked with Mary Welsh on a few stories, and he and Ernest were chummy. As Morse remembered it, "So, we're in this camp, waiting, and Hemingway says, 'You know, the Germans can't possibly have mined every road into Paris. Why don't we find a back road? We can be at the Champs-Élysées before the troops get there.'"

"I had bicycled through this area for many years," Hemingway explained. "It is by riding a bicycle that you learn the contours of a country best, since you have to sweat up the hills and can coast down them." He was sure he could get them to Paris out in front of the main columns, using just the kinds of shortcuts that made Bob Capa dubious.

For better or worse, journalistic competitiveness botched that adventure. Hemingway's plan "to get into Paris before U.S. troops headed in was scuttled," Ralph Morse said later, "because someone—maybe a reporter who wasn't invited along? Who knows?—someone leaked the plan to [General] Patton, and before we knew it, the press camp was surrounded by military police. Patton walks in and says, 'If any of you make a move toward Paris before the troops do, I'll court martial you!'" So, instead, even Ernest Hemingway had to wait until dawn like everyone. He had already violated so many rules of a war correspondent that sooner or later General Patton was going to have to look into it.

For the moment, Hemingway was grounded. As luck would have it, though, he and Red ran into the army historians Lieutenants Marshall and Westover at a local café. The lieutenants had a much greater range of motion than a journalist, and Papa was back in action. "Marshall, for God's sake, have you

got a drink?" Hemingway roared delightedly, and with a laugh Marshall pulled a bottle of whiskey out of the jeep. His militia camped that night, too, under the starlight and distant shelling, on the banks of a small river.

On National Route 20, Bob Capa, Charlie Wertenbaker, and their driver Hubert Strickland woke at dawn on August 25 to find the coordinated advance on Paris beginning, and by mid-morning they were only two miles outside the city. It looked like they were going to be there to see the liberation after all.

Then disaster struck. The French Second Armored Division stopped the reporters at a checkpoint. General Leclerc was still enforcing his orders: no one except the French division was going to be allowed that morning into Paris. "The old boy," Capa grumbled, "was definitely losing charm."

He noticed something interesting: the soldiers barring their route into the capital were speaking French with a Spanish accent. Looking over, Bob Capa saw, too, that on the column of one of their tanks someone had painted the name of one of the most fearsome battles of the Spanish Civil War—a battle he had survived along with them. It was shameful, he fumed loudly in Spanish. He knew that they were Spanish republicans who had come to France as refugees during the civil war and were now fighting for the liberation of Paris with Leclerc's army. But he was one of them. Were they really going to bar him from the greatest battle of the war? Some band of brothers was this.

When the Spanish soldiers heard him expostulating and realized that he was an old comrade-in-arms, that changed everything. They not only gave him a warm welcome and waved him grandly through the barriers. The soldiers also insisted that Capa ride on the tank with them into the capital. Strickland and Charlie followed just behind in the jeep, all the way to Paris.

At 9:40 A.M. precisely the three men passed the Porte d'Orléans, one of the historic entrances dating back centuries to when Paris was a small, walled city. There were crowds waiting along the roads with flowers, and the women shouted *"Merci, merci!"* and kissed them. In his memoirs, Capa described his feelings that early morning in August. "The road to Paris was open," he remembered, "and every Parisian was out in the street to touch the first tank, to kiss the first man, to sing and cry. Never were there so many who were so happy so early in the morning. . . . I felt that this entry into Paris had been made especially for me. On a tank made by the Americans who had accepted me, riding with the Spanish Republicans with whom I had fought against fascism long years ago, I was returning to Paris—the beautiful city where I had first learned to eat, drink, and love."

The tank rolled that morning past scenes from another lifetime, before his lover Gerda Taro had been killed on the front lines in Spain taking photographs, before her funeral in Paris, before D-Day and Normandy. In front of his old home, Robert Capa caught sight of his former landlady, waving a handkerchief, jubilant. *"C'est moi, c'est moi!"* he yelled to her, hoping she would see him and remember. But by now, "the thousands of faces in the finder of my camera became more and more blurred; that finder was very very wet." "Bob Capa and I rode into Paris," Charlie Wertenbaker recalled, "with eyes that would not stay dry. We were no more ashamed of it than were the people who wept as they embraced us."

They left the jeep on the boulevard des Invalides and rolled on in the tank toward the river and the Quai d'Orsay. In the middle of a street, a German officer was kneeling and pleading before a crowd of French patriots who were preparing to execute him. As they turned away, three French marines arrived to arrest the officer, saving his life. They stopped for a drink at the Café du Dôme in Montparnasse, where pretty girls in thin

summer dresses climbed up on their tank and covered their faces with lipstick. "Around the Chamber of Deputies we had to fight, and some of the lipstick got washed off with blood," Capa simply said later.

The French Second Armored Division now swept through Paris to the west, past the Arc de Triomphe and down the Champs-Élysées. The Allies swept along the east. At 10:30 A.M., General Dietrich von Choltitz had, at last, his long-awaited ultimatum. He was still prepared to surrender Paris. It seemed as if, miraculously, the City of Light had been saved from the final act of destruction.

Bob Capa already knew that he "wanted to spend my first night in the best of best hotels—the Ritz." There was nothing to stop him. He had beaten Ernest Hemingway to Paris by more than two hours.

Hemingway, true to form, was determined that his entrance into Paris was going to make for a good story. Already in his mind that day he was starting to compose the letter that he was going to write to Mary Welsh. He would tell her how he and his militia that morning "[r]an patrols and furnished gen to the French when they advanced." "Gen" was the signature Hemingway lingo for something that was "genuine" or good intelligence.

He and his band, along with Colonel Bruce, crossed over the bridge at Pont de Sèvres into Paris from the southwest just before noon in a jeep. Skirting along the south end of the vast forested park at the Bois de Boulogne, they came under the first gunfire from German die-hards. They would evade sniper fire all the way into the city, along a route into the capital that took them through the heart of historic Paris. At the immense axis of the Place de l'Étoile, their jeep passed the looming grandeur of the Arc de Triomphe, and then their driver headed east toward the wide avenue of the Champs-Élysées. To their right, the Eiffel Tower sparkled quietly across the river. To the

left, rising high above the tiled rooftops of Paris, was the white dome of Sacré Coeur on top of Montmartre—the mountain of the martyrs.

What Hemingway's draft letter to Mary didn't mention when he finally sat down to start writing it a day or two later—and what Jean-Marie later remembered—was that his "march on Paris seemed to be punctuated with long, winey stops at this café or that hotel." "It's a wonder he ever got to the Ritz," the Frenchman marveled. By the time their jeep had even reached the River Seine, Lieutenant Marshall had already counted sixty-seven bottles of champagne in it.

Just east of the Place de l'Étoile, Ernest Hemingway encountered an old acquaintance: Émile Vieubois, part of General Leclerc's Second Armored Division. The far western end of the Champs-Élysées was quiet, but Émile warned them that there was heavy fighting farther down where the boulevard opened onto the Place de la Concorde and to the northeast along the rue de Rivoli. It was the obvious route to the Place Vendôme. All Hemingway wanted to know was what was likely to be the fastest way to get to the Hôtel Ritz under the circumstances. He invited Émile to come along for a drink that night in the hotel bar. That's where the victory party would be happening

Avoiding the combat along the Champs-Élysées meant skirting to the north of the Place Vendôme, toward the Opéra. Hemingway and his militia had already made a number of boozy stops, and it seemed like a good time for another refresher. At the axis of the boulevard des Capucines and rue de la Paix there just happened to be a favorite bistro, only a stone's throw away from their final destination. The liberators pulled off for one more celebratory libation at the aptly named Café de la Paix—the café of the peace—and gathered up some more local recruits. By the time the band roared south to the Hôtel Ritz around the corner, there were somewhere between fifty-five and seventy-five of them. It was a glorious way to return to Paris.

Hemingway was glad they had army historians with them that afternoon. "Otherwise everyone would think it was a damned lie," he mused. He boasted later to Mary of the dangers, writing that he'd had a "strong feeling my luck has about run out but [was] going to try to pass a couple of more times with dice." Apart from sporadic sniper fire along the Champs-Élysées, though, it had been a relatively sedate entrance into Paris. But Hemingway was already composing a new element of the enduring Papa legend.

It had to be quick refreshments at the Café de la Paix, because Hemingway still hadn't yet achieved his most pressing objective. He wanted to pull up at his old entrance on the rue Cambon and liberate the Hôtel Ritz from the Germans. He and his followers were ready for some heavy action. The only question was whether he would make it there in time to be the first American.

11
ERNEST HEMINGWAY AND
THE RITZ LIBERATED

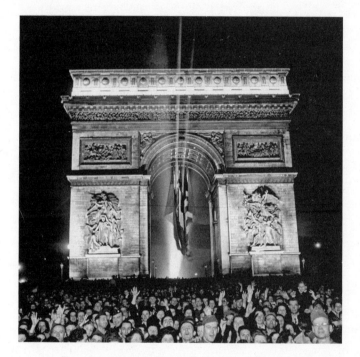

Crowds celebrate in Paris, Arc de Triomphe, 1944.

CHARLEY [RITZ] WENT WITH ME DOWN THE LOVELY RED-
CARPETED HALL AND HE WAS LOVING AS THOUGH WE WERE ALL
LOST CHILDREN WHO, NOT HAVING SENSE ENOUGH TO BE BORN
SWISS, HAD BECOME INVOLVED IN THE DIRTY TRADE OF WAR.
—*Ernest Hemingway, "A Room on the Garden Side"*

After another couple of drinks at the Café de la Paix, Colonel David Bruce and Ernest Hemingway clambered back into the truck. Archie "Red" Pelkey, still behind the wheel, turned south toward the Place Vendôme. A few moments later, Hemingway's band, accompanied by some French fighters they had picked up along the route and by a young American woman named Jacqueline Tavernier, burst into the broad expanse of the plaza and its ancient circle of Renaissance palaces at two o'clock in the afternoon.

General Dietrich von Choltitz had departed, with the last of the Germans and their loot, on August 23, and the moment they left Hans Elminger and Claude Auzello raised the French tricolor over the hotel. There was a dicey moment when word came that the Germans had taken the wrong road out of the city and were coming back down the avenues. The directors stood their ground and refused to take down the French flag, whatever the consequences. Now that flag cracked in the breeze some twenty-four hours later, and the opulent rooms were sitting empty, ripe for the picking.

The Americans weren't the first ones there, however, and Ernest Hemingway wasn't the only one who had been dreaming of some luxury accommodation. Some forward-thinking British troops had arrived an hour earlier and were planning to set themselves up in residence.

They wouldn't hold those palace suites for long. Not if Papa was going to have anything to do with it. He was primed to do battle with just about anyone.

As Hemingway's entourage pulled to a stop in front of the Hôtel Ritz, a great cheer went up around them. This was the moment he had been waiting for. Claude Auzello met him at the entrance, delighted to welcome Mr. Hemingway with a

show of studied Ritz formality. After all, elegantly unruffled feathers under any circumstances, that was the trademark welcome. Ernest boisterously announced his mission: he was there to liberate the Ritz from the Germans personally. "Of course, Mr. Hemingway," Claude intoned calmly, but his tired eyes twinkled. "But be so kind as to leave your weapon at the door, would you?"

Hans Elminger's wife, Lucienne, was standing near the entrance. In the hallways, the British soldiers were busy setting up their headquarters. It was a tense and comic moment. Ernest took one look at the British soldiers, efficiently laying claim to his Hôtel Ritz, and he swung instantly into brash offensive action. "I'm the one who is going to occupy the Ritz," he blustered at them. "We're the Americans. We're going to live just like in the good old days," he snapped. Then he started ordering the British out onto the street, barking his commands to them in German, of all things. Astonished—and astonishingly—they obeyed his orders.

Lucienne remembered that scene clearly, even decades later:

> He entered like a king, and he chased out all the British people who had arrived an hour earlier. He was dressed in khaki, but his shirt was open on his bare chest. He had a leather belt under his big stomach, with his gun beating against his thigh. . . . He had presence, the way people know Hemingway, but no chic. My husband was not very happy to see this happening, in his Ritz.

Frank Meier's deputy bartender, Georges Scheuer, remembered another reason some of the staff were uncomfortable. Ernest had come roaring through the door—in that familiar war correspondent's uniform of an official noncombatant—swinging a 9 mm British submachine gun, something everyone knew was not just "very wrong" but more than a little danger-

ous. It would only be a matter of weeks before Papa would be facing a military investigation for just this sort of breach of neutral conduct.

Hemingway, for his part, remembered Scheuer from before the war and was happy to see familiar faces everywhere. "I had known him when he was seventeen and the wisest boy of seventeen I had ever known and the fastest and the most skillful," Hemingway recalled. Georges had known Papa "when [the writer] had come in with only the money for two drinks, coming in no oftener than once a month and happy to see the stainless steel *beau monde* before there was such a thing as stainless steel." Hemingway's nostalgia for the days when he had been young in Paris was palpable.

Once the Hôtel Ritz had been liberated from its British allies, Hemingway and his men did a sweep of the building, racing up to the rooftop in his search for any lingering Germans hiding in the attics. With a series of well-placed rounds, they succeeded in bringing down a line of freshly washed bedsheets on the roof that had been rustling at just the wrong moment.

No one quite believed that the sweep of the cellars that came next was entirely a military operation. The determinedly correct Hans and Lucienne Elminger might have disapproved quietly of Hemingway's antics, but his militiaman Jean-Marie L'Allinec watched with astonishment as Claude Auzello bounced around, deliriously happy. Privately, of course, Claude always said that the real liberation of the Hôtel Ritz was that moment a day earlier when the directors raised that French flag and watched the Germans roll out with all their loot. But he was happy to let their distinguished former guest and the great American writer have his moment of glory. "We resisted the Germans—we kept the best *premiers crus* from them. We saved the Cheval Blanc!" Claude told Ernest gaily. "Well, go get it!" Papa ordered, grinning broadly. "They brought up some bottles and Papa started slugging it down," said Jean-Marie, remem-

bering the scene years later. "Imagine! This great old Bordeaux, and he's slugging it down like water."

Then Hemingway marched down to Frank's bar and ordered a round of seventy-three martinis for his men and got down to work establishing himself as camp Ritz commandant. He posted guards, assigned himself room thirty-one, and headed upstairs with a couple of bottles of champagne and brandy. "It was incredible, incredible," Lucienne Elminger remembered. "It was breathtaking to see him behave as if the hotel was his home."

Hemingway and his entourage had technically been the first American journalists on the scene. So it was a real pleasure to rib the two unlucky American correspondents who arrived only moments after him, Alan Moorehead and Ted Gilling. They rolled into the Place Vendôme like something out of the wrong decade, in a dusty Volkswagen loaded with camp gear, both men unshaven and looking pretty sorry. With gusto, Ernest suggested to them that, after a much-needed bath, they probably wanted to stop by his suite for some champagne. Papa was heading upstairs now to start celebrating having beaten them to the prize story.

Robert Capa hadn't yet arrived. He had beaten Hemingway into the city, but he hadn't beaten him to the Ritz. And for good reason. Across the city at that moment, the sporadic fighting near the river was still going on, and as always the photojournalist was determined to be at the center of the action. He was busy taking rolls of still more photographs that would become some of those days' most famous.

At four o'clock, Charles de Gaulle entered the capital at last. The Germans had capitulated formally, and most of the German soldiers who were left in the city simply surrendered en masse, their hands in the air and white flags draped on their shoulders. When General de Gaulle arrived at the Préfecture of Police—the central police headquarters—to accept the support

of the metropolitan police divisions, more vicious fighting broke out from German and pro-Vichy insurgents. It was early evening before de Gaulle finally took the stand in front of the Hôtel de Ville, to deliver his liberation speech to the tens of thousands who jammed the public squares to welcome him.

At seven P.M. General de Gaulle's first words from a free Paris were broadcast live around the world. Hearing them over the BBC radio in London, Winston Churchill might have been forgiven once again for wishing that he had been able to save Georges Mandel back in 1940, when this all started. After the mounting tensions between Generals Bradley and Leclerc, some of the Americans could share that perspective. The developing conflict between the French and the Anglo-American allies would play out for years still and shape the fate of the Hôtel Ritz after the occupation.

"Why should we hide the emotion which is taking us all, men and women," Charles de Gaulle intoned in his victory speech to a waiting world, we "who are here, at home, in Paris who stood up to liberate itself and could do so with its own hands?" Warming to his theme, he went on: "Paris! An outraged Paris! A broken Paris! A martyred Paris! But . . . a liberated Paris! Liberated by itself, liberated by its people with the help of the armies of France, with the support and the help of all of France, of the fighting France, of the only France, the real France, the eternal France!" It would not go down in history as one of Charles de Gaulle's most gracious Franco-American moments.

In the public squares and plazas of Paris, the *épurations*, the purges, had started. Among those in the crowd that afternoon listening to de Gaulle's speech was one of the old wartime Hôtel Ritz regulars, Jean Cocteau. The writer was in a bit of a post-liberation predicament. His poems—in German—had come out just that summer. Throughout the occupation, he had been chummy with the fascists and been one of the Hôtel Ritz's

jolly bystanders. It was not a bad moment to start feeling a little bit nervous.

Cocteau would end up back at the Ritz bar before the evening was over. And Ernest Hemingway would pull himself out of bed before long and carry on downstairs with boisterous gusto. For the moment, however, Hemingway was camped out in what he thought of as the middle of the best action—"action [that] takes places at the Ritz Paris." In his dream of it,

> It's a fine summer night. I knock back a couple of martinis in the bar—Rue Cambon side. Then there's a wonderful dinner. . . . After a few brandies, I wander up to my room and slip into one of those huge Ritz beds. They are all made of brass. There's a bolster for my head the size of the Graf Zeppelin and four square pillows filled with real goose feathers—two for me and two for my quite heavenly companion.

He skipped the dinner, and the night of the liberation he didn't have a heavenly companion, but it was a good way to spend an afternoon in Paris. With his celebrity, Hemingway could count on a steady stream of visitors, which was certainly flattering.

Among the first to arrive that afternoon were the philosophers and writers Jean-Paul Sartre and his lover Simone de Beauvoir. The couple had wisely left Paris in mid-July for a "vacation," worried that Jean-Paul's writing for the new underground publication *Combat* might cause some troubles. They had been back in the city since at least as early as August 22, when Jean-Paul had joined a group of dramatists occupying the Théâtre-Français. Not everyone in Paris was awed by Sartre's wartime politics. "Some wits," as one historian puts it, "remark[ed] later that Sartre joined the resistance on the same day as the Paris police." In other words: ten days before the liberation.

Later, Hemingway got his dream dinner. The party in the dining room of the Hôtel Ritz was exuberant. Soon the war correspondents were making their way to their old haunt on the Place Vendôme for a celebratory meal and rounds of champagne. Most of the press corps had set up in rooms at the Hôtel Scribe, a few blocks away, where *Time* editor Charlie Wertenbaker had opened offices for the correspondents looking for assignments.

By evening, Paris was free, and most of the Germans still in the capital had surrendered. The city was brightly lit up, for the first time in years. Despite all the military tussles for national honor and precedence that had marred the day for the generals, now the tricolor and the Stars and Stripes waved side by side on the Eiffel Tower and the Arc de Triomphe to mark the symbolic occasion.

Soon, some of those military men started trickling into the Hôtel Ritz. The rue Cambon bar was the chosen watering hole of all the high-ranking Allied officers. "That evening," said Lieutenant John Westover, one of the two army historians who had traveled into Paris with Papa, "Marshall and I went down to the Ritz and joined up with Hemingway and Col. Bruce for dinner. We all passed around a paper and each person signed their names. We said we were the first people (from the outside) in Paris."

"None of us will ever write a line about these last twenty-four hours in delirium," Hemingway proclaimed. "Whoever tries it is a chump."

It was a hopeful edict. Hemingway wasn't in much of a state just then to write anything. The idea of the others busily filing press stories rankled.

After dinner, an unthinking waiter "slapped a Vichy tax on the bill." The waiter hadn't quite comprehended that the liberation of Paris meant that no one had to follow all those repressive old wartime orders. The result was a jubilant gen-

eral insurrection at the dining room table: "Straightaway we arose as one man and told him: 'Millions to defend France, thousands to honor your fare, but not one *sou* in tribute to Vichy.'"

In offering "thousands to honor your fare," the diners were being gallant that evening. The dinner on offer the night of the liberation was, by Hôtel Ritz standards, uncharacteristically scanty. Everywhere in the city, food was in short supply, and those who weren't going hungry were already among the lucky. Even if other supplies were scarce, the wine cellars at the Hôtel Ritz—thanks to the quick thinking of Hans Elminger years earlier—were still brimming with treasures. After the fall of France, Elminger had secretly hidden, in cellars across the Seine, at 205, rue Lecourbe, 120,000 bottles of wine, one of the great collections in France and certainly the finest in all of Paris. As a result, there had never been a Bordeaux shortage during the occupation. Now hundreds of bottles of fine French wine were guzzled down merrily.

On the heels of the military men, now that the action in the capital had ended, at last came Robert Capa.

He, too, wanted to spend his first night at the Hôtel Ritz on this most amazing of all nights in Paris. He wanted to—but when he arrived at the hotel, he discovered that Hemingway had already claimed it as his personal territory. "Hemingway's army," he mused, "had come into Paris by a different road, and after a short and happy fight had taken their main objective and liberated the Ritz from the German yokels." Given how things stood and the fact that they were still feuding sullenly, Capa wasn't at all sure of his welcome.

Capa pulled up at the Hôtel Ritz. Red Pelkey was standing sentry at the doors of the palace, grinning widely and showing a smile that had all his front teeth missing. Aping his hero, Ernest Hemingway, he talked only in staccato phrases. "Red" told Capa, "Papa took good hotel. Plenty stuff in cellar. You go

up quick." The two men eyed each other for a moment. Capa headed across the grand lobby.

"It was all true," Capa remembered about the wine cellars. And the night ended happily. Ernest Hemingway had accomplished what he already knew would be a legendary objective. Surrounded by friends and admiration, he was feeling generous.

"Papa made up with me," Robert Capa wrote in his memoirs, "gave me a party, and key to the best room in the hotel."

Later, the journalists made the rounds and stopped for a drink in the bar of the Hôtel Scribe, where Capa and Hemingway saw many of the same people who had been at that party on Belgrave Square in the days before the Normandy landings. Among them were Bob Capa's friend Charlie Wertenbaker and the American "dame" photographer, Lee Miller, whose beauty had made her a Paris legend in the 1930s.

Neither Mary Welsh nor Martha Gellhorn showed up, though. Hemingway would have to go back to his brass bed that night without either of them for company.

On the streets that night, "It was an amazing sight, an amazing feeling," one of the journalists at the party remembered:

> So many people in the streets, holding hands, everyone headed for the Champs-Élysées and the Arc de Triomphe, the same way that everyone in New York heads to Times Square, for example, when something momentous happens. It really was . . . well, liberating . . . [there was] the feeling of certainty in the air. Everyone knew it was over. And I don't mean the battle for Paris. I mean the war. We all knew there was a lot of fighting left. The Battle of the Bulge a few months later proved that, and who knew what was going to happen in the Pacific? But when the Germans surrendered Paris, we all sensed it was now only a matter of time, and not much time, before we took Berlin.

It seemed as if, soon, the war might truly be over.

Although Mary Welsh wasn't there in the bar of the Hôtel Scribe, she was already in Paris. She had received her travel orders late on August 24. The next morning she wrangled a spot on a United States Army supply jeep that was taking a bored major into the capital. She had been only a few hours behind Ernest Hemingway and Robert Capa on her way into the city.

"Paris, Paris, I was like a cat in heat," she admitted with her customary sexual frankness. She, too, had wanted to capture the big story. She might have beaten them except for that bored general and his driver. The major didn't speak French and kept giving the driver the wrong directions. Then the driver got drunk on calvados over a maddeningly long lunch. By the time their jeep passed Versailles and finally entered the city through the gates at St. Cloud, where she could at last see the Place de l'Étoile in the distance, the sun was already going down over a liberated Paris. Had she scooped Ernest Hemingway, it might well have been the end of a certain love story.

Mary Welsh's first stop late in the afternoon was the Hôtel Scribe, where she couldn't manage to hunt down her editor, Charlie. "I knew I should have walked to Notre Dame to see what, if anything, was happening there," she later wrote. But she didn't. She didn't head over to the Hôtel Ritz afterward, either. Instead, exhausted, she brushed her teeth in the hotel room washbowl and fell into her bed to sleep, while the city around her partied. Downstairs in the bar, Ernest Hemingway didn't know that she was only a couple of floors above him on the night of the liberation.

When Hemingway left the Hôtel Scribe, it was to make his way back to the Place Vendôme. With Mary sleeping dreamlessly—and his wife, Martha, still a few long hours away from the city—Papa did the only thing that seemed sensible. He moved the party up to his suite, accompanied by Jean-Paul Sartre and Simone de Beauvoir, where they all camped out on

the brass bed, Papa in his pajamas. Before long, Simone and Papa had reached a silent understanding. "Look," Simone put it to a bewildered Jean-Paul, "why don't you get going? We're going to stay here and do a little drinking and serious talking."

Sartre finally accepted the inevitable around three o'clock in the morning. Simone de Beauvoir left Ernest Hemingway, surrounded by half-empty bottles of scotch and rumpled bedclothes, the next morning. The Hôtel Ritz wasn't the only thing that was liberated that night in Paris.

12
THOSE DAME REPORTERS
August 26, 1944

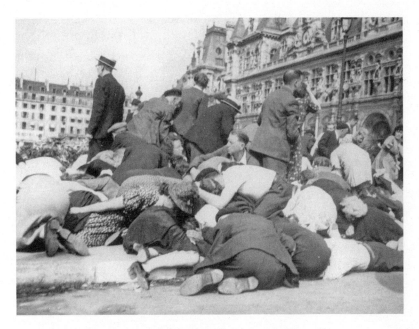

Sniper fire at the Hôtel de Ville, crowds fall to the
ground during the liberation of Paris.

I'VE NOTICED THAT BOMBS NEVER MAKE HITS ON PEOPLE THAT
LIVE IN THE CLARIDGES OR THE RITZ.

—*Clare Boothe Luce, 1940*

The next morning, for those who had survived four years of occupation, began the first day of freedom in Paris. The war wasn't over—far from it. In fact, the battle continued less than fifty miles out of the city, and it would be more than a year still before there would be peace in Europe. But it was a new day in Paris.

That morning, when Ernest Hemingway roused himself, he did what he would do every morning for the next seven months that he would live at the Hôtel Ritz. He opened a bottle of Perrier Jouët Grand Brut champagne and fussed a bit about writing.

Mary Welsh was on his mind. He started drafting her a letter, telling her about his adventures in Rambouillet, his loyal band of fighters, and, of course, his liberation of Paris. "Have been to all the old places I ever lived in Paris and everything is fine," he started writing to her. "But it is all so improbable that you feel like you have died and it is all a dream. Wish very much you were here as am all fought out and would like to have something lovely and touchable or is it tangible, same thing anyway, not something, you please. Thank you very much." He would also write a few lines about facing armed combat and killing some Germans.

Then he set the letter aside. He would finish it tomorrow maybe. After all, he wasn't even sure yet where to send it.

By then, it was time to head downstairs, and he wasn't in the least bit contrite about his late-night carousing. As the tight-knit group of Americans in the press corps gathered for a preprandial cocktail, Ernest took charge. It was a who's who of the war correspondents, with familiar faces such as Irwin Shaw, Charlie Wertenbaker, and now Helen Kirkpatrick, a crack reporter for the *Chicago Daily News* and a well-known name in America and Europe.

In the world of 1940s war journalism, Helen Kirkpatrick was anything but a minor figure. A tall and imposing blue-eyed, thirty-five-year-old American journalist with an acerbic wit and a talent for ferreting out the hard stories, she had been one of the most powerful voices reporting from Britain on the dangers of Adolf Hitler's rise to power and the various follies both of appeasement and of the Duke of Windsor. In 1940, she became the *Chicago Daily News*'s first woman reporter and covered the Blitz bravely from London. And she was there for the Normandy landings, right along with Robert Capa and Martha Gellhorn. The Free French Forces had their pick of a correspondent to be assigned to their headquarters. They chose Helen.

On August 25, she had entered the city in a tank as part of General Leclerc's Second Armored Division, something both Ernest Hemingway and Robert Capa might well have envied. It was the first wave of the action. That first day of freedom in Paris, Helen remembered that Ernest Hemingway "was a loose cannon. . . . He had gathered all these forces around him. He was totally illegal, but that didn't bother him."

At the Hôtel Ritz, drinks turned into lunch, and eventually Helen announced that it was time for her to leave. That afternoon, General Charles de Gaulle was leading a patriotic march from the Arc de Triomphe to the Place de la Concorde, and tens of thousands were already lining the broad avenues of Paris to take part in the official celebration of the liberation. The parade was going to end with a mass of thanksgiving in the Cathedral of Notre Dame, and Helen didn't want to miss out on reporting the day's story.

As she rose, there was an awkward moment. She was getting up to head over to the parade route when Ernest Hemingway, once again playing Papa, advised her, "Daughter, sit still and drink this good brandy. You can always see a parade, but you'll never again lunch at the Ritz on the 26th of August, the day after Paris was liberated."

Off Helen went anyhow, along with Lieutenant John Reinhart. That afternoon, Helen and John Reinhart would find themselves, along with Robert Capa, unexpectedly back in the middle of the fighting.

Always on the lookout for new angles, Hemingway had heard about a downed American airman who had been on the run in Paris since the end of May—and that meant that this young man had been, surely, among the very first of any of the Allies there in the city. It was bound to be an interesting perspective. So he sent off a note to Henry Woodrum, inviting him to come for a drink in the bar of the Hôtel Ritz. He wanted to shake this man's hand and hear his story. There had to be some true "gen" he could use in working up his next article for *Collier's*.

Then, piling into the jeep with some of his cronies, Hemingway set off for the Left Bank to check on how the literary scene had fared under the Nazi occupation and to visit his old friend, the American proprietor of Shakespeare and Company books, Sylvia Beach.

As the jeep rolled to a stop along rue de l'Odéon, Ernest Hemingway jumped out and started bellowing out her name. Soon "everybody in the street took up the cry of 'Sylvia!'" Her partner Adrienne finally put two and two together. "It's Hemingway! It's Hemingway!" Adrienne hollered. "I flew downstairs," Sylvia said:

> We met with a crash; he picked me up and swung me around and kissed me while people on the street and in the windows cheered. We went up to Adrienne's apartment and sat Hemingway down. He was in battle dress, grimy and bloody. A machine gun clanked on the floor. . . . He wanted to know if there was anything he could do for us. We asked him if he could do something about the Nazi snipers on the rooftops in our street, particularly on Adrienne's rooftop. He got his

company out of the jeeps and took them up to the roof. We heard firing for the last time in the rue de l' Odeon. Hemingway and his men came down again and rode off in their jeeps—"to liberate," according to Hemingway, "the cellar at the Ritz."

Never mind, of course, that he had already liberated a good portion the evening before. Telling and retelling that story was already on its way to becoming one of the defining elements of the larger-than-life Ernest Hemingway legend.

Sylvia had her own harrowing wartime stories. Along with other Allied women in Paris—like the film-star-turned-resistance-fighter Drue Tartière, the "American Angel" Laura Mae Corrigan, and the others—she had spent time in the prison internment camp at Vittel after the Americans ended their formal neutrality and entered the war in 1941. One of the women there with them at Vittel was another American who also happened to be named Sylvia and who lived at the Hôtel Ritz with a French colonel husband. She had been released immediately.

Hemingway and his entourage next went off to find Pablo Picasso, whose atelier was just a few streets away from Sylvia at 7, rue des Grands Augustins. The two men had been introduced more than twenty years earlier, when Ernest first arrived in Paris, a twenty-three-year-old unknown writer. Picasso, of course, had already been famous.

But Hemingway wasn't the first American journalist to visit the painter. Photographer Lee Miller had arrived the afternoon of the liberation.

As a war correspondent for *Vogue*, she had reported from the army hospitals in the days after the landings at Normandy, and it was known throughout the officer ranks that she played a mean game of poker. Now, she laughed about how she had been "in the doghouse" for working too close to the combat

zone at the battle at St. Malo in mid-August, where, as one of the male journalists put it with undisguised admiration, she had been "the only reporter, and only photographer, let along the only dame, who stayed through the siege" and faced down danger with the soldiers.

There, outside St. Malo, in the village of Cézembre, she had unwittingly taken dramatic shots of one air raid, not knowing then that they were documentary evidence of America's first use of napalm bombs in modern warfare. *Life* magazine had wanted to publish the images, but the censors confiscated the film, and she had been reassigned to the comparatively sleepy Nemours, some fifty miles southwest of Paris, as punishment.

That was the reason why, on the morning of August 25, Lee Miller was still waiting for travel orders that would allow her to go to Paris. She wanted to be part of the race to the capital, but with the brass angry with her, her papers were slow in coming. "I won't be the first woman journalist in Paris, but I'll be the first dame photographer, I think, unless someone parachutes in," she at least consoled herself that day. It seemed to everyone that she probably had been.

The darling of Parisian surrealist circles before the war, Lee Miller was still tremendously beautiful now in her mid-thirties. She knew everyone famous in artistic circles. A talented photographer, she had been both Man Ray's model and lover. She was Jean Cocteau's trusted confidante and the avant-garde designer Elsa Schiaparelli's favorite fashion model. Picasso once painted her portrait, and she still considered all of them her friends. So after stopping at the Palais Royal to visit Cocteau in his apartment at 36, rue de Montpensier, she headed to Pablo Picasso's atelier over on the Left Bank immediately.

When Lee arrived that afternoon, Picasso welcomed her as a dear friend. "This is the first allied soldier I've seen, and it's you!" he exclaimed delightedly. A savvy journalist, she memo-

rialized the reunion with some press photos, and that evening she went to dinner at a favorite café around the corner with Picasso and the surrealist photographer Dora Maar—a mutual friend whom the painter had unceremoniously dumped back in March, after a tumultuous ten-year liaison, for a much younger beauty.

There, in a city short on food but high on passion, the three celebrated the liberation of the city they each loved over a skinny roast chicken, some wine, and a flask of brandy. Picasso told Miller to come back soon. The war had changed her. Her face had taken on fascinating new dimensions. He wanted to paint a new portrait. Throughout the war, he had painted dozens of portraits of Maar. For Dora, it had not always been a flattering experience. One after another showed her in torment. "Dora, for me, was always a weeping woman," Picasso said. "[W]omen are suffering machines," he explained philosophically. For some strange reason, more than one of Picasso's lovers ended up with a nervous breakdown.

Meanwhile, by the morning of August 26, over at the Hôtel Scribe, Mary Welsh had finally tracked down Charlie Wertenbaker and been given an assignment. Her job was to report for Time-Life on how the occupation had changed the world of Paris fashion. *Vogue* quickly gave its correspondent Lee Miller the same assignment. Among the female war correspondents, it was meant to be a race for the best couture coverage. Many of the women journalists, after having experienced combat, were having a hard time getting too excited.

For Mary, starting her day's work at the Place Vendôme was only natural. The famous fashion houses of Paris in the 1940s were "almost all located between the Champs Elysées, Place Vendôme and Faubourg St. Honoré, in what was customarily referred to as the temple of elegant," and the 1942 telephone directory for Paris lists more than a half dozen of them clustered around the Hôtel Ritz, either on the Place Vendôme or, thanks

to the fame of Coco Chanel, just along rue Cambon, running north from the octagonal plaza.

That didn't mean Mary didn't have an ulterior motive. While there she was going to track down Ernest Hemingway. "I walked around to the Place Vendome entrance of the Hotel Ritz and asked the concierge, my acquaintance from 1940, if [Monsieur] Hemingway was by chance in the hotel," as she told the story later:

> *Bien sûr*, the concierge said, and directed me up to Room 31. I rode up the coquettish little lift, the liftboy in his proper uniform and white gloves, knocked at No. 31, and asked the freckled soldier who opened the door if Mr. Hemingway was in. "Papa, there's a dame here," Pfc. Archie Pelkey yelled into the room. Ernest emerged into the hallway, a whirlwind of good cheer, and gave me a welcoming merry-go-round bear hug. . . . Inside the room a couple of his friends from the French underground, who had been with him since Rambouillet, were sitting on the bare floor intermittently cleaning rifles and sipping champagne.

Ernest Hemingway poured her a glass of the Perrier Jouët from a tray resting on top of a fragile-looking little Empire-style desk, and for a long moment the two stood admiring the view from the French windows. One of Papa's men was sacked out in his dirty boots on top of the Hôtel Ritz's pristine pink bedspread. Stay, Hemingway told her. There was plenty of champagne on ice, and he hadn't made any bones since back in London about his intentions. Mary, though, needed to go get to work on her story for Charlie Wertenbaker. He could take her, instead, she supposed to dinner.

On her way out of the Hôtel Ritz lobby, an even better idea struck her. She asked Hans Elminger if he might be able to find her some accommodation. In a matter of moments, he gave

her the keys to room 86, a cozy suite with twin-sized brass beds and a chaise longue decorated with roses in gold brocade patterns. There was a big dressing table with a pink pincushion, and over the marble mantelpiece hung the silhouette in bronze of an old-fashioned lady. Her room "on the garden side" looked out over the green space behind the Ministry of Justice. It would be her home until March, as it turned out—home "with complications."

She told Elminger that she would return that evening with her luggage and, pleased with the world, sauntered across the lobby from the Place Vendôme side of the building to the rue Cambon exit—through that singular corridor that Marie-Louise Ritz had constructed in 1909 to expand the palace hotel. Decorated with glass cabinets displaying the finest Parisian luxuries, everyone called it the "lane of enchantment." After years of wartime rationing and shortages, all those luxuries were a heady experience.

Mary strolled east along the rue de Faubourg St. Honoré toward the avenue Matignon and the Champs-Élysées to visit more couture houses that afternoon. Everywhere on the streets, people were heading toward the boulevard, and the Champs-Élysées was a "moving mass of people," she remembered. Charles de Gaulle was arriving at any moment, and she also wanted to witness the parade that was soon beginning.

As General de Gaulle led the military procession through the central avenue of Paris, crowds lined the streets for miles, and historian after historian has only ever had one thing to say about that moment: August 26, 1944, in Paris was the world's greatest party. Over and over, the same scene was played out: crowds cheering, throwing flowers at the tanks as they rolled past and blowing kisses.

Henry Woodrum, hailed as one of the few downed Allied airmen ever to "walk out" of occupied Paris, was there to enjoy it all with the French family who had hidden him from the

Gestapo. He had received Hemingway's invitation to come to the Hôtel Ritz to meet the famous author for a cocktail. He never made it. He was having too much fun being feted—and was enjoying freedom with his friends too much—to care about a drink at the rue Cambon, even with one of the century's most famous writers.

The parade route wound its way at last to the Île de la Cité, poised in the middle of the Seine. There, at the geographical heart of France, the Cathedral of Notre Dame rang out bells of celebration, and as the military moved away, thousands gathered around to attend a "Te Deum" mass of thanksgiving. The VIPs and the press found seats within the gray cool of the building, but the service spilled out into the forecourt for the civilian population of Paris.

Helen Kirkpatrick had already taken up position and reported what happened next for the *Chicago Daily News* in her dispatch. Just at the moment of the general's arrival, a revolver shot rang out. "It seemed to come from behind one of Notre Dame's gargoyles. Within a split second a machine gun opened from a nearby room. It sprayed the pavement at my feet," she told her readers. "For one flashing instant it seemed that a great massacre was bound to take place as the cathedral reverberated with the sound of guns." Then a group of war widows suddenly burst into the "Te Deum."

The sound of gunshots rang out up and down the river at that instant. Helen learned later that it had been a coordinated attack on Notre Dame, the Hôtel de Ville, the Tuileries, the Arc de Triomphe, and along the Champs-Élysées simultaneously.

As the parade passed the Hôtel de Crillon on the Champs-Élysées end of the parade route, Jean Cocteau was once again watching from what he thought was a safe distance, this time from an upstairs window. He nearly didn't live to tell the story despite his studious precautions. Gunfire broke out between

someone in the crowd and insurgents on the rooftops, and one rifleman decided Cocteau was an enemy sharpshooter. He narrowly missed being shot down as a sniper. The bullet whizzed past him, knocking the cigarette out of his mouth and convincing him that he might be better off watching from a less lofty vantage point.

"It was," Helen was certain afterward, "a clearly planned attempt probably designed to kill as many of the French authorities as possible, to create panic and to start riots after which probably the mad brains of the militia, instigated by the Germans, hoped to retake Paris."

While inside the Cathedral of Notre Dame the generals and the worshippers had been astonishingly calm in the face of sniper fire, the scene outside on the public square was panic.

Robert Capa was there among the crowds, covering the parade as a photojournalist, and he followed Charles de Gaulle as the general had walked from the Arc de Triomphe to the Notre Dame cathedral. When the sound of gunfire cracked through the clear blue skies that afternoon, thousands of French civilians fell to their knees along the square, ducking from the gunfire. Amid the crowd, "A beautiful, lone woman wearing sunglasses, utterly fearless, stood tall, too proud to cower any more," and Capa captured the shot with his camera. It would become yet another of the haunting images of what it meant to be Parisian after the occupation.

Mary Welsh was there inside the Cathedral of Notre Dame, too. Her press badge got her inside for a seat at the service. She heard a few shots ring out. Her mind on other things, Mary dismissed them as accidental. She made her way unconcerned back to the Hôtel Ritz, where she had a dinner date with Papa. The only trouble was, by then she was once again exhausted.

As Mary staggered up the steps of the Ritz's grand entrance, dusk was settling over Paris, and she found Hemingway waiting for her alone in the half-light. He had made plans to take

her to a nice place over on the Left Bank, part of a little party he had organized.

She wanted to go to bed, she protested. "Have a little of this nourishing champagne," Papa urged, and told her that he had a surprise for her: "Pelkey got your stuff from that hotel. It's here." Convinced there was no getting around the wishes of a determined Ernest Hemingway, she went along with him resignedly.

On their way home, just before midnight, came the sounds of the air raid sirens, as the German Luftwaffe flew over the city in a last vindictive attack on the city. Once again, Paris was plunged into darkness. A large working-class suburb in the northeastern corner of the city was heavily damaged that night. But when Mary Welsh and Ernest Hemingway walked up the steps to the Hôtel Ritz, the Place Vendôme had escaped, unscathed as always. There was only the sleepy night watchman on duty to welcome them. There in Papa's room, Mary quickly stripped down to just her underwear.

To Ernest's disappointment, Mary settled down enticingly—and then fell asleep in an instant.

In the morning, Mary cracked her eyes in the sunlight streaming in from the broad French windows. Papa was uncorking a bottle of champagne. Only then did she notice that the bed across from her was covered with Garand M-1 army rifles, hand grenades, and other ammunition.

You snore, Hemingway told her bluntly and cheerfully. "You snore beautifully." In the corner of the room, one of the soldiers was brewing coffee on a camp stove.

The Last Trains from Paris

Studio with paintings by Pablo Picasso.

He has two loves—beautiful objects and making war.
—*Count Galeazzo Ciano, on Hermann Göring*

Paris was free. But the screaming nighttime air raids over Paris were not the only sign that the war was still far from over. For those in the military, the fighting just beyond the capital continued.

On August 27, a young French lieutenant named Alexandre Rosenberg, attached to General Leclerc's Second Armored Division, was not partying at the Hôtel Ritz. In fact, he wasn't just then celebrating much of anything.

Instead, Lieutenant Rosenberg was in command of an urgent and dangerous operation taking shape along the railway lines heading out of the city. All month, the Germans had been loading the trains. When it became clear at last that the Allies' advance was insurmountable, they began destroying the tracks behind them as the last conveys rolled toward the far horizon. It was Rosenberg's mission to get his men out in front of those disappearing convoys and somehow to stop them.

Even as the first morning after liberation dawned over Paris, the last trains were still creeping their way eastward, toward Berlin and peril.

There was one convoy, in particular, that the French and their Allies were watching. Alexandre had been assigned to the mission of intercepting it. Members of the French resistance in the SNCF—the national railway of France—had alerted the newly arrived French Forces of the Interior that the Germans were guarding heavily several cars on a large train heading northeast out of Paris. The switch workers across the capital were slowing down the tracks, doing their best to cause a massive traffic jam along the lines, but this train was already nine miles outside the city, in the small station at Aulnay. Throughout the war, the SNCF was a dangerous line of work. More than 1,500 *cheminots* died for

their small and systematic anti-German acts of obstruction, sabotage, and information sharing—although far fewer raised a hand to prevent the deportation of Jews.

Now, with the delay of the convoy in Aulnay, the Germans and the Gestapo were reportedly furious. Delaying the train more than another few hours would be impossible. There were already railway workers risking their lives to hold it.

Some of the trains leaving Paris in the last days of the occupation were loaded with Nazi loot, the antique chaise longues and last bits of opulent bric-a-brac collected by the retreating German officers.

It was feared that other trains might carry human cargo—the final unlucky Parisians who had been rounded up before the liberation. Some of those arrested in the last summer of the occupation were the surviving members of the city's Jewish population. Seven thousand French Jews were deported from Paris between April and August 1944. Many, however, were people suspected of supporting a now-burgeoning and emboldened French resistance movement. There were deportations still some days numbering in the hundreds. Some of the last trains carried children.

Since the winter of 1944, the roundups had intensified again fiercely. For the circle of French artists and socialites who gathered at the Hôtel Ritz during the occupation, the fact had hit home at last that there were fissures even in the gilded world they inhabited. Jean Cocteau, Sacha Guitry, Pablo Picasso, Serge Lifar, Arletty, and Coco Chanel all knew intimately the Jewish-born writer and artist Max Jacob. Arrested by the Gestapo, he died that spring in the transit camp at Drancy. He had pleaded with Cocteau in a last, desperate letter to find some way to help him. "I am writing this in a train," Max said, "profiting from the leniency of the guards. We shall soon be at Drancy. That is all I have to say. Sacha, when he was told about my sister, said, 'If it were Max himself I could do something.'

Well, this time it is myself. *Je t'embrasse*." Cocteau had at last been spurred to some kind of action, but the petition he circulated among his friends for a signature and sent to Otto Abetz was not enough to save Max Jacob.

Alexandre Rosenberg and his men had been sent into the capital to stop the last trains of deportees from leaving the city, and, on the morning of August 27, he would be far from the Hôtel Ritz. But the story unfolding that day had its origins in the group of friends and acquaintances who had gathered during the war on the Place Vendôme.

Since the days early in the twentieth century, when the Dreyfusards and American expatriates alike declared the Ritz their social province, the Paris-based international circle of film stars, artists, writers, and avant-gardists who frequented the hotel had been a tight-knit group. The Rosenberg family was an essential part of that circle. It was an old story.

This part of that story dated to the early days of the war. The spring of 1942 was the high-water mark of the glamorous life in occupied Paris. It was also one of the high-water marks of French collaboration. That season, the Ritz was once again the talk of the capital. And some of those who had been there that night decades earlier, while Marcel Proust made awkward love to the Princess Soutzo on a balcony as German bombs exploded, were still hotel regulars.

That spring there were once again fashion shows in the ballrooms at the Hôtel Ritz and dinner socials on Sunday evenings in full swing with orchestras and dancing. Since winter, leading French industrialists, designers, and politicians had been joining their German counterparts in the Ritz dining room for those convivial lunches where economic policies of long-term integration were decided. In January, Hitler's "man with the iron heart," German chief of police Reinhard Heydrich, unveiled his "Final Solution" to the Jewish "question" at a Nazi conference in Germany. Deportations to Auschwitz would begin in June.

In May 1942, though, the event drawing the attention of all of Paris back again to the Hôtel Ritz was artistic. The arts in Paris flourished during the occupation. The reasons were two-fold. The Germans—and many on the far right in France as well—had long held that modern French culture was decadent and effeminate. Letting the Parisians indulge in their moral corruption and in the frivolity of the arts was cast as a simple way, at first, to keep the capital compliant. By the second year of the occupation, however, those who governed Paris were keen to trumpet their vision of an "aryanized" French culture. The newcomers, after all, intended to occupy the city permanently as part of a unified and timeless Third Reich.

In 1942, Paris was abuzz with news of a monumental exhibition of new art. Celebrities from Paris and Berlin were turning out in droves for the festivities. The opening night party would be—of course—on the Place Vendôme.

The cause of all the fuss and excitement was a forty-two-year-old sculptor and art professor from Berlin name Arno Breker, familiar already to many in the city. He had lived in Paris throughout much of the 1920s and into the early 1930s. Jean Cocteau was an old friend. His Greek-born wife, Demetra, once posed for Picasso as a model and remained fond of the artist. Both the Brekers were keen modern art collectors. They had been part of that dazzling interwar circle in Paris. It is impossible that they did not also know Alexandre Rosenberg's father.

The day that Alexandre was born, back in 1921, Pablo Picasso was one of the witnesses. His father, Paul Rosenberg, was one of the world's two or three most famous and successful dealers in modern art, just at the moment in the 1920s and 1930s when modern art was reaching its first great acclaim. He was Picasso's exclusive art dealer, close friend, and next-door neighbor.

In fact, there were few in the art world in 1942 that Paul Rosenberg did not know personally. Among the friends and

acquaintances of Alexandre's parents were not just Picasso and his wartime lover, Dora Maar, but also Ernest Hemingway and Gertrude Stein, Coco Chanel and her prewar lover Pierre Reverdy, Jean Cocteau, Lee Miller and Man Ray, the mischievous and melodramatic Count and Countess de Beaumont, Serge Diaghilev, Sacha Guitry, and, of course, the late Max Jacob. Only a very few among that crowd had *not* been habitués of the Hôtel Ritz at one time or another. Most had spent the Second World War in and out of its salons and suites—or they had spent the war, as American correspondents, trying to get back to Paris.

But on the eve of that great event in the Parisian art world in the spring of 1942, Alexandre Rosenberg's father was not on the list of those invited. That was for the simple reason that the family—who were Jewish and prescient—had fled France for the United States in the weeks before the country fell in June 1940. The nineteen-year-old Alexandre had gone to England to fight with Charles de Gaulle and the Free French Forces. A large part of his father's vast art collection—declared abandoned Jewish property—was considered forfeit to the Germans. Among the modernist artworks lost were hundreds of pieces by artists such as Cézanne, Renoir, Braque, Toulouse-Lautrec, and Gauguin. There were dozens of paintings just by Picasso.

In the 1920s, Arno Breker had been an up-and-coming young German sculptor, interested in the avant-garde and modernism. All that had been abandoned now in favor of a public return to a more "masculine" and Teutonic neoclassicism. By 1942, Hitler had declared Breker "the best sculptor of our time," and the artist had already been a card-carrying member of the NSDAP, or the Nationalsozialistische Deutsche Arbeiterpartei—the Nazi political party—for more than half a decade.

Ironically, few Germans were interested in the art that Alexandre's father had made a name for himself collecting. And

it wasn't the daring and experimental works by the cubists and the impressionists and the fauvists that interested Hermann Göring and Adolf Hitler. Nazi tastes ran, as a matter of political philosophy, to the traditional and not to these degenerate examples.

Making that break with the "old" world of decadent Parisian art was precisely the point of that gala event in 1942. Arno Breker was there to show the world, with his towering, muscular statues, the kind of nationalist, civic art that would be rewarded.

The exhibition was supported at the highest levels of the German government. On May 5, 1942, Reinhard Heydrich arrived at the Hôtel Ritz for a weeklong stay during the crucial advance stages. On May 6, fresh from Berlin, Arno Breker and Demetra joined him. The celebrity couple settled into rooms at the Ritz for a stay that would last considerably longer than a week. Breker had arrived in preparation for *the* social event of the spring, sometimes described as "the most glittering event of the Occupation years": a massive display of his work later that month in the public space at the Musée de l'Orangerie, in the Jardin des Tuileries.

The status-conscious Brekers immediately declared that their rooms at the hotel were neither lavish nor light enough and demanded that several Louis XV lamps and some marble candelabra be installed in the suite. Then they threw themselves into a round of hobnobbing and socializing—including dinner parties with the American heiress Florence Gould and many cozy evenings with the now pro-fascist writer Paul Morand and the woman who had become his wife, Marcel's Proust's Princess Soutzo. Jean Cocteau often joined them.

When the Arno Breker exhibition opened on May 15, 1942, it was the talk of all of Paris. There was one event after another that first week to inaugurate the occasion. One of the leading novelists and pro-fascist journalists in the capital, Robert

Brasillach, gave a laudatory lecture at the Théâtre Hébertot to the flashing of camera bulbs and hearty applause.

The Vichy minister of education, poet Abel Bonnard, arranged a sumptuous reception at the Hôtel Ritz on the opening night. There to savor champagne and toast the sculptor and the remaking of French art under the Germans were the usual Hôtel Ritz regulars. Dancer Serge Lifar and Arletty chatted blithely with Sacha Guitry. Cocteau wrote a sycophantic poem "saluting" Breker's genius and national spirit. (In return, his request that several friends in the film industry be exempted from forced labor in Germany was granted.) Present, of course, were collaborationist leaders Pierre Laval and Fernand de Brinon.

From around Paris, too, came many of the most important modern artists still living in the city, including many celebrated abstract and fauvist painters. Maurice de Vlaminck, Kees van Dongen, and André Derain all accepted invitations. Paul Rosenberg's gallery collections included paintings by all of them.

Those in the inner circle of the art world were not the only ones to embrace the exhibition. It was extraordinarily well attended by Parisians. In the ten weeks it ran—from May 15 until July 31—more than 120,000 French citizens attended the exhibition. Picasso was among them. The exhibition catalog was printed in thousands more copies. With much of the pageantry and with the appearances of the cultural celebrities of Paris captured on newsreels for circulation throughout the Third Reich, it was a German propaganda triumph.

By the time the exhibition closed at the end of July, the climate in Paris had shifted precariously. As Arno Breker later remembered, the opening of his exhibition coincided with the killings on the streets of the city of several German officers out acting as tourists. The retributions were terrible. By mid-July, the Vichy government was rounding up Jewish foreign-

ers beginning to round up Jewish foreigners systematically in the capital, using stadia as makeshift internment camps.

But Arno and Demetra Breker stayed on in Paris. They would not leave the capital until he had completed, from his rooms at the Hôtel Ritz in the winter of 1942–43, a bronze portrait of the ballet star and director Serge Lifar. The couple were the beneficiaries of a massive income now in Germany, and that summer—sometimes in the company of Hermann Göring and often helped at the hotel, one supposes, by Hans Wendland, Karl Haberstock, and the mysterious Süss—the Brekers began amassing their own private modern art collection. In it, the works of Picasso, Derain, and Vlaminck were particularly well represented.

Such works were disappearing from Paris by the time the summer of 1942 ended. Disdained by the grandest collectors in Paris—the Reischsmarschall and his Führer—modern works of art found their way increasingly to the open international markets in Switzerland. On July 27, 1942, in a massive bonfire erected outside the Jeu de Paume, however, many of the works of France's "degenerate," modern, "Bolshevik" artists that remained were destroyed in a symbolic cultural cleansing by auto-da-fé. It was the grim logical conclusion of the remaking of French art in a Germanic vision that Arno Breker's exhibition had inaugurated.

That auto-da-fé was a dark portent. Soon it would not be just works of modern art that would be incinerated in a broad policy of cultural cleansing. By August 1944, no one could remain ignorant of that fact or morally neutral in the face of it. Certainly, that morning in Paris on the first day after the liberation, Alexandre Rosenberg was preparing himself for what he and his men might discover.

The train that they were bound to intercept had been loaded by a Wehrmacht soldier, and he had been given stern orders to see to it that this convoy safely reached German territories.

It had been noticed first when it was delayed, weeks earlier, at the station in Le Bourget, less than a mile and a half from the massive compound at Drancy. From the summer of 1942 until the last trains departed in 1944, as many as seventy thousand people passed through the camp on the way to their deaths in the east. As one of the main centers for the Einsatzstab Reichsleiter Rosenberg (ERR), there were also vast offices in the complex set up for processing their confiscated possessions. When the Allies liberated the compound that August, they found 1,500 survivors and acres of household objects.

The convoy that morning was one of the last trains to leave the northeastern suburbs of Paris, and, while one woman named Rose Valland—a museum director—had guessed what was on board, Alexandre Rosenberg and his men had no idea what was awaiting them. If it was true that these cars had been delayed for weeks from Drancy in the summer heat, the sight might be unbearable.

In a perilous operation, he and his men succeeded at last in exploding the tracks into twisted metal in front of the cargo as it rolled out of Aulnay toward Germany. Inside, those five priority cars contained not corpses but wooden crates, the last fruits of the German Möbel-Aktion—"Operation Furniture."

What Alexandre Rosenberg could never have anticipated was whose looted property had been intercepted. Inside the crates were hundreds of paintings. The works of the great modern artists of Paris—canvases by Cézanne, Gauguin, Toulouse-Lautrec, and Renoir. Twenty-nine Braques. Sixty-four Picassos. Everywhere portraits of faces that he recognized from his childhood gazed back at him. All around him were works that had hung on the walls of his father's gallery and in their private apartment in the 1920s and 1930s. They were faces that, on more than one occasion, had spent the occupation in luxury on the Place Vendôme with the occupiers.

The paintings had somehow survived the auto-da-fé of 1942, somehow eluded the Swiss art dealers who descended on wartime Paris. Here was that lost, last shipment that the German ERR officials had packed before evacuating the capital. And Alexandre Rosenberg, by some amazing chance, had found the tangled threads of his own family's wartime story.

14
COCO'S WAR AND
OTHER DIRTY LINEN

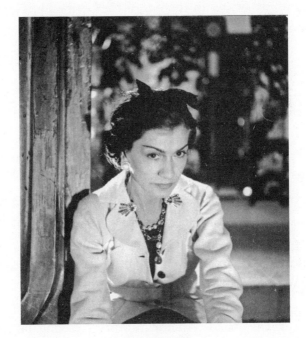

Coco Chanel.

THE FOOD WAS DONE, THE CHAMPAGNE WAS GONE, AND THE GIRLS
HAD RETURNED TO THEIR HOMES TO EXPLAIN THE FACTS OF THE
LIBERATION. THE SHOPS WERE CLOSED, THE STREETS WERE EMPTY,
AND SUDDENLY WE REALIZED THAT THE WAR WAS NOT OVER. IN
FACT, IT WAS GOING ON JUST TWENTY-FIVE MILES AWAY.

—*Robert Capa*

For Robert Capa, if the liberation of Paris was the most unforgettable day he had ever experienced, the "most unforgettable day plus seven was the bluest."

Late on that September morning, Capa's hangover was the straightforward kind that came from too much carousing. He found himself "sitting in the bar of the Scribe Hotel, the Army's grand gesture to the newspapermen, trying to teach [the bartender] Gaston to mix that most potent of pick-me-ups, the 'Suffering Bastard.'"

In fact, the sexual liberation that had taken place in Paris that first week had been nothing short of astonishing. "The city had gone crazy with rejoicing," as Mary Welsh put it. "Everybody was eighteen years old, free of shackles, bursting with joy." Few were celebrating harder than the thousands of Allied soldiers in the capital. It was already causing resentment.

At the Petit Palais, the United States military was handing out free condoms to the troops. In the gritty red-light district of Pigalle, the prostitutes were seeing more than ten thousand men a day. Allied soldiers were passed out drunk on the Place Vendôme, and a stone's throw from the Hôtel Ritz a shocked Jean Cocteau watched "American officers having lunch with whores off the street."

It was all something the military had expected, even encouraged. Before the Normandy landings in May 1944, the Allied intelligence service had put together a pamphlet titled *France Zone Handbook No. 16, Part III*, referred to, with tongue in cheek, as a guide to "Local Information and Administrative Personalities." In fact, it was a list of brothels in Paris, along with their street addresses. Venereal diseases, the pamphlet warned the troops, were common in the French capital.

For the French, who had already suffered four years of hu-

miliation, the behavior was shocking, offensive, and disturbingly familiar. Brothels had also flourished under the Nazi occupation, multiplying sixfold in the capital. Even the prostitutes recalled later how wildly fantastic the all-night orgies had been under the Germans.

Now it was more of the same under the Allies—and especially the Americans—who couldn't understand why some of the Parisians were beginning to resent the liberators' presence. Jean Cocteau was not alone in thinking that this cultural difference was only going to become more difficult as the war continued. "The great joy that one should feel," he wrote,

> has been negated by a feeling of malaise and sadness. . . . The organized disorder of the Americans contrasts with the style of German discipline; it is disturbing, it is disorienting. . . . [The] winter will be terrible because France under the German Occupation had the right and duty to be openly insolent, to eat, to glitter, to defy the oppressor, to say "you are taking everything from me and leaving me everything." The Americans will not understand this process.

The Americans had become, in the eyes of some of the French, the newest occupiers.

At the Hôtel Ritz, the American "occupation" would last for nearly two years, and it had started already, despite the fact that, by September 2, 1944, many of the war correspondents were beginning to drift out of Paris. Fresh assignments were taking them that week to the front in Belgium or ultimately Holland.

Among the American press corps who had come for the liberation, Robert Capa and Lee Miller were some of the last to leave the capital. Capa had an assignment that kept him in Paris much of September. Until mid-month, Lee Miller was still working the fashion angle as a reporter for *Vogue* magazine.

Her post-liberation photographs of Marlene Dietrich in a satin evening gown were slated for an upcoming fall issue on the post-liberation haute couture revival.

In fact, fashion had flourished under the occupation, and a good part of the luxury industry, in one way or another, had made its peace with life under the Germans. While some of the couturiers took secret pleasure in making clothes poorly for the wives of the German occupiers, few dared to refuse the commissions, and there had been regular fashion shows at the Hôtel Ritz throughout the war. The designer Lucien Lelong, a member of the hotel's infamous Franco-German "roundtable" lunches, had flourished in particular. Those wartime monthly lunches at the Ritz, which brought together French and German industrialists, politicians, and designers to hammer out the economics of collaboration, began a conversation that would culminate, in just over a decade, in the creation of the European Economic Community. The conflict that was still steadily brewing between Charles de Gaulle and the Anglo-American liberators of Paris would fuel its revival.

The Hôtel Ritz had been the center of the wartime fashion industry in more ways than just the roundtable lunches. Not only was the hotel located in the heart of the luxury district that has helped to define modern Paris but, in the first years of the occupation, some of the artists and journalists who stayed at the Ritz had been among fashion's biggest consumers. "The wife of Steve Passeur, a [French] journalist and dramatist popular at the time," for example, "missed no chance to be seen when the collections were shown. And as her position allowed her to live comfortably (the couple occupied a suite at the Ritz), expense did not bother her." Women like "the daughter of Pierre Laval, Josée de Chambrun, who had to keep up [a] position in society and who attended Franco-German receptions . . . formed a distinct and limited circle. George Dubonnet's wife, renowned for her legendary chic, was a case in point.

Like the Steve Passeurs, the couple lived permanently at the Ritz" during the occupation.

Everywhere in Paris after the liberation, the fashion houses were gearing up for a new season. The house of Chanel, however, was still shuttered. Coco Chanel had closed her atelier in 1940, when the occupation started, proclaiming proudly but some thought a bit disingenuously that it was "no time for fashion." After all, she had kept her perfume boutique across the street from the Hôtel Ritz open and had made a wartime fortune selling Chanel No. 5 to eager German officers. Now American GIs were lined up along the sidewalk, looking for a souvenir to show that they, too, had been in Paris, either not knowing or not caring that Coco Chanel had spent much of the war trying to have her Jewish business partners stripped of their majority stake in the perfume company under the anti-Semitic laws of the occupation.

Coco Chanel's fashion house on rue Cambon remained closed, and there wasn't any rush to relaunch the couture side of the business at that moment. Already past sixty and fabulously rich from the profits of Chanel No. 5 and decades at the top of the fashion world, Coco Chanel had effectively retired.

Even if she had been interested in a return to fashion in that first week or two after the liberation, Chanel had bigger problems than putting together a new couture collection. So did her old friends from Hôtel Ritz circles Arletty, Sacha Guitry, and Jean Cocteau.

There would be two kinds of justice in Paris for those accused of collaborating, neither pretty. First came the immediate extrajudicial purges. Those who had given aid and comfort to the occupiers—or were suspected of it—sometimes found a swift and brutal punishment at the hands of mobs of their neighbors.

They were stripped, shorn, beaten, tattooed, raped, or occasionally summarily executed. The greatest humiliations were

reserved for the women known as horizontal collaborators—women, in other words, who had slept with a German. The French would come to call it the *épuration sauvage*, or the "savage purging."

In town after town, the Allies and the war correspondents witnessed the same basic ritual upon liberation. Winston Churchill's personal aide, Jock Colville, "watched an open lorry drive past, to the accompaniment of boos and catcalls from the French populace, with a dozen miserable women in the back, every hair on their heads shaved off. They were in tears, hanging their heads in shame."

At Chartres, Robert Capa and *Time* journalist Charles Wertenbaker entered the city just steps behind the troops. The first thing they heard was the voices of an angry mob shouting *"Salope! Salope!"*—the French word for "whore." From the center of the town square came the stench of burning hair, a vast pile of blond and gray locks, still being shorn from the heads of the frightened women lined up against the walls of the public buildings in their torn dresses and undergarments. A young woman and a boy sold wine by the glass to the eager onlookers. At least twenty thousand women were shorn publicly in France after the landings at Normandy, perhaps more. German men, some estimates suggest, fathered during those years as many as eighty thousand French children.

Across France and especially in Paris, Robert Capa would also take some of the iconic photographs of the *épurations*.

For journalists, it was a complex business. In Chartres, a young woman in the French resistance, disgusted by wartime hypocrisy, begged someone to stop the spectacle. She bitterly told Capa, "It is cruel and unnecessary. They are soldiers' women and tomorrow they will be sleeping with the Americans." But war correspondents were another of the war's neutral parties. A journalist's right to witness the events of war depended on his or her status as an objective noncombatant.

The second kind of postwar justice came later and took longer. The French call it the *épuration légale*, a mostly legal process of truth-and-reconciliation. In the end, nearly fifty thousand French people would be convicted of the crime of *indignité nationale*, or of disgracing the nation through their wartime acts of collaboration. Among them were many of the wartime Hôtel Ritz regulars. After all, to go to the Ritz during the war was by definition to socialize with the Germans.

Arletty saw the handwriting on the wall clearly. One didn't traipse around Paris on the arm of a German and not expect a visit now from one's neighbors.

No one had seen Sacha Guitry since the morning of August 23, 1944. Armed men had hauled him off, wearing only his canary-yellow Lanvin designer silk pajamas and a fedora. The arrest had interrupted his daily telephone conversation with Arletty.

The men escorted him, she had discovered, to the infamous Vélodrome d'Hiver. During the war, this winter bicycle-racing stadium had been the site of the first mass roundup by the French police of Jewish residents in the Paris region in the summer of 1942, after the implementation of Heydrich's "Final Solution." The inmates were crammed in and kept under the glass roof of the cycling stadium in growing heat and without water for "five horrifying days." People passing by on the streets heard the screams of those who had gone mad or were trying to commit suicide.

Pierre Laval had signed some of the key documents that had made those deportations possible, and it was an almost entirely French-led massacre. "The truth," historians remind us, "is that not one German soldier—not one—was mobilized for the entire operation."

Now, in September 1944, the stadium had been turned into a detention center for Parisians who aided the Germans during the occupation. Sacha Guitry was denounced as a collaborator,

his name splashed across all the major newspapers. There were those in Paris, after all, who remembered that Hermann Göring had visited Sacha at home and that the actor had been seen socializing gaily with General von Stülpnagel. At his trial that autumn, there were accusations flying about secret cash payments and "intelligence with the enemy." Determined and unrepentant, Sacha denied it all stoutly.

After Guitry's arrest, Arletty fled her apartment, heading first to an address on rue François 1er, where she met up with Sacha's girlfriend, the Romanian actress Lana Marconi. They turned to some friends in the resistance to see if someone could protect her.

Afterward, Arletty would never quite say what happened. What she did say later, in her memoirs, was only that a "Countess X," well connected in the resistance, put her in touch with a "Lord H." With their help she was taken in a gleaming Cadillac to the house of another acquaintance—who bluntly declared when she arrived on his doorstep, "I refuse the package." There were only a few reasons for a Frenchwoman to be rushing into hiding in the days after the liberation, and none of them was admirable.

Well-connected friends shuttled her off to another apartment. For three days, she hid in a bedroom. Then her hosts came to tell her one afternoon that she had better go and wait just off the Champs-Élysées at the Hôtel Lancaster. No one could help her hide forever. Someone from the French Forces of the Interior would be coming the next morning there to arrest her. It was best to submit to the inevitable. People were already hunting her down.

Two discreet men came for her, and Arletty was taken without fuss in a car to the Préfecture of Police, under her old name, Léonie Bathiat. Here there would be no star treatment or stage names for Arletty. Her public profile during the war was now her greatest liability. She was a symbol of France's self-betrayal.

The large echoing room at the Préfecture filled up that morning quickly. They were the people fortunate enough to have escaped the most savage of the purges taking place still daily in the streets of Paris. Many of them were women.

In the rooms where they were processed for internment, Arletty met one old friend after another—other actresses and film stars, some socialites, the celebrated Wagnerian opera star Germaine Lubin, and at least one princess and a duchess. All had socialized with the Nazis.

"How are you, Bathiat?" one acquaintance asked her.

"Not very resistant," she responded dryly.

The trials had not yet begun, but the punishments had. Crammed together in a small room with eighty women, Arletty saw young girls with shaved heads weeping. A frail elderly woman tried to hide with a scarf the swastika that had been crudely tattooed on her forehead. A nun told Arletty at Sunday mass, "Whore, you are done looking at men," and who knew what that portended. Even in her painfully blunt memoirs years later, Arletty would never say much about what happened.

Retreating into bitter humor, Arletty would only say afterward, "Don't worry, ladies! I am a gentleman." These were humiliations that she was determined to keep private. She wrote of the experience later, however, "One rarely says it: condemned to live. It's often more harsh than a death sentence."

Compared to those who died at Fresnes and Drancy during the war, Arletty, who spent the war at the Hôtel Ritz cavorting with a German lover, got off lightly. Nonetheless, she only ever saw her treatment as a gross injustice and remained bitterly defiant. "After having been the most invited woman in Paris," Arletty had now "become the most avoided."

They came for Jean Cocteau with questions, too, that autumn. The writer was ordered to appear in front of a committee handling *épurations* for those in the film industry and would soon be called in front of a second committee investigating col-

laborationist authors. His determined neutrality had not been enough to spare him the interrogation and public scrutiny now.

Marcel Proust had died long before the war started, but the old Hôtel Ritz denizens Paul Morand and the Princess Soutzo were also charged in absentia with collaboration. Although Morand was posted to the French embassy in London when the war began and could have joined the forces of the Free French without the least bit of effort, he had astonished Charles de Gaulle by returning home at the princess's urgings and declaring his allegiance to Vichy. Until 1943, they had lived in luxury in occupied Paris. Transferred to the embassy in Switzerland before the liberation, the couple did not return to France until years later.

But the first person of all the Hôtel Ritz regulars that the men from FFI came to question was Coco Chanel. Her story was the most astonishing of all. It continues, perhaps more than any of the others, to trouble contemporary Parisians and the history of the occupation.

Coco Chanel rose to fame as a designer in the first and second decades of the twentieth century, after leaving a career—like Arletty's first forays into public life—as a mediocre and somewhat risqué cabaret performer. As a young woman, Coco was not opposed to making her way in the world as a rich man's mistress. Some quipped that she had been, in those early days, one of her generation's *grandes horizontales*—a grand "horizontal" woman. At any rate, she had been at one point in her youth under surveillance from the French police, suspected of prostitution.

By the early 1930s, that was all behind her. Coco was a rich and famous woman, recognized on the world stage as a brilliant *entrepreneuse* and innovator. She drove a snazzy Rolls-Royce and, like her late neighbor Georges Mandel, took up permanent residence on the Place Vendôme. As John Updike in the 1970s famously summarized Coco's wartime attitude,

"all available evidence points to Chanel's total indifference to the fate of her Jewish neighbors—or indeed the lesser deprivations and humiliations suffered by the vast majority of Parisians. . . . [She was among those who were] happy, in a world in which mountains of misfortune were rising around them . . . in the Jewish quarter, a fifteen-minute walk from the Ritz."

At the end of August 1944, before the liberation came to Paris, the *couturière* was still living in luxury on the rue Cambon side of the Ritz complex. Her old rooms on the top floor of the Place Vendôme building hadn't been a wartime option. No one except German officers had been allowed to enter that side of the hotel. As a long-term resident, "she paid the hotel to build a low flight of stairs from her two-room suite to a garret bedroom," and although the bedroom was narrow and a bit cramped, she was perfectly content with the arrangement. She scoffed that it was cheaper this way anyhow.

More important, these quiet rooms had been a convenient place for her to be with Hans von Dincklage in privacy.

By the time of the German occupation in 1940, Coco and Hans had known each other for several years. In 1936, von Dincklage was attached to the German embassy in Paris, and he had been a familiar face for several years around the capital. Recently divorced from his aristocratic German-Jewish wife, Maximiliane von Schoenebeck, Hans had become a playboy. Given his extraordinary good looks, it was a successful vocation. He and Coco probably first met each other at a party of mutual friends sometime in 1937 or perhaps the year after.

At the beginning of the occupation, both of them lived at the Hôtel Ritz and running into each other often was inevitable. Tall, handsome, and looking classically Teutonic, Hans was more than a decade Coco's junior, but Chanel remained strikingly attractive in her early sixties. The liaison lasted throughout the war and left Chanel—like so many other Frenchwomen with German wartime lovers—in a precarious position after the liberation.

Coco's troubles in those last days of August didn't just come down to her love life, though. For one thing, she had been far more careful than Arletty about keeping her liaison with a German officer a guarded secret. Blanche Auzello remembered it clearly. Blanche had come to dislike Coco Chanel during those years of their living cheek by jowl and was happy to sketch out a character portrait of her to anyone who was interested. It wasn't a flattering picture. The women had known each other for the better part of a decade by the time the war started, and between the two there was a deep, if unstated, hostility. As Blanche recalled, part of the complication was that, when the occupation started in 1940, Coco Chanel was not just having a love affair with Hans von Dincklage—she was also discreetly juggling another gentleman at the same time.

"She never appeared anywhere in the hotel with either of them," Blanche recalled. "Nobody gave a damn, but she really worked hard to keep them a secret. I knew about them because I had a direct pipeline through the floor maid. She kept me up to the minute. She was envious, not because Madame was a great couturier—that didn't mean anything to her; but living with two impressive guys was her idea of paradise. What luxury!" Blanche worked hard to foster friendly relations with all the hotel floor staff, but even so, the identity of Chanel's second paramour remains a mystery. But there is no doubt that von Dincklage was her lover.

Unlike Arletty, though, Coco Chanel had done more than just sleep with a fascist or work with the German authorities to have her Jewish business partners stripped of their assets. Chanel had involved herself with the inner workings of German political machinations. Some still say that she was a spy for the Nazi powers.

It is a murky history, and any claim to the contrary is sadly reductive. What is certain is this: the intelligence services in America and Britain had files on Coco Chanel and investigated

her possible activities as a German agent. She visited Berlin twice during the war, once at the end of 1943 and once in the early days of 1944. Those trips were arranged with the help of a German Abwehr agent named Walter Schellenberg—the man who had been sent in February 1944 to replace the secret leader of the German resistance in Paris, Admiral Wilhelm Canaris, another of the Hôtel Ritz regulars.

There were also thick files on Hans von Dincklage and his wartime activities. He was a known German operative and possibly—as Chanel always insisted—a British double agent.

Baron Hans Günther von Dincklage was born into an aristocratic Prussian family and had been a special attaché to the German embassy in Paris since 1933. Hans was tall and blond, charming and cultivated, and women loved him. Some said he had he earned his nickname "Spatz"—*sparrow*—for his undeniable skills working a room. The nickname likely had more mundane and ultimately more ominous origins: the code name *Staatsanwalt Spatz*—a roving legal representative of the German state.

Blanche Auzello called Hans "Spatzy." She couldn't stand Coco Chanel, but despite Claude's skepticism, she thought Hans was fabulous. He had first arrived in Paris with another attaché, a certain Joachim von Ribbentrop. Their mission had been to broker a political deal between France and Germany during the years of appeasement. They cozied up in Paris to rich pro-fascist journalists and politicians like Fernand de Brinon and Pierre Laval—both of whom would be ringleaders in the Vichy quisling government several years later.

Throughout the occupation, von Dincklage was among the hotel's permanent residents. There was no doubt that he had been sent to France on an intelligence-gathering and propaganda mission. After all, he was an attaché of the German government.

From there, however, the knots of the tale become difficult to untangle. Hans's mother was British. Coco Chanel insisted he was a covert British double agent. It is not impossible.

After all, the Abwehr, especially under the Paris leadership of Wilhelm Canaris, did tend to be a hotbed of German resistance. And aristocratic Prussians from military families like Hans were among those most likely to oppose the megalomania of Adolf Hitler in Germany.

On the other hand, if there are British files on Hans von Dincklage as a double agent, they have not yet been released or discovered. And everyone in the story had a motive for inventing exculpatory postwar stories.

Coco Chanel herself was undeniably both anti-Semitic and an Anglophile—and, in the upper reaches of British society, anti-Semitism was no more uncommon than in the French or German aristocracies. In the 1920s, she was the lover of Hugh Richard Arthur Grosvenor, Duke of Westminster, an English aristocrat who retained his staunch pro-German politics well into the 1940s. She knew socially the Duke and Duchess of Windsor, fascist sympathizers who stayed at the Hôtel Ritz the summer before the occupation started. In fact, Coco reputedly knew some of their embarrassing political secrets.

She certainly knew how distressing her friend Winston Churchill had found the king's abdication and his marriage to the former Mrs. Wallis Simpson. In the autumn of 1936, Winston Churchill, his brother Randolph Churchill, and Jean Cocteau had all come for dinner at her suite in the Hôtel Ritz. After too many glasses of French wine, Winston cried on her shoulder over the scandal. Afterward, the duke and duchess were shipped off to Bermuda for the war's duration because they couldn't be trusted not to conspire with the Germans. Even from their island retreat they collaborated actively.

For Coco Chanel in the days after the liberation, her fate depended, whether she knew it or not, on who could write the more persuasive letter to Winston Churchill—Coco or an old friend and former employee named Vera Bate Lombardi. Vera was the British prime minister's relative, the English-born wife

of an aristocratic fascist Italian colonel, and in Monte Carlo in 1923 she had first introduced Coco Chanel to another of her relatives, the Duke of Westminster. According to Hans von Dincklage, Vera had also been Coco's lesbian lover.

By the spring of 1944, the two women were in a high-stakes game of espionage and betrayal. It could only end with at least one of them being suspected as a fascist agent. Vera Lombardi was determined that person would not be her.

Coco Chanel knew as the liberation approached that there were going to be some red flags on the record. She had been caught up the last winter of the occupation in an attempt to open the channels of communication between Churchill and some of the Germans who wanted to negotiate a separate peace between the two countries. Her close connections to the British leadership and aristocracy meant that she was well placed to advise the Germans on who to contact and how to approach the situation.

In fact, in the lead-up to the July 20 attempt to assassinate Adolf Hitler, some of the aristocratic Abwehr agents had spent the winter of 1944 trying through back channels and double agents to negotiate advance terms with Britain if a German coup d'état were successful. If the German resistance assassinated the Führer and Hermann Göring, Churchill was asked, what would be the terms for ending the war? Churchill replied bluntly: "unconditional surrender." One of those rogue Abwehr agents was Wilhelm Canaris, who was coordinating in Paris that winter a number of German aristocrats acting as British double agents. Were Coco Chanel and Hans von Dincklage part of that circle at the Hôtel Ritz that included Carl von Stülpnagel, Caesar von Hofacker, and Hans Speidel? Admiral Canaris had run von Dincklage as a spy in the 1930s and still ran him as late as 1943, and it is distinctly possible.

Now Coco Chanel was alone in Paris. In the days leading up to the Allies' arrival, von Dincklage left along with the rest

of the German diplomatic corps, and Coco had no idea where to find him. With the war less than a hundred miles from the city and with chaos everywhere, she was worried about his safety and wanted to know what became of him. That week, she gave a young German-speaking American soldier who was heading east with the troops a valise full of precious bottles of Chanel No. 5 perfume—worth its weight in gold and a fortune on the brisk black market. She simply asked that, if he found himself in the days to come interrogating German prisoners of war and could find Hans, would he send her a postcard? He only needed to address it to *Mademoiselle Chanel, Hôtel Ritz, Paris*. Everyone knew how to find her.

Chanel also played her cards carefully with the Americans. She knew that the wind was blowing in a new direction, and Coco was nothing if not a survivor. A British intelligence officer with the MI-6 division later spoke of Coco's sense of timing with frank admiration: "By one of those majestically simple strokes which made Napoleon so successful as a general," the agent reported, "she just put an announcement in the window of her emporium that scent was free for G.I.s, who thereupon queued up to get the bottles of Chanel No. 5, and would have been outraged if the French police had touched a hair on her head."

Then she temporarily fled her suite at the Hôtel Ritz—where another regular wanted by the FFI for arrest as a collaborator, Serge Lifar, was hiding in a closet—and decamped to rooms above her atelier as an added measure.

In the end, none of it mattered. At the end of the first week of September, men with guns appeared and asked Mademoiselle to accompany them for an interrogation. They were from FFI. She had spent the war living at the hotel with her German lover, and for that alone she would have to account for her collaboration. Far worse had happened already to other women in her position. Defiant to the last, she quipped sarcastically to her

captors that, when a woman had a chance of a lover at her age, she was hardly going to ask to see what was on the gentleman's passport.

A few hours later—to the astonishment of everyone at the Hôtel Ritz—Coco Chanel was back in her suite. And she was packing. The rumor spread: the order for her release had come from the highest reaches of the British government. Lucienne Elminger heard the story. Years later, she still remembered that it was the letters from Winston Churchill "assuring her of support and friendship" that had been the deciding factor.

Released from detention and advised by Churchill to flee swiftly to exile in Switzerland, Coco Chanel remained under active Allied investigation all autumn. She would be repeatedly questioned in the capital by "invitation." In the end, whatever the truth of her covert activities during the occupation and whatever the truth about Hans von Dincklage's status as an agent, the Allies decided that the story had too many obscure angles ever to comprehend fully.

In the Churchill archives today at the University of Cambridge, there are a series of declassified top-secret files in which the French, British, and American governments each alternatively considered where justice in the matter rested: Was Coco Chanel a Nazi spy and a war criminal or was she innocent of everything except horizontal collaboration? Was Hans von Dincklage, like his boss Wilhelm Canaris, a secret MI-6 agent or was he something more pedestrian and ominous? Or was the truth lost somewhere in the shadows? The files in the French justice department on Coco Chanel have disappeared.

But in 1944 and 1945, when it was all still fresh in memory, the Americans and British alike came in the weeks that followed the liberation to a single, shared conclusion: there was just no way of telling. Among the stories of the occupation that were lost before the war even ended—among the myths and legends, evasions, counter-evasions, and sometimes even brave

192 · THE HOTEL ON PLACE VENDÔME

secrets—these kinds of tangled records were often the hardest
to unravel.

Ironically, that long, high-level government inquiry—and
her sexual discretion as an experienced woman of sixty—likely
saved Chanel from the more savage purges. The charges brought
against her were so infinitely more serious than those of simple
"horizontal collaboration" or "intelligence with the enemy" that
a tedious process of examination had been set into motion. Her
political connections with the British leadership were so inti-
mate that no one wanted to make an error. But by the time the
Allies came to the conclusion that there was no way to know
for sure what Chanel had or hadn't done precisely and that, at
any rate, there wasn't enough evidence to convict her as a war
criminal, the period of wild vigilante justice in Paris was over.

In the aftermath, Coco disappeared to Lausanne, Swit-
zerland, and reunited with Hans von Dincklage. The couple
passed the better part of a decade in self-imposed exile. What-
ever her covert activities, her public ones were enough to earn
her the disdain of her fellow citizens in Paris.

That was why, in the autumn after the liberation of Paris,
her atelier on the rue Cambon remained shuttered. Her rooms
at the Hôtel Ritz sat empty.

She would eventually return to them again only in the mid-
1950s, when the Nazi occupation was already becoming some-
thing no one in Paris wanted to remember. By then European
integration seemed more promising than the Anglo-American
alliance.

For those who had lived as guests at the Hôtel Ritz during
the German occupation, the liberation was the end of one story
about luxury and modernity and Paris. It was the passing of
the generation that had changed the shape of the future in the
1910s through the 1930s.

Already in September 1944, other film stars, socialites, and
celebrities were on their way to making new legends. Among

those working quietly in the shadows of the rue Cambon bar was a second generation of wartime spies, the men working on the Manhattan Project. They were in a desperate race to prevent Adolf Hitler from obtaining a nuclear weapon as Germany collapsed under the Allied advance.

15

THE BLOND BOMBSHELL AND THE NUCLEAR SCIENTISTS

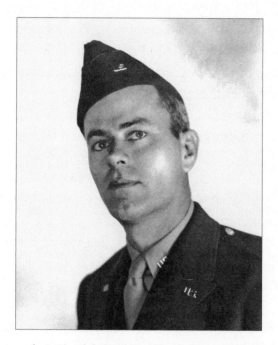

Assimilated Colonel Fred Wardenburg, 1944.

MIGHT NOT A BOMB NO BIGGER THAN AN ORANGE BE FOUND
TO POSSESS A SECRET POWER TO DESTROY A WHOLE BLOCK OF
BUILDINGS—NAY, TO CONCENTRATE THE FORCE OF A THOUSAND
TONS OF CORDITE AND BLAST A TOWNSHIP AT A STROKE?
—*Winston Churchill, "Shall We All Commit Suicide?," 1924*

n the weeks following the liberation, new visitors would arrive on the scene in Paris, in a changing cast of characters.

Sacha Guitry and Arletty still languished in prison with thousands of other French collaborators. On August 30, 1944, the Nazis executed a broken and battered Carl von Stülpnagel in Germany. On September 7, the Gestapo interrogators finally caught up with his conspirator, Hans Speidel, the last free member of the Ritz-based resistance circle that conspired in the July plot to assassinate Adolf Hitler. Amazingly, Hans Speidel survived the autumn.

In mid-September, *Vogue* correspondent Lee Miller left for a two-week assignment in the Loire Valley, but she would return to Paris by the end of the month and move into modest digs with fellow journalist Helen Kirkpatrick. The two gals still wondered what was going to happen when Martha Gellhorn found out about Ernest and Mary.

At the Hôtel Ritz in October there were immediate reminders that the war in Europe was far from over.

Baron Hans von Pfyffer arrived from Switzerland to inspect the hotel that month. It had taken weeks to arrange for the safe-conduct visa required to cross the front lines, which were still only a couple of hundred miles from Paris. His arrival sent the hotel staff in a flurry of action. Marie-Louise Ritz, who had largely taken to her rooms after the liberation, perhaps prudently, was suddenly more of a presence.

More important, that month an American engineer—and spy—named Frederic Wardenburg arrived at the Hôtel Ritz on a secret and crucial wartime assignment. He was part of the "Alsos" mission investigating German progress in developing an atomic bomb. He was there as a secret agent for the Manhattan Project in liberated Paris, a project that would end with Hiroshima.

Fred Wardenburg was thirty-nine years old. He was the father of two school-aged children, and he had spent his career as a desk-bound executive and science representative at the Du Pont chemical company, based out of Delaware. He had a pretty young wife named Martha. Although he had the requisite chiseled features and striking good looks, he was an unlikely candidate for the kind of James Bond–style adventures that had somehow unexpectedly landed him in Paris.

Fred Wardenburg never planned on a life of espionage or covert government missions, but he was exceptionally suited to the moment. He was an excellent engineer and sleuth, and he happened to speak both French and German.

He had been rigorously vetted for the assignment. After all, he was, quite simply, being trusted to carry out a mission on whose outcome the entire war potentially depended.

The United States military approached him in the first weeks after the liberation. The Second World War hadn't ended with the freedom of France. There was one way that Adolf Hitler could still achieve his long-dreamed-of world domination: by discovering how to split the atom. The race to develop the nuclear bomb was still too close to call, and the country that discovered its secret first would have a staggering advantage. In the words of one official report on the Manhattan Project, "In no other type of warfare does the advantage lie so heavily with the aggressor."

They wanted Fred Wardenburg to join the secret intelligence team based out of Paris. The team's mission was to hunt down, capture, and interrogate German nuclear physicists and to stop the Nazis from completing work on an atomic weapon. Wardenburg was one of only two American civilians entrusted with the top-secret information on the current state of the nuclear research.

For weeks Fred and his wife, Martha—who was to know none of the details of his assignment—were confined to a hotel room in

Washington, D.C., while the American brass weighed the risks of the operation. One night, late, the phone call came telling him that he was to meet agents in the lobby immediately. "I'll be in touch" was all that he could say to Martha, because even Fred didn't yet know that he was about to find himself holed up in a different hotel room by morning: a posh one at the Ritz in Paris.

In the French capital, Fred was joining a very small and elite network of Allied operatives. At the head of the scientific team was the Jewish-born Dutch-American physicist Professor Samuel Goudsmit, from the Massachusetts Institute of Technology. Two British spies, Eric Walsh and Rupert Cecil, were there to assist with intelligence, along with a civilian engineer named James Lane, who was their resident expert in facilities construction. In charge of them all—and responsible for the precarious and dangerous mission—was Lieutenant General Leslie Groves of the United States Armed Forces. The mission's code name—Alsos—was derived in his honor, it being the Greek word for "grove."

Before leaving Washington, D.C., Fred had been promoted to the "assimilated" rank of a United States colonel. All the civilians had been given military ranks for their own protection. It would give him, in case of the worst, high-level prisoner-of-war status under international treaty. On more than one occasion these scientists-turned-spies operated—like all those other wartime agents—from stools at Frank Meier's bar on the rue Cambon side of the Hôtel Ritz.

Frank was still there in the autumn of 1944, mixing up his inventive and deceptively strong cocktails. In those days after the liberation, the bar at the Hôtel Ritz was still going strong as the center of the action. Nearly fifty years after the Dreyfus Affair, it remained the chosen haunt of film stars, artists, writers, and intellectuals—Jewish or otherwise.

Down in the rue Cambon bar, Ernest Hemingway and Mary Welsh kept to their preprandial two-martini ritual, as

always. Fred Wardenburg later joked about having a drink with a resident Persian princess and the French film actress Danielle Darrieux, who was another regular. Sam Goudsmit was the life of the party and a fine-wine aficionado, and with those well-stocked Ritz cellars things often got cheerfully boisterous.

The reigning celebrity of the Hôtel Ritz and the queen of the bar, though, was Marlene Dietrich. She had been since her arrival in September. In the next two years, she would make more than five hundred appearances to entertain the Allied troops as part of the United States Overseas tour. Wardenburg and Goudsmit were soon knocking back drinks with the sultry bombshell, who had also been given the assimilated rank of a colonel by the United States government. Appearing carefree was part of their cover and part of her morale-boosting wartime performance. But all of them were taking risks.

Fred and Sam were on a covert mission. Dietrich was engaged in some undercover tactical maneuvers herself. But there was nothing altruistic about hers. For one thing, she was trying to bring about the speedy conclusion of the Hemingway-Gellhorn marriage.

Dietrich dubbed the macho writer "the pope of my personal church" (although Mary Welsh wryly noted that making money "seemed to be her religion"). She and Mary had rooms on the same floor of the hotel, and when she understood how things stood in Paris Marlene threw her support behind this amorous liaison. Marlene thought Papa was simply wonderful. "Papa," she would tell him, "you are the greatest man and the greatest artist." Ernest Hemingway unsurprisingly thought she was charming.

Marlene would come and sit on the tub in his bathroom and tell him that he just had to end his marriage to that Martha. Sometimes she would sing for him while he was shaving.

Papa didn't need much encouragement when it came to carrying on with Mary. Martha Gellhorn still didn't know

about the affair, but in later years she and Mary would exchange a couple of civil letters. Gellhorn, however, would never talk of Dietrich as anything other than a venomous, nasty little "cobra."

In truth, the hostilities between the two women had less to do with Hemingway than with a second tactical operation Dietrich soon had in the works.

That fall, just outside the small town of Nijmegen, in Holland, Gellhorn had caught her first glimpse of the dashing Major General James Gavin, commander of the 82nd Airborne Division. Still persona non grata in the eyes of the military after her rogue escape from the nurses' training camp in London after the Normandy landings, Martha had just been arrested and hauled into his office for reporting from the combat zone without press accreditation. Martha admitted that she was, indeed, reporting from the combat zone on the sly, but the general laughed and said that he guessed she'd made a pretty good guerrilla fighter. As long as she disappeared, he promised to forget this ever happened.

There was an immediate chemistry between them.

Soon another woman would set her sights on the handsome American commandant. That woman would be Marlene Dietrich. When she ultimately learned that Gellhorn and Gavin were lovers, she was "sick with rage" and frustration. Throughout the late autumn, the two women were "opposing warlords" in the Ritz bar, and, as the military pressman Colonel Barney Oldfield remembered those showdowns, "There was always the impression that each resented the other and denigrated her." Martha's love affair with the general was a call to battle, and the legendary beauty Marlene had a considerable sexual armory at her disposal.

Gellhorn would not win the war. Unfortunately for her, as with the atomic bomb, in love the advantage belongs to the aggressor.

In the bar of the Hôtel Ritz, all this plotting was business as usual. New acts of betrayal and counter-betrayal, new intelligence and counterintelligence operations had taken the place of the old ones. It was simply a new set of postwar characters.

But for Fred Wardenburg and the Alsos team, the stakes of their mission were impossibly high and the timeline frighteningly urgent. The Germans had discovered the principles of nuclear fission in 1938. In 1939, they had started a military nuclear research program, formally headed by Reichsmarschall Hermann Göring. Early in the war the Germans had captured the world's richest supplies of the necessary raw materials. The Allies—on the verge of cracking the mystery of the atomic bomb—were afraid that the Germans would be that one, fatal step ahead of them. If they were, the liberation of Paris and the losses at Normandy would be pretty well irrelevant.

The Alsos mission was created to find out exactly where the German nuclear program stood in the fall of 1944 and, as the Third Reich fell to pieces, to track down their research physicists before the Nazis could send them into hiding at a secret facility. Nothing less than the fate of the world after the Second World War hung in the balance.

Paris had been one of the wartime atomic research centers. One of the world's great physicists had been working throughout the war in the capital. Jean Frédéric Joliot-Curie, the son-in-law of the famed Marie Curie, ran research laboratories throughout the war, and the occupying forces made certain that they were well staffed with some top-notch, loyal German scientists.

Unsurprisingly, Joliot-Curie had to answer some hard question after the liberation about his collaboration. In fact, as the Allies quickly learned, he had acted with immense cunning and courage. Frédéric had spent the war secretly fighting for the French resistance. He used his scientific know-how to build Molotov cocktails for the *résistants* in the days leading up to the liberation.

The Alsos team knew, as well, that the chief German scientist in Paris, Wolfgang Gentner, had known all about Joliot-Curie's covert resistance activities and protected the scientist from the Gestapo throughout the occupation. In the gray areas of the French occupation, there is always this complication: the bad guys weren't always German. Sometimes they were French. Or British. Or American.

The first thing the Alsos team did in Paris was to search the files in Frédéric's wartime laboratories. They had been inventoried back in August, in the first days after the liberation, and the Allies had turned up only a couple of letters, written in German. Everyone was disappointed when they turned out to be from an insistent woman asking her lover to send her urgently some Chanel No. 5 from occupied Paris.

Their search led them to a second German research facility, just off the Champs-Élysées, where in October they finally had a lucky break. The scientific files had all been destroyed, but someone had forgotten to take the visitor book in the porter's lodge. It listed the names of all the German scientists and technicians who had visited the laboratory.

Now the Alsos team knew exactly who had been part of the Paris-based nuclear research program—and exactly whom they were hunting.

They caught up with one of those scientists in Paris. It was a second major break. Fred Wardenburg and Sam Goudsmit hauled the physicist in to the Hôtel Ritz for military-style questioning. "We transformed our hotel suite into a tribunal for the interrogation of our prize quarry," Sam remembered later. "We placed him facing the window so that we could observe all his reactions, [then] proceeded to shout dozens of questions at him."

It was a bust. "[H]is answers," Sam Goudsmit lamented, "were all disappointing. Either he was hiding something, or he really didn't know what it was all about."

In the scientist's suitcase, however, were some papers that terrified everyone involved with the operation. There were records of massive German industrial stockpiles of the radioactive chemical thorium. Nuclear physicists in Britain and America already suspected that thorium might be able to replace highly refined uranium in an atomic reaction. Had the Nazis discovered the last missing piece in the race to build a nuclear weapon capable of mass urban destruction?

By the fall of 1944, the world's physicists were working only on the final stages of the atomic process. How to refine uranium or how to replace it with some other element were the two questions that held the key to the puzzle of how to build a nuclear weapon. Evidence that the Germans were processing uranium was precisely what Wardenburg and his fellow agents were desperate to confirm in the last stages of the Manhattan Project. As he knew, Du Pont had been part of a secret government mission throughout the war to manufacture uranium 235, the most elusive part of the atomic project, and Fred knew that it hadn't yet found a way to isolate the isotope reliably.

The new information led the Alsos team in a frantic hunt all over Paris. New evidence led them at last to the German border in late October and early November. Caught up on the front lines in fierce fighting, it was a hair-raisingly dangerous experience. The stakes could not have been higher that autumn.

Success came at last when the city of Strasbourg was liberated in the middle of November. The Alsos agents followed on the heels of General Patton's army as the Allies made their way into the city and discovered another cache of scientific papers at a facility. Back in Paris, they pored over them, trying to work backward from the notes and to understand what the German scientists were after.

At the Hôtel Ritz there was at last cause for some jubilant celebration. The files "proved definitively that Germany had no atom bomb and was not likely to have one in any reason-

able time," as Sam Goudsmit put it officially. The Germans had been working on developing a uranium pile still as late as August—and they had missed something huge. They hadn't discovered how to use plutonium.

The Germans hadn't discovered how to use thorium in building an atomic weapon, either. Fred Wardenburg laughed when they learned why the German company was hoarding stockpiles of chemical thorium.

The company was, indeed, strategically preparing for postwar domination. That domination, however, was strictly cosmetic. The German industrialists were planning to launch a new brand of toothpaste to compete with the Americans: "thorium oxide . . . was supposed to have the same effect, probably, as peroxide, and they were already dreaming of their advertising. . . . 'Use toothpaste with thorium! Have sparkling, brilliant teeth—radioactive brilliance!' After all, America had its Bob Hope and Irium"—the old trade name for Pepsodent.

It led a too-modest Fred Wardenburg to later tease that the war medals he earned for his service "were for conspicuous bravery in riding rickety wartime Paris elevators."

Soon the Americans would unlock the secrets of nuclear weaponry, and the world would see the bomb that Winston Churchill had once been afraid to envision. Hiroshima and Nagasaki, not the liberation of Paris, would finally end the twentieth century's most lurid conflict. And it would be a distinctly modern conclusion to an ugly story that in France and in Germany and across Europe and North America had been decades in the making.

The collaboration of France in the fascist project had some of its roots in the cultural rift exposed by the trial of Alfred Dreyfus. The Second World War had some of its roots in the 1919 humiliation of a vanquished German people. Now the beginnings of the atomic age would usher in a Cold War whose parameters had already begun to take shape in the 1940s.

16
FROM BERLIN WITH LOVE
AND LAST BATTLES IN PARIS
1945

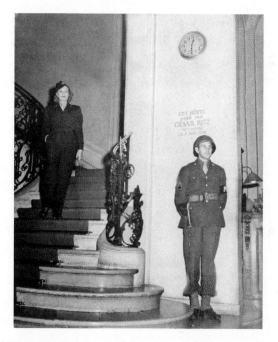

Marlene Dietrich at the Hôtel Ritz after the liberation.

GENERAL, YOU MUST NOT HATE YOUR FRIENDS MORE THAN YOU
HATE YOUR ENEMIES.

—*Clementine Churchill to Charles de Gaulle*

Before the Second World War ended, things were destined to get more ugly than anyone imagined.

The winter of 1944–45 was bruising for everyone. Beyond Paris, the war continued. The race to harness and control the power of the atom only intensified. Across Europe, the weather was punishing, and there were massive shortages of food and fuel. Life in the French capital was harder than it had been at almost any time since the beginning of the occupation. And in Germany, the numbers of people dying in the concentration camps were skyrocketing.

The winter of 1945 also marked the beginning of a new low in French relations with the British and the Americans.

At the liberation, the proud and cantankerous Charles de Gaulle got his wish. He assumed the role of prime minister of the autocratic provisional French government and largely quashed the communist-led factions that led the local resistance. Increasingly, he stopped trying to keep his antagonism toward *les Anglo-Saxons* a secret as well. Clementine Churchill, who was fond of Charles de Gaulle, sagely advised him, "General, you must not hate your friends more than you hate your enemies."

De Gaulle, however, was not in the mood for caution. The Americans, British, and Soviets found him so obstreperous that they declined to invite him to the summit at Yalta in February, where the fate of a new modern Europe was decided. France was offered a founding seat in the United Nations and an occupation zone in postwar Germany, but the general was still furious. Defeat by the Axis powers was not an option anyone entertained for a moment. But the cost of victory in the Second World War was looking more and more delicate.

In the winter of 1944–45, Marlene Dietrich and Martha

Gellhorn were both back in the French capital. The cost of victory there was also hard-fought and nasty.

When Major General James Gavin hauled her into his office on the eastern front earlier that year, Martha had dropped the hint that she would be based out of the Hôtel Lincoln in Paris. He tried on several occasions to catch up with her in the capital. Somehow they always seemed to miss each other. So Jim Gavin finally decided to act the part of the major general. He sent someone to Paris with a military plane and orders to bring Gellhorn to him in Germany.

Being ordered about didn't much suit Martha, and she was about to refuse the colonel who had been sent to fetch her, until the colonel explained that, in fact, Jim Gavin wasn't kidding. Her choice was either to come to Germany—and he was giving her the press credentials she needed as part of this bargain—or she would be returned by military order to the United States, which would be the end of her wartime reporting.

Face-to-face with her would-be paramour a few hours later, Martha's fury over the peremptory method of seduction faded when he offered her a dry martini and an unheard-of wartime steak dinner in exchange for a few hours of her company. By the time they were on to the brandy and low music in front of the woodstove, they had discovered they were mutual friends of Bob Capa. That night they became lovers.

Martha Gellhorn—once again an accredited war correspondent thanks to Jim Gavin's curious wooing strategy—returned to the front almost immediately. She had been shaken by what she had seen reporting on the torture centers in Paris. At the beginning of April, she followed the Allied troops as they liberated the first concentration camps in Germany. Some of these had been where France had sent 75,721 Jewish refugees and other citizens, many of them from metropolitan Paris. Thirty-three thousand people remained in the German camps that spring. Fewer than two thousand of these survivors were deported French Jews.

Martha arrived at Dachau, Germany, in the first days of May 1945, directly on the heels of the American troops. A typhus epidemic had swept through the camp, and conditions had deteriorated horrifically. In the woods nearby were torture chambers and everywhere hundreds of bodies. Almost half of those who died at Dachau, Martha learned, perished in the last few months before its liberation.

There was no comprehending what confronted those first observers. "Behind the wire and the electric fence," Martha wrote in her report for *Collier's*, "the skeletons sat in the sun and scratched themselves for lice. They have no age and no faces; they all look alike and like nothing you will ever see if you are lucky."

As Gellhorn stood in the infirmary, "what had been a man" entered the room, one of the only Polish detainees to survive the last transport from Buchenwald. Everyone else in the fifty boxcars that made up the convoy had perished. He was six feet tall, but he weighed less than a hundred pounds, and he wore only a prison shirt and a dirty blanket around his midriff. "This man had survived," Martha told her readers, but "he was found under a pile of dead. Now he stood on the bones that were his legs and talked and suddenly he wept. 'Everyone is dead,' he said, and the face that was not a face twisted with pain or sorrow or horror. 'No one is left. Everyone is dead. I cannot help myself. Here I am and I am finished and cannot help myself. Everyone is dead.'"

For Martha, nothing would be the same afterward. She was herself of Jewish heritage. "A darkness entered my spirit, there, in that place in the sunny early days of May 1945," she wrote. "It is as if I walked into Dachau and there fell over a cliff and suffered a lifelong concussion, without recognizing it."

The man returned not long after—and whispered something in Polish urgently. The doctor translated. He had come to tell them the news that had come too late for everyone there. The war in Europe was over.

On the evening of May 4, 1945, Germany formally began negotiations for surrender.

No one celebrated anything in Dachau.

Had the Allies pushed on past Paris, forgoing that liberation in August, would they have arrived sooner, in time to stop the last weeks of horror? It was a question too agonizing even to formulate.

A few days later, Martha was back in Paris, assigned to cover the V-E Day celebrations. She tried to find Jim Gavin in the capital. Instead she ended up in a room at the Hôtel Scribe, where a French friend held her for hours in bed while she wept, talking of Dachau. Soon thereafter, Martha returned to Germany, where at Bergen-Belsen she witnessed Allied soldiers bury thousands of bodies. James Gavin seemed to be the last thing on her mind.

Conflict with Marlene Dietrich, however, was looming on the horizon, even if Martha didn't yet know it.

Dietrich had often said in her wartime USO act that, when the Americans took Berlin, she hoped some nice soldier would look up her aged mother. The German-born Dietrich was passionately antifascist, and she had taken up American citizenship in defiance of Adolf Hitler. The chance of her mother surviving that insubordination was dicey.

In that search for her mother, she had the help of a powerful American general. One night that spring, Ernest Hemingway invited James Gavin and Marlene Dietrich to the same late-night party at the Hôtel Ritz. The night ended for the new acquaintances with a passionate romp in the general's bedroom. Sometime between pillow talk and breakfast, Gavin found that he had been enlisted to lead the search for Frau Dietrich.

The Gellhorn-Hemingway marriage had ended—and ended acrimoniously—months earlier, and it is hard to say if Ernest knew that he was causing mischief in making this introduction. But regardless of whether he relished now the fresh

heartache and humiliation coming Martha's way or not, heartache was coming. It was only a question of when and how Martha would learn of her lover's betrayal.

She would not learn of it quickly for the simple reason that Martha was less and less in Paris that summer. At the Ritz bar, however, Dietrich soon found another "warlord" to contend with in her absence. By July 6, 1945, another famous starlet had moved into the Ritz, and it was probably a good thing that Marlene missed Ingrid Bergman's big entrance. Marlene Dietrich was not a gracious loser.

When Bergman arrived at the Hôtel Ritz that July morning it was a showstopper. Journalists were elbowing each other out of the way at the imposing Place Vendôme entrance to get the best shots of the stunning Swedish actress. Her role as Ilsa Lund in the 1942 film *Casablanca*, opposite Humphrey Bogart, had made her immensely famous. Everyone remembered those lines: "We'll always have Paris."

Dietrich was annoyed to hear that she had celebrity competition in the Ritz circle. "Ah, now you're coming—when the war's over!" she snidely offered her Swedish nemesis as words of welcome.

Irwin Shaw and Robert Capa, bent over their poker chips, perked up considerably as Bergman glided past. By then Capa was being held captive at the Hôtel Ritz, where the staff refused to let him check out until he could settle up his bar tab with Frank and his hotel bill with Claude Auzello. Unsurprisingly, there were also some sizable gambling debts that needed clearing.

Throwing in their cards, Capa and Shaw immediately started composing Bergman a warmer welcome letter. They pushed the note under her bedroom door an hour later, and they couldn't believe their good luck. The thirty-one-year-old Ingrid found it sweet and funny.

They wrote in the letter:

Part 1. This is a community effort. The community consists of Bob Capa and Irwin Shaw. 2. We were planning on sending you flowers with this note inviting you to dinner this evening—but after consultation we discovered it was possible to pay for the flowers or the dinner, or the dinner or the flowers, not both. We took a vote and dinner won by a close margin. 3. It was suggested that if you did not care for dinner, flowers might be sent. No decision has been reached on this so far. 4. Besides flowers we have lots of doubtful qualities. 5. If we write much more we will have no conversation left, as our supply of charm is limited. 6. We will call you at 6.15. 7. We do not sleep.

Then the two men repaired to the rue Cambon bar, where they enjoyed a few more of Frank's cocktails.

Astonishingly, when they called upstairs to her room, she agreed to join them. She told them cheekily that, as they had promised to take her out to dinner, "I hope you have enough money, because I'm very hungry." Off they went to one of the swankest cafés in Paris, Fouquet's, on the Champs-Élysées, where they promptly ordered champagne.

Poor Irwin Shaw was about to find himself, once again, on the losing side of an amorous competition. He would fare no better up against Capa than he had fared against Hemingway that fateful afternoon with Mary Welsh in London. Capa had talent with the ladies. Before long, he and Bergman were camped out together at the Hôtel Ritz as lovers. That romance, too, would last all summer.

On August 6, 1945, the Americans dropped the first atomic bomb, on Hiroshima, Japan. The second bomb was dropped on August 9, on Nagasaki. On August 14, Emperor Hirohito made a radio broadcast to the world and announced that Japan, too, would surrender. The Second World War ended at last, nearly a year after the liberation of Paris.

Driving down the Champs-Élysées with Robert Capa in a jeep for the V-J celebrations, Ingrid Bergman—for months now a Hôtel Ritz resident—took to kissing some pleasantly surprised soldiers.

Still wrangling bitterly with the Allies, Charles de Gaulle forbade British troops from taking part in the celebrations. Banning the Americans from the party in Paris was harder. In the summer of 1945, the Americans were still a dominant presence. Until the war was over and all the treaties signed and delivered, Allied troops provided security in the capital. And since spring, another breed of visitors had been steadily arriving. They were there to cover and to lead the European war crimes tribunals.

Those men and women headed to the Hôtel Ritz like generations before them. Among the newest residents on the Place Vendôme were Justice Robert H. Jackson, Thomas S. Dodd, Colonel John H. Amen, and General Edward C. Betts. President Harry S. Truman tapped Robert Jackson to serve as the United States' chief prosecutor at the international military tribunal slated to get under way in the autumn in Nuremberg, Germany.

Thomas Dodd, one of the American prosecutors assisting Justice Jackson, described life in the French capital that summer. There were still shortages of everything. "Paris," he wrote on August 4, 1945, "is so crowded. No taxicabs at all—a few horse carriages at fabulous prices. There are some automobiles on the streets—not many—and very few after dark." Inflation and the devaluation of the French franc were crippling an economic recovery. Butter on the black market was ten dollars a pound, well beyond the reach of most in the city.

The trials at Nuremberg would last until 1946 and unfold the extent of the horrors of which Martha Gellhorn had witnessed a small fraction. Eventually, two of the old Hôtel Ritz regulars, Joachim von Ribbentrop and Hermann Göring, received death sentences in Germany.

In Paris, justice—or justice of a sort—came faster. While the French celebrated V-J Day in the streets of the capital, behind the scenes Philippe Pétain, the head of the Vichy collaborationist government, and his right-hand man, Pierre Laval, were engaged in another life-and-death struggle to indict each other. On August 15, 1945, Pétain's three-week trial ended. It was another death sentence. De Gaulle controversially commuted it to life in prison.

In custody and preparing for his trial that autumn, Laval guessed that his fate would not have this same quality of mercy. He didn't have much faith in due process in that punishing season. "Do you want me to tell you the setup?" he asked his lawyer on August 4. "There will be no pretrial hearings and no trial. I will be condemned—and got rid of—before the elections."

Laval ultimately faced the firing squad, executed for his wartime collaboration. As he predicted, death came before the end of October and the first postwar elections of the new French government. Historians have long acknowledged that, despite his many sins during the occupation, the trial of Pierre Laval did not follow any defensible judicial process. It was the last of the savage *épurations*.

By autumn, the trials at Nuremberg had started, and the postwar story was no longer unfolding in the French capital. By 1945, the legend that was Paris was something the world looked back on as a beautiful symbol of a uniquely modern moment that had shaped the destiny of Europe. That moment was now passing.

The story had moved to London, Los Angeles, and, that year, Berlin especially. By September, Martha Gellhorn left the French capital for good to report on postwar Germany and to be full-time with Jim Gavin. She had to leave Bob Capa—eager

to be back out reporting, too, and now looking for a way out of his love affair with the increasingly serious Ingrid Bergman—stuck miserably in Paris.

Gellhorn ultimately was able to purchase Bob Capa's freedom. She promised to take one of his old suits to sell on the flourishing German black market. If she succeeded, she'd send him the money. One morning, on the Alexanderplatz, an old friend of theirs from Spanish Civil War days, Freddy Keller, found her there hawking the garment and handed her enough cash to give Capa his second Paris liberation. Capa briefly followed Bergman to Los Angeles—but before long he left her for Berlin.

And in those last months of the autumn, Marlene Dietrich was also in Berlin and not Paris. That September, two lieutenant colonels with the 82nd Airborne in Germany finally tracked down her frail and elderly—but living—mother. It was headline news. Marlene was flown from Paris and her home base at the Hôtel Ritz to Berlin for the dramatic reunion in front of flashing cameras. Her host was none other than the dashing General Gavin. There she finally went on the full-bore romantic offensive. She whispered to an unsuspecting Gavin that Martha Gellhorn had been unfaithful. Hurt and angry, Gavin once again went to bed with the film star out of pride and vengeance.

This time Gellhorn at last discovered the betrayal—as she was always meant to do. Shattered by the news, she broke off completely with the general. There in Berlin, Marlene Dietrich had won her quarry.

Soon even Charles de Gaulle would be looking toward Germany in his vision of a postwar Europe. It was either there or looking westward. And the old general was determined to turn his back on the Anglo-Americans and the special relationship that he was convinced excluded France from world power. When he was, at last, elected to the presidency of France in

the 1950s, with the Cold War now under way, de Gaulle set about building a new relationship, not with his old Allies but with the Germans. Once again, the Germans and the French sat down, at tables in Berlin, on the Champs-Élysées, and even at the Hôtel Ritz in Paris, to hammer out a vision of a shared economic and politic vision that would unify a pan-European community.

17
WANING POWERS IN PARIS
June 1951

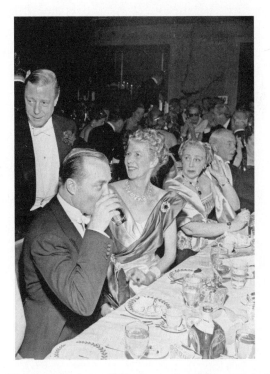

Party for the Duke and Duchess of Windsor in the 1950s, with the Woolworths.

THE TWO PEOPLE WHO HAVE CAUSED ME THE MOST TROUBLE IN
MY LIFE ARE WALLIS SIMPSON AND HITLER.

—*Queen Elizabeth (later the Queen Mother)*

n the spring of 1951, Paris was once again, briefly, the center of the world's attention. That April, six European countries ratified an agreement known as the Treaty of Paris and established the European Coal and Steel Community—a supranational pact binding France and Germany in a new economic and diplomatic collaboration. It was the second time in just over a decade, this time under far more auspicious circumstances.

In the spring of 1951, the Duke and Duchess of Windsor were also in the capital. That June, the royal couple was negotiating a new place on the world stage again, too. It was a plan that involved more than a little sneakiness and double-crossing, and what the Duke and Duchess of Windsor couldn't yet know was that it was about to end badly for both of them. That drama was unfolding—as so many of the dramas of their generation had unfolded—on the Place Vendôme in Paris.

The Hôtel Ritz had been one of the couple's favorite retreats since the 1930s. Back in the days when the young duke had still been styled Edward, Prince of Wales, he had partied there boisterously, once leading the discerning maître d'hôtel Olivier Dabescat to observe that, in his experience, only three people knew how to host a dinner party properly—Prince Esterhazy, Elsa Maxwell, and the Prince of Wales. The duke and duchess had later kicked off their honeymoon at the Ritz in 1937, in company with their pro-fascist American friends Charles and Fern Bedaux, whose château at Candé hosted the wedding celebrations.

They had stayed on as regular visitors until the eve of the occupation. In the days before the fall of France in June 1940, the Windsors fled the capital along with the rest of French high society. Much of the *gratin* that spring decamped to Biarritz, where, waiting for visas that would mostly never come, the

glitterati blithely continued a dizzying round of more cocktail parties and dinners, this time from rented suites and mansions. The Duke and Duchess of Windsor, however, had a distinct advantage when it came to crossing the border out of France in the spring of 1940: the British government was determined that the royals would not fall into the hands of the Germans as prisoners of war. The British leaders were equally determined that the Windsors wouldn't go willingly over to the Germans, either. There were periodic disturbing reports that the couple had secretly received the promise of Hermann Göring and the Führer himself that, if the Germans occupied Britain, they would be returned to power. The Duchess of Windsor was an old friend of Pierre Laval, and American intelligence files uneasily noted that "the Duke of Windsor was labeled as no enemy of Germany [and was] considered to be the only Englishman with whom Hitler would negotiate any peace terms, the logical director of England's destiny after the war." Even rumors of this sort were a potential political and public relations disaster for the Allies. So the British stashed the royals for the duration of the war on the island of Bermuda, where they still caused Winston Churchill more headaches than he needed.

After the war, with antifascist antipathy running high in post-Blitz London and with King George VI wary of testing the limits of his brother's political ambitions, the Windsors returned again to France. And George VI was wise to be cautious: the duke and duchess definitively had not given up their dream of ceremonially ruling again over Britain and its territories. Far from it: grasping the reins of power in England was something they were planning.

In his abdication speech to the British nation on December 11, 1936, Edward had announced resolutely, "I now quit altogether public affairs, and I lay down my burden." He couldn't imagine life, he proclaimed, without the woman he loved beside him. Less than a decade later, he was no longer convinced

that having both was impossible. As early as 1946, the duke and Wallis were covertly hatching a plan to prevent Princess Elizabeth from inheriting the throne as Queen Elizabeth II. At fifty-seven, the duke had discovered that the charm of the life of the idle playboy was not inexhaustible. And living up to the love affair of the century was sometimes hard going.

This postwar plot to return the duke of Windsor to the throne of Britain has only recently been discovered in private royal correspondence, by a particularly intrepid archivist. What the documents reveal for the first time is that, astonishingly, from 1946 until as late as 1952, the duke and duchess, in conversations in Paris and in a series of letters, worked backroom channels and strategized ways to displace the young princess.

As long as George VI remained hearty, there was no question of a coup d'état in Britain. But the king's health was uncertain. It was a tempting opportunity. In 1946, the king was seriously ill, and Princess Elizabeth was barely twenty. With a fellow British aristocrat, Kenneth de Courcy, the duke and duchess began taking steps that would allow the duke to fill the power vacuum that would surely develop if the king died before his daughter's role was firmly established.

The trouble was that the king inconveniently kept pulling through one health crisis after another before concrete plans could be implemented. And the Duke of Windsor was perhaps a bit too equivocating in his approach to political betrayal. By the time his brother was hospitalized for a second time, in the spring of 1949, the young Princess Elizabeth was still vulnerable, and some in the British aristocracy and government were anxious about her recent marriage to a young Greek nobleman named Philip, from a German ducal house. Had the duke acted then, it was a dangerous moment, and it is not impossible that he could have succeeded.

The strategy set out for the duke by his advisers was a straightforward one of political rehabilitation. Kenneth de

Courcy, on the ground in London, recommended that the duke and duchess return to England and establish themselves in a quiet and respectable life of rural retirement—but not too far from the city. Buy a large estate and take up agricultural modernization and domestic industry, he advised them. And make sure this new estate is near enough to London that those who worked the levers of power could drive down for country weekends and dinner parties. The princess was vulnerable because of her age and what some saw as the overreaching ambitions of the prince's relatives. When the king passed away, so the logic went, the Duke of Windsor would be the obvious, reassuringly familiar "English" postwar alternative, if only he played his cards sensibly.

There was just one crucial caveat. The duke was a notorious roué as a younger man. His womanizing and tawdry affairs in the 1920s and 1930s were a constant source of public—and private—censure and some disgust in elite circles. His marriage to the twice-divorced Wallis was not generally looked upon still with any great favor, but perhaps the nation could get used to it, as long as there were no hint of fresh scandal. Thus, de Courcy advised, "There should be a rigid refusal to be seen anywhere which might in the faintest degree give enemies the chance of putting out a play-boy propaganda." There must also be no whispered innuendos about the duchess's predilections. Too many people still remembered her love affair with Benito Mussolini's late son-in-law, the Italian count Galeazzo Ciano, or the fact that Joachim von Ribbentrop sent her carnations.

Once again, in 1949, the duke had hesitated. And in truth, it was a risky and sensitive undertaking that required treading lightly. In the spring of 1951, there seemed to be a new opportunity on the horizon. The king's health was deteriorating badly. He was, by now, "walking with death," as Winston Churchill famously put it. The duke's mother, Queen Mary, was ailing. Coming home to sit at his mother's bedside was as

good a way as any to justify a return to Britain, and on June 3, 1951, the duke set off from Paris for London.

Who knows what the duke was thinking on that fresh June morning. Perhaps he was still entertaining the fantasy of once again ruling over the country whose throne was his indisputable birthright. Certainly, many historians think so. That spring had seen the publication of his self-promotional memoirs, largely written the year before in rooms on the Place Vendôme, and the autobiography set just the tone of seriousness and sober reflection that the plan required. The wheels, he could have been forgiven for thinking, were in motion.

Unfortunately for the duke, those dreams were already unraveling as a scandal took shape around him. That week in Paris it would escalate dramatically in his absence. In his planned political rehabilitation of his reputation, the duke had already made his first and fatal tactical error: he had unwisely left Wallis alone in the capital. In the six days that he was away, she would manage to do immense damage to the Windsors' reputation—and to destroy any last chance of its rehabilitation.

It all came down, of course, to sex and discretion. The duke must have suspected already that Wallis was carrying on in some fashion or another with their mutual friend and constant companion, the handsome and ultrarich American-born rake Jimmy Donahue. Jimmy's cousin and staunch ally, the Princess Troubetzkoy, had until recently been famous as Mrs. Cary Grant. Most of the world knew her simply as the richest girl in the world, the heiress Barbara Hutton. Barbara and Jimmy's mother shared between them the largest portion of the immense Woolworth drugstore fortune—among the most sizable in the world in the 1950s. And Barbara Hutton lived, of course, in a grand suite at the Hôtel Ritz in Paris.

The duke might have suspected the liaison—after all, it was hard to miss being the fifth wheel in one's own marriage. But since Jimmy Donahue was boisterously homosexual, a good

deal of indiscretion was put down to mere flirtation in the beginning by wagging tongues in the capital. It was a convenient cover. The truth was that, despite Jimmy's sexual preference, he and Wallis had been lovers since they all sailed together on the transatlantic crossing of the RMS *Queen Mary* a year earlier.

In the beginning, the duchess tried to be discreet. On riotous evenings out at nightclubs with Jimmy that first year, she made sure there were aristocratic chaperones to vouch for her good conduct. Opening the doors of a limousine unexpectedly, his friends found Wallis crouching on the floor so no one would catch sight of her in passing. But that weekend, when the duke was in London, things in the nightclubs on Montmartre escalated at last into some very public dirty dancing—and into a weeklong fling that took Wallis and Jimmy from one hot spot to another across the capital by night and found them in the afternoons cavorting *in delicto* at the Ritz, in the lavish suite lent to him for the purpose of some privacy by his millionaire cousin.

"I knew it was physical," Barbara Hutton's personal secretary, Mona Eldridge, later admitted. It was just a confirmation of what everyone saw was happening. "I knew from the maid there was sexual activity," Mona acknowledged. "She was in love with him, she was besotted by him, she chased him. She really fell for him." And once the affair was out in the open anyhow, the duchess made a display of it. "No one," one aristocratic onlooker put it, "could have behaved worse than the Duchess when she got her infatuation with Jimmy Donahue. She really flaunted her affair in a way that was quite unnecessary." Soon she and Jimmy would publicly torment the duke with their liaison.

Even if the duchess hadn't tipped her hand, the storm of gossip about to break upon the Duke of Windsor was inevitable. Jimmy Donahue had a reputation as an incorrigible gossip with a mean-spirited sense of humor. That same aristocratic

onlooker described him thus: "He was an alcoholic, he was a drug taker. He was sadistic and depraved and seriously vicious." Once, he cruelly—but comically—impersonated the notoriously dumpy Ritz hostess Elsa Maxwell in a prank that earned him shocked gasps and snide giggles. He "turned up [at a popular restaurant] in a dress stuffed with pillows, wearing odd shoes and a five o'clock shadow, claiming to be Miss Maxwell, and noisily demanding her table." Another time the heiress of the Guinness beer fortune, Aileen Plunket, remembered how at a dinner party he unzipped his pants, laid his privates on the dinner plate in front of him, amid the potatoes and gravy, and joked crudely about the enticements of this prize-specimen pink sausage, knife at the ready, to anyone who would listen. Now he bought the Duchess of Windsor half a million dollars' worth of jewels as a present, charged to his mother's account, and considered himself at perfect liberty to blithely tell all of Paris the details of their congress.

By the time the duke returned to Paris on June 9, 1951, the duchess's hijinks were the talk of the capital. In the cruel way of gossip, of course, there is no way of knowing precisely when the duke discovered the public nature of the scandal. One night not long afterward, though, the duchess's flagrant badinage with Donahue reduced the duke to tears at a late-night cocktail table in a crowded room. And the worst of it was that the duchess was still smitten with her vicious playboy all that summer and autumn. She toyed with leaving the duke and ending even now the marriage that had cost him so dearly.

In the end, of course, Wallis stayed, and her passion for Jimmy Donahue faded. But the spectacle destroyed any last hopes the duke still entertained of returning to Britain as the steady and domestic alternative to his niece. When his brother, King George VI, passed away at last on February 6, 1952, the youthful princess became Queen Elizabeth II. In the end, it was a sad and slightly shabby irony: among the rumpled sheets

in a bedroom suite at the Hôtel Ritz, the Duke of Windsor had lost for a second time perhaps his chance at the throne of Britain, once again because of Wallis Simpson.

And the duke and the duchess did buy their rural country estate and fade at last into a retirement. But this new estate was not an easy drive from London. They divided their time in the years to come, instead, between a villa in the posh suburb of Neuilly-sur-Seine, northwest of Paris, and a sprawling retreat some fifteen miles southwest, in the village of Gif-sur-Yvette.

And for a certain circle in the capital—those who looked to the past as their brightest moment—life in the decades to come mirrored the old prewar patterns and prejudices. At their country estate, the Windsors entertained their neighbors and friends Sir Oswald Mosley, better known to history as the notorious founder of the British Union of Fascists, and his unapologetically pro-Nazi wife, the former Diana Mitford. Never quite understanding how the new world had its tangled roots in old conflicts, the Duke of Windsor would callously comment in the decade that followed, "I never thought Hitler was such a bad chap." Instead of the power brokers of London, an aging Marlene Dietrich came down instead for weekend visits. In Coco Chanel's suite at the Hôtel Ritz, the duke and duchess again enjoyed private dinners in the company of many of the old friends who had passed the war in comfort. In the space of just a few short years, even Paul Morand and Marcel Proust's Princess Soutzo would again be part of the dinner company. It was an old world of privileged glamour, only slightly wrinkled now at the edges.

The Ritz was starting to show its age as well in the 1950s. The only question was whether the hotel could find a way to entice a new generation to its doors by reviving the spirit of avant-garde daring and innovation that had, in those closing years of the nineteenth century, first made it famous. At the end of the nineteenth century, the reverberations of the Drey-

fus Affair had launched the hotel on the path to decades of celebrity. In the 1960s, however, Charles de Gaulle's determined anti-Americanism discouraged tourism in the capital. Soon long-standing season reservations were being canceled. New customers weren't coming in the same numbers to replace them.

And the global social scene moved, as it had been doing steadily since the 1930s, to New York City and increasingly Hollywood. The stars and starlets who had once clamored for cocktail tables at the Ritz bar had largely retreated to sprawling mansions under the palm trees of Los Angeles. That moment when Paris was the heartbeat of all that was new and glamorous had passed. For the Hôtel Ritz in Paris, that would mean trouble. Its celebrity was slowly fading and before long it would be on the brink of bankruptcy unless something could be done to change direction.

There were those who doubted that it was possible. Already the longtime hotel staff was dubious. Soon bad tempers and squabbles would escalate into tragedy on the Place Vendôme in Paris.

18
THE WAR'S LONG SHADOW
May 29, 1969

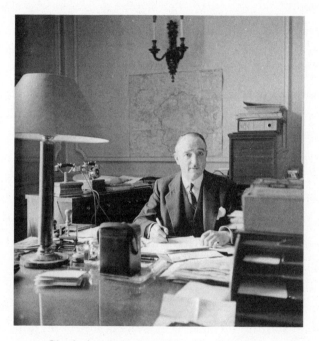

Claude Auzello, in his office at the Hôtel Ritz.

THERE ARE STILL SCARS ON PARIS. CHUNKS OF SOME BUILDINGS
SHOW IT PHYSICALLY. BUT A DEEPER, SPIRITUAL SCAR SHOWS
EVERYWHERE.

—Thomas S. Dodd, United States chief of coun-
sel for the prosecution of Axis criminality

The lobby of the Hôtel Ritz was quiet. Things at the Hôtel Ritz had been quieter in recent years in general, now that the Americans came less regularly and the hotel's star was dimming. In fact, the Ritz was already sliding toward bankruptcy.

It would be easy to blame Charles de Gaulle for that. He had resigned his presidency at last just weeks before, after a tumultuous decade in power. But in that decade, France had turned its back against its Anglo-American allies and sought new alliances with Germany. Twice he had used France's veto power to exclude Great Britain from the emerging European Economic Community, a coalition that had its formal roots in a treaty signed in the spring of 1951 by the nations of France, West Germany, Belgium, Luxembourg, Italy, and the Netherlands. Those alliances, in the decades to come, would lay the foundations for the establishment of the European Union in 1993—and for the crises that would face that union in the new millennium to follow.

In that time, France's colonial possessions had spiraled further out of control, both in Indochina and in Africa. The senior hotel staff might have remembered an immigrant busboy named Ho Chi Minh who worked in the Ritz kitchens in the 1920s. By the 1960s, Ho Chi Minh had been a legend already for years in his country—the communist-run and still highly contested Democratic Republic of Vietnam.

Fears of new conflicts and, in this post-atomic age, the power of new weaponry loomed large too. Somewhere over a desert in Algeria, France exploded its first atomic bomb in 1960. De Gaulle, convinced that "[n]o country without an atom bomb could properly consider itself independent," withdrew his country from the North Atlantic Treaty Organization. Iron-

ically, the commander in chief of NATO's ground troops in postwar central Europe was the Ritz's own Hans Speidel. He alone of the ringleaders at the hotel had survived that failed plot by the German resistance to assassinate Adolf Hitler.

It was all a sign of just how many things in the world that Claude Auzello had known were rapidly shifting. He couldn't help but find it alarming. Only a year ago—in May 1968—Paris had exploded with two weeks of strikes and a different kind of street warfare than what Claude remembered from those dizzying days of the liberation.

Across France in the spring of 1968, eleven million workers and students took to the streets. Panicked, Charles de Gaulle fled the country, heading for refuge at French military bases in Baden-Baden, Germany. Half a million in Paris took to the streets, wishing him good riddance. Newspapers across the world flashed astonished headlines and told the world of the newest French "insurrection, there is no other word for it, [that] swept a stupefied Paris."

Graffiti slogans and hastily handmade posters appeared across the capital, urging revolution: "Run, comrades, the old world is behind you!"

Even if Claude hadn't seen the poster, he knew the feeling. The workers' uprising of 1968 hadn't left the Hôtel Ritz unscathed. "Students passing the unguarded Ministry of Justice in the Place Vendôme," the papers reported, "threw stones through the windows." Those who were there at the Ritz, however, didn't need journalists to tell them of the turmoil playing out before them.

Seventy years earlier, on the spring night the Hôtel Ritz opened its doors in the heady days of the Belle Époque, the square had been quiet enough for shrill voices and the clatter of wheels to disturb the peace of a fragile writer. Now the Place Vendôme—some days little more than a parking lot—throbbed with the sound of horns and engines.

In 1898, women wouldn't have dreamed of dining in public in Paris, not until Auguste Escoffier made it possible. Sunday dinner dances took place with white gloves and orchestras. Men in bespoke dinner jackets smoked serenely in the shadows.

In 1969, Paris was reeling from Twiggy and miniskirts and the London "mod" look, which was taking over fashion. News drifted in from America of hippies and draft protests, birth control pills and the "Summer of Love."

The old world—the world where Paris was the pulse of the modern—was, indeed, behind them. The Hôtel Ritz was in danger of becoming no more than another of its legends. Occupancy was down. The hotel was teetering on the brink of financial collapse. It was easy to blame the absence of old visitors on de Gaulle's determined anti-Americanism and on a new world rushing in upon them all too quickly.

Claude Auzello knew better, though.

Charley Ritz was the cause of this fiasco.

It didn't help, of course, that the hotel's legendary residents—good and bad—had largely already departed. Even Claude couldn't hold Charley Ritz responsible for the passing of a generation—and their passing was, it had to be said, often early and violent. Hermann Göring, the eccentric and uncomfortably charismatic Reichsmarschall, had swallowed contraband cyanide in the hours before his death sentence at Nuremberg could be carried out. Nuremberg concluded with ten executions and two suicides. Claude had no pity for them. He simply quipped: "We have lost twelve steady customers."

He was less sanguine on hearing the news about Robert Capa. The photojournalist had been killed in 1954, in a landmine explosion in the war zone in Indochina. Capa was on assignment for *Life* magazine, and he wasn't yet forty.

Irwin Shaw on hearing the news promptly rounded up some friends and held an all-night wake in Capa's favorite bar afterward in Paris, over bottles of champagne. Of his old friend

and sometime enemy, Ernest Hemingway simply said, "It is bad luck for everybody that the percentages caught up with him. . . . He was so much alive that it is a hard, long day to think of him as dead."

Now "Papa" himself had been among the more recent departures. Ernest Hemingway, mentally ill and hopelessly alcoholic, shot himself to death in Key West in 1961, after years of wavering. In 1964, Mary Welsh—at last, Mrs. Ernest Hemingway—published a posthumous volume of his work, *A Moveable Feast.*

In a letter to a friend in 1950, Hemingway had written of what it had meant, those magical years when the world had been young in the French capital. "If you are lucky enough to have lived in Paris as a young man," he had written, "then wherever you go for the rest of your life it stays with you, for Paris is a moveable feast." The memoir was an elegy to that city and that moment, and it had been pieced together from a notebook the writer found in a trunk of his papers that had rested in basement storage at the Hôtel Ritz since at least the 1940s.

The only ones among the old legends left now at the Hotel Ritz were an eighty-year-old Coco Chanel and, on the odd occasions still, the aging Duke and Duchess of Windsor or their friend in the postwar years, an increasingly pain-ridden and drug-addled Marlene Dietrich. Mostly, the Windsors kept to their villa on the edge of the Bois de Boulogne, and the film star kept to her apartment across town on avenue Montaigne. Claude Auzello knew where Marlene Dietrich lived because he and Blanche had an apartment nearby, and they were soon looking at leaving the Ritz themselves. He could never forgive Charley Ritz for this greatest of changes especially. And the reason was simple: Claude Auzello was being pushed out of his position as the managing director, a job that had been his life and his passion since 1925. He had guarded the reputation of the Hôtel Ritz and, at moments, had gone to heroic lengths

to keep up its trademark standard of service, under the most unusual and trying of circumstances. But now his time at the legendary palace hotel was closing.

In 1961, Marie-Louise Ritz, too, had died, at ninety-three, in that same room under the mansard roof overlooking the hotel garden where she and César Ritz had started on their bold adventure. Charley Ritz had returned to Paris and, after years of absence and equivocation, had at last taken charge of the family business.

As far as Claude was concerned, Charley had been busy ever since driving it into the ground, and the familiar old quarrels between them had started almost immediately. The two men never saw eye to eye on the fundamentals. Claude hadn't spent the Second World War holding up the old traditions in the face of air raids and food shortages only to allow gentlemen into the dining room now in velour lounge pants and outlandish blazers.

Charley insisted that the world was changing. They needed to keep pace with it. Life was more casual now. Stuffy formality was outdated. The hotel was a business: it was just a matter of practical common sense. Both men agreed that the Ritz was losing its prestige, but they could not agree on why it was happening.

The bottom line, of course, was that Charley Ritz and his family were the owners. And he probably wasn't wrong, either, in his assessment of the ways in which the world was changing. Claude had quarreled and railed with Charley for nearly eight years, knowing full well that the younger man wanted him fired. Claude hadn't minded for himself. He was worn out from waiting on others and ready to retire to a quiet villa in the south of France. It was Blanche who couldn't bear it. She could not leave Paris, she said, as she wept and threatened. She could not leave the Hôtel Ritz—the place that had been her home since those long ago days now in the Années Folles—the crazy years of the 1920s. Claude knew that leaving would break her.

For Blanche, things had been precarious for a long time. After the war had come a new kind of madness. She never recovered from those months in a Gestapo prison during the occupation or from the years of terror, living as the Jewish-born wife of the hotel's managing director. Like Dietrich and Hemingway, she turned to alcohol to numb the pain. Now she was having blackouts even in the hotel lobby. While Claude had been able to keep them at the Hôtel Ritz, it was all just about manageable. Then, in April, came word that it was time for Claude Auzello to retire. He would not be getting a new contract as the managing director.

It had been a month of anguish. They had fought the war here, even if no one had ever heard the sounds of the cannons. But now Claude was tired of fighting. He had finally made his decision.

Hidden away carefully, in some desk drawer or perhaps in one of the closets that had been César Ritz's innovation, he kept a dark memento: a German gun taken from a nameless soldier during the occupation.

The night of May 28, 1969, Claude Auzello was sleepless. The sounds of traffic had died away, and only the thinnest crescent of the new moon broke the darkness. Perhaps he thought back in those quiet hours to Hermann Göring and Arletty. Sacha Guitry and Jean Cocteau, Scott Fitzgerald and Papa. Pierre Laval and Georges Mandel. Laura Mae Corrigan's emeralds and Elsa Maxwell's parties. The stories of Marcel Proust and Escoffier and his divine Sarah. Or perhaps his thoughts simply turned to the long-ago afternoon in the 1920s when he took Blanche Rubenstein to tea at the Hôtel Ritz for their first date and told her, sitting in the garden, of his dream of being its manager.

Just as light began to show on the horizon of a perfect springtime Paris morning, Claude surely turned to watch Blanche for a moment. Then he placed the gun to her hairline and pulled the trigger.

While Claude waited and considered, the sun rose over the capital. To the north rested the gleaming tower of Sacre Coeur, high on Montmartre. To the south was the Eiffel Tower. Between them, the water of the Seine flowed as slowly and inexorably as ever, past the heart of France, as it had done for millennia. The Place Vendôme was just stirring. As he brought the gun slowly upward, drowsy neighbors heard a second pop, like the sound of a tire exploding somewhere not far off in the distance.

Afterword

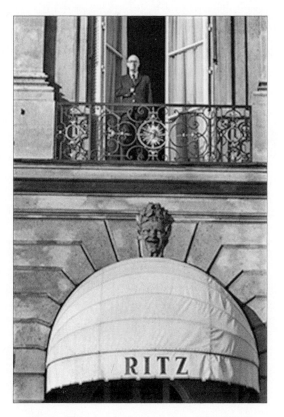

Charley Ritz, on the balcony of the Hôtel Ritz.

TIME PASSES, AND LITTLE BY LITTLE EVERYTHING THAT WE HAVE
SPOKEN IN FALSEHOOD BECOMES TRUE.

—*Marcel Proust*

By the 1970s, it was no longer possible to ignore the fact that the Hôtel Ritz was failing. Its legend was waning, and profits were disappearing with it. Charley Ritz struggled to keep the palace hotel afloat, until his own death in 1976. Ultimately, looming bankruptcy made its sale inevitable. In 1979, the lease of the Hôtel Ritz went up for bidding. Salvation came from an unlikely quarter.

A fifty-nine-year-old Egyptian-born business mogul named Mohamed Al Fayed had once visited the palace hotel as a boy and had vowed that someday he would own it. Mohamed Al Fayed purchased the Hôtel Ritz that year for the now unimaginably modest sum of $20 million. A year later, he embarked, with a team of innovative new talent, on a stunning nine-year wing-to-wing renovation. They stinted on nothing. The price tag for the remodeling averaged more than $1 million per room in the palace.

Completed in 1987, those renovations transformed the Ritz into a freshly modern hotel and restored its fortunes. As the world knows, a new celebrity following flocked again to its corridors. That, of course, was why on a late-summer night in 1997 a royal British divorcée and Mohamed Al Fayed's son slipped from a back doorway on rue Cambon to flee the pursuing paparazzi.

While the Hôtel Ritz was once again among the most luxurious and splendid establishments in the capital during the 1990s, Charles de Gaulle never realized his dream of returning Paris to the center stage of world attention. But politicians and entrepreneurs and undoubtedly a few double agents have since haggled over cocktails in the rue Cambon bar and in the suites where Laura Mae Corrigan and Hermann Göring once lounged in their pajamas.

By 1991, it was the town of Maastricht, in the Netherlands, that dominated world conversation. There, the six countries of France, West Germany, Belgium, Italy, Luxembourg, and the Netherlands, joined by Denmark, Greece, Spain, Portugal, Ireland, and, at last, the United Kingdom, met and extended the principles of integration established in the postwar treaties of the 1950s and ultimately created a common currency and the European Union.

It was the long-delayed conclusion of those talks that began at the roundtable lunches at the Hôtel Ritz during the occupation. Even more immediately, it was the conclusion of Charles de Gaulle's wish for a united Europe that would rival the alliances of Anglo-Americans during an era of Cold War superpowers. And that has led some to wonder if, at the core of the agreement, bitter quarrels dating back to the 1930s and 1940s weren't also unwittingly ratified. After decades of pointed exclusion from the European Economic Community and wary of the French turn toward Germany as its core economic partner, Great Britain at last did negotiate a special kind of separate peace with its continental neighbors and declined to integrate fully with the common currency. A unified postcommunist Germany threw itself into an industrial revival and France into the business of luxury. Switzerland remains, as ever, quietly and watchfully neutral.

For a time, a new world order seemed on the horizon. Old fault lines are once again showing. Great Britain awaits another referendum on the future of a European community sometime before 2020. France and Germany tussle again publicly over economic and cultural superiority. The world that survived that second great war of the twentieth century is once again in flux. Another *époque* is perhaps emerging.

And on the Place Vendôme, for the third time in its 115-year history, the Hôtel Ritz is reopening, this time after another cutting-edge, $164 million renovation. Perhaps for a

second time, it will bring a new generation of global expatri-
ates back to the always beautiful city of Paris. Perhaps for a
second time, it will be the Hôtel Ritz where France and the
world are remade again as all that is freshly modern.

ACKNOWLEDGMENTS

Researching and writing about the occupation of Paris, I have discovered, requires historical sleuthing of the first order, and along the way many people with far greater experience and expertise than I have reached out to share information, leads, memories, and archival materials. My first and abiding thanks must go to those, especially in Berlin and Paris, who asked to remain anonymous but who spoke with me candidly and movingly about their recollections and knowledge.

I would also like to thank for their correspondence, assistance (great and small), materials, editorial comments, and conversation along the way Raffael Scheck, Alan Marty, Xavier Demange, Robert Paxton, Kenneth Marx, Richard Marx, Rosanna Warren, Sylvia Crouter, Alan Riding, Andy Tolan, Don and Selma Wilson, Anne Dubonnet Shaio, Jacqueline de Chollet, Angela Cotterell, Richard Wendorf, Henry Woodrum Jr., Connie Lowenthal, John Beichman, Francis de Marneffe, Gerry Mannion, the archivists and librarians at the Jewish History Center in Paris, the library of the French Prefecture of Police in Paris, the library of the History of the City of Paris, the national archives in Paris, London, Berlin, and Washington, D.C., the Commission for Art Recovery in New York City, the Foreign Office archives in Berlin, the John F. Kennedy Presidential Library in Boston, the Paul Rosenberg Archives at the Museum of Modern Art in New York City,

the Huntington Library in San Marino, California, and, especially, the New York Public Library, where significant parts of this book were written. All errors are entirely my own.

I have been supported with time and space by a number of institutions, and I would like to thank especially the Brown Foundation at the Houston Museum of Fine Art for its generous support as a fellow at the Dora Maar House in Ménerbes, France; the Clara C. Piper endowment at Colby College; and the Jenny McKean Moore Foundation for its support as a writer-in-residence at George Washington University.

Barbara Klingenspor did preliminary work, unpublished here, on some German translations; my thanks to Rob Madole for his research assistance in Berlin and for all otherwise unattributed translations from the German included in the book. Bradley Hart was a superb research assistant in Britain, and I thank him for his work at the National Archives and in the Churchill Archives at the University of Cambridge once again.

In the course of this book, I have had the pleasure to work at HarperCollins with no fewer than four editors—and each came along at just the right moment to shape the project in the best possible direction; my thanks to Matt Inman, Jason Sack, Julia Cheiffetz, and Gail Winston. The constant, of course, has been my could-not-be-more-fabulous literary agent Stacey Glick; thanks also to my film agent, Lou Pitt, for forward-looking wisdom.

Among the personal acknowledgments, Eric Bryant and Charlene Mazzeo provided perceptive comments on early chapters of the book. Mark Lee was, as always, the most generous of fellow writers. Noelle Baker, Bill Hare, and Nish Gera were, as always, the most generous of friends. In Berlin, thanks to Ursula Vogel and especially to Axel Witte, at whose table this book first took shape; in New York City, my thanks to Mark Anderson, and my love and immense gratitude to Emmanuel Gradoux-Matt, to whom this book is dedicated, for his

comments on draft versions of the manuscript, for countless conversations, and for protecting a shared vision of art and true kinship amid all the tumult. Finally—first and last and always—thank you to my much-loved husband, Robert Miles, for believing in narrative arcs and for trusting in a happy end to long stories in all their different media.

NOTES

1: This Switzerland in Paris

9 "It would be foolish to disguise": Winston Churchill Centre and Museum, Churchill War Rooms, London, online archive, www.winstonchurchill.org/learn/speeches/speeches-of-winston-churchill/91-be-ye-men-of-valour.

9 on May 31, 1940, Winston Churchill: Roy Jenkins, *Churchill* (New York: Plume, 2002), 571ff.

9 "the only reason not to stay at the Ritz": A. E. Hotchner, "The Ritz, Then and Now," *New York Times*, January 31, 1982, www.nytimes.com/1982/01/31/travel/the-ritz-then-and-now.html?pagewanted=all; also Carlos Baker, *Ernest Hemingway: A Life Story* (New York: Scribner, 1969).

9 Georges Mandel, the Jewish-born French minister of the interior: John M. Sherwood, *Georges Mandel and the Third Republic* (Stanford: Stanford University Press, 1970); Francisque Varenne, *Georges Mandel, Mon Patron* (Paris: Éditions Défense de la France, 1947); and Paul Coblentz, *Georges Mandel* (Paris: Éditions du Bélier, 1946).

9 darkened rooms on the fourth floor: Claude Roulet, *Ritz: une histoire plus belle que la légende* (Paris: Quai Voltaire, 1998), 81ff.

10 The railway system ground to a halt: Hanna Diamond, *Fleeing Hitler: France 1940* (Oxford: Oxford University Press, 2008), 5.

10 In the mass exodus that followed: Ibid., xiv. For firsthand accounts of the *exode*, see, for example, Francis de Marneffe, *Last Boat from Bordeaux* (Cambridge, MA: Coolidge Hill Press, 2001); my thanks to Dr. de Marneffe for personal conversations in 2011 and 2012 that contributed to the background of this book.

10 Claude Auzello, had been called up: There are a few early histories of the Hôtel Ritz in Paris, and I am indebted to all of them for some materials in this book, here and throughout the narrative. These books include: Claude Roulet, *The Ritz: A Story That Outshines the Legend*, trans. Ann Frater (Paris: Quai Voltaire, 1998); Marie-Louise Ritz, *César Ritz* (Paris: Éditions Jules

Tallandier, 1948); Stephen Watts, *The Ritz* (London: Bodley Head, 1963); and Mark Boxer, *Le Ritz de Paris* (London Thames & Hudson, 1991).

11 "we are down to thirty-six masters and seven servants": Roulet, *The Ritz*, 106.

11 "Unfortunately": Ibid.

11 the wartime staff would stabilize at around twenty: National Archives in Paris, F7 14886, "Affaires Allemands," item 533; Foreign Office in Berlin confirm the Swiss nationality of Hans Elminger (Paris 2463 [42]: "Ritz-Hotel, deutschfeindliches Verhalten des leitenden Personals," 1943).

11 At Coco Chanel's table: Justine Picardie, *Coco Chanel: The Legend and the Life* (London: It! Books, 2011); groundbreaking early archival research appeared in Axel Madsen, *Chanel: A Woman of Her Own* (New York: Holt, 1991). For information on other figures mentioned here, see Nöelle Giret, *Sacha Guitry* (Paris: Éditions Gallimard, 2007); Sacha Guitry, *If Memory Serves: Memoirs of Sacha Guitry*, trans. Lewis Galantière (Whitefish, MT: Kessinger, 2009); Francis Steegmuller, *Cocteau: A Biography* (New York: David R. Godine, 1992); Claude Arnaud, *Jean Cocteau* (Paris: Éditions Gallimard, 2003); *The Journals of Jean Cocteau*, ed. and trans. Wallace Fowlie (Bloomington: Indiana University Press, 1964).

12 Béatrice Bretty made history: Denis Demonpion, *Arletty* (Paris: Flammarion, 1996), 196.

12 Spanish painter Pablo Picasso . . . the surrealist artist Dora Maar . . . Lee Miller: See Anne Baldassari, *Picasso: Life with Dora Maar, Love and War, 1935–1945* (Paris: Flammarion, 2006); Mary Ann Caws, *Picasso's Weeping Woman: The Life and Art of Dora Maar* (New York: Bulfinch Press, 2000); Françoise Gilot, *Life with Picasso* (New York: Virago Press, 1990); Marina Picasso, *Picasso* (New York: Vintage, 2002); Arianna Stassinopoulos Huffington, *Picasso* (New York: HarperCollins, 1996); Carolyn Burke, *Lee Miller: A Life* (Chicago: University of Chicago Press, 2007).

12 Duke and Duchess of Windsor gave up their extravagant: Charles Hingham, *The Duchess of Windsor: The Secret Life* (New York: Wiley, 2004); and Michael Bloch, *The Duke of Windsor's War: From Europe to the Bahamas, 1939–1945* (London: Weidenfeld & Nicholson, 1982).

12 her maids, sisters Germaine and Jeanne: Roulet, *The Ritz*, 109.

13 A nine-year-old girl named Anne Dubonnet: Anne Dubonnet Shiao, personal interview, April 2013, New York City.

13 "It is because I am a Jew that I won't go": Sherwood, *Georges Mandel and the Third Republic*, 255.

13 "small, steep country, much more up and down than sideways": Ernest Hemingway, "The Hotels in Switzerland: Queer Mixture of Aristocrats, Profiteers, Sheep, and Wolves at the Hotels in Switzerland," *Toronto Star Weekly*, March 4, 1922. Ernest Hemingway's writings for the *Toronto Star* are collected in *Dateline, Toronto*, ed. William White (New York: Scribner's, 1985).

14 "you will never get it back, Madame Ritz": Samuel Marx, *Queen of the Ritz* (New York: Bobbs-Merrill, 1978), 134; various details on the lives of

Blanche and Claude Auzello are drawn from this recollection written by Blanche Auzello's nephew.

14 "You are Swiss": Roulet, *The Ritz*, 107.

14 "thousands upon thousands": *Times,* June 12, 1940, quoted in Diamond, *Fleeing Hitler,* jacket material.

15 Otto von Hapsburg: Gordon Brook-Shepherd, *Uncrowned Emperor: The Life and Times of Otto von Hapsburg* (New York: Continuum, 2007).

15 "incredibly macabre": "Remembrance: It Was Incredibly Macabre," *Time,* September 4, 1989.

15 "I have passed": Louis P. Lochner, "Germans Marched Into a Dead Paris: Muddy Uniforms at the Ritz," *Life,* July 8, 1940, 22, 74.

15 "Paris' famed galaxy": Lochner, "Germans Marched Into a Dead Paris," 22.

16 German lieutenant colonel Hans Speidel: Jean-Pierre Levert, Thomas Gomart, and Alexis Merville, *Paris: Carrefour des résistances* (Paris: Paris Musées, 1994), 19.

16 "vain manager": Lochner, "Germans Marched Into a Dead Paris," 74.

16 "As if by magic": Ibid.

17 other elite hotel establishments: For numerous details on locations and building histories in Paris during the Nazi period, my thanks to Dr. Alan T. Marty, who shared in manuscript his "Index of Names and Locations in Occupied Paris" and his "A Walking Guide to Occupied Paris: The Germans and Their Collaborators."

17 When Marie-Louise Ritz had expanded the hotel: Watts, *The Ritz*, 21.

18 "Hôtel Ritz": Roulet, *The Ritz*, 107; Levert, Gomart, and Merville, *Paris: Carrefour des résistances*, 17.

18 The Place Vendôme side: Ibid., 17.

18 "In the entry of the Hôtel Ritz": Ibid.

18 the Germans would take a 90 percent discount: On what the Germans paid at the Hôtel Ritz, see Watts, *The Ritz*, 119; Levert, Gomart, and Merville, *Paris: Carrefour des résistances*, 17; Marx, *Queen of the Ritz*, 148.

18 Hans Elminger explained: Roulet, *The Ritz*, 110.

19 So, too, did the young Anne Dubonnet and her parents: Anne Dubonnet Shiao, personal interview, April 2013.

19 "Champagne flowed, and the German officers": Hal Vaughn, *Sleeping with the Enemy: Coco Chanel's Secret War* (New York: Knopf, 2011), 138.

19 "The occupiers": Roulet, *The Ritz*, 114.

20 Hans Elminger could report: Ibid., 110.

20 "You didn't hear cannons": Marx, *Queen of the Ritz*, 133.

2: All the Talk of Paris

25 tome on the disease, called neurasthenia: William C. Carter, *Marcel Proust: A Life* (New Haven: Yale University Press, 2002), 221.

25 the other symptoms of his newfangled disease: Ibid.

26 "little flatterer" and "a vulgar little creature": Edmund White, *Proust* (New York: Viking, 1999), excerpted at www.nytimes.com/books/first/w/white-

proust.html; *Letters of Marcel Proust*, trans. Mina Curtiss (New York: Random House, 1949), 41.

26 "Everyone is talking about the Ritz": Ken James, *Escoffier: The King of Chefs* (London: Hambledon Continuum, 2003), 75.

28 "divine Sarah" was Auguste Escoffier's great consuming passion: Ibid., 75, 144–45.

30 "I have no choice of opinions": *Letters of Marcel Proust*, 54; letter dated February 1898.

31 "madwoman of the place Vendôme": Scot D. Ryersson and Michael Orlando Yaccarino, in *Infinite Variety: The Life and Legend of the Marchesa Casati* (Minneapolis: University of Minnesota Press, 2004), 22, note that she lived at no. 26. However, more reliable evidence indicates that by this date she had moved nearby to an address on rue Cambon. My thanks to Xavier Demange, coauthor of the New York Metropolitan Museum catalog *La Divine Comtesse: Photographs of the Countess de Castiglione* (New Haven: Yale University Press, 2000), for this archival information.

34 in every room a small bronze clock: Craig Clairborne, "The Ritz: Fifty Years After Proust, It's Still a Civilized Refuge," *New York Times*, December 26, 1968, 45.

34 "A harsh and ugly light": Quoted in A. E. Hotchner, "As the Ritz Shutters, Remembering its Mysteries: A Legend as Big as the Ritz," *Vanity Fair*, July 2012, www.vanityfair.com/society/2012/07/paris-ritz-history-france.

34 "Some of its side rooms look out": Elizabeth Otis Williams, *Sojourning, Shopping, and Studying in Paris: A Handbook Particularly for Women* (Chicago: McClurg, 1907).

36 "when one goes by the name": Marcel Proust, *The Guermantes Way, Remembrance of Things Past* (*À la recherche du temps perdu*, 1913–27), trans. C. K. Scott Moncrieff, 6 vols., vol. 3 (New York: Henry Holt, 1922), www.gutenberg.org/ebooks/7178.

37 "[H]e who has taken the side of Dreyfus": Ibid.

3: Dogfight above the Place Vendôme

40 Hélène Chrissoveloni Soutzo: Carter, *Marcel Proust*, 632.

40 "The writer had studied her black wrap and ermine muff": Nash Rambler, "Proust's Last Infatuation: Hélène Chrissoveloni, Princesse Soutzo, Madame Morand," Esoterica Curiosa, http://theesotericcuriosa.blogspot.com/2010/01/prousts-last-infatuation-helene.html.

42 "the only woman": Ibid.

42 "thirty years' captivity": Carter, *Marcel Proust*, 634.

43 dressed only in furs to walk her pet cheetahs: John Richardson, *Life of Picasso: The Triumphant Years, 1917–1932* (New York: Knopf, 2010), 29–46, details here and following.

45 "I found the Marquise Casati screaming hysterically": Ryersson and Yaccarino, *Infinite Variety*, 84; 81–84.

46 Franz Mesmer: Ibid., 33.

47 "We watched": Carter, *Marcel Proust*, 643ff.

48 "Just as the voice of a ventriloquist": White, *Proust*, www.nytimes.com/books/first/w/white-proust.html?

48 "If we are to make reality endurable": Marcel Proust, *Within a Budding Grove*, in *Remembrance of Things Past* (*À la recherche du temps perdu*, 1913–27), trans. C. K. Scott Moncrieff, 6 vols., vol. 2 (New York: Henry Holt, 1922), www.gutenberg.org/ebooks/7178, pt. 1.

4: Diamonds as Big as the Ritz

50 It wasn't just that the German Luftwaffe commander enjoyed: David Irving, *Göring: A Biography* (New York: William Morrow, 1989), 296.

51 "submerge Göring in a tub of water, give him injections": Hotchner, "A Legend as Big as the Ritz," *Vanity Fair*, July 2012, www.vanityfair.com/society/2012/07/paris-ritz-history-france.

51 Mrs. Corrigan could afford: All figures calculated from "Measuring Worth," www.measuringworth.com/uscompare/relativevalue.php.

52 she and Jimmy Corrigan dismayed: Lucius Beebe, *The Big Spenders: The Epic Story of the Rich Rich, the Grandees of America and the Magnificoes, and How They Spent Their Fortunes* (Mount Jackson, VA: Axios Press, 2009), 269; Alan Dutka and Dan Ruminski, *Cleveland in the Gilded Age: A Stroll Down Millionaires' Row* (Stroud, UK: History Press, 2012), 89.

52 "Laura Corrigan who established a formidable handicap": Elsa Maxwell, *Art of the Hostess*, quoted in Ted Schwarz, *Cleveland Curiosities: Eliot Ness and His Blundering Raid, a Busker's Promise, the Richest Heiress Who Never Lived and More* (Stroud, UK: History Press, 2010), 118.

53 "did land-office business": Marx, *Queen of the Ritz*, 117.

53 "generally considered at the time": Beebe, *The Big Spenders*, 271.

53 "was not beautiful, she was not educated or particularly clever": Elsa Maxwell, *Art of the Hostess*, quoted in Schwarz, 120.

54 Bienvenue au Soldat: Brian Masters, *Great Hostesses* (London: Constable, 1982), 232–33.

55 Dietrich had ended a liaison with Joseph Kennedy there: Sam Staggs, *Inventing Elsa Maxwell: How an Irrepressible Nobody Conquered High Society, Hollywood, the Press, and the World* (New York: St. Martin's Press, 2012), Kindle location 3544.

55 The socialite Clare Boothe Luce: Cari Beauchamp, *Joseph P. Kennedy Presents: His Hollywood Years* (New York: Knopf, 2009), 366; see also Sylvia Morris, *Rage for Fame: The Ascent of Clare Boothe Luce* (New York: Random House, 1997).

55 Florence Jay Gould was insisting: Details from Jenkins, *Churchill*, 589; and Roulet, *The Ritz*, 106. See also Cyril Eder, *Les Comtesses de la Gestapo* (Paris: Bernard Grasset, 2006).

56 Wartime dinner guests: Marty, unpublished manuscript, citing Martin Allen, *Hidden Agenda: How the Duke of Windsor Betrayed the Allies* (London: Macmillan, 2000), 296; the dinner took place on October 24, 1940.

56 "I can't say I feel sorry for them": Charles Hingham, *Trading with the Enemy: The Nazi-American Money Plot 1933–1949* (New York: Barnes & Noble Books, 1995), 313.

56 "looked after by a German caretaker and handed back in 1944": David Pryce-Jones, *Paris in the Third Reich: A History of the German Occupation, 1940–1944* (New York: Holt, Rinehart, Winston, 1981), 8. Many of the details here and below are drawn in part from Dr. Alan Marty's unpublished manuscript, "A Walking Guide to Occupied Paris"; my thanks to the author for his generosity in sharing his extensive research and for his suggestions throughout.

56 still sent her seventeen carnations each morning: Michael Bloch, *Ribbentrop: A Biography* (New York: Crown, 1993), 355. FBI files related to this matter and corroborating suspicions were published in British newspapers in 2002; see, for example, "Royal Affair: The Duchess and the Nazi," *Scotsman*, June 29, 2002, www.scotsman.com/news/uk/royal_affair_the_duchess _and_the_nazi_1_610744.

56 she had been friendly with the Duke of Windsor: "Prince of Wales Enables Former Waitress to Laugh at Scoffers," *Boston Globe*, August 2, 1931, B5.

57 "With a carload of detectives following": Irving, *Göring*, 302.

58 Laura Mae Corrigan's furs: Masters, *Great Hostesses*, 234–35.

58 "lavish gowns trimmed in ermine and mink": Hotchner, "A Legend as Big as the Ritz."

59 "Göring talked of little else but the jewels": Hugh Gibson, *The Ciano Diaries 1939–1943: The Complete, Unabridged Diaries of Count Galeazzo Ciano, Italian Minister of Foreign Affairs, 1936–1943* (New York: Doubleday, 1946), entry of February 2, 1942, 443.

59 Even the German soldiers on sentry: Boxer, *Le Ritz de Paris*, 101.

59 sold a gold dressing case to Adolf Hitler: Masters, *Great Hostesses*, 234–35.

59 Laura Mae Corrigan began funneling: Mary Van Rensselaer Thayer, "Fabulous Era Ended with Laura Corrigan," *Washington Post*, January 27, 1948, B3; "Sells Furs to Aid French: U.S. Woman, Unable to Get Funds, Plans to Leave Vichy," *New York Times*, September 26, 1942, 4.

60 "American Angel": "Sells Furs to Aid French," 4.

60 "Mrs. Corrigan had the distinction": Masters, *Great Hostesses*, 234–35.

60 Laura Mae would also spend time as a prisoner: Ibid., 236; Jewish History Center, Paris, archives 411 AP/5.

60 awarded her the King's Medal: "American Relief Worker Leaves Vichy," *Los Angeles Times*, November 4, 1942, 15.

60 "she was not beautiful, she was not educated or particularly clever": Elsa Maxwell, *Art of the Hostess*, quoted in Schwarz, *Cleveland Curiosities*, 120.

5: The Americans Drifting to Paris

61 "When I dream of an afterlife": Hotchner, "A Legend as Big as the Ritz."

62 "the best of America drifts to Paris": Quoted in interview by Harry Salpeter, "Fitzgerald, Spenglerian," *New York World*, April 3, 1927, 12M;

F. Scott Fitzgerald, "A Diamond as Big as the Ritz," *Tales of the Jazz Age* (New York: Soho Books, 2011).

62 reported that Hemingway had perished: Jeffrey Meyers, *Hemingway: A Biography* (New York, Da Capo Press, 1999), 541.

63 "was a sore sight for sore eyes": Details from Alex Kershaw, *Blood and Champagne: The Life and Times of Robert Capa* (New York: Da Capo, 2002), 119.

63 "Papa's got troubles": Ibid., 118; Capa, *Slightly Out of Focus* (New York: Random House, 1999), 128–29.

63 "ten-gallon glass jug": Capa, *Slightly Out of Focus*, 129.

64 "There, on an operating table": Ibid.

64 As a fellow war correspondent: Mary Welsh, *How It Was* (New York: Ballantine, 1977), 93.

64 Allied war correspondents: Capa, *Slightly Out of Focus*, 20.

65 "God bless the machine": Welsh, *How It Was*, 93–94.

65 "Nice sweater": Ibid.

65 "Introduce me to your friend, Shaw": Bernice Kert, *Hemingway's Women* (New York: Norton, 1998), 393.

65 "the only thing that ever really frightened me": Details from "Battle of the Atlantic, January 1942–May 1945," World War II Multimedia Database, http://worldwar2database.com/html/atlantic43_45.htm/page/0/1.

66 "for Christ's sake don't run into me": Caroline Moorehead, *Martha Gellhorn: A Life* (New York: Vintage, 2004), 254.

66 "Oh no, I couldn't do that": Kert, *Hemingway's Women*, 392.

66 "The way it looks": Moorehead, *Martha Gellhorn*, 253.

67 Hemingway was already back to partying: Ibid., 256.

67 Ernest's "mock-heroics" only got her laughing: John Walsh, "Being Ernest: John Walsh Unravels the Mystery Behind Hemingway's Suicide," *Independent*, August 9, 2012, www.independent.co.uk/news/people/profiles/being-ernest-john-walsh-unravels-the-mystery-behind-hemingways-suicide-2294619.html.

67 "[i]f he really had a concussion": Kert, *Hemingway's Women*, 398.

67 bouncing into his room afterward: Welsh, *How It Was*, 98.

68 "I don't know you": Ibid., 94.

68 "This war may keep us apart for a while": Ibid.

69 Sylvia Beach, the American owner: Noel Riley Fitch, *Sylvia Beach and the Lost Generation: A History of Literary Paris in the 1930s* (New York: Norton, 1985), 384.

69 Scott Fitzgerald tried his charms: Hotchner, "A Legend as Big as the Ritz," 141.

69 "Afterwards, I always referred": Quoted in Hotchner, "The Ritz, Then and Now."

70 "the most critical person I ever knew": Watts, *The Ritz*, 128.

70 that the ladies could drink in the hotel bars: Marx, *Queen of the Ritz*, 94–95.

70 Charley Ritz and Claude Auzello were left to bicker: Ibid., 197, 89.

70 he promised, he'd even make her a character: Ibid., 97; my thanks also to

Blanche Auzello's descendants, Kenneth S. Marx, of Jacksonville, Florida, and Richard Marx, of Los Angeles, for personal communications.

70 Ernest Hemingway saw the D-Day invasion: Ernest Hemingway, "Voyage to Victory: Collier's Correspondent Rides in the War Ferry to France," *Collier's Weekly*, July 22, 1944, 11–13, www.unz.org/Pub/Colliers–1944jul22–00011?View=PDF.

71 "sounded as though they were throwing": Stephen E. Ambrose, *D-Day, June 6, 1944: The Climactic Battle of World War II* (New York: Simon & Schuster, 1994), 9.

71 "If your pictures aren't good enough": Quoted in Maryann Bird, "Robert Capa: In Focus," *Time*, June 30, 2002, www.time.com/time/magazine/article/0,9171,267730,00.html.

71 "The war correspondent has his stake": Capa, *Slightly Out of Focus*, 137.

71 "It didn't matter whether you won or lost": Ibid., 122.

72 "I was thinking a little bit of everything": Ibid., 139.

72 "Fight to get your troops ashore": Ibid., 123.

72 "the flat bottom of our boat hit": Ibid.

72 his rolls of films protected from the damp: Ibid., 120.

72 He took 106 photographs of the combat: Ibid., 140, 125.

72 "This is my last chance to return to the beach": Ibid., 149.

73 back on the beaches by the next morning: Ibid., 128, 132.

73 "9.46 or so": Moorehead, *Martha Gellhorn*, 257; also Martha Gellhorn, *Travels with Myself and Another: A Memoir* (New York: Tarcher, 2001).

73 "Pulling out of the harbor that night": Martha Gellhorn, "The Wounded Come Home: Under the Sign of the Red Cross, the White Ship Returns to London with its Precious Freight," *Collier's Weekly*, August 5, 1944, 14–15, www.unz.org/Pub/Colliers-1944aug05-00014.

73 "Badly spooked": Moorehead, *Martha Gellhorn*, 258.

6: The French Actress and Her Nazi Lover

75 "It's tough, collaboration is": Vaughn, *Sleeping with the Enemy*, 157.

76 Jean-Paul Sartre was in Paris: Alan Riding, *And the Show Went On: Cultural Life in Nazi-Occupied Paris* (New York, Knopf, 2010), 336.

77 "an enormous success": Arletty, *La Défense* (1971; reprint, Paris: La Ramsay, 2007), 337.

77 The lovers enjoyed long lunches: Ibid., 134.

77 They were often seen around the capital: Ibid., 91.

77 nothing more than a "Gauloise": Demonpion, *Arletty*, 196.

78 courageous resistant Drue Tartière: Drue Tartière, *The House Near Paris: An American Woman's Story of Traffic in Patriots* (New York: Simon & Schuster, 1946), 255.

78 "food is power": Antony Beevor, "An Ugly Carnival: How Thousands of French Women Were Treated after D-Day," *Guardian*, June 4, 2009, www.guardian.co.uk/lifeandstyle/2009/jun/05/women-victims-d-day-landings-second-world-war.

79 "who loved to take hostages and kill them": Tartière, *The House Near Paris* 81; this is Otto von Stülpnagel, not his cousin Carl-Heinrich, who later held the same post. The name of the Dutch provocateur is not detailed in her memoir.

79 Josée de Chambrun, the aristocratic daughter: Ibid., 235.

79 Her movie-star salary that spring: Jean-Pierre Rioux, "Survivre," in *Résistants et collaborateurs*, ed. François Bédarida (Paris: Seuil, 1985), 84–100, 90.

79 steady air raid alerts in the city: Demonpion, *Arletty*, 260.

79 Noël Coward: Dick Richards, *The Wit of Noël Coward* (London: Sphere Books, 1970), 105.

80 "Paris decrees, France follow": Demonpion, *Arletty*, 264.

80 "a gangster": Andrew Roberts, review of Antony Beevor, *D-Day: The Battle for Normandy*, *Telegraph*, May 24, 2009, www.telegraph.co.uk/culture/books/bookreviews/5360866/D-Day-The-Battle-for-Normandy-by-Antony-Beevor-review.html.

80 the organized resistance would swell: As Robert Paxton has noted, "the résistance even at its peak . . . was never more than a slim 2% of the adult French population" (approximately 400,000 people). Robert Paxton, *Vichy France: Old Guard and New Order, 1940–1944*, rev. ed. (New York: Columbia University Press, 2001), 294. He continues: "there were, no doubt, wider complicities, but even if one adds those willing to read underground newspapers, only some two million persons, or around 10% of the adult population."

81 "[t]he first German official I met": Demonpion, *Arletty*, 262. Sacha Guitry, *Quatre ans d'occupation* (Paris: Éditions L'Elan, 1947); Gerhard Heller, *Un Allemand à Paris, 1940–1944* (Paris: Éditions de Seuil, 1981).

81 offered to arrange for her to go to Switzerland: Jérôme Dupuis, "Le beau nazi d'Arletty," *L'Express*, October 2, 2008, www.lexpress.fr/culture/livre/le-beau-nazi-d-arletty_823070.html.

82 "With camp sleeping pills": Sherwood, *Georges Mandel and the Third Republic*, 286.

82 The orders had come from Ministry of Justice offices: Details here and throughout this chapter drawn especially from Bertrand Favreau, *Georges Mandel, ou, La passion de la République 1885–1944* (Paris: Édition Fayard, 1996).

83 the British prime minister could be heard: Sherwood, *Georges Mandel and the Third Republic*, 261.

83 "We regret that the Jew Mandel": Ibid., 290.

83 "You are to go immediately to the German embassy": The historical record on this chain of information is contested; other versions report that Laval heard from Fernand de Brinon on July 8 and then summoned Joseph Darnand, who denied knowledge and referred him to Max Knipping. For Pierre Laval's perspective on the death of Mandel and his wartime activities in general, often mediated through his daughter, see Yves Pourcher,

Pierre Laval vu par sa fille (Paris: Cherche Midi, 2002); and Pierre Laval, *The Diary of Pierre Laval* (New York: Scribner's, 1948).

84 "the trustee in bankruptcy": J. Kenneth Brody, *The Trial of Pierre Laval: Defining Treason, Collaboration and Patriotism in World War II France* (Piscataway, NJ: Transaction, 2010), 74.

84 decrying his "policy of 'neutrality'" and demanding fuller French support: *The Diary of Pierre Laval, with a Preface by Josée Laval, Countess R. de Chambrun* (New York: Scribner's, 1948), 222.

84 "capable of interceding effectively": Sherwood, *Georges Mandel and the Third Republic*, 294.

85 "Me, leave?": Arletty, *La Défense*, 264.

85 "She was already uneasy": Ibid., 265.

86 "My heart is French, but my ass is international": Modris Eksteins, "When Marianne Met Fritz," *Wall Street Journal*, December 11, 2010, http://online .wsj.com/article/SB10001424052748703377504575650590689790202.html.

86 "What do you think is going to happen?": Demonpion, *Arletty*, 265.

7: The Jewish Bartender and the German Resistance

88 Both general Carl-Heinrich von Stülpnagel: There were two generals von Stülpnagel in residence at the Ritz during the war: Otto von Stülpnagel and later his replacement and cousin Carl von Stülpnagel, who took over as the head military administrator of Paris—the MBF, or Militärbefehlshaber in Frankreich.

89 She was also working with the resistance: Marx, *Queen of the Ritz*, 150–52, 180–84, 158–63, and passim.

89 He had lived at the Hôtel Ritz full-time for several years: Watts, *The Ritz*, 118; Roulet, *The Ritz*, 103, 108.

90 the "Desert Fox," Field Marshal Erwin Rommel: Details on the conspirators and Operation Valkyrie drawn from several sources, here and throughout, including James P. Duffy and Vincent Ricci, *Target Hitler: The Plots to Kill Hitler* (New York: Praeger, 1992); Hans Speidel, *Invasion 1944* (New York: Paperback Library, 1972); Hans Bernd Gisevius, *Valkyrie: An Insider's Account of the Plot to Kill Hitler* (New York: Da Capo Press, 2008); and B. H. Liddell-Hart, *The Rommel Papers* (New York: Da Capo, 1982).

90 Mademoiselle Blanche Rubenstein: Marx, *Queen of the Ritz*, 137; Watts, *The Ritz*, 95.

90 "One of my salesgirls told me": Marx, *Queen of the Ritz*, 142.

90 René de Chambrun: On the history of Coco Chanel's relations with her Jewish business partners, see Bruno Abescat and Yves Stavridès, "Derrière l'Empire Chanel . . . la Fabuleuse Histoire des Wertheimer," *L'Express*, April 7, 2005, 16–30; July 11, 2005, 84–88; July 18, 2005, 82–86; July 25, 2005, 76–80; August 1, 2005, 74–78; August 8, 80–84, part 1, 29. I summarize this history in more detail in Tilar J. Mazzeo, *The Secret of Chanel No. 5: The Intimate Story of the World's Most Famous Perfume* (New York: HarperCollins, 2012).

91 He was still helping forge passports: Foreign Office Archives, Berlin, file Paris 2463 (42), "Ritz-Hotel, deutschfeindliches Verhalten des leitenden Personals, 1943"; see also Marx, *Queen of the Ritz*, 136–37.

91 Greep was also part of the resistance: Marx, *Queen of the Ritz*, 150–52.

91 She liked the ill-timed show of defiance: There are a number of questions surrounding the issue of Blanche Auzello's arrests during the occupation, and some sources suggest that her arrest at Maxim's bistro occurred during the summer of 1943. Most likely, however, she was arrested on more than two occasions, and these multiple arrests account for the confusion in various reports.

91 Some said a tipsy Blanche repeatedly demanded: According to the files in the Foreign Office in Berlin (Paris 2463 [42]), in the summer of 1943 the Germans investigated reports that the kitchen lights at the Hôtel Ritz had not been extinguished during an air raid alert. It seems clear that Blanche Auzello and other members of the hotel staff were interrogated as a result of this security breach. As Allan Mitchell writes, "In spite of regulations for a complete blackout of Paris by night, light was emanating from the Hôtel Ritz onto the Place Vendôme, illuminating the Ministry of Justice on the opposite side of the square. Investigation revealed that the director of the Ritz was married to a Jew, who was arrested one evening at Maxim's for repeatedly demanding that the orchestra play 'God Save the King.'" Allan Mitchell, *Nazi Paris: The History of an Occupation 1940–1941* (New York: Berghahn Books, 2008), 131. However, Blanche Auzello's nephew, Samuel Marx, who met with his aunt after the war, reports that her arrest at Maxim's occurred immediately following the D-Day landings at Normandy, and this does make sense of certain other anecdotal evidence. Thus, it is most likely that two separate events are being conflated. Blanche was also arrested and interrogated on at least one other occasion, as well, after a visit to the apartment of Lily Kharmayeff early in the war. As noted above, some of the confusion stems from the fact that Blanche was arrested during the occupation on at least two occasions. According to files in Berlin, she was arrested for asking for a rendition of "God Save the King" sometime before April 14, 1943, and interned on that occasion for three months (File NR 786/439, "Enemy Espionage in the Hotel Ritz"). The air raid in question took place on or around April 10, 1943.

92 Her nephew later remembered: Marx, *Queen of the Ritz*, 183; Watts, *The Ritz*, 95.

92 Perhaps she and Blanche first met on the set: Blanche starred in two early films with Van Daële and directed by Protazanov during her early years in Paris, and she also knew both Jean Cocteau and the aristocratic Vincent de Noailles (in film financing) from the early 1920s; Marx, *Queen of the Ritz*, 26–30.

92 hid Lily and a wounded communist fighter named Vincenzo: Ibid., 175.

93 It was Marie-Louise Ritz: Ibid., 170.

93 "every damned thing": Watts, *The Ritz*, 81.

93 if she cracked now: Marx, *Queen of the Ritz*, 185; Foreign Office Archives, Berlin, Paris 2463 (42).

93 Both Frank and the hotel's doorman: Foreign Office Archives, Berlin, Paris 2463 (42).

93 "potato": Marx, *Queen of the Ritz*, 149.

93 When his counterpart at the Georges V refused: Ibid., 140–49.

94 And the Austrian-born Frank had been their secret mailbox: Foreign Office Archives, Berlin, Paris 2463 (42).

94 Hauptmann Wiegand, had his quarters: National Archives, London, HS7/139, "Agents and Suspects, Paris."

94 the buxom German socialite named Inga Haag: Jonathan Fryer, "Inga Haag Obituary: German Socialite and Spy Who Conspired to Overthrow Hitler," *Guardian*, January 13, 2010, www.guardian.co.uk/theguardian/2010/jan/13/inga-haag-obituary.

94 came to swill Frank's signature cocktails: Ibid.

95 Pierre André was able to make a dramatic escape: Roulet, *The Ritz*, 118.

95 Frank had passed messages for Inga and her friends: Ibid.; Foreign Office Archives, Berlin, Paris 2463 (42).

95 No one knew precisely what: On the vexed question of Coco Chanel's wartime activities and different perspectives on her relationship with Walter Schellenberg, see Picardie, *Coco Chanel*; Vaughn, *Sleeping with the Enemy*; Walter Schellenberg, *The Labyrinth*, trans. Louis Hagen (New York: Da Capo, 2000).

98 "if the pig were dead": Guido Knopp, *Die Wehrmacht: Eine Bilanz* (München: C. Bertelsmann Verlag, 2007), 251.

99 "Stauffenberg just called": Duffy and Ricci, *Target Hitler*, 191.

100 tell Hitler and Himmler that it was a joint exercise: Ibid., 197.

8: The American Wife and the Swiss Director

104 The young lieutenant colonel's Martin Marauder: Henry C. Woodrum, *Walkout* (n.p.: iUniverse, 2010), 19ff.

104 "tourists were German soldiers": Ibid., 249.

105 "taking their cue from Göring": Irving, *Göring*, 430.

105 What annoyed Hans Elminger: Marx, *Queen of the Ritz*, 193.

105 "One more move in this direction, Göring": Irving, *Göring*, 244.

105 "let's hope it's all over quickly": Ibid., 450.

106 "unofficial 'king' of the Paris art world": "OSS (USS [*sic*] Office of Strategic Services) Art Looting Intelligence Unit (ALIU) Reports, 1945–1946, and ALIU Red Flag Names List and Index," www.lootedart.com/MVI3RM469661_print;Y.

106 "Anyone who sees and paints": Attributed to Dorothy Thompson, January 3, 1944.

107 "the staff having effected": "Post-War Reports: Activity of the *Einsatzstab Reichsleiter Rosenberg* in France: C.I.R. No.1 15 August 1945," Commission for Looted Art in Europe, www.lootedart.com/MN51H4593121.

107 Süss, suggesting the possibility of German-Jewish heritage: Reinhard Hey-
 drich, arguably the most vicious and determinedly anti-Semitic of all the
 elite Nazi leadership, had a family history connected with the name of Süss,
 and he was widely rumored to have a secret Jewish ancestry, in large part on
 this basis of this family name. See Robert Gerwarth, *Hitler's Hangman: The
 Life of Heydrich* (New Haven: Yale University Press, 2011), 61ff.

107 a Swiss citizen, from the city of Brunnen, and worked at the Ritz: Foreign
 Office Archives, Berlin, Paris 2463 [42].

107 "Suess. Paris, Hôtel Ritz": "OSS Red Flag Names List and Index."

108 Operating under the cover name "Colonel Renard": Marty, unpublished
 manuscript, citing Cyril Eder, *Les Comtesses de la Gestapo* (Paris: Bernard
 Grasset, 2006), 54.

108 "fanatic enemy of Germany": Foreign Office Archives, Berlin, Paris 2463
 [42].

108 "urgently suspected": Ibid.

108 "wedged between false ceilings and corridors": Roulet, *The Ritz*, 151.

109 "as far as we could observe": Foreign Office Archives, Berlin, Paris 2463 [42].

109 "one of the most influential": Ibid.

109 Hans von Pfyffer and Marie-Louise Ritz shared: Marx, *Queen of the Ritz*,
 48.

110 "[I]n the interest of the reputation": Foreign Office Archives, Berlin, Paris
 2463 [42].

110 Those on the watch in Paris deeply suspected: Mitchell, *Nazi Paris*, 131.

111 "When women went to the Gestapo headquarters": Steegmuller, *Cocteau*,
 444–45.

111 Those lucky enough to survive: Woodrum, *Walkout*, 156.

111 "I am afraid": "France opens doors of Gestapo's Paris headquarters to public
 for first time," *Taipei Times*, September 19, 2005, www.taipeitimes.com/
 News/world/archives/2005/09/19/2003272328/2; see also the film http://
 www.britishpathe.com/video/gestapo-torture-chamber.

111 "I was sure I'd never get out of there alive": Marx, *Queen of the Ritz*, 187.

112 "Let the damned French take care of her": Ibid., 189.

113 *"Le Boche est fini!"*: Ibid., 194.

113 "I had a hate for Germans": Ibid.,187.

9: *The German General and the Fate of Paris*

115 "Ever since our enemies": "World War II: The Liberation of Paris," *World
 War II*, June 12, 2006, www.historynet.com/world-war-ii-the-liberation-
 of-paris.htm.

117 "destructive measure": Mitchell, *Nazi Paris*, 149.

118 Ambassador Otto Abetz sent: "Dietrich von Choltitz," www.choltitz.de.
 The German-language site is not neutral and is intended as a defense of the
 general during the occupation of Paris and managed by his son; however,
 it provides copies and transcripts of historical materials related to these
 questions. The extent to which General von Choltitz can be credited with

saving Paris from destruction is a subject of historical controversy, and perspectives on it differ significantly in France and in Germany. Von Choltitz and his family claimed after the war that the general defied Adolf Hitler in an act of heroism and ethical rebellion. However, many of those who lived in occupied France during those final weeks in August saw the general as a vicious Nazi, who ordered mass executions, attempted to starve the population of Paris, and disobeyed Hitler only as a calculated effort at self-protection when it became clear that success was impossible. This position is supported, generally, by the archival records and by the firsthand testimony of both Raoul Nordling and Pierre Taittinger; see, for example, Pierre Taittinger, *Et Paris Ne Fut Pas Détruit* (Paris: Temoignages Contemporains Élan, 1948).

119 "not more than 24–48 hours left": "Dietrich von Choltitz," www.choltitz.de.

119 Dietrich von Choltitz moved out: Watts, *The Ritz*, 148; Roulet, *The Ritz*, 121.

120 "If von Choltitz was to deliver the city": Omar Bradley, *A Soldier's Story* (New York: Random House, 1999), 392; Bradley to OCMH, January 7, 1955, OCMH Files.

120 "stumbled reluctantly": Bradley, *A Soldier's Story*, 392.

121 de Gaulle had already made it clear to Philippe Leclerc: General de Gaulle to M. Luizet, 2230, August 23, 1944; see Adrian Dansette, *Histoire de la libération de Paris* (1946; reprint, Paris: Perrin, 1994), 329–30.

121 "To hell with prestige": Bradley, *A Soldier's Story*, 392.

10: The Press Corps and the Race to Paris

123 "I had a funny choke in my throat": Stephen Ambrose, "Citizen Soldiers: The U.S. Army From the Normandy Beaches to the Bulge to the Surrender of Germany," CNN, August 5, 1998, www.cnn.com/books/beginnings /9808/citizen.soldier.

124 "The road to Paris was calling": Kershaw, *Blood and Champagne*, 178.

125 "the best, the nearest in every way": Moorehead, *Martha Gellhorn*, 170.

125 Martha struggling with depression that spring: Ibid., 254.

125 "I was a young freelance photographer": Capa, *Slightly Out of Focus*, 128–29.

125 "was having a good war for a photographer": Ibid., 176–77; Beevor, "An Ugly Carnival," 140.

126 He had a certain lieutenant "Stevie" Stevenson: Capa, *Slightly Out of Focus*, 177.

126 His right-hand man: Michael Taylor, "Liberating France Hemingway's Way: Following Author's 1944 Reclaiming of the Ritz Hotel," *San Francisco Chronicle*, August 22, 2004, www.sfgate.com/travel/article/Liberating-France-Hemingway-s-way-Following-2731590.php#ixzz24qFzKEty.

126 "every weapon imaginable": Kershaw, *Blood and Champagne*, 139.

126 "Hungarian strategy": Ibid.

128 "standing by during his crisis": Capa, *Slightly Out of Focus*, 178.

128 "relations were somewhat strained": Ibid.

128 Charles Wertenbaker as part: Kershaw, *Blood and Champagne*, 141.

128 "My own war aim at this moment": Taylor, "Liberating France Hemingway's Way."

129 "more than 300 members of the press corps": Kershaw, *Blood and Champagne*, 139.

129 "we have had very strange life": Hemingway letters, August 27, 1944, Ernest Hemingway to "Small Friend," manuscript, John F. Kennedy Presidential Library, Boston.

129 Hemingway and his men: See William E. Cote, "Correspondent or Warrior? Hemingway's Murky World War II 'Combat' Experience," *Hemingway Review* 22, no. 1 (Fall 2002).

129 Lieutenant Colonel S. L. A. Marshall and Lieutenant John Westover: See *OSS Against the Reich: The World War Two Diaries of Colonel David K. E. Bruce*, ed. Nelson Douglas Lankford (Kent, OH: Kent State University Press, 1991).

130 "Hey, Jean-Marie": Taylor, "Liberating France Hemingway's Way."

130 As Jean-Marie told a *San Francisco Chronicle* reporter: Ibid.

130 "spitting short sentences": Capa, *Slightly Out of Focus*, 179.

131 "went out to harass the remaining Germans": Ibid., 172.

131 "From beneath the Big Dipper": Kershaw, *Blood and Champagne*, 144.

132 "So, we're in this camp": "The Liberation of Paris, August 1944: A Photographer's Story," *Life*, http://life.time.com/history/paris-liberated-rare-unpublished/#ixzz20hVX4nNZ.

132 "I had bicycled through this area": Stephen E. Ambrose, *Citizen Soldiers: The U.S. Army from the Normandy Beaches, to the Bulge, to the Surrender of Germany* (New York: Simon & Schuster, 2002).

132 "to get into Paris before U.S. troops headed in": "The Liberation of Paris, August 1944: A Photographer's Story," *Life*.

132 "Marshall, for God's sake, have you got a drink?": Taylor, "Liberating France Hemingway's Way."

133 "The old boy": Capa, *Slightly Out of Focus*, 187.

134 In his memoirs, Capa described: Kershaw, *Blood and Champagne*, 144.

134 "The road to Paris was open": Capa, *Slightly Out of Focus*, 187.

134 "the thousands of faces": Ibid.

134 "Bob Capa and I rode into Paris": Kershaw, *Blood and Champagne*, 144.

135 "Around the Chamber of Deputies": Robert Capa: *The Definitive Collection*, ed. Richard Whelan (London, Phaidon Press, 2004).

135 "wanted to spend my first night": Capa, *Slightly Out of Focus*, 188.

135 "ran patrols and furnished gen": Hemingway letters, August 27, 1944, Ernest Hemingway to "Small Friend," manuscript, John F. Kennedy Presidential Library, Boston.

136 "It's a wonder he ever got to the Ritz": Taylor, "Liberating France Hemingway's Way."

136 Just east of the Place de Étoile: John Follain, "Hemingway Staged Own 'Liberation' by Invading Ritz Bar," *Deseret News*, August 25, 1944, www

.deseretnews.com/article/371853/HEMINGWAY-STAGED-OWN-LIBERATION-BY-INVADING-RITZ-BAR.html?pg=all.

137 "Otherwise everyone would think": Ibid.

11: Ernest Hemingway and the Ritz Liberated

139 "Charley [Ritz] went with me": On Hemingway's unpublished story, set at the Ritz, see Susan F. Beegel, "'A Room on the Garden Side': Hemingway's Unpublished Liberation of Paris," *Studies in Short Fiction* 31, no. 4 (Fall 1994): 627–37; Files 356a, Hemingway papers, quoted in Jacqueline Tavernier-Courbin, *Ernest Hemingway's A Moveable Feast: The Making of Myth* (Boston: Northeastern University Press, 1991), 11.

141 "Of course, Mr. Hemingway": Follain, "Hemingway Staged Own 'Liberation.'"

141 "I'm the one who is going to occupy the Ritz": Ibid.

141 "He entered like a king": Ibid.

142 "I had known him when he was seventeen": Taylor, "Liberating France Hemingway's Way."

142 Claude always said that the real liberation: Roulet, *The Ritz*, 147.

142 "Well, go get it!": Watts, *The Ritz*, 158.

143 ordered a round of seventy-three martinis: Ibid., 148.

143 "It was incredible, incredible": Taylor, "Liberating France Hemingway's Way."

143 Alan Moorehead and Ted Gilling: Watts, *The Ritz*, 148.

143 Most of the German soldiers who were left: Demonpion, *Arletty*, 269.

144 "Why should we hide the emotion": "Charles de Gaulle's speech at the City Hall of Paris: August 25, 1944," www.everything2.com/title/Charles+de+Gaulle%2527s+speech+at+the+City+Hall+of+Paris%253A+August+25%252C+1944, http://news.bbc.co.uk/onthisday/hi/dates/stories/august/25/newsid_3520000/3520894.stm.

144 a post-liberation predicament: Steegmuller, *Cocteau*, 444.

145 "It's a fine summer night": A. E. Hotchner, "The Ritz, Then and Now," *New York Times*, January 31, 1982, www.nytimes.com/1982/01/31/travel/the-ritz-then-and-now.html.

145 "Sartre joined the resistance": Riding, *And the Show Went On*, 309.

146 tricolor and the Stars and Stripes: Kershaw, *Blood and Champagne*, 145.

146 The rue Cambon bar was the chosen watering hole: Roulet, *The Ritz*, 124.

146 "Marshall and I went down": Taylor, "Liberating France Hemingway's Way."

146 "None of us will ever write a line": Ibid.

147 "Millions to defend France": Watts, *The Ritz*, 119–20.

147 "Hemingway's army": Here and following from Capa, *Slightly Out of Focus*, 188.

148 Among them were Bob Capa's friend Charlie Wertenbaker: Taylor, "Liberating France Hemingway's Way."

148 "So many people in the streets, holding hands": Ibid.

149　"I knew I should have walked to Notre Dame": Welsh, *How It Was*, 107.

150　"Look," Simone put it: Follain, "Hemingway Staged Own 'Liberation.'"

12: Those Dame Reporters

151　"I've noticed that bombs": Vaughn, *Sleeping with the Enemy*, 100.

152　"Have been to all the old places": Letter, August 27, 1944, Ernest Hemingway to "Small Friend," manuscript, John F. Kennedy Presidential Library, Boston.

153　The French Forces had their pick of a correspondent: Helen Kirkpatrick Milbank, obituary, *Independent*, January 8, 1998, www.independent.co.uk/news/obituaries/obituary-helen-kirkpatrick-milbank–1137424.html.

153　"was a loose cannon": Taylor, "Liberating France Hemingway's Way."

153　"Daughter, sit still and drink this good brandy": Nancy Caldwell Sorel, *The Women Who Wrote the War* (New York: HarperCollins, 2000), 259.

154　"It's Hemingway! It's Hemingway": Taylor, "Liberating France Hemingway's Way."

155　One of the women there with them at Vittel: Records of Vittel internees from the archives of Mémorial de la Shoah Musée, Centre de Documentation Juive Contemporaine, especially 411 AP/5; other figures who appear in this book in passing who were also interned at Vittel include Laura Mae Corrigan and Drue Tartière. See also Charles Glass, *Americans in Paris: Life & Death Under Nazi Occupation* (New York: Penguin, 2010), 253ff. Efforts to cross-reference Sylvia Beach's allusion to another woman named Sylvia, who lived at the Ritz, was nicknamed the "giraffe," and was married to a French military officer with Vittel records, have been unsuccessful.

155　Picasso, of course: James Button, "Shooting Picasso," *Age*, February 18, 2006, www.theage.com.au/news/arts/shooting-picasso/2006/02/17/1140151813201.html.

156　"the only reporter, and only photographer": Burke, *Lee Miller*, 223–24.

156　America's first use of napalm bombs: My thanks to Alan Marty and Xavier Demange for information on this point.

156　"I won't be the first woman journalist in Paris": Burke, *Lee Miller*, 228.

156　after stopping at the Palais Royal to visit Jean Cocteau: Ibid., 230.

156　"This is the first allied soldier I've seen, and it's you!": Ibid., 231.

157　celebrated the liberation of the city: Ibid.

157　"Dora, for me": Picasso to André Malraux, in André Malraux, *Picasso's Mask* (New York: Holt, Rinehart & Winston, 1976), 138.

157　*Vogue* quickly gave its correspondent: Burke, *Lee Miller*, 232.

157　"almost all located between": Dominique Veillon, *Fashion Under the Occupation*, trans. Miriam Kochan (New York: Berg, 2002), viii. Other information on nearby businesses during the occupation drawn from *Annuaire almanac du commerce* (Paris: Didot Bottin, 1942); and *Bulletin de la Chambre de Commerce de Paris, Année 1941* (Paris: Hôtel de la Chambre de Commerce, 1941). Information on locations in Paris and street views from archival materials in La Bibliothèque historique de la ville de Paris, mainly the file series labeled NA

IV, NA Album 4, Photo Divers, VII, 119, NA Divers XIV, NA Divers XXXI, 10, NA Divers XIV, NA Divers VI, and NA Album 40.

158 "I walked around": Welsh, *How It Was*, 109–10.

159 "with complications": Ibid., 110.

159 "lane of enchantment": Ibid.

159 "moving mass of people": Ibid., 111.

160 "It seemed to come from behind": Sorel, *The Women Who Wrote the War*, 259.

161 "a clearly planned attempt": Helen Kirkpatrick, *Chicago Daily News*, August 27, 1944.

161 "A beautiful, lone woman": Capa, *Slightly Out of Focus*, 145.

161 Her mind on other things, Mary: Welsh, *How It Was*, 112.

162 "Have a little of this nourishing champagne": Ibid.

13: The Last Trains from Paris

164 young French lieutenant named Alexandre Rosenberg: Lynn H. Nicholas, *The Rape of Europa: The Fate of Europe's Treasures in the Third Reich and the Second World War* (New York: Vintage, 1995), 292.

165 "I am writing this in a train": Steegmuller, *Cocteau*, 447.

167 It is impossible that they did not also know: Materials in the Rosenberg Family Archives at the Museum of Modern Art, New York, compellingly document the extent of the family's connections in the modern art world; see www.moma.org/interactives/exhibitions/2010/paulrosenberg.

169 with the now pro-fascist writer Paul Morand: Steegmuller, *Cocteau*, 443.

170 Paul Rosenberg's gallery collections: Rosenberg Family Archives, Museum of Modern Art, indicate holdings by all these artists in the records; see www.moma.org/learn/resources/archives/EAD/PaulRosenbergf.

170 The exhibition catalog: *Exposition Arno Breker: á l'Orangerie: 15 Mai–31 Juillet* (Paris: n.p., 1942).

171 modern works of art found their way: On the Swiss art market, see Paul Rosenberg, "French Artists and the War," *Art in Australia* 4, no. 4 (December–February 1941–42); and Jonathan Petropoulos, "Co-Opting Nazi Germany: Neutrality in Europe During World War II," *Dimensions: A Journal of Holocaust Studies* 11, no. 1 (1997), http://archive.adl.org/Braun/dim_14_1_neutrality_europe.asp.

14: Coco's War and Other Dirty Linen

175 "The food was done": Capa, *Slightly Out of Focus*, 189.

176 "most unforgettable day plus seven was the bluest": Ibid.

176 "The city had gone crazy with rejoicing": Welsh, *How It Was*, 109.

176 "American officers having lunch with whores": Beevor, "An Ugly Carnival."

176 Venereal diseases, the pamphlet warned: Beevor, *Paris*, 123.

177 Even the prostitutes recalled: Matthew Moore, "French Brothels 'Flourished During the Nazi Occupation,'" *Telegraph*, Mary 1, 2009, www.telegraph.co.uk/news/worldnews/europe/france/5256504/French-brothels-flourished-during-the-Nazi-occupation.html.

177 "The great joy that one should feel": Frederic Spotts, *The Shameful Peace: How French Artists and Intellectuals Survived the Nazi Occupation* (New Haven: Yale University Press, 2009), 230.

178 photographs of Marlene Dietrich: Burke, *Lee Miller*, 235. The sources are conflicting on these dates: Lee Miller left Paris in mid-September and Marlene Dietrich arrived at nearly the same time, so the dates of the crossover must have been short; ibid., 228.

178 "The wife of Steve Passeur": Veillon, *Fashion Under the Occupation*, 118.

178 "daughter of Pierre Laval, Josée de Chambrun": Ibid., 118. The identification as George Dubonnet is likely an error. There were two branches of the Dubonnet family in Paris and at the hotel during the occupation. One family—Ruth and André Dubonnet—were fascist sympathizers who spent the occupation in the capital. The other was the family of Paul and Jean Dubonnet, who are listed, with small daughter (Anne) and their Scottish nanny, Catherine Cameron (b. 1895), briefly on the Hôtel Ritz registers early in the war during 1941. My thanks to Anne Dubonnet Shiao for her extensive interview and to Alan Marty for some of the additional information related to this subject.

179 Coco Chanel had closed her atelier in 1940: Picardie, *Coco Chanel*, 246.

179 Coco Chanel had spent much of the war: Bruno Abescat and Yves Stavridès, "Derrière l'Empire Chanel . . . la Fabuleuse Histoire des Wertheimer," *L'Express*, April 7, 2005, 16–30; July 11, 2005, 84–88; July 18, 2005, 82–86; July 25, 2005, 76–80; August 1, 2005, 74–78; August 8, 2005, 80–84, part 1, 29.

180 "watched an open lorry drive past": Beevor, "An Ugly Carnival."

180 German men, some estimates suggest, fathered: Ibid.

180 "It is cruel and unnecessary": Kershaw, *Blood and Champagne*, 142.

181 Armed men had hauled him off: Demonpion, *Arletty*, 266.

181 "five horrifying days": Paul Webster, "The Vichy Policy on Jewish Deportation," February 17, 2011, *BBC History*, www.bbc.co.uk/history/worldwars/genocide/jewish_deportation01.shtml; Adrian Gilbert, "Vél d'Hiv, Paris 1942: 'These Black Hours Will Stain Our History Forever,'" *Guardian*, July 22, 2011, www.guardian.co.uk/sarahs-key/vel-dhiv-paris-1942-world-war-two-adrian-gilbert.

181 "The truth," historians remind us: Jon Henley, "Letters from Drancy," *Guardian*, July 18, 2002, www.guardian.co.uk/world/2002/jul/18/world dispatch.jonhenley.

182 "I refuse the package": Arletty, *La Défense*, 159.

183 Germaine Lubin: Ibid. Here and following quotes from ibid., 158–69.

183 They came for Jean Cocteau: His arrest was on November 23, 1944. He was ultimately acquitted.

185 "all available evidence": Quoted in Vaughn, *Sleeping with the Enemy*, 149.

185 "she paid the hotel to build a low flight": Madsen, *Chanel*, 159.

185 He and Coco probably first met: Ibid., 230.

186 "She never appeared anywhere": Marx, *Queen of the Ritz*, 174.

186 Some still say that she was a spy for the Nazi powers: For example, Vaughn, *Sleeping with the Enemy.*

187 He was a known German operative and possibly: Picardie, *Coco Chanel,* 241.

187 Baron Hans Günther von Dincklage was: See Laurence Pellegrini, "La séduction comme couverture: L'agent secret Hans-Gunther von Dincklage en France," www.dokumente-documents.info/uploads/tx_ewsdokumente/Seiten_74-76_Pellegrini_Dincklage.pdf.

188 In fact, Coco reputedly knew: Vaughn, *Sleeping with the Enemy,* 98.

188 Even from their island retreat: Bloch, *The Duke of Windsor's War,* 355.

189 According to Hans von Dincklage: Vaughn, *Sleeping with the Enemy,* 164.

189 Admiral Canaris had run von Dincklage: Ibid., 75, 178; see also Picardie, *Coco Chanel,* 240ff.

190 she gave a young German-speaking American soldier: Madsen, *Chanel,* 264–65; quoted in Mazzeo, *The Secret of Chanel No. 5,* 158.

190 "By one of those majestically simple": Madsen, *Chanel,* 263; quoted in Mazzeo, *The Secret of Chanel No. 5,* 161.

190 Serge Lifar: Vaughn, *Sleeping with the Enemy,* 182.

190 she quipped sarcastically: Madsen, *Chanel,* 262; quoted in Mazzeo, *The Secret of Chanel No. 5,* 159.

191 "assuring her of support and friendship": Roulet, *The Ritz,* 115.

191 The files in the French justice department: Vaughn, *Sleeping with the Enemy,* 193.

191 the Americans and British alike: Churchill Archives, University of Cambridge, CHAR 20/198A.

15: The Blond Bombshell and the Nuclear Scientists

195 "Might not a bomb": Winston Churchill, "Shall We All Commit Suicide," *Pall Mall,* September 1924; reprinted in Winston Churchill, *Thoughts and Adventures* (London: Thornton Butterworth, 1932), 250.

195 Marie-Louise Ritz: Marx, *Queen of the Ritz,* 195.

197 Fred Wardenburg never planned: My thanks to Sylvia Crouter for sharing details on this family history and for sharing a family essay on the topic by Andrew Tolan, April 10, 2000, "ALSOS: Defusing the Nazi Bomb Program," unpublished manuscript. As Andrew Tolan notes, the other relevant sources, to which I am indebted in my research, include Samuel A. Goudsmit, *ALSOS,* intro. David Cassidy (New York: Henry Schuman, 1947); Leslie R. Groves, *Now It Can Be Told* (New York: Harper, 1962); and Robert Thomas, "Frederic Wardenburg 3d Dies, War Hero and Executive, 92," *New York Times,* August 17, 1997, A8, www.nytimes.com/1997/08/17/us/frederic-a-c-wardenburg-3d-92-war-hero.html?_r=1.

197 "In no other type of warfare": "Report of the Committee on Political and Social Problems: Manhattan Project, 'Metallurgical Laboratory,' University of Chicago, June 11, 1945" (Franck Report), U.S. National Archives, Washington, D.C., Record Group 77, Manhattan Engineer District Re-

cords, Harrison-Bundy File, folder 76, www.dannen.com/decision/franck. html.

199 "the pope of my personal church": Welsh, *How It Was*, 127.

199 "Papa," she would tell him: Ibid.

200 venomous, nasty little "cobra": Moorehead, *Martha Gellhorn*, 296.

200 "sick with rage": Ibid., 290.

200 "There was always the impression": Donald Spoto, *Blue Angel: The Life of Marlene Dietrich* (New York: Cooper Square Press, 2000), 197.

201 Early in the war the Germans: Goudsmit, *ALSOS*, xiv, xvii, 5.

201 He used his scientific know-how: Ibid., 10, 35.

202 Wolfgang Gentner: According to Goudsmit, *ALSOS*, 35, Gentner was in Paris from 1940 until mid-1942; he was replaced by Wolfgang Riezler.

202 Everyone was disappointed: Ibid., 36.

202 "We transformed our hotel suite into a tribunal": Ibid., 59.

203 processing uranium was precisely: Ibid., 246ff.

203 "proved definitively that Germany had no": Ibid., 69.

204 "thorium oxide": Ibid., 64–65; see also Eric Zorn, "Whiter Days Ahead for Pepsodent?," *Chicago Tribune*, June 15, 2007, http://blogs.chicagotribune. com/news_columnists_ezorn/2007/06/whiter_days_ahe.html.

204 "were for conspicuous bravery in riding": Thomas, "Wardenburg," A8. He was made Member of the Order of the British Empire and awarded the Medal of Freedom from the United States, the nation's highest civilian honor.

16: From Berlin with Love and Last Battles in Paris

207 Fewer than two thousand: Webster, "Vichy Policy on Jewish Deportation."

208 A typhus epidemic: Moorehead, *Martha Gellhorn*, 282.

208 "Behind the wire and the electric fence": Ibid.

208 "This man had survived": Ibid.

208 "It is as if I walked into Dachau": Ibid.

209 Ernest Hemingway invited: Spoto, *Blue Angel*, 202–3.

211 "Part 1. This is a community effort": Kershaw, *Blood and Champagne*, 159.

211 "I hope you have enough money": Ibid.

212 Charles de Gaulle forbade British: Martin Gilbert, *The Day the War Ended: May 8, 1945, Victory in Europe* (London: Henry Holt, 1996).

212 the newest residents on the Place Vendôme: Irving, *Göring*, 86. See also Christopher John Dodd and Lary Bloom, *Letters from Nuremberg: My Father's Narrative of a Quest for Justice* (New York: Crown, 2008).

212 "Paris," he wrote: Dodd and Blom, *Letters from Nuremberg*, 65.

213 "Do you want me to tell you the set-up?": Jacques Baraduc, *Dans la cellule de Pierre Laval* (Paris: Éditions Self, 1948), 31.

214 Gellhorn at last discovered: Moorehead, *Martha Gellhorn*, 290.

17: Waning Powers in Paris

217 "The two people who have caused me": Hugo Vickers, "The People Who

Caused Me the Most Trouble Were Wallis Simpson and Hitler," *Mail Online*, March 26, 2011, www.dailymail.co.uk/femail/article-1370242/Queen-Mother-The-people-caused-trouble-Wallis-Simpson-Hitler.html#ixzz2SWSigJs.

219 "the Duke of Windsor was labeled": Robert Gottlieb, "Duke, Duchess and Jimmy D.: Question Time for the Windsors," *New York Observer*, May 3, 2001, http://observer.com/2001/03/duke-duchess-and-jimmy-d-question-time-for-the-windors; see also Christopher Wilson, *Dancing with the Devil: The Windsors and Jimmy Donahue* (New York: St. Martin's Press, 2002), 2–3.

219 "I now quit altogether public affairs": Christopher Wilson, "Revealed: The Duke and Duchess of Windsor's Secret Plot to Deny the Queen the Throne," *Telegraph*, November 22, 2009, www.telegraph.co.uk/news/uknews/theroyalfamily/6624594/Revealed-the-Duke-and-Duchess-of-Windsors-secret-plot-to-deny-the-Queen-the-throne.html.

220 recently discovered in private royal correspondence: Ibid.

221 "There should be a rigid refusal": Ibid.

221 "walking with death": Gottlieb, "Question Time for the Windsors."

223 "I knew it was physical": Wilson, *Dancing with the Devil*, 3.

223 "She was in love with him": Ibid.

223 "No one," one aristocratic onlooker put it: Caroline Blackwood, *The Last of the Duchess: The Strange and Sinister Story of the Final Years of Wallis Simpson, Duchess of Windsor* (New York: Vintage, 2012), 259.

224 "He was an alcoholic, he was a drug taker": Ibid.

224 Guinness beer fortune, Aileen Plunket: Gottlieb, "Question Time for the Windsors."

225 "I never thought Hitler was such a bad chap": Lord Kinross, "Love Conquers All," *Books and Bookmen* 20 (1974): 5.

225 an aging Marlene Dietrich came down: John Lichfield, "In Wallis's Footsteps: The Holiday Home by Royal Appointment," *Independent*, March 25, 2010, http://www.independent.co.uk/travel/europe/in-walliss-footsteps-the-holiday-home-by-royal-appointment-192878.html.

225 In Coco Chanel's suite: Lynn Karpen, "Chanel, No. 1," *New York Times*, November 15, 1998, www.nytimes.com/1998/11/15/books/books-in-brief-nonfiction-chanel-no-1.html?src=pm.

Chapter 18: The War's Long Shadow

227 "There are still scars on Paris": Dodd, letter of August 4, 1945, 65.

229 "insurrection, there is no other word for it": Joseph Carroll, "Paris Gripped by Insurrection," *Guardian*, May 26, 1968, http://century.guardian.co.uk/1960-1969/Story/0,6051,106493,00.html.

230 "We have lost twelve steady customers": Marx, *Queen of the Ritz*, 195.

231 "If you are lucky enough": Quoted in Ernest Hemingway, *A Moveable Feast* (New York: Scribner, 1996), jacket material.

231 a notebook the writer found: There is a significant scholarly debate on the history and contents of Ernest Hemingway's trunk of papers left at the

Hôtel Ritz. On the various positions in the debate, see A. E. Hotchner, "Don't Touch A Moveable Feast," *New York Times*, July 19, 2009, www .nytimes.com/2009/07/20/opinion/20hotchner.html?_r=3, and Tavernier-Courbin, *Ernest Hemingway's A Moveable Feast*, 3–19.

233 Now, she was having blackouts: Marx, *Queen of the Ritz*, 197.

233 only the thinnest crescent of the new moon: Ibid., 199–200.

Afterword

236 The price tag for the remodeling: Mohamed Al Fayed, personal website, www.alfayed.com/biography.aspx.

SELECTED BIBLIOGRAPHY

Abescat, Bruno, and Yves Stavridès. "Derrière l'Empire Chanel . . . la Fabuleuse Histoire des Wertheimer." *L'Express*, April 7, 2005, 16–30; July 11, 2005, 84–88; July 18, 2005, 82–86; July 25, 2005, 76–80; August 1, 2005, 74–78; August 8, 2005, 80–84, part 1, 29.

Allen, Martin. *Hidden Agenda: How the Duke of Windsor Betrayed the Allies*. London: Macmillan, 2000.

Ambrose, Stephen E. *Citizen Soldiers: The U.S. Army from the Normandy Beaches, to the Bulge, to the Surrender of Germany*. New York: Simon & Schuster, 2002.

———. "Citizen Soldiers: The U.S. Army from the Normandy Beaches to the Bulge to the Surrender of Germany." CNN, August 5, 1998, www.cnn.com/books/beginnings/9808/citizen.soldier.

———. *D-Day, June 6, 1944: The Climactic Battle of World War II*. New York: Simon & Schuster, 1994.

"American Relief Worker Leaves Vichy." *Los Angeles Times*, November 4, 1942, 15.

Amory, Cleveland. "'Like a Little Girl on Christmas Morn': *R.S.V.P.* Elsa Maxwell's Own Story." *New York Times*, October 24, 1954, BR6.

Annuaire almanac du commerce. Paris: Didot Bottin, 1942.

Arletty. *La Défense*. 1971; reprint, Paris: Ramsay, 2007.

Arnaud, Claude. *Jean Cocteau*. Paris: Editions Gallimard, 2003.

Baker, Carlos. *Ernest Hemingway: A Life Story*. New York: Scribner, 1969.

Baldassari, Anne. *Picasso: Life with Dora Maar, Love and War, 1935–1945*. Paris: Flammarion, 2006.

Baraduc, Jacques. *Dans la cellule de Pierre Laval*. Paris: Éditions Self, 1948.

Beauchamp, Cari. *Joseph P. Kennedy Presents: His Hollywood Years*. New York: Knopf, 2009.

Beebe, Lucius. *The Big Spenders: The Epic Story of the Rich Rich, the Grandees of America and the Magnificoes, and How They Spent Their Fortunes*. Mount Jackson, VA: Axios Press, 2009.

Beegel, Susan F. "'A Room on the Garden Side': Hemingway's Unpublished Liberation of Paris." *Studies in Short Fiction* 31, no. 4 (Fall 1994): 627–37.

Beevor, Antony. *D-Day: The Battle for Normandy*. New York: Penguin, 2009.

———"An Ugly Carnival: How Thousands of French Women Were Treated af-

ter D-Day." *Guardian*, June 4, 2009, www.guardian.co.uk/lifeandstyle/2009/jun/05/women-victims-d-day-landings-second-world-war.

Beevor, Antony, and Artemis Cooper. *Paris After the Liberation: 1944–1949*. New York: Penguin, 2007.

Bibliothèque historique de la ville de Paris, archival files NA IV, NA Album 4, Photo Divers, VII, 119, NA Divers XIV, NA Divers XXXI, 10, NA Divers XIV, NA Divers VI, and NA Album 40.

Blackwood, Caroline. *The Last of the Duchess: The Strange and Sinister Story of the Final Years of Wallis Simpson, Duchess of Windsor*. New York: Vintage, 2012.

Bloch, Michael. *The Duke of Windsor's War: From Europe to the Bahamas, 1939–1945*. London: Weidenfeld & Nicholson, 1982.

———. *Ribbentrop: A Biography*. New York: Crown, 1993.

Boxer, Mark. *Le Ritz de Paris*. London Thames & Hudson, 1991.

Bradley, Omar. *A Soldier's Story*. New York: Random House, 1999.

Brody, J. Kenneth. *The Trial of Pierre Laval: Defining Treason, Collaboration and Patriotism in World War II France*. Piscataway, NJ: Transaction, 2010.

Brook-Shepherd, Gordon. *Uncrowned Emperor: The Life and Times of Otto von Hapsburg*. New York: Continuum, 2007.

Bruce, David K. E. *OSS Against the Reich: The World War II Diaries of Colonel David K. E. Bruce*. Ed. Nelson Douglas Lankford. Kent, OH: Kent State University Press, 1991.

Büchner, Alex. *German Infantry Handbook, 1939–1945: Organization, Uniforms, Weapons, Equipment, Operations*. N.p.: Schipper, 1991.

Buchwald, Art. "Art Buchwald from Paris: Elsa and the Duchess Bury the Hatchet." *Boston Daily Globe*, June 2, 1957, C1.

Bulletin de la Chambre de Commerce de Paris, Année 1941. Paris: Hôtel de la Chambre de Commerce, 1941.

Burke, Carolyn. *Lee Miller: A Life*. Chicago: University of Chicago Press, 2007.

Button, James. "Shooting Picasso." *Age*, February 18, 2006, www.theage.com.au/news/arts/shooting-picasso/2006/02/17/1140151813201.html.

Capa, Robert. *Slightly Out of Focus*. New York: Random House, 1999.

Carroll, Joseph. "Paris Gripped by Insurrection." *Guardian*, May 26, 1968, http://century.guardian.co.uk/1960–1969/Story/0,6051,106493,00.html.

Carter, William C. *Marcel Proust: A Life*. New Haven: Yale University Press, 2002.

Caws, Mary Ann. *Picasso's Weeping Woman: The Life and Art of Dora Maar*. New York: Bullfinch Press, 2000.

Claiborne, Craig. "The Ritz: Fifty Years After Proust, It's Still a Civilized Refuge." *New York Times*, December 26, 1968, 45.

Coblentz, Paul. *Georges Mandel*. Paris: Éditions du Bélier, 1946.

Cocteau, Jean. *The Journals of Jean Cocteau*. Ed. and trans. Wallace Fowlie. Bloomington: Indiana University Press, 1964.

Cole, Hubert. *Laval: A Biography*. New York: Putnam Books, n.d., www.archive.org/stream/lavalabiography007674mbp/lavalabiography007674mbp_djvu.txt.

Cote, William E. "Correspondent or Warrior? Hemingway's Murky World War II 'Combat' Experience." *Hemingway Review* 22, no. 1 (Fall 2002).

Dansette, Adrian. *Histoire de la libération de Paris*. 1946; reprint, Paris: Perrin, 1994.

Demonpion, Denis. *Arletty*. Paris: Flammarion, 1996.

Diamond, Hanna. *Fleeing Hitler: France 1940*. Oxford: Oxford University Press, 2008.

Dicken-Garcia, H. *Journalistic Standards in Nineteenth-Century America*. Madison: University of Wisconsin Press, 1984.

Dodd, Christopher John, and Lary Bloom. *Letters from Nuremberg: My Father's Narrative of a Quest for Justice*. New York: Crown, 2008.

Duffy, James P., and Vincent Ricci. *Target Hitler: The Plots to Kill Hitler*. New York: Praeger, 1992.

Dupuis, Jérôme. "Le beau nazi d'Arletty." *L'Express*, October 2, 2008, www.lexpress .fr/culture/livre/le-beau-nazi-d-arletty_823070.html.

Dutka, Alan, and Dan Ruminski. *Cleveland in the Gilded Age: A Stroll Down Millionaires' Row*. Stroud, UK: History Press, 2012.

Eder, Cyril. *Les Comtesses de la Gestapo*. Paris: Bernard Grasset, 2006.

Favreau, Bertrand. *Georges Mandel, ou, La passion de la République 1885–1944*. Paris: Édition Fayard, 1996.

Fest, Joachim. *Plotting Hitler's Death: The Story of the German Resistance*. Trans. Bruce Little. New York: Metropolitan Books/Henry Holt, 1996.

Fitch, Noel Riley. *Sylvia Beach and the Lost Generation: A History of Literary Paris in the 1930s*. New York: Norton, 1985.

Fitzgerald, F. Scott. *Tales of the Jazz Age*. New York: Soho Books, 2011.

Follain, John. "Hemingway Staged Own 'Liberation' by Invading Ritz Bar." *Deseret News*, August 25, 1944, www.deseretnews.com/article/371853/ HEMINGWAY-STAGED-OWN-LIBERATION-BY-INVADING-RITZ-BAR.html?pg=all.

Foreign Office Archives, Berlin, file Paris 2463 (42). "Ritz-Hotel, deutschfeindliches Verhalten des leitenden Personals, 1943."

"France Opens Doors of Gestapo's Paris Headquarters to Public for First Time." *Taipei Times*, September 19, 2005, www.taipeitimes.com/News/world/archives/ 2005/09/19/2003272328/2.

Frischauer, Willi. *Goering*. London: Oldham's Press, 1950.

Fryer, Jonathan. "Inga Haag Obituary: German Socialite and Spy Who Conspired to Overthrow Hitler." *Guardian*, January 13, 2010, www.guardian.co.uk/ theguardian/2010/jan/13/inga-haag-obituary.

Gaulle, Charles de. *The Complete War Memoirs of Charles de Gaulle*. Trans. Richard Howard. New York: Carroll & Graf, 1998.

Gellhorn, Martha. *Travels with Myself and Another: A Memoir*. New York: Tarcher, 2001.

———. "The Wounded Come Home: Under the Sign of the Red Cross, the White Ship Returns to London with its Precious Freight." *Collier's Weekly*, August 5, 1944, 14–15, www.unz.org/Pub/Colliers-1944aug05-00014.

Gellner, Ernest. *Anthropology and Politics: Revolutions in the Sacred Grove*. Oxford: Blackwell, 1995.

Gerwarth, Robert. *Hitler's Hangman: The Life of Heydrich*. New Haven: Yale University Press, 2011.

Gilbert, Adrian. "Vél d'Hiv, Paris 1942: 'These Black Hours Will Stain Our History Forever.'" *Guardian*, July 22, 2011, www.guardian.co.uk/sarahs-key/vel-dhiv-paris–1942-world-war-two-adrian-gilbert.

Gilbert, Martin. *The Day the War Ended: May 8, 1945, Victory in Europe*. London: Henry Holt, 1996.

Gildea, Robert. *Marianne in Chains: Daily Life in the Heart of France During the Occupation*. New York, Picador, 2004.

Gilot, Françoise, and Carlton Lake. *Life with Picasso*. London: Thomas Nelson & Sons, 1965.

Giltay, Christophe. "Chanel: une étoffe pas très résistante." RTL-Info, August 18, 2012, http://blogs.rtl.be/champselysees/2011/08/18/chanel-une-etoffe-pas-tres-resistante.

Giret, Nöelle. *Sacha Guitry*. Paris: Éditions Gallimard, 2007.

Gisevius, Hans Bernd. *Valkyrie: An Insider's Account of the Plot to Kill Hitler*. New York: Da Capo Press, 2008.

Glass, Charles. *Americans in Paris: Life & Death Under Nazi Occupation*. New York: Penguin, 2010.

Gottlieb, Robert. "Duke, Duchess and Jimmy D.: Question Time for the Windsors." *New York Observer*, May 3, 2001, http://observer.com/2001/03/duke-duchess-and-jimmy-d-question-time-for-the-windors.

Goudsmit, Samuel A. *ALSOS*. Intro. David Cassidy. New York: Henry Schuman, 1947.

Groves, Leslie R. *Now It Can Be Told*. New York: Harper, 1962.

Guieu, Jean-Max. "Chronology of the Dreyfus Affair." www9.georgetown.edu/faculty/guieuj/DreyfusCase/Chronology%20of%20the%20Dreyfus%20Affair.htm.

Guitry, Sacha. *If Memory Serves: Memoirs of Sacha Guitry*. Trans. Lewis Galantière. Whitefish, MT: Kessinger, 2009.

———. *Quatre ans d'occupation*. Paris: Éditions L'Elan, 1947.

Harpprecht, Klaus. *Arletty und ihr deutscher Offizier*. Fischer e-books, 2011.

Heller, Gerhard. *Un Allemand à Paris, 1940–1944*. Paris: Éditions de Seuil, 1981.

Hemingway, Ernest. *By-Line: Ernest Hemingway: Selected Articles and Dispatches of Four Decades*. Ed. William White. New York: Scribner, 1998.

———. *Letters of Ernest Hemingway*. Ed. Sandra Spanier. Cambridge: Cambridge University Press, 2011.

———. "Voyage to Victory: *Collier's* Correspondent Rides in the War Ferry to France." *Collier's Weekly*, July 22, 1944, 11–13, www.unz.org/Pub/Colliers–1944jul22–00011?View=PDF.

Hemingway, Leicester. *My Brother, Ernest Hemingway*. Sarasota, FL: Pineapple Press, 1996.

Henley, Jon. "Letters from Drancy." *Guardian*, July 18, 2002, www.guardian.co.uk/world/2002/jul/18/worlddispatch.jonhenley.

Higham, Charles. *The Duchess of Windsor: The Secret Life*. New York: Wiley, 2004.

———. *Trading with the Enemy: The Nazi-American Money Plot 1933–1949*. New York: Barnes & Noble Books, 1995.

Hotchner, A. E. "Don't Touch *A Moveable Feast*." *New York Times*, July 19, 2009, www.nytimes.com/2009/07/20/opinion/20hotchner.html?_r=3.

———. "A Legend as Big as the Ritz." *Vanity Fair*, July 2012, www.vanityfair.com/society/2012/07/paris-ritz-history-france.

———. "The Ritz, Then and Now." *New York Times*, January 31, 1982, www.nytimes.com/1982/01/31/travel/the-ritz-then-and-now.html?scp=1&sq=ritz+then+and+now&st=nyt.

Huffington, Arianna Stassinopoulos. *Picasso*. New York: HarperCollins, 1996.

Hughes, Judith M. *To the Maginot Line: The Politics of French Military Preparation in the 1920s*. Cambridge, MA: Harvard University Press, 2006.

International Committee of the Red Cross. "Geneva Convention (IV) Respecting the Laws and Customs of War on Land and Its Annex: Regulations Concerning the Laws and Customs of War on Land, 18 October 1907," www.icrc.org/ihl.nsf/FULL/195?OpenDocument.

Irving, David. *Göring: A Biography*. New York: William Morrow, 1989.

Jackson, Julian. *The Fall of France: The Nazi Invasion of 1940*. Oxford: Oxford University Press, 2004.

James, Ken. *Escoffier: The King of Chefs*. London: Hambledon Continuum, 2003.

Jewish History Center, Paris. Archives 411 AP/5.

Jucker, Ninetta. *Curfew in Paris: A Record of the German Occupation*. London: Hogarth Press, 1960.

Kaplan, Richard L. *Politics and the American Press: The Rise of Objectivity, 1865–1920*. Cambridge: Cambridge University Press, 2002.

Karpen, Lynn. "Chanel, No. 1." *New York Times*, November 15, 1998, www.nytimes.com/1998/11/15/books/books-in-brief-nonfiction-chanel-no-1.html?src=pm.

Katznelson, Yitzak. *Vittel Diary, May 22, 1943–September 16, 1943*. Trans. Myer Cohen. N.p.: Kibbutz Lohamei Hagettaot, 1972.

Kershaw, Alex. *Blood and Champagne: The Life and Times of Robert Capa*. New York: Da Capo, 2002.

Kert, Bernice. *Hemingway's Women*. New York: Norton, 1998.

Knopp, Guido. *Die Wehrmacht: Eine Bilanz*. München: C. Bertelsmann Verlag, 2007.

Koyan, Kenneth. "Snapshots of Mary Welsh Hemingway." *Eve's Magazine*, www.evesmag.com/hemingway.htm.

Laub, Thomas J. *After the Fall: German Policy in Occupied France, 1940–1944*. Oxford: Oxford University Press, 2010.

Laval, Pierre. *The Diary of Pierre Laval, with a Preface by Josée Laval, Countess R. de Chambrun*. New York: Scribner's, 1948.

Levert, Jean-Pierre, Thomas Gomart, and Alexis Merville. *Paris, Carrefour des resistances*. Paris: Paris Musées, 1994.

Lichfield, John. "In Wallis's Footsteps: The Holiday Home by Royal Appointment." *Independent*, March 25, 2010, www.independent.co.uk/travel/europe/in-walliss-footsteps-the-holiday-home-by-royal-appointment-1926878.html.

Liddell-Hart, B. H. *The Rommel Papers.* New York: Da Capo, 1982.

Lifar, Serge. *Ma Vie, from Kiev to Kiev: An Autoboigraphy.* London: Hutchinson, 1970.

Lochner, Louis P. "Germans Marched Into a Dead Paris: Muddy Uniforms at the Ritz." *Life,* July 8, 1940.

Madsen, Axel. *Chanel: A Woman of Her Own.* New York: Holt, 1991.

Malraux, André. *Picasso's Mask.* New York: Holt, Rinehart & Winston, 1976.

Marneffe, Francis de. *Last Boat from Bordeaux.* Cambridge, MA: Coolidge Hill Press, 2001.

Marty, Alan T. "Index of Names and Locations in Occupied Paris." Unpublished manuscript.

———. "A Walking Guide to Occupied Paris: The Germans and Their Collaborators." Unpublished manuscript.

Marx, Samuel. *Queen of the Ritz.* New York: Bobbs-Merrill, 1978.

Masters, Brian. *Great Hostesses.* London: Constable, 1982.

Maxwell, Elsa. "My Troubles with the Windsors: The Famous Hostess at Last Talks About Her 'Feud.'" *Washington Post,* December 5, 1954, AW1.

Mazzeo, Tilar J. *The Secret of Chanel No. 5: The Intimate Story of the World's Most Famous Perfume.* New York: HarperCollins, 2012.

Mémorial de la Shoah Musée, Centre de Documentation Juive Contemporaine, 411 AP/5.

Meyer, F. M. "Ein Beitrag zum Morphinismus und zu der Behandlungsmethode nach Kahle." *Deutsche medizinische Wochenschrift,* 1928.

Meyers, Jeffrey. *Hemingway: A Biography.* New York, Da Capo Press, 1999.

Mitchell, Allan. *Nazi Paris: The History of an Occupation 1940–1941.* New York: Berghahn Books, 2008.

Moore, Matthew. "French Brothels 'Flourished During the Nazi occupation.'" *Telegraph,* May 1, 2009, www.telegraph.co.uk/news/worldnews/europe/france/5256504/French-brothels-flourished-during-the-Nazi-occupation.html.

Moorehead, Caroline. *Martha Gellhorn: A Life.* New York: Vintage, 2004.

Morris, Sylvia. *Rage for Fame: The Ascent of Clare Boothe Luce.* New York: Random House, 1997.

National Archives, Paris, 2463 [42]. "Ritz-Hotel, deutschfeindliches Verhalten des leitenden Personals," 1943.

National Archives, Paris, F7 14886. "Affaires Allemands," item 533.

National Archives, Washington D.C. "Report of the Committee on Political and Social Problems: Manhattan Project 'Metallurgical Laboratory.' University of Chicago, June 11, 1945." Record Group 77, Manhattan Engineer District Records, Harrison-Bundy File, folder 76, www.dannen.com/decision/franck.html.

Neitzel, Sönke. *Tapping Hitler's Generals: Transcripts of Secret Conversations, 1942–1945.* New York: Frontline Books, 2007.

Nemirovsky, Irene. *Suite Française.* Trans. Sandra Smith. New York: Knopf, 2006.

Nicholas, Lynn H. *The Rape of Europe.* New York: Knopf, 1994.

Orwell, George. "You and the Atomic Bomb." *Tribune,* October 19, 1945.

Paxton, Robert O. *The Anatomy of Fascism.* New York: Knopf, NY, 2004.

———. *Vichy France: Old Guard and New Order, 1940–1944.* 1972; reprint, New York: Columbia University Press, 2001.

Pellegrini, Laurence. "La séduction comme couverture: L'agent secret Hans-Günther von Dincklage en France." www.dokumente-documents.info/uploads/tx_ewsdokumente/Seiten_74–76_Pellegrini_Dincklage.pdf.

Petropoulos, Jonathan. *Art as Politics in the Third Reich.* Chapel Hill: University of North Carolina Press, 1999.

Petters, H. F. W. "The Method of Hubert Kahle for the Abrupt Withdrawal of Narcotics." *Medical Journal and Record*, 1930.

Picardie, Justine. *Coco Chanel: The Legend and the Life.* London: It Books, 2011.

Picasso, Marina. *Picasso.* New York: Vintage, 2002.

"Post-War Reports: Activity of the Einsatzstab Reichsleiter Rosenberg in France: C.I.R. No.1 15 August 1945." Commission for Looted Art in Europe, www.lootedart.com/MN51H4593121.

Pourcher, Yves. *Pierre Laval vu par sa fille.* Paris: Cherche Midi, 2002.

"Prince of Wales Enables Former Waitress to Laugh at Scoffers." *Boston Globe*, August 2, 1931, B5.

Proust, Marcel. *The Guermantes Way, Remembrance of Things Past (À la recherche du temps perdu, 1913–27).* Trans. C. K. Scott Moncrieff. 6 vols. Vol. 3. New York: Henry Holt, 1922.

———. *Letters of Marcel Proust.* Trans. Mina Curtiss. New York: Random House, 1949.

Pryce-Jones, David. *Paris in the Third Reich: A History of the German Occupation 1940–1944.* New York: Holt, Rinehart, and Winston, 1981.

Rambler, Nash. "Proust's Last Infatuation: Hélène Chrissoveloni, Princesse Soutzo, Madame Morand." *Esoterica Curiosa*, http://theesotericcuriosa.blogspot.com/2010/01/prousts-last-infatuation-helene.html.

"Remembrance It Was Incredibly Macabre." *Time*, September 4, 1989.

Reynolds, Michael. *Hemingway: The 1930s Through the Final Years.* New York: Norton, 2012.

Ricchiardi, Sherry. "Gun-Toting Journalists." *American Journalism Review*, October/November 2005, www.ajr.org/Article.asp?id=3969.

Richards, Dick. *The Wit of Noël Coward.* London: Sphere Books, 1970.

Richardson, John. *Life of Picasso: The Triumphant Years, 1917–1932.* New York: Knopf, 2010.

Riding, Alan. *And the Show Went On: Cultural Life in Nazi-Occupied Paris.* New York: Knopf, 2010.

Rioux, Jean-Pierre. "Survivre." In François Bédarida, ed., *Résistants et collaborateurs.* Paris: Seuil, 1985, 84–100.

Ritz, Marie-Louise. *César Ritz.* Paris: Éditions Jules Tallandier, 1948.

Robb, Graham. "Parisians: An Adventure History of Paris." *Guardian*, April 20, 2010, www.guardian.co.uk/books/2010/apr/03/parisians-adventure-history-graham-robb.

Roulet, Claude. *The Ritz: A Story That Outshines the Legend.* Trans. Ann Frater. Paris: Quai Voltaire, 1998.

Ryersson, Scot D., and Michael Orlando Yaccarino. *Infinite Variety: The Life and Legend of the Marchesa Casati*. Minneapolis: University of Minnesota Press, 2004.

Salpeter, Harry. "Fitzgerald, Spenglerian." *New York World*, April 3, 1927, 12M.

Schallert, Edwin. "Snooty Stars Always Giving One Another the Ritz." *Los Angeles Times*, November 19, 1933, A1.

Schellenberg, Walter. *The Labyrinth*. Trans. Louis Hagen. New York: Da Capo, 2000.

Schudson, Michael, and Chris Anderson. "Objectivity, Professionalism, and Truth-Seeking in Journalism." In *Handbook of Journalism Studies*, ed. Karin Wahl-Jorgensen and Thomas Hanitzsch. New York: Routledge, 2008, 88–101.

Schwarz, Ted. *Cleveland Curiosities: Eliot Ness and His Blundering Raid, a Busker's Promise, the Richest Heiress Who Never Lived and More*. Stroud, UK: History Press, 2010.

"Sells Furs to Aid French: U.S. Woman, Unable to Get Funds, Plans to Leave Vichy." *New York Times*, September 26, 1942, 4.

Sherwood, John M. *Georges Mandel and the Third Republic*. Stanford: Stanford University Press, 1970.

Shnayerson, Michael. *Irwin Shaw*. New York: Putnam, 1989.

Sorel, Nancy Caldwell. *The Women Who Wrote the War*. New York: HarperCollins, 2000.

Soussen, Claire. *Le camp de Vittel, 1941–1944*. Ed. André Kaspi. Paris: Pantheon Sorbonne, 1993, degree thesis.

Speer, Albert. *Inside the Third Reich*. New York: Simon & Schuster, 1997.

Speidel, Hans. *Invasion 1944*. New York: Paperback Library, 1972.

Spotts, Frederic. *The Shameful Peace: How French Artists and Intellectuals Survived the Nazi Occupation*. New Haven: Yale University Press, 2009.

Staggs, Sam. *Inventing Elsa Maxwell: How an Irrepressible Nobody Conquered High Society, Hollywood, the Press, and the World*. New York: St. Martin's Press, 2012.

Steegmuller, Francis. *Cocteau: A Biography*. New York: David R. Godine, 1992.

Sutcliffe, Theodora. "Bar Icon: Frank Meier." May 1, 2012, www.diffordsguide.com/class-magazine/read-online/en/2012–05–01/page–7/bar-icon?seen=1.

Taittinger, Pierre. *Et Paris Ne Fut Pas Detruit*. Paris: Temoignages Contemporains Élan, 1948.

Tartière, Drue. *The House Near Paris: An American Woman's Story of Traffic in Patriots*. New York: Simon & Schuster, 1946.

Tavernier-Courbin, Jacqueline. *Ernest Hemingway's A Moveable Feast: The Making of Myth*. Boston: Northeastern University Press, 1991.

Taylor, Michael. "Liberating France Hemingway's Way: Following Author's 1944 Reclaiming of the Ritz Hotel." *San Francisco Chronicle*, August 22, 2004, www.sfgate.com/travel/article/Liberating-France-Hemingway-s-way-Following–2731590.php#ixzz24qFzKEty.

Thayer, Mary Van Rensselaer. "Fabulous Era Ended with Laura Corrigan." *Washington Post*, January 27, 1948, B3.

Thomas, Robert. "Frederic Wardenburg 3d Dies, War Hero and Executive, 92." *New York Times*, August 17, 1997, A8.

United Nations Office on Drugs and Crime. "Bibliography: Treatment of Morphine Addiction, II." www.unodc.org/unodc/en/data-and-analysis/bulletin/bulletin_1952–01–01_1_page007.html.

University of Cambridge. Churchill Archives. CHAR 20/198A.

Valland, Rose. *Le front de l'art: défense des collections française, 1939–1945*. Paris: Librarie Plon, 1961.

Varenne, Francisque. *Georges Mandel, Mon Patron*. Paris: Éditions Défense de la France, 1947.

Vaughn, Hal. *Sleeping with the Enemy: Coco Chanel's Secret War*. New York: Knopf, 2011.

Veillon, Dominique. *Fashion Under the Occupation*. Trans. Miriam Kochan. New York: Berg, 2002.

Vickers, Hugo. "The People Who Caused Me the Most Trouble Were Wallis Simpson and Hitler." *Mail Online*, March 26, 2011, www.dailymail.co.uk/femail/article–1370242/Queen-Mother-The-people-caused-trouble-Wallis-Simpson-Hitler.html#ixzz2SWSigJs.

Wallace, Mike. Interview with Elsa Maxwell, November 16, 1957. Harry Ransom Center, University of Texas at Austin, archives. Transcript and video, www.hrc.utexas.edu/multimedia/video/2008/wallace/maxwell_elsa_t.html.

Walsh, John. "Being Ernest: John Walsh Unravels the Mystery Behind Hemingway's Suicide." *Independent*, August 9, 2012, www.independent.co.uk/news/people/profiles/being-ernest-john-walsh-unravels-the-mystery-behind-hemingways-suicide–2294619.html.

Watts, Stéphane. *The Ritz*. London: Bodley Head, 1963.

Webster, Paul. "The Vichy Policy on Jewish Deportation." BBC History, February 17, 2011, www.bbc.co.uk/history/worldwars/genocide/jewish_deportation_01.shtml.

Welsh, Mary. *How It Was*. New York: Ballantine, 1977.

Whelan, Richard, ed. *Robert Capa: The Definitive Collection*. London: Phaidon Press, 2004.

White, Edmund. *Proust*. New York: Viking, 1999, excerpt at www.nytimes.com/books/first/w/white-proust.html.

White, William, ed. *Dateline, Toronto: The Complete Toronto Star Dispatches, 1920–1924*. New York: Scribner's, 1985.

Whiting, Charles. *Papa Goes to War: Ernest Hemingway in Europe, 1944–1945*. Ramsbury, UK: Crowood Press, 1991.

Williams, Elizabeth Otis. *Sojourning, Shopping, and Studying in Paris: A Handbook Particularly for Women*. Chicago: A. G. McClurg, 1907.

Wilson, Christopher. *Dancing with the Devil: The Windsors and Jimmy Donahue*. New York: St. Martin's Press, 2002.

———. "Revealed: The Duke and Duchess of Windsor's Secret Plot to Deny the Queen the Throne." *Telegraph*, November 22, 2009, www.telegraph.co.uk/

news/uknews/theroyalfamily/6624594/Revealed-the-Duke-and-Duchess-of-Windsors-secret-plot-to-deny-the-Queen-the-throne.html.

Woodrum, Henry C. *Walkout*. N.p.: iUniverse, 2010.

Zorn, Eric. "White Days Ahead for Pepsodent?" *Chicago Tribune*, June 15, 2007, http://blogs.chicagotribune.com/news_columnists_ezorn/2007/06/whiter_days_ahe.html.

PHOTOGRAPHY CREDITS

Prologue, "The Hôtel Ritz" (page 1): German troops and French civilians, 1940 (Getty Images, 141555216, Mondadori).

1. "This Switzerland in Paris" (page 7): A Frenchman weeps, watching Nazi troops occupy Paris, June 14, 1940 (Office of War Information, National Archives, Washington, DC, ARC 535896).

2. "All the Talk of Paris" (page 23): Courtroom trial, the Dreyfus Affair, 1896–99 (Getty Images, 107412386, RM/Gamma/Keystone).

3. "Dogfight above the Place Vendôme" (page 39): Luisa, Marquise Casati (Getty Images, 141555399, Mondadori).

4. "Diamonds as Big as the Ritz" (page 49): Laura Mae Corrigan (Cleveland State University Archives, Michael Schwartz Library).

5. "The Americans Drifting to Paris" (page 61): Ernest Hemingway, 1944 (Getty Images, 3312466, Picture Post, Kurt Hutton/Stringer).

6. "The French Actress and Her Nazi Lover" (page 75): Still shot, Arletty in *Les visiteurs du soir* (The Devil's Envoys), 1942 (Getty Images, 2638086, Hulton Archive/Stringer).

7. "The Jewish Bartender and the German Resistance" (page 87): The Hôtel Ritz Bar, Paris, just before the occupation (Getty Images, 145253043, Roger Viollet).

8. "The American Wife and the Swiss Director" (page 103): Blanche Auzello (photograph from the first decade of the twentieth century).

9. "The German General and the Fate of Paris" (page 115): General Leclerc's arrival in Paris during the liberation, August 1944 (Getty Images, 152232439, Universal Images Group).

10. "The Press Corps and the Race to Paris" (page 123): Robert Capa, Olin L. Tompkins, and Ernest Hemingway at Mont Bocard, France, July 30, 1944 (Getty Images, 50691570, Time/Life Images).

11. "Ernest Hemingway and the Ritz Liberated" (page 139): Crowds celebrate in Paris, Arc de Triomphe, 1944 (Getty Images, 50654762, Time/Life Images).

12. "Those Dame Reporters" (page 151): Sniper fire at the Hôtel de Ville, crowds fall to the ground during the liberation of Paris (Getty Images, 104420310, Gamma/Keystone, August 1, 1944).

13. "The Last Trains from Paris" (page 163): Studio with paintings by Pablo Picasso (Getty Images, 50516574, Time/Life Pictures, Nat Farbman, October 31, 1948).

14. "Coco's War and Other Dirty Linen" (page 175): Coco Chanel (Getty Images, 56226843, Roger Viollet Collection, January 1, 1937).

15. "The Blond Bombshell and the Nuclear Scientists" (page 195): Assimilated Colonel Fred Wardenburg, 1944 (Courtesy Sylvia Crouter).

16. "From Berlin with Love and Last Battles in Paris" (page 205): Marlene Dietrich at the Hôtel Ritz after the liberation (Getty Images, 50409886, Time/Life Pictures, Ralph Morse, October 1, 1944).

17. "Waning Powers in Paris" (page 217): Party for the Duke and Duchess of Windsor in the 1950s, with the Woolworths (Getty Images, 3088537, Premium Archive, Slim Aarons/Stringer).

18. "The War's Long Shadow" (page 227): Claude Auzello, in his office at the Hôtel Ritz (Getty Images, 106501020, Gamma/Keystone).

Afterword (page 235): Charley Ritz, on the balcony of the Hôtel Ritz (Getty Images, 121508742, Robert Doisneau, Gamma-Rapho).

INDEX

Page numbers in italics refer to illustrations.

Abetz, Otto, 81–83, 100, 118, 166
Abwehr (German intelligence), xvi, 2,
 55–56, 94, 117, 187–89
Abetz, Suzanne, 81
À la recherche du temps perdu (Proust),
 38, 46, 48
Algeria, 228
Allied airmen, 79, 91, 104–5, 154,
 159–60
Allied intelligence, 186–87
 nuclear weapons and, 196, 198,
 201–4
Allies, 201
 casualties of, 121
 Charles de Gaulle vs. Anglo-
 American, 83, 121, 144, 178, 206,
 212, 214–15, 226, 228–30, 237
 liberation of Paris and, xvi, 118–22,
 133–35, 146
 Normandy invasion and advance of,
 70–74, 77, 80–81, 104
 in Paris, post-liberation, 176, 212
Alsos mission, 196, 198, 201–4
Amen, John H., 212
anti-Semitism, 27, 29–30, 42, 83, 179,
 188. *See also* Dreyfus Affair; Jews
Apollinaire, Guillaume, 41
Ardennes forest, 8
Arletty (Léonie Marie Julie Bathiat,),
 xv, xix, xx, xxii, 12, 19, *75*, 165,
 170, 233

advance of Allies and, 81, 85–86
affair with Hans-Jürgen Soehring
 and, 77–78, 80–81, 85–86
arrested for collaboration, 179,
 181–83, 186, 196
background of, 76–79
Georges Mandel and, 84
Pierre Laval and, 84–85
Arman de Caillavet, Madame, 28–29,
 38
Artistry of Mixing Drinks, The (Meier),
 87, 95
art. *See also* specific artists
 Breker exhibition and Nazi, xvi,
 167–71
 "degenerate," 106, 169, 171, 173
 German looting of, 105–8, 113–14,
 165–69, 171–73
Aurore, L' (newspaper), 29, 38
Auschwitz, 166–67
Austro-Hungarian Empire, 15
Auzello, Blanche Rubenstein (Ross),
 xiii, 10, 55, *103*
 air raids and, 109–10, 112, 114
 Coco Chanel and, 186–87
 Ernest Hemingway and, 70
 film industry and, 78
 Gestapo arrest and torture of, 88–95,
 102, 109–13, 233
 Jewish background of, 89–92
 murder-suicide and, 234

Auzello, Blanche Rubenstein (Ross)
 (cont.)
 postwar problems of, 231–33
 resistance and, 92–95, 109–10
 Hans Günther von Dincklage and,
 187
Auzello, Claude, xiii–xiv, 10, 20, 55,
 70, 93, 210, 227
 Blanche's arrest and, 108–9, 113
 Ernest Hemingway and, 140–43
 liberation and, 140
 loses Ritz position, 229–33
 May 1968 and, 229–30
 murder-suicide and, 233–34
 resistance and, 93, 95, 102
avant-garde, 41–46, 168

"Babylon Revisited" (Fitzgerald), 49
Baker, Josephine, 60
Bakst, Léon, 43
Ballets Russes, 16, 43
Bank of France, 18
Barjansky, Catherine, 45
Barton, Raymond "Tubby," 126
Bastille Day riots of 1944, 89, 96, 98
Bathiat, Léonie. See Arletty
BBC, 144
Beach, Sylvia, 69, 154–55
Beaumont, Count de, 42, 168
Beaumont, Countess de, 42, 168
Beauvoir, Simone de, xix, 145, 149–50
Bedaux, Charles, 56, 218
Bedaux, Fern, 56, 218
Belgium, 10, 15, 228, 237
Belle Époque, 27, 32, 36
Bergen-Belsen, 209
Bergman, Ingrid, xvii, xviii, xxii,
 210–12, 214
Bergson, Henri, 23
Bernhardt, Sarah, xiv, xx, 28, 36, 38,
 233
Betts, Edward C., 212
Bienvenue au Soldat, 54, 60
black market, 42, 63, 108, 190, 212,
 214

Bogart, Humphrey, xxii, 210
Boineburg Lengsfeld, Baron Hans
 von, 116
Bonnard, Abel, 170
Bradley, Omar, 120, 121–22, 144
Braque, Georges, 168, 172
Brasillach, Robert, 83, 169–70
Breker, Arno," xvi, 167–71
Breker, Demetra, xvi, 167, 169, 171
Bretty, Béatrice, 12–13, 76, 82, 84
Brinon, Fernand de, 170, 187
Britain (United Kingdom). See also
 Allies; London
 European Union and, 228, 237
British intelligence (MI-6), 56, 93–94,
 187–91, 198
British Royal Air Force, 70, 91
British troops, 140–41
British Union of Fascists, 225
Bruce, David, 129, 132, 135, 140, 146
Buchenwald, 82, 117, 208

Café de la Paix, 136, 137, 140
Café Voisin, 77
Canadian Royal Air Force, 96–97
Canaris, Wilhelm, xvi, 56, 78, 187–89,
 191
 British double agents and, 94, 189
 disappearance of, 95
Capa, Robert, xvii, xviii, xxii, 74, 123
 affair with Ingrid Bergman and,
 210–14
 D-Day and, 71–73, 153
 death of, 230
 Ernest Hemingway's race to liberate
 Ritz and, 124–35, 143–44,
 147–49
 London party of, before D-Day,
 63–65, 67–68
 Martha Gellhorn and, 125, 207,
 214–15
 post-liberation Paris and, 154, 161,
 175–77, 180
Carné, Marcel, 76, 79
Cartier firm, 58

Casablanca (film), xxii, 210
Casati, Luisa, Marquise, xx–xxi, *39*, 43–46
Castiglioni, Virginia Oldoini Verasis, Countess di, 30–31
Cecil, Rupert, 198
Cézanne, Paul, 168, 172
Chambrun, Josée Laval, Countess de, xxi–xxii, 19, 79, 81, 90, 178–79
Chambrun, René, Count de, 75, 90
Chanel, Coco, xv, xvi, xvii, xix, xxi, xxii, 2, 168, *175*
 affair with Hans Günther von Dincklage and, 78, 185–89, 192
 affair with Vera Lombardi and, 189
 air raids and, 79
 Berlin trips of, 95, 187
 Blanche Auzello and, 90
 collaboration suspected of, 179, 184–92
 German advance on Paris and, 11–13, 19
 Jews and, 90, 165, 179
 liberation and, 158
 postwar Ritz and, 225, 231
 prewar Ritz and, 44, 53, 69
 Windsors and, 225
Chanel No. 5, 57, 179, 190, 202
Chavannes, Pierre André, 95
Chicago Daily News, 152, 153, 160
Choltitz, Dietrich von, xv–xvi, 115–19, 122, 135, 140
Churchill, Clementine, 205–6
Churchill, Randolph, 188
Churchill, Winston, xvi, 55, 180, 195
 atomic bomb and, 204
 Charles de Gaulle and, 80, 83, 121, 144
 Coco Chanel and, 11, 188–89, 191
 Georges Mandell and, 9–10, 13, 82–83
 Windsors and, 188, 219, 221
 U-boats and, 65
Ciano, Count Galeazzo, 58–59, 163, 221

Cocteau, Jean, xvi, xvii, xix, 12, 39, 233
 collaboration suspected of, 179, 183–84, 188
 collaborators and Breker circle and, 144–45, 169–70
 liberation of Paris and, 144–45, 156, 160–61, 176–77
 Max Jacob's deportation and, 165–66
 occupation and, 110–11
 Paul Rosenberg and, 167–68
 Princess Soutzo party with Proust and, 40–41, 43, 46–48
Cold War, 4–5, 204, 215, 237
collaborators, 5
 Arletty as "horizontal," xx, 79, 83–86, 182–83, 196
 Coco Chanel as "horizontal," 184–93
 Dreyfus Affair and, 204
 head shaving or *épuration sauvage* of "horizontal," 144–45, 179–83
 Jean Cocteau and, 144–45
 legal purges and, 181–84, 196
 resistance strikes vs., 117
 Ritz socialites and, 166–67
 Philippe Pétain and Pierre Laval convicted as, 213
Collier's, 65, 66, 68, 70, 71, 74, 128, 154, 208
Colville, Jock, 180
Combat (newspaper), 145
Compagnie Intercommerciale, 94
concentration camps, 82, 117, 166–67, 206–9. *See also* specific camps
Constantini, Pierre, 94
Corrigan, James, 52
Corrigan, Laura Mae Whitrock, xx, *49*, 51–60, 155, 233, 236
Courcy, Kenneth de, 220–21
Cousteau, Pierre-Antoine, 83
couture houses, 12–13, 47, 95, 157–59, 178–79
Coward, Noël, 79
Creative Evolution (Bergson), 23
Curie, Marie, 201

Dabescat, Olivier (maître d'hôtel), xiv, 31, 35, 40, 42, 44–45, 48, 218
Dachau, 208–9
D'Annunzio, Gabriele, 36, 44
Darnand, Joseph, 80
Darrieux, Danielle, 199
D-Day, 70–74, 77, 79-80, 89, 91–92.
 See also Normandy campaign
Degas, Edgar, 29
Denmark, 237
Depression, 52
Derain, André, 170–71
Diaghilev, Serge, 12, 16–17, 43, 168
Didion, Joan, 1
Dietrich, Marlene, xvii, xviii, xxi, 205
 affair with James Gavin and, 209, 214
 affair with Joseph Kennedy and, 55
 Ernest Hemingway and, 199–200
 Lee Miller photos of, 178
 Martha Gellhorn and, 199–200, 206–7, 209–10, 214
 postwar life of, 225, 231, 233
 search for mother and, 209, 214
Dincklage, Baron Hans Günther von "Spatzy," xv, xxi, 78, 185–92
Dodd, Thomas S., 212, 227
Donahue, Jimmy, 222–24
Dongen, Kees van, 170
Doudeauville, Duke de, 54
Drancy transit camp, 108, 165, 172, 183
Dreyfus, Alfred
 charged with treason, 27
 second inquiry and, 27, 29
Dreyfus Affair and Dreyfusards, 23, 26–32, 36–38, 41–42, 83, 166, 225–26
Dronne, Raymond, 122
Dubonnet, Anne, 13, 19
Dubonnet, George, 178–79
Dubonnet, Jean, 19
Dubonnet, Paul, 19
Du Pont laboratories, 203

Eiffel Tower, 15, 47, 135, 146, 234
Eisenhower, Dwight D., 119
Einsatzstab Reichsleiter Rosenberg (ERR), 107, 172–73
Eldridge, Mona, 223
Elizabeth, Queen Mother of England, 217
Elizabeth II, Queen of England, 220–21, 224
Elminger, Hans Franz, xiii
 eve of occupation and, 10–11, 14–15
 German arrival and, 16, 20, 55
 German looting and, 105–7
 Göring and, 57
 Hemingway and, 140, 142, 158–59
 refugees hidden by, 108–9
 Ritz finances and, 18
 wines hidden by, 147
Elminger, Lucienne, xiii, 108, 141–43, 191
Enfants du paradis, Les (film), 79
Escoffier, Auguste, xiv, xx, 233
 affair with Sarah Bernhardt, 28, 35
 dining modernized by, 33–35, 230
Esterházy, Prince, 29, 218
European Coal and Steel Community, 218
European Economic Community (ECC), 178, 228, 237
European Union (EU), 3, 228

Fayed, Mohamed Al, 236
Fellowes, Daisy Glücksbierg, 55–56
Figaro, Le (newspaper), 26
Final Solution, 166–67, 181
Fitzgerald, F. Scott, xix, 12, 49, 52, 62, 69, 233
Flanner, Janet, 53
Folies Bergère, 35
France
 atomic bomb and, 228
 colonies of, 228
 Nazi invasion of, 8
 postwar elections and, 213–15
 postwar Europe and, 121, 218, 237

France, Anatole, 28
France Zone Handbook No. 16, Part III (Allied pamphlet), 176
Franco-German "roundtable" lunches, 3, 178, 237
Free French Forces, xxi, 119, 153, 168, 184
Free French government-in-exile, xvi, 13
French Forces of the Interior (Forces Françaises de l'Intérieur, FFI), 108, 117, 164, 182, 190
French Gestapo. *See* Milice
French government. *See also* Free French government-in-exile; Vichy France
Dreyfus Affair and, 26–27, 29
flees to Bordeaux, 10, 13–14
French Ministry of Justice, 30, 109
French national railway (SNCF), 10, 164–65
French resistance, 20, 88–94, 104, 108–14. *See also* Maquis
Arletty attempt to hide and, 182–83
Auzellos and, 87–96, 109–14
burning of Paris and, 118–19
Charles de Gaulle and, 206
Frank Meier and, 87–91, 93–96, 102, 108, 110
gray area and, 5
Jean Frédéric Joliot-Curie and, 201–2
Jean-Paul Sartre and, 145
last deportations and, 164–65
memories of, in modern France, 4
murder of Georges Mandel as warning to, 81
post-liberation purges and, 180
size of, in France, 80
SNCF workers and, 164–65
torture of, 110–11
French Second Armored Division, 131, 133, 135–36, 153, 164
French soldiers, Corrigan charity for, 60

Fresnes prison camp, 183
Freud, Sigmund, 46

Gauguin, Paul, 168, 172
Gaulle, Charles de, xvi, xxi, 77, 168
Anglo-American Allies vs., 80, 83, 120–21, 178, 205–6, 212, 214–15, 226, 228, 230, 237
elected president of France, 214–15
enters Paris on liberation, 143–44
German invasion and, 7–8, 14, 50
Laura Mae Corrigan and, 60
liberation parade and, 153, 159–61
May 1968 and, 229
Paul Morand and, 184
Philippe Pétain sentence and, 213
postwar Europe and, 214–15, 228, 236–37
resignation of, 228
V-J Day and, 212
Winston Churchill and, 13, 80, 83
Gaullist party, 77
Gavin, James, xviii, 200, 207, 209, 213–14
Gellhorn, Martha "Marty," xvii, xviii, xxi
affair with James Gavin and, 200, 207, 209, 213–14
concentration camps and, 207–9, 212
D-Day and, 70–74, 124, 153
divorces Hemingway, 209–10
Marlene Dietrich and, 199–200, 206–7, 209–10, 214
marriage to Ernest Hemingway and, 65–70, 74, 124, 125, 196, 199
postwar Germany and, 213–14
race to liberate Ritz and, 124, 148–49
Robert Capa and, 125
V-E Day and, 209
Gentner, Wolfgang, 202
George VI, King of England, 219–21, 224

Gestapo, xviii, 79, 88–89, 99, 202
 Blanche Auzello arrested by, 91–93,
 109–13
 end of occupation and, 117, 165
 plot to kill Hitler and, 101, 196
German Möbel-Aktion "Operation
 Furniture," 172
German resistance, 78, 87–102, 116,
 187–88
 arrest of SD and SS by, 96–100
 seek separate peace, 189–90
 plot to kill Hitler and Göring,
 88–89, 94–102, 189–90
German submarines (U-boats), 65–66
Germany
 postwar, 206, 215, 218, 228
 unified post-communist, 237
 Weimar Republic, 50
 World War I and, 40, 43, 45–47
Germany, Nazi, xv–xvi, 3. See also
 specific events; individuals; and
 military and governmental units
 Aryanized French culture and,
 167–68
 D-Day landings and, 91–92
 entry to Paris of, June 14, 1940, 7,
 8–21
 evacuation of Paris by, on advance of
 Allies, 20–21, 81–82, 85, 119–22,
 140
 final tourism in Paris with Allied
 advance, 104–5
 invasion of France by, 7–8, 56
 last shots vs. liberators in Paris,
 160–61
 looting of art and luxury goods by,
 105–7, 113–14, 164–65, 171–73
 nuclear physicists, 197, 201
 nuclear weapons research and, 201
 officers arrival at Ritz and, 16–17
 resistance attacks of officers and,
 170–71
 surrender of, in Europe, 209
 surrender of, in Paris, 143–44, 146
Gibson, Hugh, 15

Gilling, Ted, 143
Goebbels, Joseph, 17
Gorer, Dr. Peter, 63–64
Göring, Hermann, xv, 233, 236
 art and luxury goods and, 56–59,
 105–6, 163, 169, 171
 Adolf Hitler and, 105
 Claude Auzello's nickname for, 93
 morphine and, 50–51, 58
 nuclear weapons and, 201
 Nuremberg trials and, 212
 plot to assassinate, 88, 91, 94, 96,
 98–99, 189
 Ritz suite of, 18–19, 50–51, 54
 Sacha Guitry and, 182
 suicide of, 230
 Windsors and, 219
 World War I and, 47
Goudsmit, Samuel, 198–99, 202,
 204
Gould, Florence Jay, 55, 169
Grant, Bruce, 130
Great Gatsby, The (Fitzgerald), 52
Greece, 237
Greep (Jewish forger), 91
Greffulhe, Countess de, 28
Grey, Lady de, 29, 34–35
Groves, Leslie, 198
Grüger, Dr. Franz, 94
Guerlain perfume, 57
Guitry, Sacha, xix, xxii, 11, 29, 77, 81,
 85–86, 165, 168, 170, 179, 233
 arrest of, 181–82, 196
Gulbenkian, Calouste, 35

Haag, Inga, 55–56, 94–95
Haberstock, Karl, 106–7, 171
Happy Honey Annie cocktail, 95
Hapsburg, Otto von, 15
Hemingway, Ernest "Papa," xiv, xvii,
 xviii, xix, xxi, 9, 12, 13, 61, 168,
 233
 affair with Mary Welsh and, 64–65,
 67–68, 124, 149–50, 152, 158–59,
 161–62, 196, 198–200, 211

affair with Simone de Beauvoir and, 150

Blanche Auzello and, 70

Charley Ritz and, 69–70

D-Day and, 70–71, 74

divorces Gellhorn, 209–10

Helen Kirkpatrick and, 153–54

in London on eve of D-Day, 62–68

marriage to Martha Gellhorn and, 65–69, 74, 124–25, 196, 199–200

race to liberate Ritz and, *123*, 124–33, 135–37, 139–43, 145–53, 160

Ritz bar and, pre–World War II, 68–69

Robert Capa and, 125–28, 231

suicide of, 231

Sylvia Beach and, 154–55

Hemingway, Mary. *See* Welsh, Mary

Heydrich, Reinhard, 166, 169

Himmler, Heinrich, 88, 100

Hirohito, Emperor of Japan, 211

Hiroshima and Nagasaki bombings, 196, 211

Hitler, Adolf, xv

art and, 106, 168–69, 171

atomic bomb and, 193, 197

Corrigan goods and, 59

D-Day and, 70

failure of war and, 105

orders burning of Paris, xvi, 117–19, 122

plot to assassinate, xv, 20, 88–89, 91, 94–100, 104, 116, 188–89, 229

rise to power of, 50, 153

Ritz kept open by, 18

tours Paris, 16–17, 89

Windsors and, 56, 219, 225

Ho Chi Minh, 228

Hofacker, Caesar von, xv, 88, 96–101, 189

Hôtel Crillon, 17, 160

Hôtel du Nord (film), 76

Hôtel Georges V, 17, 93

Hôtel Lincoln, 207

Hôtel Lutétia, 94

Hôtel Majestic, 100

Hôtel Meurice, 119

Hôtel Raphäel, 99, 100

Hôtel Ritz, xiii

Adolf Hitler's tour of Paris and, 16–17

air raids and, 79–80, 109–10, 114

American press corps and, post-liberation, 177–79, 209–10

artists and social networks in, pre-occupation, 11–13

artists and socialites in, and collaboration with Germans, 77–81, 84–86 165–71, 178–79

artists and socialites in, post-liberation, 198–99

artists and socialites in, xix, 11–13, 19, 32–33, 35–45, 74

art looted by Germans and, 20, 105–8, 164, 166–70, 171–73

as epitome of modern luxury and, 8–9, 32–34

as mirror of Paris, 1–5

Charles de Gaulle and plan for postwar Europe and, 178–79, 214–15, 237

Claude Auzello let go by, 231–34

collaborators and, 3–5, 19–20

collaborators and purges and, post-liberation, 181–92, 196, 212–13

coutures and, 33, 157–58, 178–79

design of, 8–9, 17–18, 32–34, 108

Dietrich von Choltitz's arrival in, and Hitler's order to burn Paris, 116–22

dinner in, on eve of occupation, 14–15

dinner in, on night of liberation, 146–48

Dreyfus Affair and, 26–32, 36–39, 41–42, 166

Hôtel Ritz *(cont.)*
 Ernest Hemingway and journalists
 and, post-liberation, 152–62,
 198–200, 208–9
 Ernest Hemingway and Robert
 Capa's race to "liberate," xix, 62,
 123–50
 Ernest Hemingway on, 61, 231
 espionage and spies in, 2–3, 19–21
 evacuation on eve of liberation and,
 81-
 eve of liberation and, 76–77, 79–86
 eve of occupation and, 9–16
 F. Scott Fitzgerald on, 49
 fading of, postwar, 225–26, 229–33,
 236
 film industry and glitterati and, xx–
 xxi, 19, 78–79, 210–12
 finances of, 18, 29
 French resistance and, 5, 20, 88–94,
 104, 108–14
 gala opening of, 24–36
 German arrival in Paris and, 7–9,
 15–21
 German officers and, xv–xvi 3–4,
 19–20
 German officers and, affairs with
 French women, 77–79, 185–92
 German resistance and plot to kill
 Adolf Hitler and, 88, 94–102,
 188, 196, 229
 Hans von Pfyffer inspects, post-
 liberation, 196
 Hermann Göring takes Laura Mae
 Corrigan's imperial suite in, 18,
 50–59
 hidden rooms and closets in, 58,
 108
 Ingrid Bergman's affair with Capa
 and, 210–12, 214
 journalists and writers and, xvii–xix,
 14–16, 64–65, 68–70, 74
 kept open during occupation, 13–14,
 17–19
 liberation and, 140–43, 192–93

 Marcel Proust at Princess Soutzo's
 party in, during World War I,
 40–48
 Marcel Proust's novel and, 37–38, 46
 May 1968 uprising and, 229
 nuclear scientists and, 193, 196–98,
 201–4
 Nuremberg tribunal officials and,
 212
 partitioning of, and corridor joining
 sides of, 17–19
 politicians and, xvi–xvii, 9
 postwar problems of, 225–26,
 228–32
 remodeled and reopening of, in 2014,
 237–38
 remodeled, in 1979, 236
 rue Cambon side, 17, 19, 33
 spies in, 78, 108
 staff of, xiii–xiv, 11, 20
 Swiss ownership of, 10, 13–14,
 33–34, 105 109, 196
 war crimes tribunals and, 212–13
 Windsors and, 218–25
 Winston Churchill visits, 9–10
Hôtel Ritz bar (rue Cambon side), 88
 Ernest Hemingway liberates, 137,
 143, 145–47, 198–201
 espionage and resistance at, 94–95,
 102, 108
 Marlene Dietrich at, 210–11
 nuclear scientists at, 198, 201–2
 pre–World War II, 68–69
 Robert Capa and Ingrid Bergman at,
 210–11
Hôtel Scribe, 146, 148, 149, 157, 176,
 209
Huis Clos (Sartre), 76–77, 84
Hutton, Barbara (Princess Troubetz-
 koy), 55, 222–23

Indignité nationale, 181
Indochina, 228, 230
Ireland, 237
Italy, 125, 228, 237

J'accuse (Zola), 29
Jackson, Robert H., 212
Jacob, Max, 165, 168
Japan, surrender of, 211
Jarreau, Charles, 72
Je Suis Partout (newspaper), 83
Jeu de Paume, 171
Jews
 Blanche Auzello as, 89–90, 112
 Coco Chanel and, 90, 179, 185–86,
 188
 concentration camps and, 207–8
 deportations of, xvii, 83, 165–67,
 171–72, 207
 Dreyfus Affair and, 26–38
 Elmingers hide, 108
 extermination of, in Russia, 118
 false papers for, 95
 flee Paris, 168
 Georges Mandel as, 13, 83
 Marcel Proust as, 29–30
 property confiscated, 168
 Ritz celebrities and, 37, 42
Joliot-Curie, Jean Frédéric, 201–2
Jünger, Ernst, 78
Justin, Elaine "Pinky," 67

Kahle, Hubert, 51
Keitel, Wilhelm, 103
Keller, Freddy, 214
Kennedy, Joseph, 55
Kharmayeff, Lily, 91–93, 109, 111–13
Khokhlova, Olga, 41
Kirkpatrick, Helen, xvii, 152–54, 160,
 196
Kluge, Günther von, 96–100

L'Allinec, Jean-Marie, 129–30, 136,
 142–43
La Roche-Guyon (German military
 headquarters), 90, 98
Laval, Pierre, xvii, xxi, 79–81, 170,
 178, 187, 233
 assassination of Georges Mandel
 and, 82–85

daughter Josée and, 90
deportations of Jews and, 181
trial and execution of, 213
Windsors and, 219
Leclerc, Philippe, *115*, 120–22, 131,
 133, 136, 144, 153, 164
Lelong, Lucien, 178
liberation, xvi, xvii, xviii, xix, xxii,
 139, 151
 Charles de Gaulle and, 143–44
 Charles de Gaulle's parade celebrat-
 ing, 159–61
 collaborationists fear of reprisals and,
 83–84
 Free French arrive in Paris and, *115,*
 119–22
 purges following, 144–45, 179–84,
 192, 213
 Robert Capa vs. Ernest Hemingway
 race to Ritz and, 124–37
 women journalists and, 152–62
Lifar, Serge, 165, 170–71, 190
Life, 15, 55, 67, 71, 124, 156, 230
Linstow, Hans von, 99, 101
Lochner, Louis, 15–16
Lombardi, Vera Bate, 188–89
London
 Baby Blitz, 63
 Blitz, 80, 153
Lost Generation, 12, 62
Lubin, Germaine, 183
Luce, Clare Boothe, 15, 55, 151
Luftwaffe (German air force), 10
 bombing of London" 63
 Hermann Göring and, 50
 last attack on Paris, post-liberation,
 162
 thefts by, on evacuation, 105
 World War I and, 47
Luxembourg, 228, 237

Maar, Dora, 12, 157, 168
Maginot Line, 8–9
Mamelles de Tirésias, Les (Apolli-
 naire), 41

Mandel, Claude, 13
Mandel, Georges, xvi–xvii, 11, 184, 233
 affair with Bretty and, 12–13, 82
 assassination of, 81–83
 flees Paris on eve of occupation, 13–14
 internment of, 81–82, 84
 Winston Churchill and, 9–10, 12, 121, 144
Manhattan Project, xviii, 193, 196–98, 203
"Manifesto of the Intellectuals," 29
Maquis (French pro-communist resistance forces), 129
Marat, Princess, 42
Marcel (resistance fighter), 129
Marconi, Lana, 182
Marshall, S. L. A., 129, 132–33, 136, 146
Mata Hari (Margaretha Zelle), 43
Maxwell, Elsa, xx, 52–53, 60, 218, 224, 233
Meier, Frank (bartender), xiv, 141, 198
 resistance and, 87–91, 93–96, 102, 108, 110
Mendl, Lady, 55
Mesmer, Franz, 46
Meurice, Hotel, 17
Mikhailovich, Michael, Grand Duke, 35
Milice (French Gestapo), 20, 80–82, 108
Miller, Lee, xvii, 12, 148, 155–57, 168, 178–79, 196
Mitford, Diana, 225
modernism, 37, 42, 57, 168–69, 171–72
Monier, Adrienne, 154–55
Monks, Noel, 65
Montesquiou, Robert, Comte de, 26, 28, 30–31, 36, 38
Moorehead, Alan, 143
Morand, Paul, xvii, xxi, 40–42, 46, 48, 169, 184, 225
Morse, Ralph, 132

Mosley, Sir Oswald, 225
Moveable Feast, A (Hemingway), 231
Mussolini, Benito, 59, 221

Nacht und Nebel (German terrorism policy), 103, 110
napalm, 156
Nazi Party (NSDAP), 168
Netherlands, 228, 237
New Yorker, 53
Normandy campaign, 70–74, 77, 79–81, 91, 121, 124–25, 134, 148, 153, 155, 180, 200, 201
North Atlantic Treaty Organization (NATO), 228–29
Notre Dame Cathedral, 160–62
nuclear weapons, xviii, 196–204, 206, 211, 228
Nuremberg tribunals, 212–13, 230

Oberg, Carl, 100
occupation. See also collaborators; French resistance; German resistance; Germany, Nazi; liberation; Paris; and specific events and individuals
 Americans stay in Paris during, 54–56
 arts and, 165–69
 brothels and, 178
 fashion industry and, 178–79
 as mass urban terrorism, 5
 Normandy invasion foreshadows end of, 77
 sensitivity of subject of, in modern France, 3–5
 theaters and, 76
 Windsors escape from France on eve of, 219
Office of Strategic Services (OSS), 106, 107, 129
Oldfield, Barney, 200
Omaha Beach, 71
Otero, Carolina "La Belle," 36

Parade (ballet), 41

Paris. *See also* specific events and
 locations
 Adolf Hitler orders burning of,
 117–19, 122
 Adolf Hitler tours, 16–17
 aftermath of liberation in, 175–76
 air raids and, 79–80, 112, 162
 Allied airmen hidden in, 104–5
 Allied conflict, and liberation of,
 119–21
 art world and Nazi looting of, 106–7,
 113–14, 164, 166–73
 as artistic center, 32
 atomic research and, 201–3
 bombing of, by Nazis, 10
 Charles de Gaulle's liberation parade
 in, 159–61
 Dreyfus Affair and, 26–27
 exodus from, on eve of occupation,
 10, 12–15
 food shortages in, 78, 147, 206
 journalists race to, on liberation,
 124–53
 last days of occupation, in 1944, 62
 last trains from, at end of occupation,
 117
 May 1968 uprising in, 229–30
 Nazi executions in, 117
 Nazi exodus from, pre-liberation,
 105, 116–22
 Nazi fascination with, 9, 104–5
 Nazi invasion and occupation of,
 7–10, 15–21
 Nazi torture and fear pervading,
 110–13
 Nazi victory parade in, 16
 postwar, 212–13
 purges in, post-liberation, 144–45
 reprisals in, for shooting of German
 officers, 170–71
 salons and society of 1890s and,
 27–38
 war between resistance and collabo-
 rators in, 83–84
 war's long shadow in, 227
 World War I and, 40–48

Paris, Treaty of (1951), 218

Passeur, Steve, 178, 179

Patton, George S., 132, 203

Pelkey, Archie "Red," 126–27, 129,
 132, 140, 147–48, 158, 162

Pétain, Philippe, 60
 trial and sentence of, 213

Pfyffer, Hans von, xiii, 109, 196

Pfyffer d'Altishofen, Baron Maximil-
 ien von, 109

Philip, Prince Consort of England,
 220

Picasso, Pablo, xvi, xvii, 12, 77, *163*,
 165
 Ballets Russes and, 41, 43
 exhibitions banned, 106–7
 liberation and, 155–57
 paintings of, as "degenerate," 106
 paintings of, bought and looted by
 Germans, 57, 106–7, 167–68,
 170–72

Place Vendôme, 17–18, 33, 94

Plunket, Aileen, 224

Polish émigré government, 15

Portugal, 237

Pougy, Liane de, 35

Pourtalès, Mélanie, Countess de, 28,
 36–38

Pour une nuit d'amour (film), 92

prostitutes, 176–78, 184

Protazanov, Yakov, 92

Proust, Marcel, xiv, xvii, xix, xxi, 70,
 166, 184, 233, 235
 Dreyfus Affair and, 27–32, 37–38
 gala opening of Ritz and, 24–26,
 34–38
 novel by, 38, 46
 Princess Soutzo and, 40–42,
 46–48
 salons and, 28–29, 31
 World War I and, 47

Pushkin, Aleksandr, 35

"Putting on the Ritz" (song), 69

Ray, Man, 156, 168
Rebattet, Monsieur "Colonel Renard,"
 108
Reinach, Joseph, 29, 42
Reinhart, John, 154
"Renard, Colonel." *See* Rebattet,
 Monsieur
Renoir, Pierre-Auguste, 168, 172
Reverdy, Pierre, 168
Reynaud, Paul, 9
Ribbentrop, Joachim von, 187, 212
 affair with Wallis Simpson and, 56,
 221
Ritz, Betty, 70
Ritz, César, xiii, 10, 17, 24, 33–34, 108
Ritz, Charles "Charley," xiv, 69–70,
 139, 230–33, *235*, 236
Ritz, Marie-Louise "Mimi"; "Madame
 Ritz," xiii, xvi
 death of, 232
 design and furnishings of Ritz and,
 17, 44, 159
 eve of occupation and arrival of
 Germans and, 10–11, 13–14, 16,
 18, 82
 Hans von Pfyffer and, 109, 196
 opening of Ritz and, 24
 resistance and, 93
 son Charley and, 69–70
Rommel, Erwin, 15, 90
 death of, 96–97
 plot to kill Hitler and, 96–97, 101
"Room on the Garden Side, A" (Hem-
 ingway), 139
Rooney, Andy, 130
Rosenberg, Alexandre, xxi, 164,
 166–73
Rosenberg, Paul, 167–70
Russia, 118

St. Malo, battle of, 156
San Francisco Chronicle, 130
Sartre, Jean-Paul, xix, 76–77, 84,
 110–11, 145, 149–50
Schellenberg, Walter, 95, 187

Scheuer, Georges, xiv, 141–42
Schiaparelli, Elsa, 156
Schoenebeck Maximiliane von, 185
Schutzstaffel militia (SS), 88, 95,
 97–98, 100
Shakespeare and Company, 69, 154
"Shall We All Commit Suicide?"
 (Churchill), 195
Shaw, Irwin, xviii, 64–65, 67, 130,
 152, 210–11, 230–31
Sicherheitsdienst (SD), 97, 99, 100
Soehring, Hans-Jürgen, xv, xx, 77,
 80–81, 85–86
Soutzo, Princess Hélène Chrissove-
 loni, xvii, xxi, 40–43, 46–48, 166,
 169, 184, 225
Spanish Civil War, 70, 92, 125,
 133–34, 214
Speidel, Hans, xv, 16, 189
 arrest of, 196
 NATO and, 229
 plot to kill Hitler and, 88–90, 94–97,
 101
 residence in Ritz and, 18, 89–90
Stauffenberg, Prince Claus von, 97,
 98, 99
Stein, Gertrude, 168
Stevens, George, 130
Stevenson, "Stevie," 126–27
stock market crash of 1929, 53–54
Straus, Geneviève, 28, 29, 42, 47
Strickland, Hubert, 133
Stülpnagel, Carl-Heinrich von, xv,
 78–79, 182, 189
 arrest of, 88, 100–101
 execution of, 196
 plot to kill Hitler and, 94–100, 116
surrealism, 41–43
Süss, Monsieur, xiv, 107, 109, 113–14,
 171
Switzerland, 237
 art market and, 106–7, 173
 Claude Auzello's resistance network
 and, 93
 neutrality of, 13–14

ownership of Ritz and, 10, 13–14, 33–34, 105, 109, 196

Taro, Gerda, 134
Tartière, Drue, 78, 155
Tavernier, Jacqueline, 140
Time, 55, 65, 128, 132, 146, 157
Tompkins, Olin L., *123*
Torby, Countess of, 35
Toulouse-Lautrec, Henri de, 168, 172
Tour d'Argent, 78
Toward a Professional Army (de Gaulle), 7
Troubetzkoy, Princess. *See* Hutton, Barbara
Truman, Harry S., 212

United Nations, 206
United States
 Laura Mae Corrigan funds frozen by, 54
 World War I and, 45–46
U.S. 82nd Airborne Division, 200
U.S. Fourth Infantry Division, 121–22, 125, 129
United States Overseas (USO), 199, 209
Updike, John, 184–85

Valkyrie, Operation. *See* Hitler, Adolf, plot to assassinate
Valland, Rose, 172
Vélodrome d'Hiver, 181–82
Versailles, Treaty of (1917), 46, 101
Vichy France, xvii, 179, 187
 German expenses at Ritz paid by, 18
 Jews rounded up by, 171
 last days of occupation and, 117
 Laura Mae Corrigan and, 59–60
 Paul Morand and, 184
 taxes and, 146–47
 terror operations of, 80
Vichy Ministry of Justice, 82
Vietnam, 228
Vieubois, Émile, 136

Vittel internment camp, 60, 155
V-J Day, 212–13
Vlaminck, Maurice de, 170, 171
Vogue, xvii, 155, 157, 178, 196

Wardenburg, Fred, xviii, *195*, 196–99, 201–4
Wardenburg, Martha, 197–98
Wash, Eric, 198
Wehrmacht (German army), 104, 110, 171
 Group B, 90, 96
Welsh, Mary (*later* Mary Hemingway), xviii, 74, 129, 148
 affair with Ernest Hemingway, begun in London, 64–65, 67–68
 affair with Ernest Hemingway, in Paris, 152, 158–59, 161–62, 196, 198–99, 211
 arrives in Paris, 149–50, 157–58, 161–62, 176
 death of Ernest Hemingway and, 231
 Ernest Hemingway's race to liberate Ritz and, 124, 132, 135–37
Wendland, Hans, 106, 107, 171
Wertenbaker, Charles, 128, 131, 133–34, 146, 148, 152, 157–58, 180
Westminster, Richard Arthur Grosvenor, Duke of, 188, 189
Westover, John, 129, 132, 146
Wiegand, Hauptmann, 94
Wilde, Oscar, 31, 32, 34, 45
William, Elizabeth, 34
Windsor, Duchess of (*formerly* Wallis Simpson), xx, 12, 32, 217–25, *217*, 231
 affair with Jimmy Donahue and, 222–25
 affair with Joachim von Ribbentrop and, 56
 duke's plan to regain throne and, 218–22, 225
 marries former Edward VIII, 56, 188

Windsor, Duke of (*formerly* Edward
VIII, King of England), xx, 12,
153, *217*
 abdication of, 219–20
 affairs of, 221
 marries Simpson, 56, 188
 memoirs of, 222
 postwar, 231
 postwar attempt to regain throne
 and, 219–25
 as Prince of Wales, 32, 218

Woodrum, Henry, xviii, 104, 154,
159–60
World War I, 8, 40–48
World War II, end of, 20–21, 209,
211–13. *See also* specific events;
individuals; and locations

Yalta summit (1945), 206

Zelle, Margaretha (Mata Hari), 43
Zola, Émile, 29–30, 38

About the Author

Tilar J. Mazzeo is the author of numerous works of cultural history and biography, including the *New York Times* bestselling *The Widow Clicquot*, *The Secret of Chanel No. 5*, and nearly two dozen other books, articles, essays, and reviews on wine, travel, and the history of luxury. The Clara C. Piper Associate Professor of English at Colby College, she divides her time between coastal Maine, Paris, and New York City.